SIENA AND THE VIRGIN

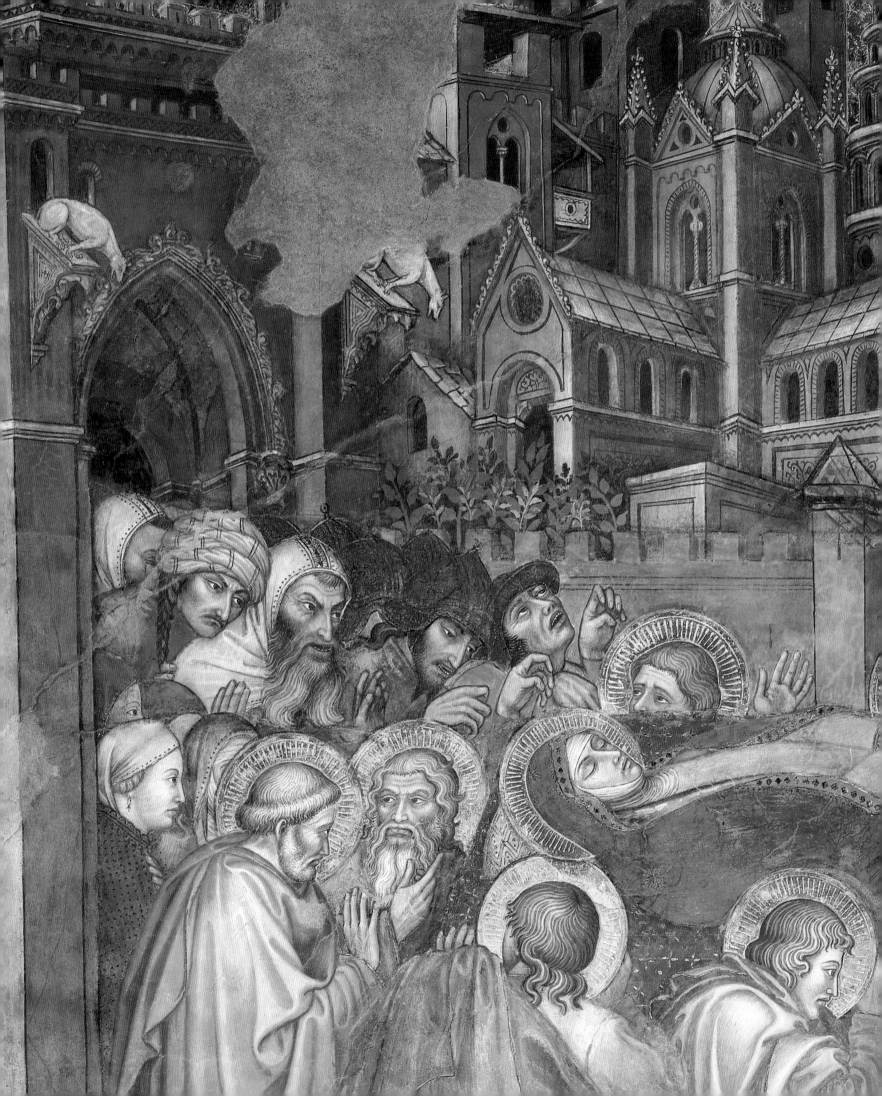

Siena and the Virgin

ART AND POLITICS IN A LATE MEDIEVAL CITY STATE

Diana Norman

YALE UNIVERSITY PRESS
NEW HAVEN AND LONDON

Designed by Kate Gallimore
Typeset in Bembo by Best-set Typesetter Ltd., Hong Kong
Printed in Italy

This book is published with the assistance of the Getty Grant Program.

Library of Congress Cataloging-in-Publication Data
Norman, Diana, 1948–
 Siena and the Virgin: art and politics in a late medieval city state / Diana Norman.
 p. cm.
 Includes bibliographical references and index.
 ISBN 0-300-08006-9 (cloth: alk, paper)
 1. Art—Political aspects—Italy—Siena Region. 2. Art patronage—Italy—Siena
 Region. 3. Art, Gothic—Italy—Siena Region. 4. Art, Italian—Italy—Siena Region.
 5. Mary, Blessed Virgin, Saint—Art.
 I. Title
 N72.P6N67 1999
 704.9 4855 09455809023—dc21 99–25442
 CIP

Title page illustration: Taddeo di Bartolo, *The Funeral Procession of the Virgin*, detail of Pl. 212.

CONTENTS

O Maria, la tua Siena difendi
(traditional Sienese hymn)

FOREWORD

As any visitor to the city will swiftly learn, modern Siena remains, self-consciously, the 'city of the Virgin' and the Sienese still retain a particular devotion to Mary which reaches a triumphant climax twice yearly in the staging of the world-famous Palio, when horses, representing different sections of the city, race around Siena's central square, the Campo, competing to win a banner designed and decorated in honour of the Virgin. It is also quickly apparent to anyone who consults one of the numerous guidebooks to the city that this honouring of the Virgin as the patron saint and spiritual protector of the city originated as early as the thirteenth century, when Siena enjoyed considerable political power and influence within southern Tuscany. Such devotion also had a marked impact upon late medieval Sienese art when painters, such as Duccio, Simone Martini, and both Pietro and Ambrogio Lorenzetti, and sculptors, such as Tino di Camaino, Goro di Gregorio, and Agostino di Giovanni, produced graceful and majestic images of the Virgin. These expressions of late medieval Sienese culture have long received due acknowledgement from generations of scholars, both in the chronicles and reminiscences of earlier periods and in the scholarly research of the nineteenth and twentieth centuries.

Like other late medieval city communes, Siena was dependent on its outlying subject territories, or *contado*, which provided the city with food, materials, manpower and political influence. Indeed, within the rich holdings of the state archive in Siena, there survives an impressive amount of documentation regarding the acquisition of towns, castles and communities within the Sienese *contado* and their subsequent administration by the Sienese government. In many of these subject communities there were also further striking examples of artistic projects – and especially images celebrating the Virgin – frequently executed by the same artists who worked so influentially and impressively in Siena itself. And again, the existence of such a cultural and artistic interaction between Siena and its subject territories has been recognised in previous scholarship and research.

In recent years there has also been a trend towards the reassessment – in much more positive terms – of the Sienese art of the latter half of the fourteenth century. In place of an older and more conventional view that, after the impact of the Black Death in 1348, Sienese art lost its creative edge and innovative capacity – becoming instead inward-looking and 'old-fashioned', whilst creativity and innovation passed elsewhere, and above all to Florence – there have been a number of laudable attempts to reassess Sienese artists of the second half of the fourteenth century and to recognise their own continuing vitality and achievements. What has not so far been examined with sufficient care, however, is the extent to which both the relationship

between the work of Sienese artists before and after the crisis of the Black Death, and the relationship between Marian imagery in Siena itself and in the *contado*, are intimately linked to the self-conscious development of a Sienese civic ideology during the fourteenth century and its expression through specifically Marian art and imagery.

It is the aim here to explore the growth of this civic ideology during the fourteenth century, and its expression in a succession of artistic projects dedicated to the celebration of the Virgin, both in Siena itself and in prominent locations within the Sienese *contado*. Thus, the first half of the book explores the development of this ideology and its artistic expression in the three principal civic locations within Siena: the cathedral, the Palazzo Pubblico, and the Spedale di Santa Maria della Scala. The remainder of the book then explores the expression of this ideology in the context of the *contado*: at a prominent rural hermitage belonging to the Augustinian Hermits at San Leonardo al Lago, and in the three influential subject towns of Massa Marittima, Montalcino, and Montepulciano.

While acknowledging the existence of much more overtly and explicitly political imagery in such prestigious schemes as the frescoes of the Sala dei Nove and the ante-chapel in the Palazzo Pubblico, this study deliberately focuses exclusively on Marian imagery and its potential ideological dimensions and implications for the Sienese and their associates and allies in the *contado*. The particular examples of such imagery that are studied suggest a marked preference for two specific types of Marian iconography, one depicting the Virgin enthroned with her son and surrounded by saints and angels – the *Maestà* type – and the other encompassing a rich variety of subjects derived from hagiographical accounts of the Virgin's early life and the circumstances surrounding her death and assumption into heaven. This is not to deny that there were also other important iconographic types utilised by late medieval Sienese painters to honour the Virgin – the example of the Madonna of Humility being a case in point. What is striking, however, is that it was the *Maestà* and images drawn from the early and late life of the Virgin which were the consistently favoured subjects for the most prestigious commissions both in Siena and its subject territories during the fourteenth century. The following chapters will explore why this was the case and suggest how these particular subjects proved so effective in establishing and celebrating the Virgin as the supreme advocate and protector not only of Siena itself but also of the Sienese *contado*.

ACKNOWLEDGEMENTS

The initial research for this book was undertaken under the auspices of a Leverhulme fellowship which I held from 1990 to 1992. Subsequent research was assisted by the financial support of the Research Committee of the Faculty of Arts at the Open University. In Britain, I am grateful to the staff of the libraries of the Open University, the University of Cambridge, and the Warburg Institute of the University of London. I am also grateful to Tim Benton, Joanna Cannon, Tony Coulson, Jonathan Davies, Susan Dobson, Martin Kemp, Erika Langmuir and Erica Scroppo Newbury for their support, advice and practical assistance, and to Kate Gallimore, my editor, for her astute and efficient handling of the production of this book.

In Italy, my greatest debts are to the staff of the Archivio di Stato, Siena, and its director Carla Zarilli; the staff of the Archivio Arcivescovile; the staff of the Archivio dell'Opera Metropolitana; the staff of the Biblioteca Comunale degli Intronati; and the staff of the Soprintendenza per i beni artistici e storici delle province di Siena e Grosseto, and its superintendent, Bruno Santi, all of whom helped to make the task of exploring the history and culture of fourteenth-century Siena enjoyable as well as rewarding. My work was also greatly enriched by the assistance I received from the staff of the communal archives of Massa Marittima and Montalcino. For many of the high quality photographs in this book, I am indebted to Fabio Lensini and his colleagues at Foto Lensini, Siena.

I am profoundly grateful to Connie Ricono Martellini and her family for many years of hospitality and for helping me to deepen my understanding of many aspects of Sienese culture. I owe a debt of thanks to my family who have always taken an interest in my work and offered me encouragement at every turn. My partner, Gerald, and his daughter, Ellie, deserve my special gratitude for discovering Siena and its *contado* with me and supporting the production of the book at every stage. The book is dedicated to them.

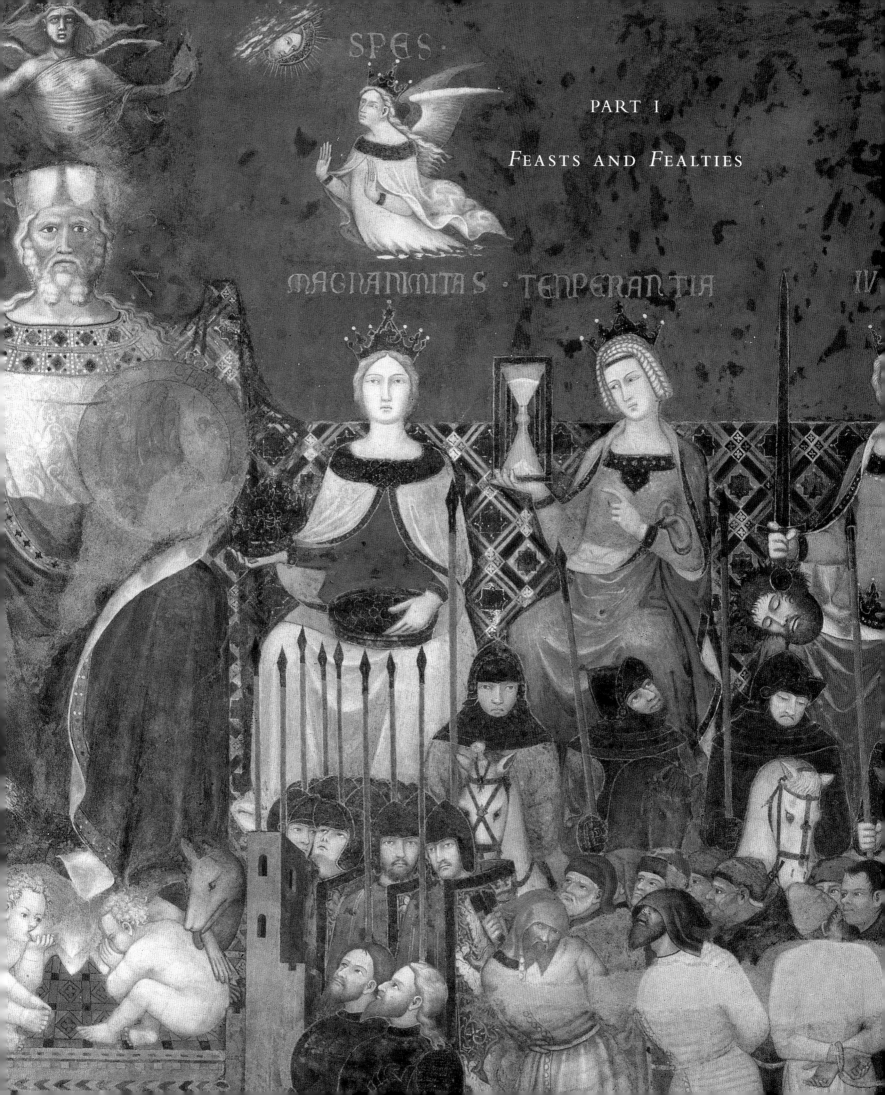

SPES

MAGNANIMITAS · TENPERANTIA

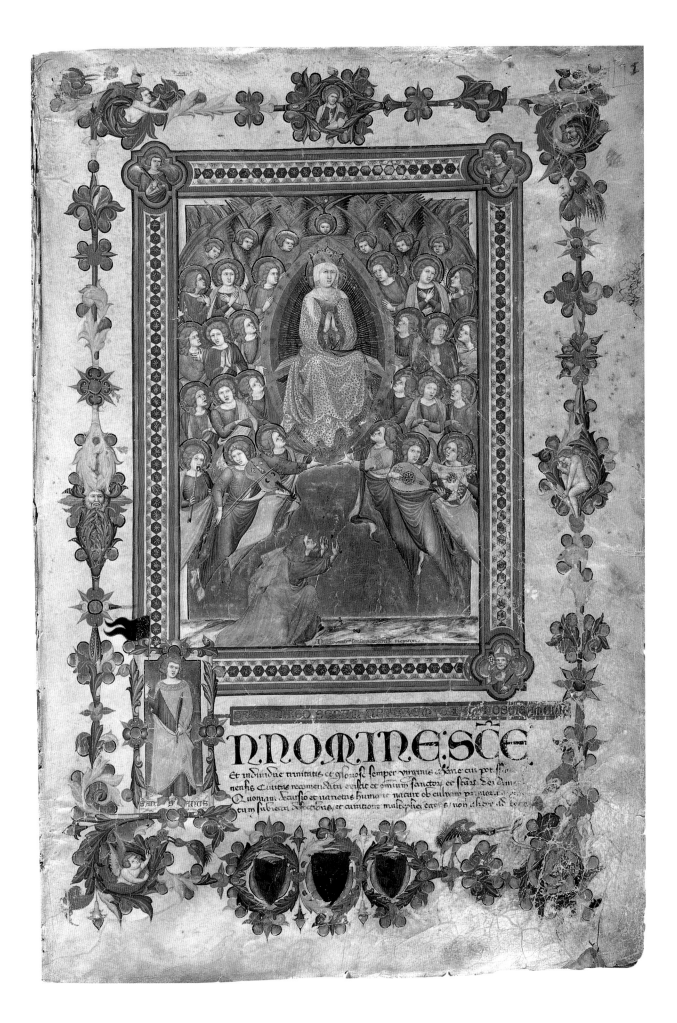

NNOMINE SCE
et individue trinitatis et gloriose semper virginis Marie cui potissi
nensis Civitas recomendata existit et omnium sanctorum, et scatis dei omni
Quoniam decursio et varietas humane nature ob culum premia agere
cum subiecta descriptione, et carnitione multiplici caget, non abhorr ab hers

1

Civic Rituals and Images

In the late medieval statutes of Siena, which can be dated between 1337 and 1339, several substantial rubrics are devoted to the organisation and ordering of the festivities which marked the annual feast of the Assumption of the Virgin.[1] Reproducing a much older statute of 1200,[2] the governors of Siena are instructed that all male inhabitants between the ages of eighteen and seventy must go to the cathedral on the eve of the feast and offer a candle there. Representatives of Siena's subject territories, meanwhile, are required on the day of the feast itself to bring to the cathedral precisely specified amounts of wax in the form of candles.[3] Further rubrics instruct the city's principal officials to publish notices about the festivities, grant a full amnesty to all but certain categories of offender, and fine absentees and those intent on disrupting this important civic event.

From these and other sources, such as the city's detailed and precisely itemised accounts and *libri dei censi* (books of tributes), it is possible to reconstruct the intricate rituals that marked this civic event.[4] The festivities, which lasted over a three day period, began on the eve of the feast of the Assumption with an extensive procession of the Sienese themselves arranged according to an elaborate system of precedence. First came a great candle presented by the Commune of Siena, a hundred pounds in weight and accompanied by the city musicians. Next came Siena's principal magistrates – the Nine and their close counterparts such as the Four Provveditori of the Biccherna[5] – each with twelve pound candles set in elaborate candlesticks. Then came the representatives of the subject communities and noble families with their candles, followed by the inhabitants of Siena divided into their local neighbourhoods – or *contrade* – and escorted by the military companies of the city. To the sound of music this procession wound through the streets to the cathedral, an imposing marble-faced building set on the summit of one of the city's hills, a short distance from the ancient citadel of Castelvecchio which formed the oldest nucleus of the city (Pl. 3). There, after the ceremony of the offerings, the government officials attended a banquet in the sacristy, as guests of the Opera del Duomo, the official government body in charge of the construction and upkeep of the cathedral. Meanwhile, in the square outside the cathedral, wine was dispensed to the people from innumerable barrels.

In the evening, in the Palazzo Pubblico – the Sienese town hall and seat of government – the city's chief magistrates held an elaborate banquet for the representatives of

1. (previous pages) Ambrogio Lorenzetti, *The Good Government*, detail of Pl. 12

2. (facing page) Niccolò di Ser Sozzo, *The Virgin of the Assumption*, c. 1336–8, frontispiece to the 'Caleffo dell'Assunta'. Siena, Archivio di Stato, Sala di Conferenza.

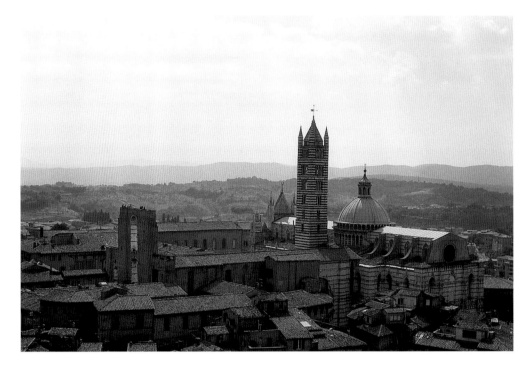

3. View of Siena towards the cathedral.

4. Palazzo Pubblico and the Campo, Siena.

Siena's subject territories (Pl. 4). The following day, on the feast of the Assumption itself, the representatives of the subject communities, castles, towns and noble families took their candles and other tributes to the cathedral.[6] It was also a day of feasting and recreation. Shops were closed and commercial dealings prohibited. Games and jousts

Feasts and Fealties

were held including a horse-race for an elaborate banner or *palio* – the antecedent of the Palio which is still run in modern Siena.[7]

Siena was by no means unique in conducting festivities which thus combined the celebration of key days in the religious calendar and the affirmation of civic identity and authority. In many late medieval Italian cities, religious festivals were important occasions of solemn civic celebration.[8] Town criers were dispatched to the countryside to announce the advent of the festival, shops were closed, judicial sessions interrupted, prisoners released, city buildings decorated, streets and public squares cleaned and bells rung. As in Siena's celebration of the feast of the Assumption, the most significant episode of such festivals was characteristically a procession staged within the public arena of the city's streets and culminating in the ritualised offering of gifts.

In Siena, however, it was the feast of the Assumption which provided a particular and specific focus of such civic celebration. The Virgin had long been held in special esteem in Siena. Thus the high altar of the twelfth-century cathedral had been dedicated to her, and when the building of the present cathedral was initiated in the early thirteenth century, this dedication was then extended to the cathedral as a whole, which took as its title Santissima Maria Assunta.[9] It was, however, in the mid-thirteenth century that the cult of the Virgin apparently assumed its full political and civic pre-eminence in Siena.

In 1260 Siena was severely threatened by its powerful northern neighbour Florence, then intent on extending its political and economic hegemony in the direction of Siena and its territories in southern Tuscany. According to the chronicle of Paolo di Tommaso Montauri,[10] the *sindaco* of Siena, Buonaguida Lucari, urged the Sienese, outside the church of San Cristoforo, to give 'all the city and *contado*' to the 'queen and empress of life eternal', the Virgin Mary. He then led the Sienese barefoot and penitent to the cathedral. The procession entered the cathedral just at the point when the bishop was at the high altar 'before our Mother, the Virgin Mary'. The bishop duly met Buonaguida and together, hand-in-hand, they went up to the high altar. Having prostrated himself on the ground, Buonaguida then approached the high altar 'in front of the Virgin Mary' and addressed an emotive petition to the Virgin ending with the words: 'I most miserable and unfaithful of sinners give, donate and concede to you this city of Siena and all its *contado*, its [military] force and its district, and as a sign of this I place the keys of the city of Siena on this altar'. Once he had done so, and the act had been duly recorded by a notary, Buonaguida then spoke again to the Virgin, begging her to accept this gift and guard the city and *contado* and its citizens from 'the iniquitous and evil dogs, the Florentines'.[11] The illustrator of another fifteenth-century account of these events,[12] Niccolò di Giovanni Ventura, provides a visual recreation of the dramatic events enacted before the high altar. In a lively drawing, Buonaguida, dressed as a penitent with a rope around his neck, gives the keys of the city to the bishop who, in turn, points towards the altar and its altarpiece – a Gothic triptych with an image of the enthroned Virgin and Child at its centre (Pl. 5). Behind Buonaguida appear a deacon and a group of citizens, and to the right, a notary records the dedication of the city to the Virgin.[13] On the following day, the fourth of September, the Sienese gained an unexpected and overwhelming victory against Florence and its allies in the Guelph league at the battle of Montaperti, an historic event which still features prominently within the civic consciousness of modern Siena.

Compelling as this vivid account of the dedication of the city to the Virgin is, it has, nevertheless, been subjected to critical scrutiny by a number of modern scholars.[14] Early accounts of the dedication only survive as fifteenth-century copies and many of these appear to be elaborations of earlier, more austere versions of the historical

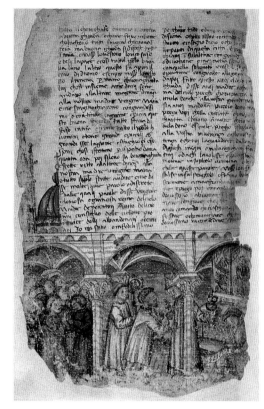

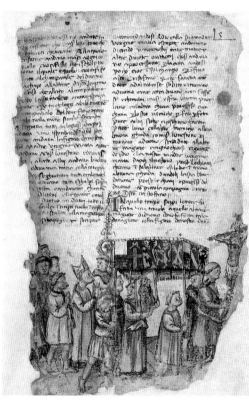

5. Niccolò di Giovanni Ventura, *Buonaguida Lucari Presenting the Keys of the City to the Bishop of Siena before the High Altar*, and *Procession with a Crucifix and an Image of the Virgin and Child*, c. 1442–3. Siena, Biblioteca Comunale, MS A IV 5, fols 4[v], 5[r].

events surrounding the battle of Montaperti.[15] It is unlikely, however, that the dedication was a complete fabrication on the part of later chroniclers. By 1260, the cult of the Virgin was not only well-established in the cathedral but also in the city as a whole, as demonstrated by a new civic seal produced in 1252 which had inscribed upon it a written appeal to the Virgin together with a depiction of her and her Son framed by candle-bearing angels.[16] The city statutes, moreover, compiled in 1262, two years after the victory of Montaperti, committed the Commune to keep two candles burning before the altar of the Virgin in the cathedral and also a lamp before the city's war chariot – the *carroccio*. The same statutes refer to plans to build a chapel in honour of the Virgin and to dedicate it specifically to Siena's victory over its enemies at Montaperti.[17] Even more significantly, in the records of the re-submission of Montalcino to Siena four days after the battle of Montaperti, specific reference is made to the Virgin as 'defender and governor' of the city.[18] Since 'governor' was not a title given to the Virgin in earlier official documents, it has plausibly been argued that this title may well be an expression of a status newly accorded to the Virgin in a formal act of homage five days earlier.[19] There is, therefore, sufficient contemporary historical evidence to suggest that the Virgin's status as a protector of Siena was considerably enhanced at the time of Montaperti. The annual feast of the Assumption then duly became an even more important religious festival for the Sienese, precisely because it provided an opportunity for the annual reaffirmation of the dedication of the city to the Virgin and a renewed appeal for her protection, whilst also providing an opportunity to recall Siena's greatest triumph over its traditional enemy, Florence.

Moreover, as already noted, an important feature of the Sienese celebration of the feast of the Assumption was the participation of the inhabitants of the surrounding *contado*, especially by the presentation of candles and other kinds of tribute to the city's patron and protector. A petition brought before Siena's principal legislative assembly, the Consiglio Generale, on 14 October 1400, confirms the political significance and importance of this annual event. It describes how the Four Provveditori requested the council to compile a list of tributes owing to Siena from various lords, barons, communities, territories and villages, the reason being that at a recent feast of the Assumption: 'the Virgin Mary, our advocate, had lacked many of the *palii*, candles and tributes for which our ancestors had expended much sweat, money and blood to the glory of the city'.[20] From the contents of the resulting 'Libro dei Censi' (Pl. 6), it is possible to glean precise details of the annual tributes themselves.[21] Characteristically, the three main administrative districts of Siena, the *terzi*, each took responsibility for the annual levy of tributes from specific subject communities located within the *contado*. These tributes almost invariably took the form of a stipulated weight of wax for elaborately moulded *fogliati* and simple unadorned candles and a banner or *palio* of velvet, lined with samite and worth a particular amount of money. Similarly, representatives of powerful noble families – such as the Counts of Santa Fiora from the mountainous region of Monte Amiata in southern Tuscany – were to bring *fogliati*, accompanied by the family's tenant farmers, again carrying candles. Larger Sienese subject towns and cities, meanwhile, such as Montalcino and Montepulciano, also brought *fogliati* and, in addition, specified and substantial amounts of money.[22] This practice also had a very long pedigree, dating back to the earliest records of the Sienese Commune. Thus in 1147, three brothers, the *signori* of Montepescali, when making an act of political submission to Siena, agreed to offer candles to the bishop of Siena in the cathedral on the feast of the Assumption. Other similar acts are also recorded, such as those of the *signori* of Asciano in 1175, of the men of Montelaterone in 1205, and those of Montalcino in 1212 (Pl. 7).[23] The *contado* was, therefore, an area

6. (facing page) *The City of Siena, the Four Patron Saints and the Civic Emblem of the Wolf and Twins*, opening page of the 'Libro dei Censi'. Siena, Archivio di Stato, Sala di Conferenza.

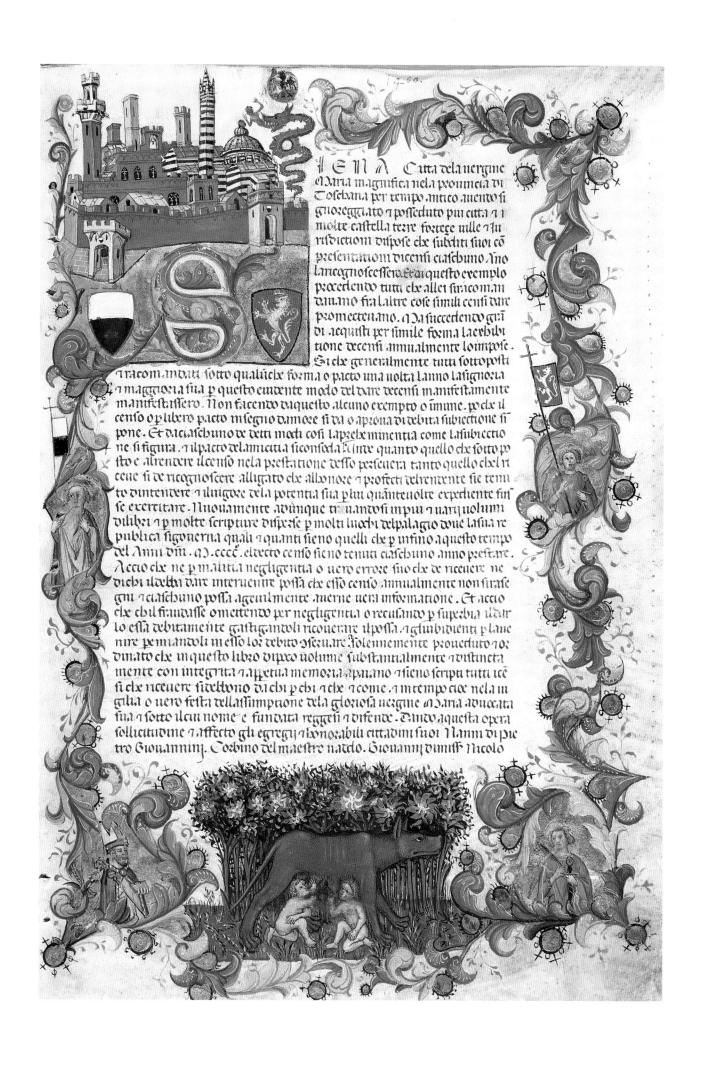

SIENA Citta dela vergine
et Maria magnifica nela provincia di
Toscana per tempo antico avendo si
gnoreggiato e posseduto piu citta e
molte castella terre fortece ville e iu
risdictioni disperse che subditi suoi co
presentationi dicensi ciaschuno Ano
la recognoscessero. Et di questo exemplo
precedento tutti che allei siracoman
davano fra laltre cose simili censi dare
promettevano. Ma succedento gra
di acquisti per simile forma la exhibi
tione decensi annualmente loimpose.
Si che generalmente tutti sottoposti
e racomandati sotto qualuche forma o pacto una volta lanno lasignoria
e maggioria sua p questo euidente modo del dare decensi manifestamente
manifestassero. Non facendo daquesto alcuno exempto o immune. pche il
censo o libero pacto insegno damore si da o aprona di debita subiectione si
pone. Et daciaschuno de detti modi cosi lapreheminentia come lasubiectio
ne si figura. e ilpacto delamicitia siconsecra ksme quanto quello che sotto po
sto e abrendere ilcenso nela prestatione desso persevera tanto quello chel ri
ceve si de ricognoscere alligato che albonore e profecti delrecevente sie tenu
to dintendere e ilivigore dela potentia sua piu quanteuolte expediente fus
se exercitare. Nuovamente adunque trouandosi impiu e marj uolumi
edilibri e p molte scripture disperse p molti luochi delpalagio doue lasua re
publica sigouerna quali e quanti sieno quelli che p infino aquesto tempo
del Anni dni. M. cccc. electo censo sieno tenuti ciaschuno anno prestare.
Accio che ne p malitia negligentia o uero errore suo che de ricevere ne
debii iledetti dare interuenite possa che esso censo annualmente non sirase
gni e ciaschuno possa agevilmente auerne uera informatione. Et accio
che chi fraudasse omettendo per negligentia o recusando p superbia ildar
lo essa debitamente gastigandoli ricouerare ilpossa e gliubidienti plane
nire pemantoli in esso lor debito iseruare. Solennemente proueduto e or
dinato che inquesto libro o uero uolume substantialmente e distincta
mente con integrita e appetua memoria apiano e sieno scripti tutti ice
si che ricevere sidebbono da chi p chi e che e come. e intempo cioe nela ui
gilia o uero festa dellassumptione dela gloriosa uergine Maria aduocata
sua e sotto ilcui nome e fundata reggesi e difende. Tanto aquesta opera
sollicitudine e affecto gli egregii e honorabili cittadini suoi Namm di pie
tro Giouannini. Cosbino del maestre natcolo. Giouanni dimiss Nicolo

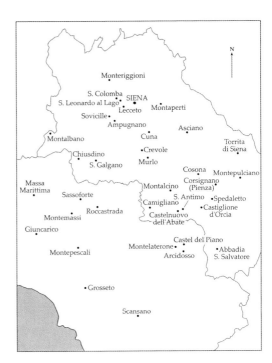

7. Map of the Sienese *contado* (adapted from Waley, 1991).

that had long possessed considerable political and economic significance for the city of Siena.

From the third century onwards Siena, like many other Italian cities, had been subject to invasion from foreign powers and to the depredations of war and social disorder.[24] The city owed its survival primarily to its status as a seat of diocesan and provincial government. The bishop exercised his episcopal authority within the city and its diocese. Civil authority, meanwhile, lay in the hands of the *gastaldo* – an official of the Lombard kings who from the sixth to ninth centuries held political sway in Italy. Under Frankish rule in the ninth and tenth centuries, this official was succeeded by the *conte* or count whose jurisdiction extended to a geographical area outside the city which was accordingly known as the *contado*. Over the centuries, however, the lands of the *contado* came increasingly under the control of powerful local families who, while owing loyalty to their feudal overlord, also considered themselves sovereign within their own lands, basing such claims upon a variety of imperial charters, privileges and immunities.[25]

As in the case of other Italian cities, from the tenth century onwards, Siena enjoyed an economic renaissance marked by a spectacular increase in the city's population, trade and industry.[26] The principal cause of the city's growth lay in substantial emigration of rural inhabitants who took up residence within new suburbs which quickly became incorporated into the city proper, forming three principal districts – the Terzo di Città, the Terzo di San Martino and the Terzo di Camollia.[27] Clearly one of the principal attractions of the city for the rural population lay in the increased possibilities it offered for various kinds of work and for the gaining of professional skills. Thus as late as 1360, Naddo di Corbo, a woodworker from the village of Monselvoli, declared to the Sienese government that his original reason for moving to Siena had been to provide his sons with professional training and that they were now 'satisfactorily trained in the art of manufacturing wool' and consequently were 'unable to work the land'.[28] The city also provided its inhabitants with increased prospects of protection and a regular supply of varied food and other commodities. Closely allied to Siena's economic and demographic expansion was the development of the city's political autonomy and governing institutions which, over the eleventh and twelfth centuries, were gradually freed of dependence upon, first, the bishop and second, the Sienese nobility.[29] The assertion of the city's authority within the *contado* was a further important part of the development of the new Commune's institutions and identity.

Like other medieval Italian communes, Siena sought to extend its territorial jurisdiction in order to levy taxation and secure the supply of both troops and food – particularly grain – for the city. The *contado* also provided a source of raw materials and a market for Sienese goods. In addition, Siena had to defend its own territory from the aggression of powerful neighbours. Florence, for example, lay only 54 kilometres to the north of Siena and regarded southern Tuscany as a potential area of political and economic expansion. Indeed, the frontier between the two city states lay a mere 15 kilometres north of Siena, thereby necessitating the erection of a number of heavily fortified bastions – Monteriggioni built in the second decade of the thirteenth century being the most spectacular survivor of these (Pl. 8).[30] To the north-west, meanwhile, lay Volterra and Pisa, to the north-east Arezzo, and to the south-east Perugia. The greatest scope for Siena's own expansion therefore was to the south and south-west of the city.[31] While rich in pastures and mineral deposits, this area was also mountainous and hence difficult to secure and control. It was also a region dominated by long-established feudal families such as the Aldobrandeschi who laid claim to a considerable number of castles and communities within this region. Similarly, around Massa Marittima, a city lying some 45 kilometres south-west of Siena (see Pl.

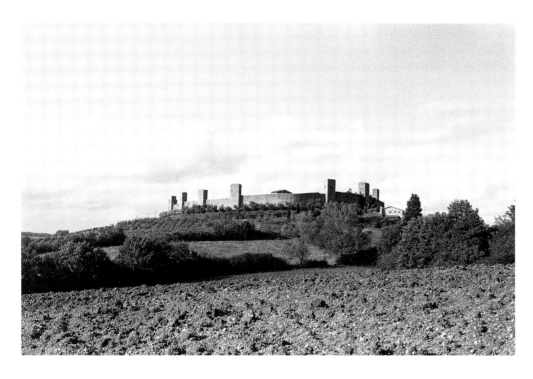

8. View of Monteriggioni.

7), were the fortresses of the Pannocchieschi. Indeed Massa Marittima provides a striking example of the ways in which Sienese expansion was limited by the ambitions of neighbouring city states. Thus as late as the 1330s Pisa and Florence both exerted considerable political influence over Massa Marittima and the surrounding area, Siena only succeeding in establishing firm and decisive political control in 1335.[32]

Once Siena had secured control over a noble family or community, this event would be recorded and ratified by a document of submission. Many such submissions have been preserved and gathered together in the Archivio di Stato, Siena, the most famous collections being the 'Caleffo Vecchio' and the 'Caleffo dell'Assunta'.[33] Appropriately enough – given the prominence of the Virgin of the Assumption within Sienese political life and her close association with the annual re-enactment of such submissions – the latter owes its name to the striking full-page illumination of the Virgin of the Assumption which once acted as a frontispiece to this important collection of legal documents (see Pl. 2).[34] From these documents it is clear that the particular relationships between Siena and its subject communities were very varied, the differences usually arising from the actual circumstances under which the subject territories had been incorporated into the Sienese state. Such circumstances included an outright military victory, long processes of political intimidation, and possibly straightforward, pragmatic, commercial transactions whereby the Sienese Commune purchased the feudal rights of a noble family over a particular locality.

Submission typically took the form of an oath involving a number of clearly specified commitments to Siena. These included, characteristically, a promise to aid Siena in times of peace and war, to supply a specified number of cavalry and infantry, to accept a Podestà and other major officials who were either Sienese or chosen by Siena and to receive a Sienese garrison.[35] In return, those making the submission might be conceded Sienese citizenship. This, however, generally carried with it the obligation of acquiring or building a residence in Siena and living there for at least part of the year. But it was also recognised that citizenship offered a number of tangible advantages, allowing participation in government, the holding of influential and potentially lucrative offices, protection by the communal courts, free medical

treatment of war wounds and – if one's own resources were insufficient – payment of ransom at the public expense.[36] Since it entailed the purchase of property, it also involved liability for taxation and the performance of communal duties including service with the civic militia.[37]

As well as acquiring, through a variety of political and military means, towns, villages and castles within the surrounding territory, the Sienese Commune also occasionally established new towns in the *contado*. The most celebrated example was the port of Talamone over 85 kilometres south-west of Siena. Famously mocked by Dante for their ambition,[38] the Sienese had acquired Talamone in 1303, together with the castle of Castiglione d'Orcia, from the Benedictine abbey of San Salvatore. The Sienese Commune quickly initiated a building programme of walls, fortress, church and houses, evidence for which survives in a schematic ground plan of the town contained amongst documents relating to Talamone in the 'Caleffo Nero'.[39] The ambitious project arose from the Sienese need for a port through which merchants from Siena and its allies could trade – thereby avoiding unfavourable tariffs imposed by Pisa for the use of Porto Pisano, an alternative port for Siena's commercial activity. On the whole Talamone was not a successful enterprise. The port and garrison were a considerable distance from Siena and the roads between the two crossed mountainous territory dotted with castles belonging to feudal nobility. Nevertheless the project represented a considerable symbolic value for the Commune: the city statutes of 1309–10 required the Nine to debate the fortification of Talamone every two months and in Ambrogio Lorenzetti's celebrated cycle of paintings of the *Good Government* in the Sala dei Nove, the council room of the Nine in the Palazzo Pubblico, Talamone is the one location specifically referred to by name (see Pls 11, 16).[40]

Older histories of Siena and its subject territories tend to suggest that over the centuries the great feudal families of the *contado* were steadily defeated, obliged to settle within Siena itself and forced to adopt an essentially civic and mercantile existence. More recent scholarship, however, has emphasised the tenacious survival of such families.[41] Although some of their descendants lost their feudal and rural identities and merged into Siena's urban population, families such as the Aldobrandeschi and the Pannocchieschi maintained a clear sense of their local identity and continued to maintain armed retinues.[42] Conversely, it is also clear that a great deal of land in the *contado* was acquired by Sienese citizens. Thus, for example, it is apparent from a will drawn up in 1293 that a Sienese woodworker (*magister lignaminum*), Grimaldi di Ventura, owned not only a house and workshop in Siena but also houses, a vineyard and extensive woodland around Ampugnano and Sovicille, south-west of the city (see Pl. 7).[43] Indeed, the early fourteenth-century taxation records known as the 'Tavola delle Possessioni', indicate that for those Sienese citizens whose total property was valued at over 5000 *lire*, eighty-five per cent of that value was due to holdings in rural property.[44] Accordingly, wealthy banking dynasties such as the Salimbeni, Bonsignori, Tolomei, Piccolomini and Malavolti had extensive holdings in the *contado*. Lack of sources earlier than the thirteenth century, frustrate attempts to determine whether such families once owned a rural territorial base before moving to the city to make their commercial fortunes. It is clear, however, that wealth from land provided capital for investment in banking and success in finance was swiftly followed by the acquisition of more land.[45]

In addition to the land and rural properties owned by the Commune, by individual citizens and by major Sienese families, other religious and civic institutions also owned substantial areas of the *contado*. The bishop of Siena still owned the area south of the city known as the Vescovado, an area of countryside which included several fortified castles and village communities such as Crevole and Murlo. A relic of earlier

centuries when the bishop had been a feudal overlord in his own right, the Sienese Commune, from time to time, challenged the bishop's rights of jurisdiction over this area.[46] Also dating from earlier centuries were important Benedictine foundations whose abbots had once acted as temporal overlords over wide areas of the country-side. Although by the thirteenth and fourteenth centuries their influence had waned, abbeys such as San Salvatore on the slopes of Monte Amiata, and Sant'Antimo, south-east of Montalcino (see Pl. 7), still exerted a considerable local influence.[47] Similarly, the great Cistercian abbey of San Galgano lying to the south-west of the city, also owned considerable areas of farmland within the fertile river valley of the Merse.[48] Other more recently established religious orders such as the Augustinian Hermits had also established specifically rural hermitages in the Sienese *contado*, particularly to the south-west of the city. Although modest in scale, these foundations secured extensive rights over the local rural communities in their vicinity.[49]

The Sienese *contado* also contained numerous hospitals which attracted bequests from Sienese citizens.[50] Founded either as independent institutions or associated with hospitals in Siena itself, these establishments performed an important function as hostels for travellers, particularly pilgrims. Such foundations also owned farming land within the *contado* – thus facilitating another of their charitable functions of distrib-uting food to the poor and indigent. During the thirteenth century, the principal hospital of Siena, that of Santa Maria della Scala, had already begun to acquire land within Siena's southern *contado*, a process which accelerated during the early decades of the fourteenth century, halted during the mid-century, and then entered another period of expansion during the last years of the fourteenth century during which it almost doubled its holdings.[51] The means by which the hospital maintained and administered its rural holdings was by the building of *grance* – fortified complexes comprising a tower, living accommodation for the *granciere* and the agricultural workers and their families, granaries, mills, cattle byres, and quite often a simple church – examples of which can still be seen south of Siena at Cuna and Spedaletto (Pl. 9).[52] The intensity of the farming of the *contado* by the Spedale di Santa Maria della Scala is illustrated by the purchase in the second half of the fourteenth centu-ry of circa 100 to 150 oxen a year to work its extensive estates.[53]

A rubric in the 1337–9 statutes of Siena indicates that the Sienese claimed gener-al rule over an area of a radius of 30 *miglia* – approximately 50 kilometres from the

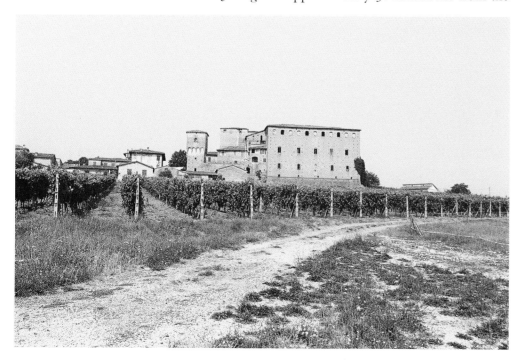

9. View of the *grancia* at Cuna.

city.[54] In point of fact, the city enjoyed political and economic influence over a much larger area, reaching as far south as Orbetello which was some 100 kilometres south-west of Siena. Siena's rule over this territory did not correspond, however, to that of a modern state with a cohesive internal jurisdiction.[55] Rather, it encompassed several different kinds of jurisdiction. Working from Siena outwards, these comprised four broad categories. Immediately adjacent to the city were the communities of the Masse and the Cortine which were directly subject to the city with Siena enjoying exclusive and unconditional political power over them.[56] Next came the Vescovado which, as we have already seen, was an area south of the city under the authority of the bishop of Siena. Further afield again lay the *contado* proper which by the late 1330s numbered some 300 communities.[57] Within the *contado*, moreover, there were also areas in which *signori* still enjoyed considerable political autonomy as a result of special agreements with the Sienese state.[58]

Finally, yet another category of jurisdiction applied to larger communities such as the cities of Grosseto, Massa Marittima, Montalcino and Montepulciano (see Pl. 7). At various times, these significant urban centres had entered into the Sienese political and military orbit, but were not directly administered by the city.[59] They therefore enjoyed the status and rights of *raccomandati* or *accomandati* according to which they were promised the right of protection in exchange for acknowledging Siena's ultimate supremacy. They were thus not included within the *contado* as such, but rather constituted important centres owing military and financial services to Siena. They were controlled by specially constructed fortresses and garrisoned by Sienese troops and officials, and they also accepted a Sienese Podestà and made an annual tribute on the feast of the Assumption. They paid no taxes, however, and preserved their own territories, magistracies and administration. They also necessitated constant political and military intervention. Thus, during the fourteenth century, Grosseto, Massa Marittima, Montalcino and Montepulciano all rebelled against Sienese supremacy. As late as 1361, the Sienese were obliged to issue new articles of association between themselves and the Montalcinesi, in the process conceding Sienese citizenship to the men of Montalcino. In the case of Montepulciano, the Sienese eventually lost control to the Florentines in 1390.

As one recent historian of medieval Siena has shrewdly observed, the Sienese state was anything but a coherent and consolidated bloc of territory. Rather, 'it was a fragmented, haphazard collection of lordships and townships, having almost nothing in common except its fragile subordination to Siena'.[60] The fragmentary and eclectic nature of the Sienese territorial holdings should not, however, obscure the fundamental and enduring importance of these lands for the Sienese state. Siena was dependent upon these territories for taxes, timber, food and military manpower, and in return promised to maintain peace, security and justice. Thus, on assuming office, the Podestà of Siena swore to maintain and conserve the cathedral of Siena, the bishop and canons of the cathedral, the hospital of Santa Maria della Scala and all the venerable places of the city and *contado* of Siena. Significantly, exactly the same formula occurs in the opening rubric of the 1309–10 statutes of the city.[61] Thus the ownership and protection of the *contado* was clearly understood to be an integral part of Siena's political ideology. It was ratified in the city's constitutions and statutes, woven into the oaths of office of the city's leading officials and incorporated into the rituals for the celebration of the major feast day of the city's patron saint, the Virgin Mary.

The acquisition of the *contado* was also explicitly celebrated in works of art commissioned by the Sienese government. We know, for example, that the large room in the Palazzo Pubblico used for the meetings of the Consiglio Generale was once decorated with castles that had been conquered by the Commune in the early decades

of the fourteenth century. Thus, on 30 March 1314, the Consiglio Generale discussed the recent conquest of Giuncarico, a castle lying south-east of Massa Marittima and under the control of Conte Raniero d'Elci, a member of the Pannocchieschi family. In addition to resolving that Giuncarico should remain under Sienese control for perpetuity, the council agreed that this castle should be depicted in the council room where an unspecified number of other castles had already been painted. Furthermore, no-one was to damage or vilify these images in any way. Biccherna payments in 1330 and 1331 to a 'maestro Simone' (generally assumed to be the well-known Sienese painter, Simone Martini), suggest that this series of castles was later extended to include paintings of Montemassi, Sassoforte, Arcidosso and Castel del Piano – all castles once ruled by the Aldobrandeschi or their close associates and incorporated into the Sienese state between 1328 and 1331 by a variety of military and diplomatic means.[62] It appears, therefore, that the main council hall of the Palazzo Pubblico was once decorated with an extensive series of at least seven, and quite possibly more, depictions of specific locations in the Sienese *contado* – places, moreover, whose formal submissions were the subject of detailed records within the deliberations of the Consiglio Generale and the 'Caleffo dell'Assunta'.[63]

An early fourteenth-century fresco on the east wall of the Sala del Consiglio offers a vivid example of the form that such pictorial propaganda might take (Pl. 10). Although damaged and with only two-thirds of its painted surface presently visible,[64] it presents a striking, if schematic, representation of a typical Tuscan hill town, dominated by a well-fortified castle and adjacent church. Two figures appear prominently outside the main gateway. The door of the castle is open as are the gateways of the inner and outer palisades that form a defensive surround to the castle and the other

10. *The Submission of a Castle*, after 1314. Siena, Palazzo Pubblico, Sala del Consiglio.

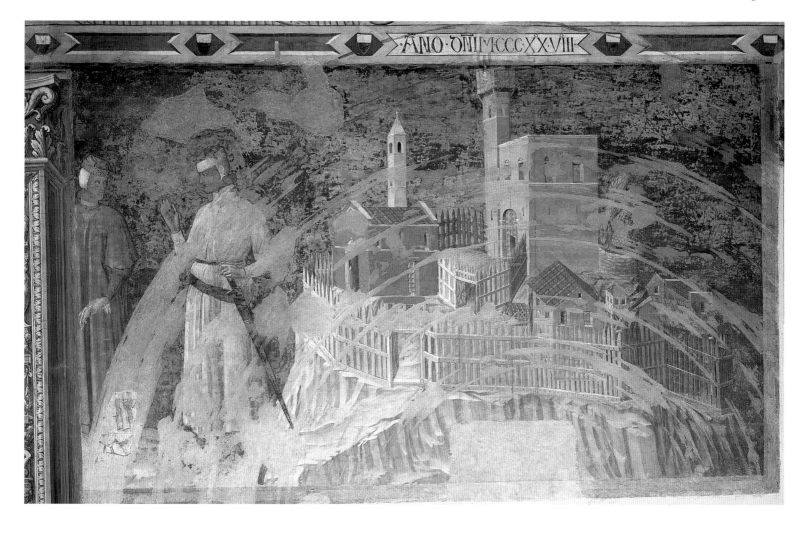

11. Siena, Palazzo Pubblico, Sala dei Nove (also known as the Sala della Pace).

buildings in its vicinity. The image presented, therefore, is of a castle which is now undefended and thus potentially accessible to a new overlord. The two figures add impact to this impression. Both are dressed in costume which, in the early fourteenth century, would have denoted high social status. The central figure, in particular, wears a belt which was once gilded and supports a sword with a long, sheathed blade.[65] Such details suggest a person who owes his standing to his military prowess. His emphatic hand gesture is also indicative of a superior interacting with a subordinate. The detail of the glove held by the second figure similarly denotes acquiescence to the superiority of the other.[66] Setting aside the complex issues of who painted this mural and which castle it might represent – both of which remain matters of considerable and intense debate[67] – the primary significance of the painting, in the present context, lies in the fact that it provides striking physical evidence of the government's stated intention to commemorate their territorial acquisitions in the southern *contado* by means of paintings in a prominent civic setting. It is also possible, that these commemorative paintings, although generic in appearance, may well have included recognisable topographical details of specific locations and even representations of the participants in the official ceremonies marking the submissions of these castles.[68]

The depiction of specific submissions in the Sala del Consiglio was, however, by no means the only celebration of Sienese territorial expansion to be found in the paintings commissioned for the Palazzo Pubblico in the first half of the fourteenth century. Between 1338 and 1339 the room next to the Sala del Consiglio was painted with a series of murals by Ambrogio Lorenzetti (Pl. 11).[69] This room – known from the early fifteenth century as the Sala della Pace – was originally designed as a meeting room and audience chamber for the Nine, the ruling elite within Siena between 1287 and 1355.[70] Conventionally known as *Il Buon Governo* (*The Good Government*), Ambrogio Lorenzetti's complex and innovative painted scheme for the Sala dei Nove famously combines sophisticated and subtle allegorical references with vivid portrayals of contemporary life.[71] For the main part, it has been the allegorical aspects of the scheme which have received most attention and, in particular, the symbolic figures representing the qualities and consequences of, respectively, good and

bad government. In the present context, however, it is the relatively more neglected contemporary details within these murals that are of particular significance.

The mural scheme is divided, essentially, into three main sections. The north wall and the northern end of the west wall are devoted principally to allegorical personifications of the characteristics of good and bad government. The east wall is given to an exhaustive portrayal of the practical and beneficial consequences of good government for both city and countryside; and the remaining section of the west wall is given to the depiction of the destructive effects of bad government, again in both urban and rural contexts. In each case, moreover, there are particular details which reflect the Sienese Commune's consistent preoccupation with the *contado* and its importance for the city. Thus the principal figure in the painting on the north wall – designated by a painted text as *Ben Comune* – wears a black and white robe which corresponds exactly to the strikingly simple colours and design of Siena's principal civic emblem of the *balzana*, a shield divided horizontally into black and white sections (Pls 12, 13). The association of this figure with Siena is further emphasised by the golden shield which he holds and which once carried an inscription and image of the Virgin and Child corresponding exactly to Siena's communal seal.[72] Beneath *Ben Comune's* feet appears another of Siena's most revered civic symbols, namely the wolf suckling the twins – a pictorial reference to the city's mythical foundation by Aschius and Senus, the sons of Remus. Surrounded by female personifications of the virtues that his government embodies, *Ben Comune* is also portrayed in the company of other representatives of Siena's civic and military power.

In the left-hand foreground appears a procession of civic dignitaries[73] and below the Virtues appear six mounted knights and two groups of infantry. The shields of the infantry carry the heraldic device of a lion on a red field, the coat-of-arms of the Popolo, together with the *balzana*, the principal emblem of the Sienese Commune.[74] In the right-hand foreground are two bareheaded figures in armour, kneeling in respect and presenting a castle in an act of submission to the Sienese Commune (Pl. 14). Behind and to the right of these figures, meanwhile, is another group of figures which reiterates the theme of submission to Siena. Thus, at the head of this group appear two figures whose costumes denote persons of official standing. The first and older of the two proffers a pair of keys in the general direction of *Ben Comune* – a

12. Ambrogio Lorenzetti, *The Good Government*, 1338–9. Siena, Palazzo Pubblico, Sala dei Nove.

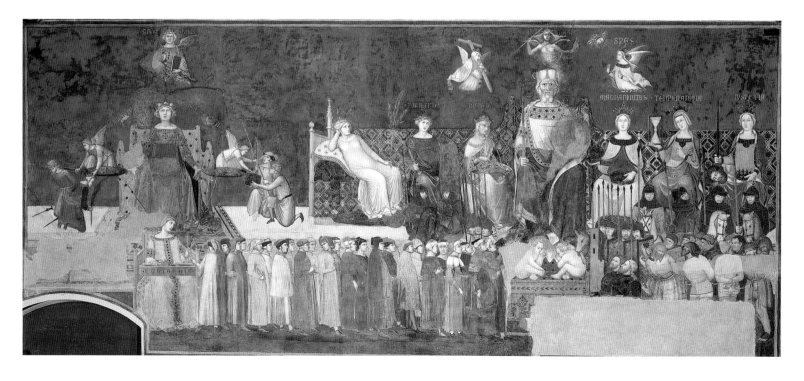

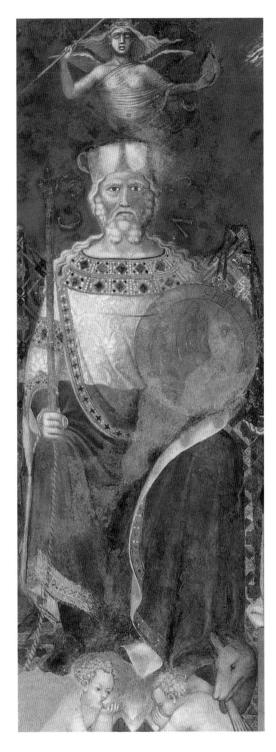

time-honoured, symbolic gesture for handing over a city and its inhabitants to a superior political power. Other figures in the foreground confirm the theme of submission by virtue of their being roped together as prisoners.

The importance of Siena's relationship with the *contado* is similarly emphasised in the paintings on the east and west walls of the Sala dei Nove. On the east wall an idealised portrayal of Siena is combined with a similarly idealised portrayal of the Sienese *contado* (Pls 15, 16). Both city and *contado* prosper and enjoy a reciprocal relationship in which the city extends its protection and security over the countryside and the countryside provides food and resources for the thriving life of the city. That the countryside is indeed intended to be an idealised image of the Sienese *contado* is confirmed – as we noted earlier – by the inclusion of the word 'Talamone' beneath a fortress beside an expanse of water in the upper right-hand corner of the painting.[75] In the painting on the west wall, meanwhile, are portrayed the dire consequences for the countryside of the absence of secure and good government. Destruction and desolation are shown as the consequences of the failure of the civic ideals so positively celebrated elsewhere in the room (Pls 17, 18). Significantly, moreover, the Sienese *contado* had suffered such destruction only some six years prior to the painting of the Sala dei Nove scheme, when the military forces of Pisa, Siena's great rival in the Maremma, had laid waste to Sienese territory to within a few kilometres of Siena itself.[76]

In short, quite apart from providing an erudite painted commentary on the virtues of good government, this impressive addition to the interior embellishment of the Palazzo Pubblico also provided an array of painted detail which firmly associate these highly idealised political concepts with Siena and its communal government. In addition, as in the case of the paintings of castles within the adjacent Sala del Consiglio, it also provided a pictorial validation of Siena's policy of territorial acquisition and an

13. (above) Ambrogio Lorenzetti, *Ben Comune and Charity*, detail of Pl. 12.

14. (right) Ambrogio Lorenzetti, *Presentation of a Castle to Ben Comune*, detail of Pl. 12.

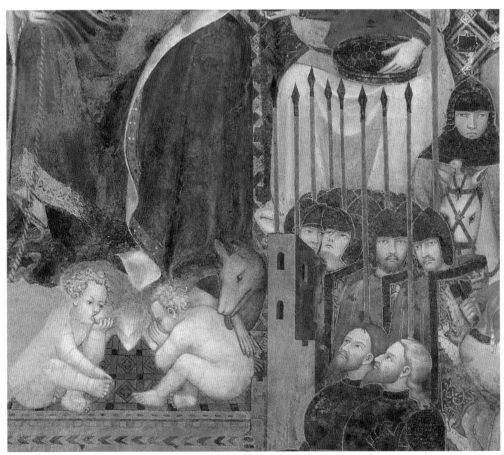

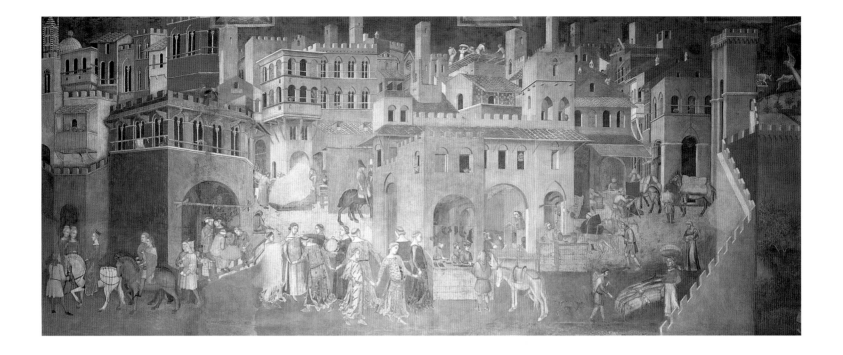

exemplification of some of the perceived advantages and consequences of Sienese rule over the *contado* itself.

In the preceding pages two significant features of the relationship between fourteenth-century Siena and its subject territories in the Sienese *contado* have been emphasised. First, we noted that a central feature of the most important religious festival within the Sienese calendar was a ritual re-enactment of the submission of those subject territories to Siena, by means of the annual symbolic presentation of candles to the Virgin of the Assumption, the Virgin being understood to be the patron and protector of Siena. Second, we saw how the expansion and maintenance of control over the *contado* was consistently celebrated in the works of art commissioned for the two most important council rooms in the Palazzo Pubblico.

15. Ambrogio Lorenzetti, *The Well-governed City*, 1338–9, detail of the east wall. Siena, Palazzo Pubblico, Sala dei Nove.

16. Ambrogio Lorenzetti, *The Well-governed Countryside*, 1338–9, detail of the east wall. Siena, Palazzo Pubblico, Sala dei Nove.

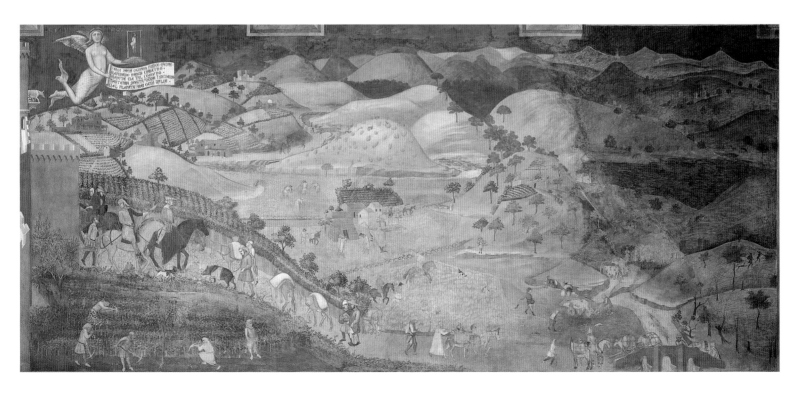

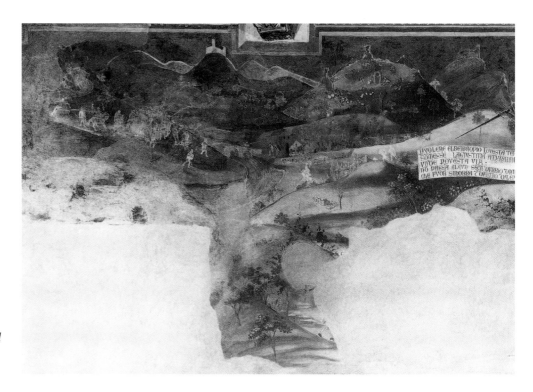

17. Ambrogio Lorenzetti, *The Badly-governed Countryside*, 1338–9, detail of the west wall. Siena, Palazzo Pubblico, Sala dei Nove.

18. (below) Ambrogio Lorenzetti, *The Badly-governed City with Tyranny and the Vices*, 1338–9, detail of the west wall. Siena, Palazzo Pubblico, Sala dei Nove.

19 (facing page) Ambrogio Lorenzetti, *The Well-governed City*, detail of Pl. 15.

At this point, however, it is also appropriate to recall that, in fourteenth-century Sienese art, there was no subject more central or more frequent than that of the Virgin. Whether in images of the Virgin with the Christ Child, or of the Virgin of the Assumption, or of scenes from her life, the figure of Mary constituted the single most predominant image in the art of fourteenth-century Siena. Given that this was so, and given that, as we have seen, the relationship between Siena and its subject territories was itself bound up with both the celebration of the Virgin and the commissioning of art for civic purposes, a number of questions arise concerning the potential political significance of Marian imagery in this context. How far is it possible to discern a political as well as devotional significance in portrayals of the Virgin in fourteenth-century Sienese art? Were images of the Virgin intentionally deployed

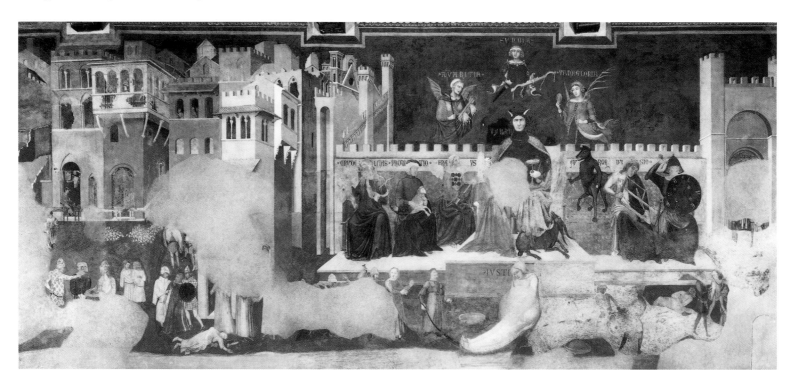

as part of a self-conscious civic and political ideology by the Sienese? And is it possible to trace specific patterns of influence and intention in the diffusion of particular Marian themes and images within the art produced in Siena and the Sienese *contado* during the fourteenth century?

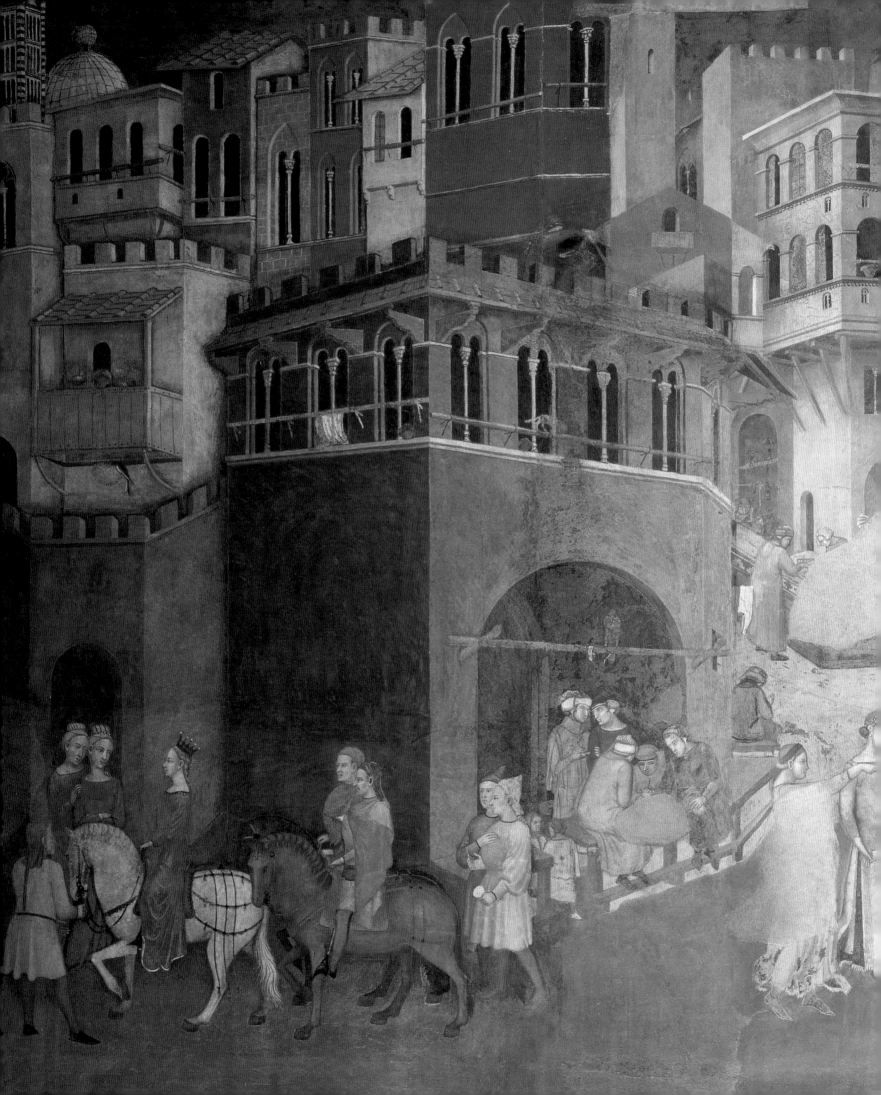

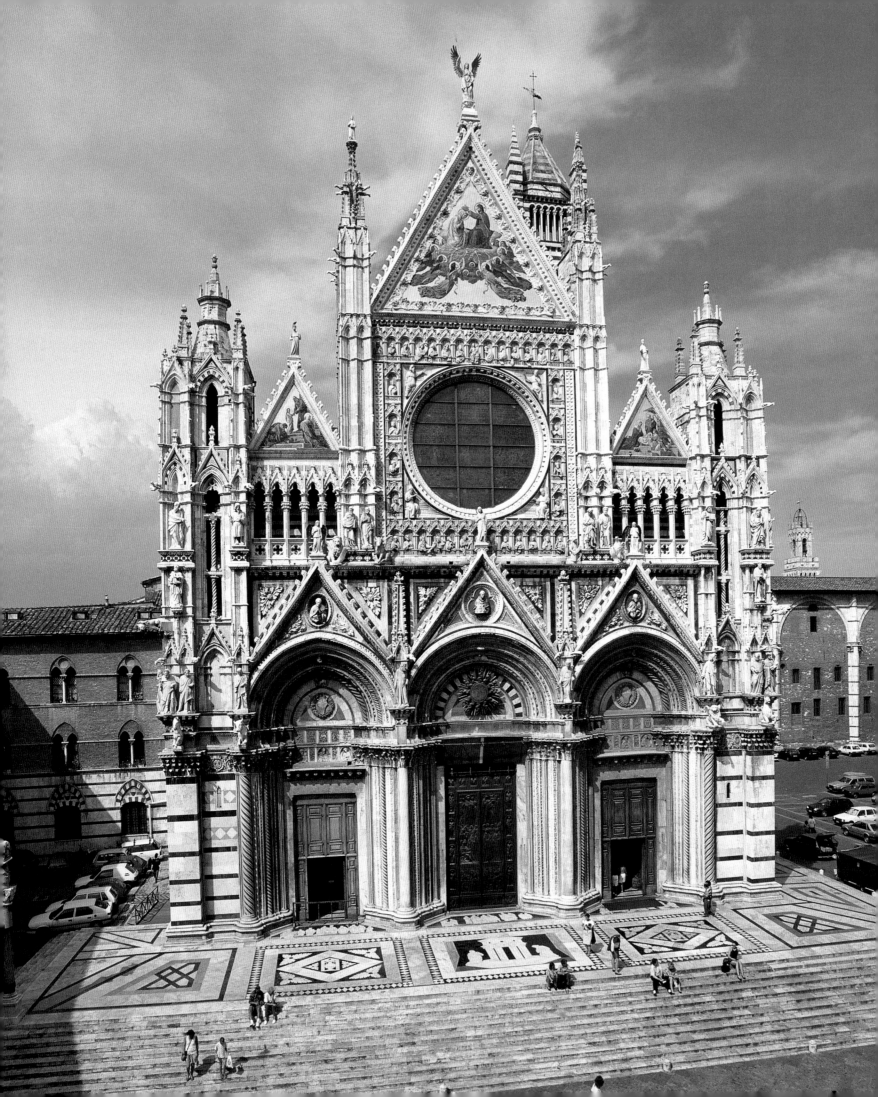

2

The Cathedral

On 9 June 1311, a civic procession to rival that of the feast of the Assumption, wound its way through the streets of Siena to the cathedral (Pls 21, 22). The focus of the procession was the monumental and complex double-sided altarpiece known to us today as Duccio's *Maestà* (Pl. 23). According to one fourteenth-century chronicler:[1]

On the day on which it was carried to the Duomo, the shops were locked up and the Bishop ordered a great and devoted company of priests and friars with a solemn procession, accompanied by the Signori of the Nine and all the officials of the Commune, and all the populace. All the most worthy were hand in hand next to the said panel [painting] with lights lit in their hands; and then behind were the women and children with much devotion; and they accompanied it right to the Duomo making procession round the Campo, as was the custom, sounding all the bells in glory, out of devotion for such a noble panel as was this. Which panel Duccio di Niccolò, the painter, made and he made it in the house of the Muciatta outside the gate of Stalloreggi. And all that day they remained in prayer, with much alms, which they gave to poor persons, praying to God and his Mother, who is our advocate, who defends us through her infinite mercy from every adversity and every evil, and guards us from the hands of traitors and enemies of Siena.

Although this account subsequently gives the destination of Duccio's painting as the high altar of the cathedral, it does not describe either the physical appearance or the subject matter of the new altarpiece. Modern reconstructions of this remarkable work, however, provide a sense both of its imposing scale and the complexity of its iconographic programme (Pl. 24).[2] The *Maestà* originally comprised a wide panel painting set on a sturdy predella and framed by substantial architectonic piers. Above this two-tiered structure were sets of pinnacle panels whose irregular contours were rendered the more decorative by the presence of tall, slender pinnacles. Every surface of this complex wooden structure was once embellished with painted detail or gold leaf. Moreover, the composite nature of the overall design of the altarpiece offered scope for a large number of paintings to be included on it. It also imposed a logical organisation upon its varied imagery. Thus the entire surface of the main part of the front of the altarpiece was taken up by an imposing iconic image of the

20. (previous pages) Ambrogio Lorenzetti, *The Well-governed City*, detail of Pl. 15.

21. (facing page) The cathedral façade, Siena.

22. The cathedral, Siena.

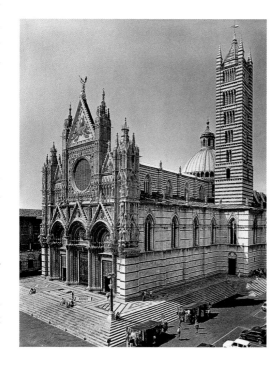

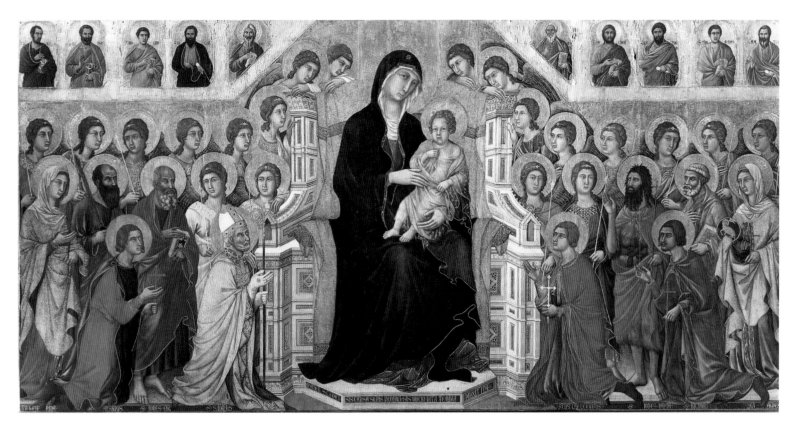

23. Duccio, *The Virgin and Christ Child with Saints and Angels*, the principal painting on the front of the *Maestà*, *c.* 1308–11. Siena, Museo dell'Opera del Duomo.

24. Reconstructions of the *Maestà*.

enthroned Virgin and Child in the company of saints and angels. On the predella below appeared a series of narrative paintings relating to the infancy of Christ. These lively scenes alternated with a series of standing figures of prophets each of whose painted text related directly to the subject depicted beside him (see Pl. 46). Above

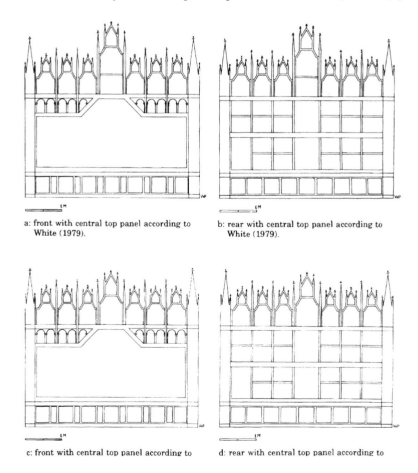

a: front with central top panel according to White (1979).

b: rear with central top panel according to White (1979).

c: front with central top panel according to

d: rear with central top panel according to

25. (facing page) Duccio, *The Virgin and Christ Child* detail of Pl. 23.

The City

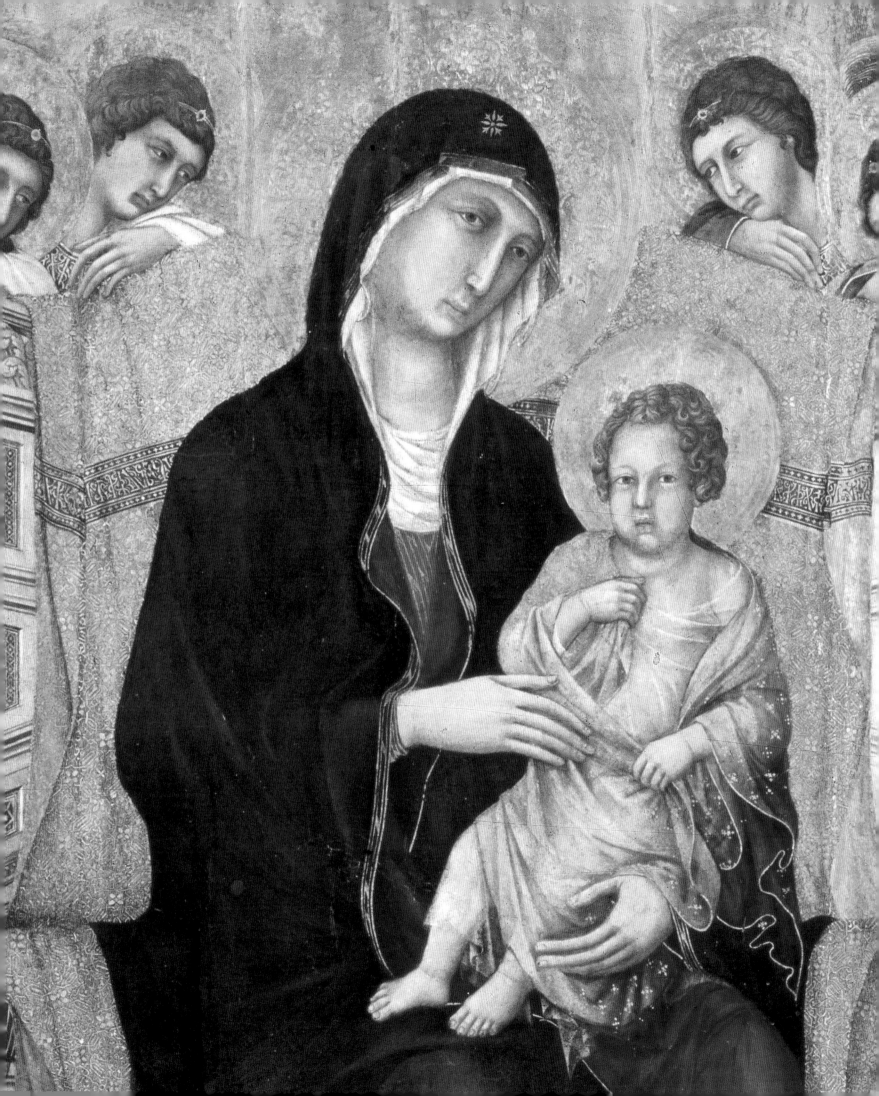

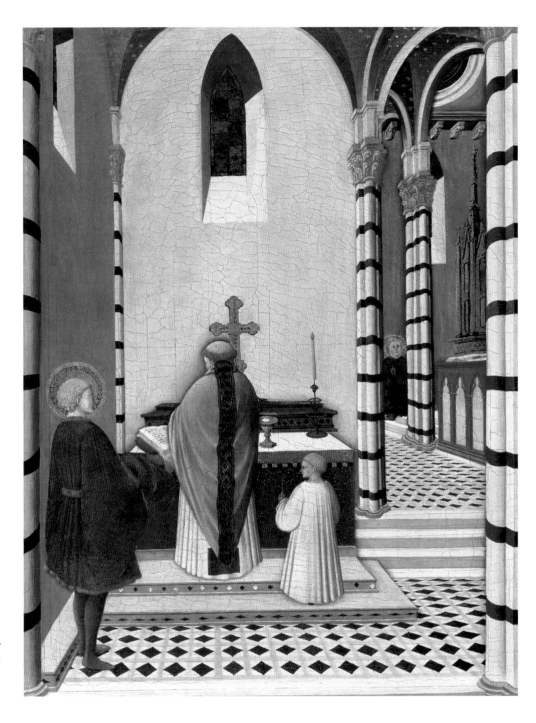

26. Master of the Osservanza, *Saint Anthony Attending Mass*, *c.* 1435–40. Berlin, Staatliche Museen Preussischer Kulturbesitz, Gemäldegalerie.

27. (facing page) Master of the Osservanza, *Saint Anthony Praying*, detail of Pl. 26

the main painting of the *Maestà* itself appeared a further series of narrative paintings depicting the last days of the Virgin (see Pl. 47). This series of pinnacle panels probably once had a larger (but now lost) central panel depicting a later stage in this narrative sequence – probably the Virgin's assumption into heaven. A final feature of this side of the altarpiece was a series of small gable panels, each depicting either an angel or, in the case of the now missing central panel, probably a half-length figure of Christ himself.[3]

The rear face of the altarpiece was no less complex in design. It comprised an extensive series of narrative scenes divided, as it were, into three discreet 'chapters' (see Pl. 44). Thus the predella provided a 'prologue' of nine scenes depicting events in the ministry of Christ; the main panel presented a detailed cycle of scenes from the Passion of Christ; and the pinnacle panels offered 'an epilogue' of seven scenes depicting Christ's appearances after the Resurrection. As in the case of the front face,

the centrepiece of this series is now missing but probably once depicted the Ascension of Christ. The uppermost tier of panel paintings was, once again, a sequence of half-length figures, probably showing at the centre an image of God the Father and, on either side, angels.[4]

As the high altarpiece, Duccio's complex painting naturally became one of the visual focal points of the cathedral's interior space. It also constituted the principal embellishment of the most revered altar in the cathedral. It had, therefore, to support and assist the religious devotions not only of the canons officiating in the cathedral itself but also of the populace as a whole. The question of the exact location of the high altar within the cathedral – and also, therefore, the matter of its accessibility to the public – is thus of considerable significance. Two painted images provide us with valuable – if schematic – information regarding the location of the high altar and its altarpiece during the fifteenth century. A small panel painting, dated to the mid-1430s and once part of a series of narrative scenes illustrating the life of Saint Anthony Abbot, records a contemporary impression of the interior of Siena cathedral with its striped marble piers and columns (Pls 26, 27).[5] It also affords a glimpse of the side of the high altar together with the outline of a monumental framing pier of an altarpiece, which may plausibly be assumed to be Duccio's *Maestà*. Both monuments are apparently situated in the first bay of a vaulted chancel, the east wall of which is pierced by one (or more) simple lancet windows and an oculus set high above a cornice. In addition, the detail of Saint Anthony shown praying behind the high altar suggests that both the back and the front of the high altarpiece were used for devotional purposes. If this painting is indeed an accurate depiction of the *Maestà* in its original situation over the high altar of Siena cathedral, then it is likely that masses were celebrated both in front of the imposing image of the Virgin and saints and also the detailed Passion series.

A painted wooden cover for a volume of financial records for 1483, provides a further opportunity to reconstruct the interior of the cathedral and its furnishings at that date. It depicts the re-dedication of the city to the Virgin in 1483 by Siena's leading magistrates (Pl. 28).[6] One of these magistrates in the company of a cardinal[7] is shown presenting the keys of the city to an image of the Virgin, located in a chapel opening off the south aisle of the cathedral.[8] In the left-hand background, is a view down the nave of the cathedral towards the high altar and its multi-tiered altarpiece. The altarpiece is seen silhouetted against the striped wall of the east end of the building, which includes a stained-glass oculus set high within it. Since a thirteenth-century stained-glass oculus remains in this position to this day, there are good grounds for regarding this panel as an attempt to render a broadly accurate portrayal of the internal organisation of the cathedral in the late fifteenth century (see Pl. 43). In front of the altarpiece is a substantial walled enclosure, access to which is by a wrought iron gate. Just inside this enclosure is a pulpit embellished with the civic insignia of the *balzana*. This may be a simplified representation of Nicola Pisano's thirteenth-century sculpted pulpit, although it strikingly lacks any indication of the statuary and narrative reliefs of this monumental work (Pl. 29). On the basis of this image, therefore, it appears that, by 1483, the high altar and its altarpiece, together with the pulpit, were once separated from the rest of the cathedral by a substantial choir which reached well into the crossing under the dome of the cathedral. This, however, was not the original location of the high altar.

It is clear from the records of the Opera del Duomo that the high altar and its altarpiece were subjected to a fairly drastic relocation in the second half of the fourteenth century. From 1317 onwards (that is, only six years after the installation of Duccio's altarpiece upon the high altar) the east end of the cathedral became the site of an ambitious programme to remodel and extend its fabric.[9] The initial motivation

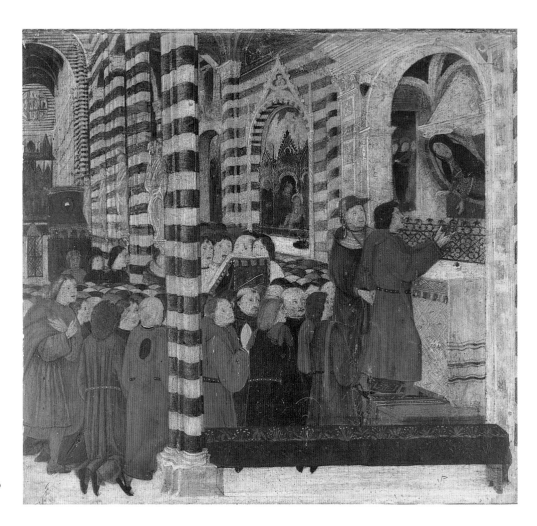

28. *Presentation of the Keys of the City to the Virgin*, 1483. Siena, Archivio di Stato, Museo delle Tavolette di Biccherna.

29. Nicola Pisano, pulpit, 1265–8. Siena, cathedral.

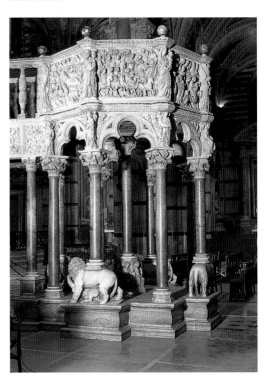

for this was the construction of a new baptistery. This was achieved by a bold scheme of excavating into the hillside beneath and beyond the chancel of the thirteenth-century cathedral thus providing the space for this new building. Once constructed the baptistery provided a base for extending the east end of the cathedral itself (Pl. 30). These plans were further complicated by the decision in 1339 to change the entire orientation of the cathedral by extending the body of the cathedral southwards to make the Duomo Nuovo and turn the newly extended east end into a transept. This project encountered enormous structural and technical problems, however, and on the advice of various experts it was abandoned in 1356, the earlier work on the baptistery and new chancel and transepts being brought to completion. In 1362 the decision was made to dismantle the existing high altar and relocate it in the newly extended chancel. Payments to workmen in October 1375 and January 1376 suggest that by that date it had indeed been reconstructed in its new location. By 1382 it was again crowned by the *Maestà*.[10]

The organisation of the cathedral prior to the mid-fourteenth-century remodelling is, however, far from clear. It is generally agreed, however, that it comprised a building of Latin cross plan, with a nave and aisles five bays long; a hexagonal crossing; transepts, a single bay in depth and two bays in length; and a rectangular chancel, two bays deep and three bays wide. Where exactly the high altar was located in the thirteenth-century cathedral remains a matter of debate. On 16 November 1259, the Consiglio Generale appointed a committee of nine men to formulate a proposal for a new layout of the canons' choir in relation to the high altar.[11] On 28 November, the committee duly reported back to a meeting of the Nine. At first sight, the record of this meeting would seem to suggest that the committee was recommending that the

high altar and choir stalls be constructed beneath the dome of the cathedral (Pl. 31).[12] A more detailed reading of the 1259 document demonstrates, however, that the suggestion that the altar be placed under the dome was the expression of a minority point of view of three of the committee. The other six, meanwhile, were apparently urging the merits of a less radical solution whereby 'the altar of the Blessed Virgin and the choir must be built and completed as planned by the honourable canons of the cathedral and the officials of the Opera del Duomo'.[13] Moreover, a document of 2 July 1368, concerning the manufacture of a new set of choir stalls records an agreement that these choir stalls, '. . . are to be built in a straight line, as in the old choir'.[14] It is likely, therefore, that the high altar was located in the first bay of the chancel and that the thirteenth-century choir stalls were arranged in a rectangular pattern behind the high altar (Pl. 32).[15]

It is thus probable that Duccio's monumental altarpiece would have been installed on an altar located within the first bay of the chancel of the thirteenth-century cathedral. This altar was undoubtedly set upon a number of steps thus rendering the altarpiece even more clearly visible and eye-catching. The present high altar is sixteenth-century but, given the impressive size of the *Maestà*, the original high altar must have been of a monumental scale in order to accommodate both the altarpiece's width and

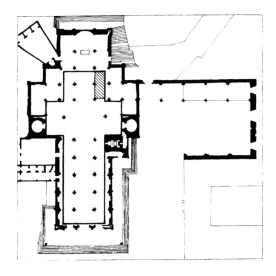

30. Ground plan of the twelfth-century cathedral superimposed on the present cathedral. The remains of a crypt lie below the shaded bays.

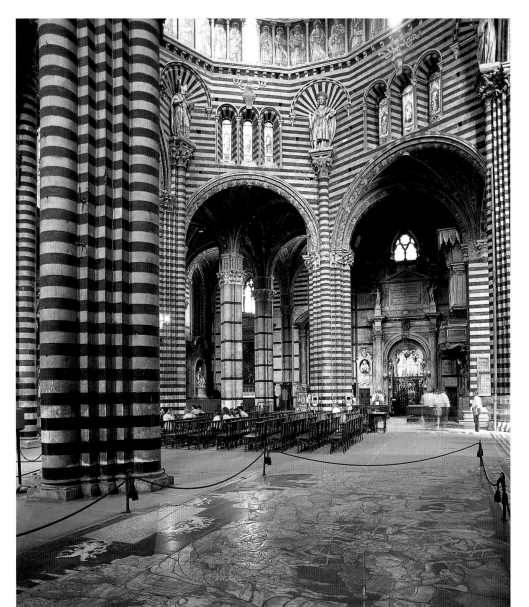

31. (*left*) The crossing of the cathedral looking towards the Cappella del Voto.

32. Reconstruction by Kees van der Ploeg of the thirteenth-century chancel and its furnishings.

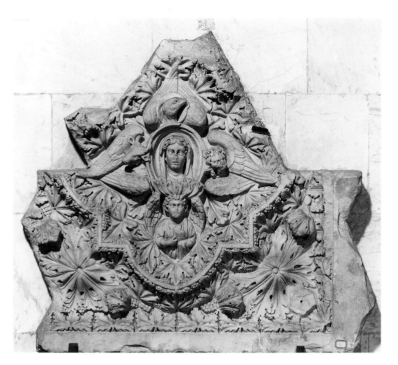

33. *Ecclesia and Symbols of the Four Evangelists*, fragment probably from the thirteenth-century high altar of the cathedral. Siena, Museo dell'Opera del Duomo.

34. Carved panel probably from the thirteenth-century choir of the cathedral. Siena, Museo dell'Opera del Duomo.

also support its great height.[16] There is also evidence that this thirteenth-century altar had as its carved centre-piece a sculpted relief of a veiled woman surrounded by the symbols of the four evangelists (Pl. 33) and that there may, in addition, have been a series of carved stone panels forming an outer enclosure to the thirteenth-century choir stalls (Pl. 34).[17] It is likely, therefore, that when it was installed upon the high altar in 1311, Duccio's *Maestà* would have been situated within an already rich and complex context of sculpted reliefs on both altar and choir as well as in close proximity to Nicola Pisano's monumental pulpit (see Pl. 29).

In reporting the installation of the *Maestà*, the anonymous fourteenth-century chronicler was notably less concerned to describe the subject matter and imagery of the altarpiece than to relate the manifestations of religious devotion which attended this event. It is also clear from his description that the act of taking the painting through the city to the cathedral was closely linked to the cult of the Virgin as the city's supreme protector and advocate.[18] Indeed, it appears that the civic ritual which surrounded this event closely mirrored the well-established civic rituals for the feast of the Assumption. As noted in the previous chapter, this annual event not only honoured the Virgin on one of her major feast days, as the titular saint of both the cathedral and its high altar, but probably also reiterated the city's dedication to the Virgin on the eve of the battle of Montaperti.[19] Moreover, since all the early accounts of the event state that this act of dedication took place at the high altar of the cathedral, it is clear that, from the 1260s onwards, the high altar of the cathedral became the focus of a particularly intense manifestation of civic religion and devotion. Clearly, therefore, whatever image stood above the high altar would also have come to share in the intensity of such devotion.

What image, then, may have embellished the high altar at the time of Montaperti? The account given by the anonymous fourteenth-century chronicler strongly implies that the dedication of the city in 1260 was made before an image of the Virgin. Thus the account runs: 'On the morning when they had to engage in battle, they celebrated a solemn mass and made grand offerings to the Virgin Mary. . . . And the bishop made a solemn procession, and placed the keys [of the city] in the hands

of the Virgin and it was recorded in the documents and the city was given the title of the Virgin Mary'.[20] In accordance with long-established devotional practice in late medieval Italy, it is likely that either the bishop or, if other later accounts are accurate, the bishop and the city's syndic, Buonaguida Lucari, were enacting this ritual act in front of a specific image of the Virgin Mary. This is certainly what the fifteenth-century artist, Niccolò di Giovanni Ventura, understood to have happened (see Pl. 5). Such an act would also, moreover, be consistent with the widespread belief in late medieval Christianity that the divine power attributed to a holy person could also reside in an image of that person and that this image might accordingly possess sensory attributes and be capable of responding to acts of petition and appeal. There was, in short, often a blurring between the identity of the holy person and the identity of her (or his) image.[21]

The prevailing view amongst most modern scholars is that the image to which the Sienese addressed their petition survives today in the form of an early thirteenth-century panel which, like many other panels of this date, is both sculpted and painted (Pl. 35). Known conventionally, but somewhat misleadingly, as the *Madonna degli occhi grossi* it will be referred to here as the *Madonna of the Vow*.[22] It offers an austere but compelling image of the Virgin seated upon a ceremonial throne, presenting, as it were, the Christ Child to the viewer. The Child, by virtue of his gesture of blessing and the scroll he is shown holding in his other hand, appears in the guise of priest and legislator. The importance and sanctity of these two figures is further emphasised by two angels silhouetted against the gold background who are shown in the act of censing. Originally the impression of a richly crafted artefact would have been further enhanced by the presence of gems which would have embellished the Virgin's halo, throne and footstool and the intricately worked border framing the two holy figures. It is clear from the present state of the panel that its dimensions were once much larger. On the basis of other surviving examples, it appears likely that its original format was that of a horizontal dossal with a series of smaller paintings arranged symmetrically around a central image of the Virgin and Child (Pl. 36). It has also been suggested that the panel once formed an antependium for an altar and that around 1240 – possibly as a result of new liturgical practice whereby the priest celebrated mass with his back to the congregation – it was placed on the high altar to act as backdrop to the liturgy of the mass. If this was the case, then this Marian image would have played a major role in the history of the altarpiece as a genre.[23]

It is also generally believed that as a result of the victory of Montaperti, the *Madonna of the Vow* was replaced by a new and more up-to-date altarpiece. This also survives today in truncated form as the revered *Madonna delle Grazie* (the *Madonna of Thanks*) located over the altar of a votary chapel, the Cappella del Voto, constructed in the mid-seventeenth century in order to house and honour this ancient image (Pl. 37).[24] The *Madonna of Thanks* is generally dated to the 1270s and is attributed to Guido da Siena, the most celebrated and prolific Sienese painter during the later decades of the thirteenth century. What survives of this painting shows a half-length image of the Virgin with the Christ Child supported on her left arm (Pl. 38). The angle of her head and her hand gesture correspond to that of the revered 'Hodegetria' icon, believed to have been painted by Saint Luke.[25] Like the earlier painting, the Christ Child is shown in the act of blessing with his right hand whilst holding a scroll in his left. It is also apparent from what remains of the mouldings above the two figures that they once appeared beneath a cusped arch. On the basis of other contemporary examples, it would appear that this altarpiece once comprised a horizontal dossal whose upper contour was in the shape of a shallow gable (Pl. 39). The central image of the Virgin and Christ Child would have been framed by depictions of other

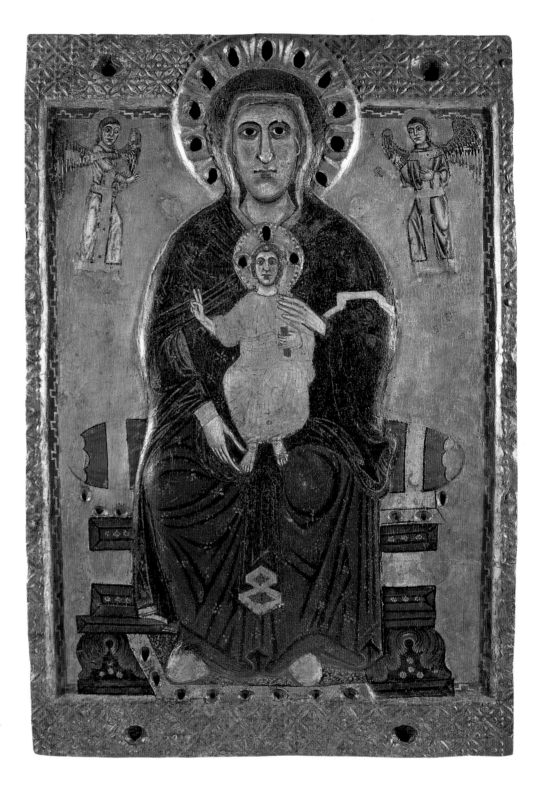

35. *The Madonna of the Vow*, popularly known as the 'Madonna degli occhi grossi', early thirteenth century. Siena, Museo dell'Opera del Duomo.

saints, probably four in number. These figures would have been given further distinction and visibility by being framed by a series of round-headed arches, embellished by simple cusping and perhaps supported by attached colonettes as in the case of Deodato Orlandi's early fourteenth-century altarpiece (Pl. 40).[26]

Once displaced from the high altar, it appears that both the *Madonna of the Vow* and the *Madonna of Thanks* continued to function as cult objects in their own right. From Niccolò di Giovanni Ventura's detailed account of Montaperti, it is clear that, by his day, the *Madonna of the Vow* had already been cut down and, at some point, had been hung beside the cathedral's principal southern doorway – the Porta del Perdono.[27] Although Niccolò specifically disassociates it with any altar, the

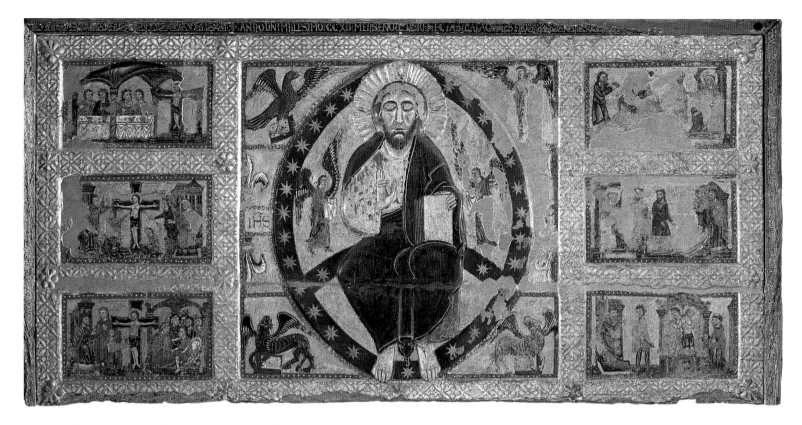

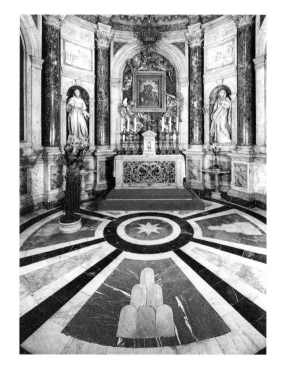

36. *Christ in Majesty with Scenes of the Legend of the Cross*, 1215. Siena, Pinacoteca.

37. Siena, cathedral, Cappella del Voto.

cathedral inventories of 1420 and 1423 refer to an altar in the vicinity of the Porta del Perdono and designate it the altar of Santa Maria delle Grazie (see Pl. 73). These entries suggest that by the early fifteenth century, if not considerably earlier, the early thirteenth-century *Madonna of the Vow* had been placed over an altar, the title of which made direct reference to both the Virgin and the city's gratitude towards her. It is also significant that these inventories name one of the altars in the south transept (and thus in close proximity to the Porta del Perdono), the altar of the Crucifix.[28] According to the chronicle accounts of Paolo di Tommaso Montauri and Niccolò di Giovanni Ventura a crucifix was a prominent feature in the intercessory procession that took place through the streets of Siena on the eve of Montaperti. The altar of the Crucifix may, therefore, have housed this ancient and presumably highly venerated object (see Pl. 5).[29] Significantly, moreover, the Porta del Perdono provided access to the cathedral on a direct route from the Campo and the Palazzo Pubblico.[30] Given the pre-eminence of Montaperti and the devotion associated with it in both the civic and religious life of Siena, it seems highly likely that the officials of the Opera del Duomo decided that this area of the cathedral should be embellished with revered and ancient artefacts associated with the victory and celebrating the Virgin's apparent concern for the fortunes of the city that had been so dramatically placed under her protection.

As for the *Madonna of Thanks* by Guido da Siena (Pl. 38) the fourteenth- and fifteenth-century accounts of the high altarpiece all agree that the painting was subsequently taken from the high altar and placed on another altar dedicated to Saint Boniface. Given that the victory of Montaperti was won on the feast of Saint Boniface, this decision would have been both entirely appropriate and also a further elaboration of the complex mosaic of memorials to this key event which the Sienese steadily developed. Entries within the fifteenth-century inventories of the cathedral indicate that an altar dedicated to Saint Boniface was then located within the third bay of the south aisle (see Pl. 73) and that it had placed upon it, 'the ancient and principal panel painting of this church'.[31] The inventory entries thus substantially

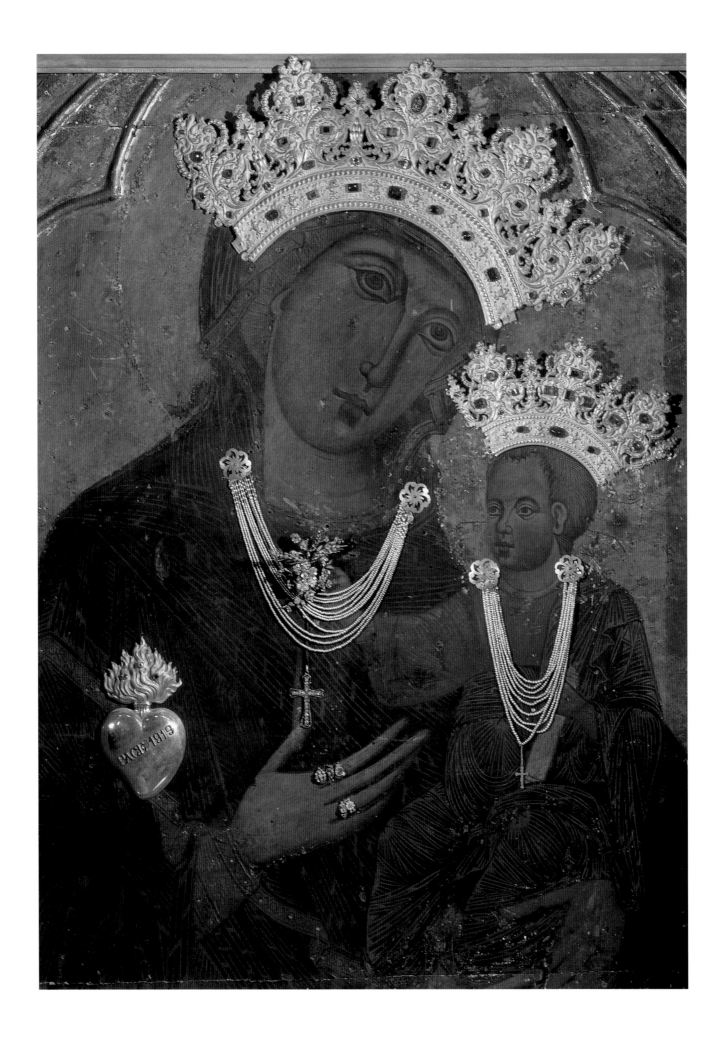

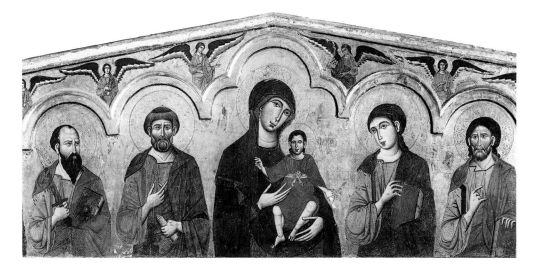

39. Guido da Siena, *The Virgin and Child with Saints*, popularly known as the 'Polyptych no. 7', 1270s. Siena, Pinacoteca.

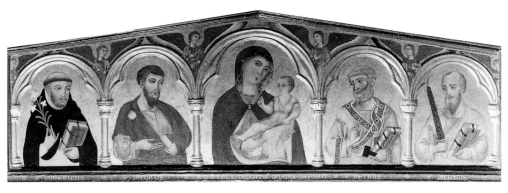

40. Deodato Orlandi, *The Virgin and Child with Saints*, 1301. Pisa, Museo Nazionale di San Matteo.

confirm the accounts given by the chroniclers that the *Madonna of Thanks* (Pl. 38) was once on the high altar. In the 1450s the existing altar niche or 'chapel' of Saint Boniface in the south aisle was much enlarged and decorated with relief sculpture and the dedication was changed to Santa Maria delle Grazie.[32] This chapel thus became a sizeable addition to the cathedral's fabric projecting from the south aisle wall into what was then the archiepiscopal palace (Pl. 41). It is this chapel which is shown on the 1483 panel (see Pl. 28). It should be noted, however, that as early as 1262 – and thus two years after the victory of Montaperti – the city statutes make reference to plans to build a chapel in honour of the Virgin and to dedicate it specifically to Siena's victory over its enemies.[33] It seems, however, that attention was focused first upon the high altar which, quite apart from its new sculpted and painted embellishment, was also the recipient of two candles burning day and night at the expense of the Commune.[34] Although the precise history of the building of the new chapel in honour of the Virgin, first mentioned in 1262, remains uncertain, it is at least clear that, when the altarpiece commissioned from Guido da Siena was removed from the high altar in order to install Duccio's *Maestà*, the earlier painting became firmly associated with an altar dedicated to Saint Boniface, upon whose feast day the victory of Montaperti had occurred.

It is clear, then, that when Duccio's *Maestà* was placed upon the high altar of the cathedral, it was located in a space already closely associated with two previous images of the Virgin, both of which were revered by the Sienese, not least because of their intimate association with the myth of Montaperti and the consequent dedication and devotion of the city to the Virgin. Equally clearly, an understanding of the significance of the *Maestà* will therefore include an appreciation of its place within a specific Sienese tradition of devotion to the Virgin, expressed not least by means of revered images of their protector and advocate. But were these the only images

38. (facing page) Guido da Siena, *The Madonna of Thanks*, popularly known as the 'Madonna delle Grazie' or the 'Madonna del voto', 1270s. Siena, cathedral, Cappella del Voto.

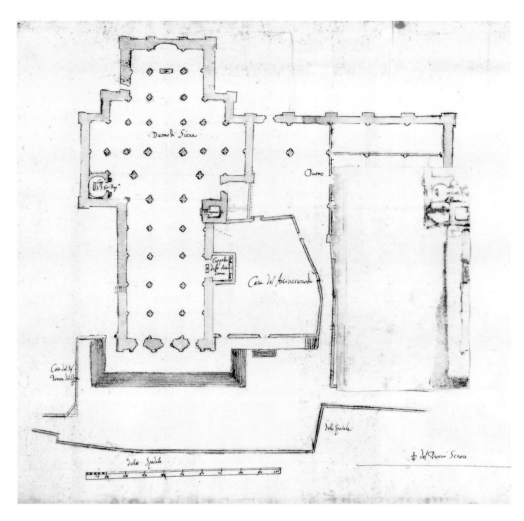

41. Plan of the cathedral showing, on the right, the archiepiscopal palace before its demolition, *c.* 1658. Rome, Biblioteca Apostolica Vaticana, Archivio Chigi P.VII 11, fols 38ᵛ–39ʳ.

42. Reconstruction by Kees van der Ploeg of the twelfth-century cathedral choir and its furnishings.

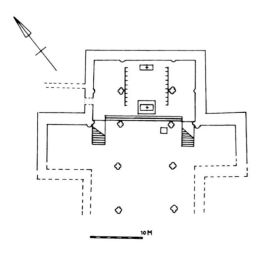

already in the cathedral which are significant for a proper appreciation of Duccio's *Maestà* and its meaning and function? In fact, there are good grounds for thinking that the *Madonna of the Vow* and the *Madonna of Thanks* are by no means the only pre-existing images of such significance.

It has been argued that another early panel painting once stood over a second altar located inside the canons' choir and thus behind, but in the close vicinity of, the high altar (Pl. 42). Now in the Pinacoteca of Siena, the painting in question, which may have been an altarpiece or an altar frontal, carries a painted inscription which states that the panel was made in 1215 (see Pl. 36).[35] The subject matter of the panel – Christ in Majesty surrounded by the symbols of the four evangelists and six scenes relating to the cult of the Cross of the Crucifixion – is highly eucharistic.[36] Moreover, entries within a detailed Sienese Customary of 1215, supplying directives for liturgical practice in the cathedral, suggest that the feasts of the Invention and Exultation of the Cross were celebrated with great solemnity and that, at the feast of the Invention of the Cross, a particular panel whose imagery commemorated 'the wood of the life-giving Cross' was placed over an altar as an object of devotion.[37] If this early panel painting was used in connection with particular feasts on an altar located within the canons' choir then it provides compelling evidence for a well-established cult of eucharistic imagery within the chancel of the cathedral.

The subsequent removal of this panel, together with the *Madonna of the Vow* from the high altar, would in all probability have occurred during the renovation of the chancel which took place in the years following the victory of Montaperti. This scheme, it should be recalled, included a new Marian altarpiece by Guido da Siena, a new high altar and an enclosed canons' choir behind it, the sculpted work probably

being executed by the workshop of Nicola Pisano, who had been primarily responsible for the monumental stone pulpit which now stands just north-east of the cathedral crossing (see Pl. 29). Executed between 1265 and 1268, the original location of the pulpit is likely to have been beneath the dome on the south-east side of the crossing and thus just to the right of the entrance to the chancel.[38] In addition to the paintings on various altars, therefore, when Duccio came to execute his high altarpiece, there was also already a sophisticated programme of sculpted imagery which combined both statuary and narrative reliefs – imagery, moreover, rendered striking by the use of richly patterned, glazed backgrounds on the reliefs and gilding on many of the sculpted details. The pulpit in particular provided a powerful series of visual reminders of the Church's teaching on the Incarnation of Christ and its redemptive significance. And, as appropriate in a cathedral dedicated to the Virgin, the figure of Mary appears prominently within each of the six narrative reliefs, and also as a statuette between the second and third panels of the pulpit. Portraying her simultaneously as a tender mother and – by virtue of her graceful demeanour and delicately ornamented crown – as a person of royal status, Nicola Pisano and his assistants provided an impressive visual model for the work of subsequent artists.

As well as the high altar, its altarpiece, sculpted choir and monumental pulpit, this ambitious scheme of later thirteenth-century embellishment of the east end of the cathedral also included a magnificent stained-glass oculus (Pl. 43). Commissioned in 1287 and apparently completed by 1288,[39] it was installed on the easternmost wall of the thirteenth-century chancel – only to be taken down in the middle decades of the fourteenth century in order to allow for the rebuilding and extension of the chancel. It was then reinstalled in 1365 and is still a striking feature of the east end of the cathedral – particularly when viewed down the entire length of the nave.[40] Further developing the emphasis on the Virgin and the Incarnation in Nicola Pisano's pulpit, the stained-glass figures focus explicitly and centrally upon the Virgin herself and in particular upon key hagiographical episodes of the dormition of the Virgin (the moment when her soul was taken to heaven while her body remained in the tomb to be mourned by the apostles), the assumption of her body into heaven and her coronation as Queen of Heaven. Moreover, the depiction of these three episodes in the life of the Virgin is, in turn, located within a subtle and sophisticated iconographic scheme.

On either side of the imposing central image of the Virgin of the Assumption appear a pair of saints. Titles behind their heads identify these four figures as Saints Bartholomew, Ansanus, Crescentius and Savinus. By the date of the execution of the stained-glass window all four had been adopted as patron saints of Siena – none of them as important as the Virgin herself but, nevertheless, the focus of considerable devotion and allegiance. Ansanus, Crescentius and Savinus were all early Christian saints, martyred for their faith during the early fourth-century persecution under the Emperors Diocletian and Maximian.[41] Ansanus and Crescentius were young Roman noblemen whilst Savinus was a bishop of the early Church. Although there are differing views as to exactly when their cults were first introduced to Siena, Ansanus was reputed to have baptised the Sienese and to have been executed on the banks of the Arbia just outside Siena. Similarly, according to popular tradition, Savinus was the first bishop of Siena. In 1058, meanwhile, Bishop Antifredus of Siena was reputed to have acquired the relics of Saint Crescentius from the pope.[42] In 1190, it appears that the city's cathedral had three principal altars dedicated to the Virgin, Ansanus and Savinus.[43] The 1215 Customary, mentioned previously in connection with the celebration of feasts relating to the Cross, makes reference to the presence of an altar in the cathedral dedicated to Savinus, as well as to the relics of Ansanus and Savinus.[44] There is no clear indication why the apostle,

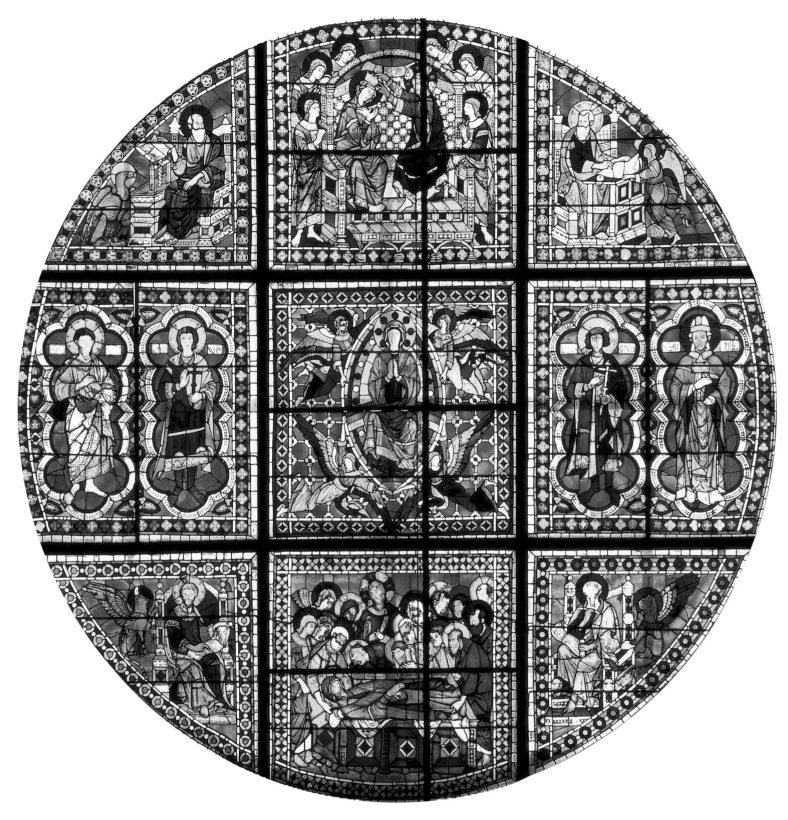

43. *The Dormition, Assumption and Coronation of the Virgin, Four Evangelists and Four Patron Saints of Siena*, 1287–8, stained-glass window (before restoration). Siena, cathedral.

Bartholomew, was made the object of a special civic cult but the 1215 Customary indicates that there was an altar dedicated to Crescentius and another to Bartholomew, together with two other fourth-century martyrs, Sebastian and Fabian.[45] Although, it is by no means certain, it is likely that these altars were located in a crypt directly below the chancel of the twelfth-century cathedral and accessible by two flights of steps set on either side of the entrance to the chancel.[46] If this was, indeed, the case, the relics of these revered patron saints would have been kept

in the heart of the cathedral directly below the high altar, itself dedicated, in turn, to the Virgin of the Assumption.

Nor does the combination of the central, vertical sequence of the Virgin's death, assumption and coronation and the central horizontal sequence of the four patron saints either side of the Virgin of the Assumption exhaust the complexity of this stained-glass oculus. In each corner of the oculus appears an image of one of the four evangelists, with their appropriate symbols, thus allowing for a third axis of meaning within the glass as a whole: vertically, a celebration of the Virgin; horizontally, a celebration of the patron saints of Siena; and diagonally, a celebration of the Church represented by the authority of the four evangelists and the person of Mary, herself widely understood to have been a personification of *Ecclesia* in medieval Christianity. A design of such elegance and with such potential for multi-directional readings may also be regarded as at least circumstantial evidence in favour of the attribution of the design of this oculus to Duccio himself. Although well short of providing conclusive evidence on this much-debated point, it is notable that the design of the oculus is similar in kind to the complexity and capacity for multi-directional readings of the rear-face of Duccio's *Maestà*: there, also, the potential for reading the narrative sequence in a variety of ways is a striking feature of the work.[47]

Whoever was, in fact, responsible for the design of the stained-glass oculus, once it had been installed in the east end of the church, the relatively modest scale of Guido da Siena's altarpiece must have appeared distinctly lacking in visual impact and dignity for the embellishment of the cathedral's principal altar. By contrast, Duccio's *Maestà* clearly provided a strikingly monumental and sophisticated alternative to the older altarpiece (see Pl. 24). One of the most remarkable features of the *Maestà* was the fact that it was, indeed, a double-sided altarpiece. Other earlier or near contemporary examples of double-sided altarpieces all suggest that their manufacture was dictated by the special demands of their particular liturgical locations.[48] A similar imperative is also discernible in the case of the *Maestà*. Duccio's altarpiece, as we have noted already, was situated in the first bay of the chancel of the cathedral. Directly behind it, in the exclusive and reserved space of their enclosed choir, the canons of the cathedral met daily to observe their offices. In the twelfth and early thirteenth centuries, moreover, as we have again noted, these devotions may also have been assisted by the presence of a subsidiary altar, embellished – from time to time – by a painted retable depicting scenes relating to the cult of the Cross of the Crucifixion (see Pls 36, 42). The installation of a monumental high altar in the 1260s providing space for masses to be celebrated on both sides of it, would have rendered the earlier choir altar redundant.[49] Nevertheless, the rich sequence of narrative imagery on the back of the *Maestà* would certainly have facilitated the continuation of the tradition of veneration for the Cross in the canons' choir (Pl. 44). At the centre of this painted scheme is a strikingly moving image of the Crucified Christ (Pl. 45). Around this image is an intricate painted narrative which, like the liturgy for Easter, rehearses the events preceding Christ's death on the Cross. Clearly, the overtly eucharistic nature of much of this imagery would have been highly relevant to the canons who, as priests, regularly celebrated mass at the various cathedral altars. In addition, the relatively intimate scale of these scenes suggests an audience who had both the time and the opportunity to absorb the detail of the narrative and explore the varied alternative paths within its intricate sequence. Such spiritual exercises combining visual contemplation and meditation would have been highly appropriate for the community of canons whose lives were ordered by a structured, daily round of communal acts of worship and devotion within their choir.

As well as its function as a focus for the devotional life of the canons, however, Duccio's *Maestà* also performed an important role in the public and civic devotions

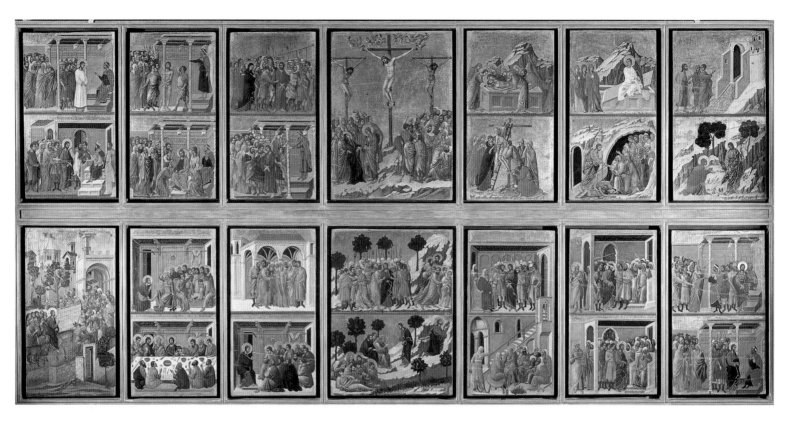

44. Duccio, *Scenes from the Passion of Christ*, the principal painting on the back of the *Maestà*, *c.* 1308–11. Siena, Museo dell'Opera del Duomo.

45. (facing page) Duccio, *Crucifixion*, detail of Pl. 44.

in the cathedral. The chronicle accounts describing the installation of the altarpiece, make it clear that the *Maestà* inspired devotion from a wide range of social groups.[50] Moreover, until 1367, there is no evidence of a choir screen excluding the laity from access to the high altar – although there were, no doubt, detailed prescriptions about when the laity could approach the high altar, particularly in the case of women.[51] The front face of the *Maestà*, with its extraordinarily compelling Marian iconography (see Pl. 23), would thus have been intended for the benefit of Siena and the Sienese in general and not only government officials, the Nine, or members of the Consistory or the Opera del Duomo.

On the edge of the step of the Virgin's throne of marble and inlaid mosaic, runs a finely written text executed in gold leaf against a deep crimson background. It reads: 'Holy mother of God be the cause of peace for Siena, and, because he painted you thus, of life for Duccio'.[52] The text thus has an extraordinarily personal note for Duccio himself. In addition, the very fact that the city officials and the bishop allowed the inclusion of his name and personal petition upon the most important of the cathedral's altarpieces suggests a high regard and gratitude for his abilities and achievement. More importantly, this text, with its direct address to the Virgin and the petition that it makes, locates this image firmly within the well-established cult of the Virgin as the city's principal patron saint and intercessor. At the same time, however, Duccio's *Maestà* significantly extends and develops the imagery and iconography associated with this civic cult. The front face of the altarpiece was dominated by a single, large painting depicting the Virgin and Christ Child in the company of angels, apostles and saints. Despite the unified figural composition, the two most important cult figures are emphasised and set apart by virtue of their central position, the Virgin's imposing scale and the magnificent framework furnished by the architecture of the throne. As in the case of Nicola Pisano's statue on the nearby pulpit (see Pl. 29), however, Duccio took care to convey both the Virgin's maternal and regal qualities. Thus, she is portrayed holding her Child on her left arm and right knee and thus close to her body. Like the *Madonna of Thanks* (see Pl. 38), her inclined head and hand gesture conform to the tradition of the Hodegetria – yet the hand

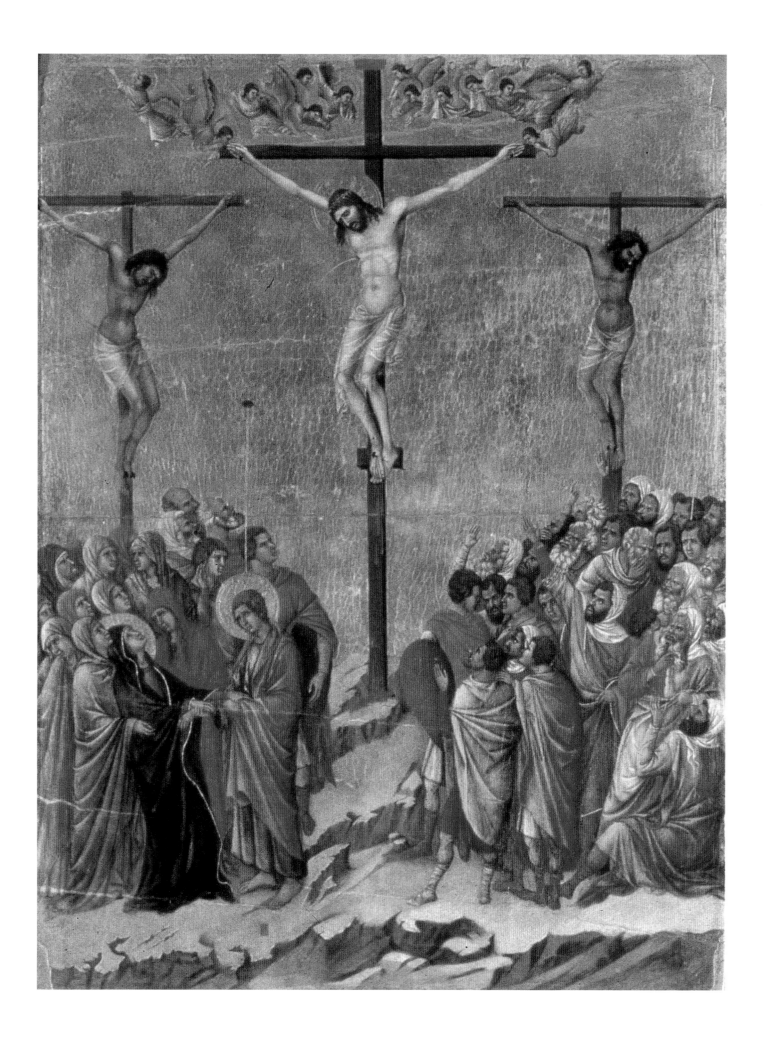

gesture is also suggestive of a degree of intimacy and tenderness towards her young son. At the same time, her regal status is amply suggested by the finely gilded edges to her traditional crimson robe and blue mantle and by the rich materials of her throne, hanging and cushion. The impression of the court of heaven is further developed by the shimmering gold background of the painting and the presence of twenty angels – eight of whom carry ceremonial wands – a detail derived from Byzantine court ritual.

Another striking and innovative feature of the *Maestà* is the portrayal of the Virgin and Child within the same setting as their companions. Hitherto, altarpieces of this type had presented the Virgin and Child as separate from other subsidiary figures or scenes. The impression in the *Maestà*, however, is that these two enthroned figures are indeed presiding over a ceremonial gathering in heaven. The nearest prototype would appear to be the monumental mosaics which embellished the principal apses of early Christian churches – and generally showed Christ crowning the Virgin as queen of heaven – an iconography specifically designed to emphasise the majesty of the Virgin. A number of such mosaics are to be found in Rome's most venerable churches.[53] One of Duccio's achievements in the *Maestà*, therefore, was to transfer this type of image designed for the embellishment of the eastern end of a church, to a panel painting to be placed over the high altar.

A further innovation is the presence of the four patron saints of Siena depicted kneeling on either side of the Virgin. Clearly identified by gilded titles in the lower border, they represent Ansanus, Savinus, Crescentius and a new addition to the pantheon of patron saints, Victor. The iconography of the first three saints had already been established not least in the imagery of the stained-glass oculus (see Pl. 43). Thus Ansanus and Crescentius appear on both the stained-glass window and on the *Maestà* as beardless youths, dressed in classical tunics and mantles. The former carries a small, portable red cross and the latter, a white cross. Savinus, meanwhile, appears as an elderly, bearded bishop arrayed in full pontificals.[54] The fourth saint, Victor, was a second-century saint believed to be martyred by decapitation (see Pl. 23).[55] It appears from the 1215 Customary that the cathedral possessed, at this date, the relic of the saint's head and that it was then housed in the altar dedicated to Saint Savinus. In 1229, Victor became more significant for the Sienese when, on his feast day, they won an important victory over Montepulciano. Sometime between 1288 and 1311 the city authorities must therefore have decided to adopt this saint as the fourth of the city's protector saints.[56] It appears that it was Duccio who then established the basic iconography of this saint, portraying him as a dark-haired, bearded, mature man – an iconography which was adopted for other representations of this saint in the fourteenth and fifteenth centuries.[57]

What is most significant in the *Maestà*, however, is that in place of the row of standing saints on the stained-glass window, Duccio chose to portray them as kneeling petitioners before the Virgin. Although derived from early Christian and Byzantine mosaics, in which donors were shown kneeling before God, Christ or the Virgin and occasionally presenting gifts such as churches or cities,[58] this imagery must also have had a powerful local association for the Sienese – possibly evoking the image of the bishop of Siena and Buonaguida Lucari kneeling before the Virgin petitioning her to save the city from its enemies.[59] The text beneath the Virgin's throne in the painting further underlines this message. Its forthright appeal clearly signifies the precise nature and import of the four saints' collective act of homage. Significantly, the four protector saints are located in the immediate foreground of the painting and indeed, the edges of their drapery appear to fall over the edge of the painted border which carries their names. They thus give the appearance of being very close to the spectator and intervening with the Virgin on his or her behalf. Their

outstretched hands similarly invoke an impression of active mediation. These four figures are therefore seen as acting on behalf of the citizens of Siena and commending them to the Virgin – an imaginative and effective portrayal of the intercessory role of the four patron saints, which, moreover, was to be highly influential for another of Siena's major civic images.[60]

This majestic Marian painting was once framed by smaller narrative scenes which continued the broad celebratory theme of the main panel. Thus, although ostensibly celebrating the infancy of Christ, the predella scenes and the painted texts of the framing prophets also served to emphasise the crucial role of the Virgin in the doctrine of the Incarnation. Furthermore, the centrally placed predella scene of the Presentation in the Temple, with its detail of the high priest presiding over the altar of the Temple, further underlined the presence of the eucharist upon the high altar and also invoked another of the metaphors used by the Church to convey the sanctity of the Virgin's role as the mother of Christ – namely that of *Aracoeli*, the altar of heaven itself (Pls 24, 46). Finally, as a culmination to this extraordinary celebration of the Virgin, the series of pinnacle panels depicted the sequence of events which were believed to have marked the end of the Virgin's life, namely the gathering of the apostles at her deathbed, the dormition, the funeral procession and the entombment (Pl. 47). Although now lost, it is likely that the central panel of this series once depicted the Virgin's assumption into heaven, an appropriate scene for the very top of an altarpiece, the front face of which constituted a sustained celebration of the Virgin.

By 1311, therefore, the high altar of Siena cathedral was graced by an extraordinarily sophisticated array of painted imagery. Inserted into a tradition of civic veneration for the Virgin, which itself focused upon the high altar and an ancient and highly venerated image of the Virgin in majesty, Duccio's *Maestà* substantially enriched and extended the range and impact of such associations. Adopting a scale

46. Duccio, *The Presentation in the Temple (with Prophets)*, part of the front predella of the *Maestà*, *c.* 1308–11. Siena, Museo dell'Opera del Duomo.

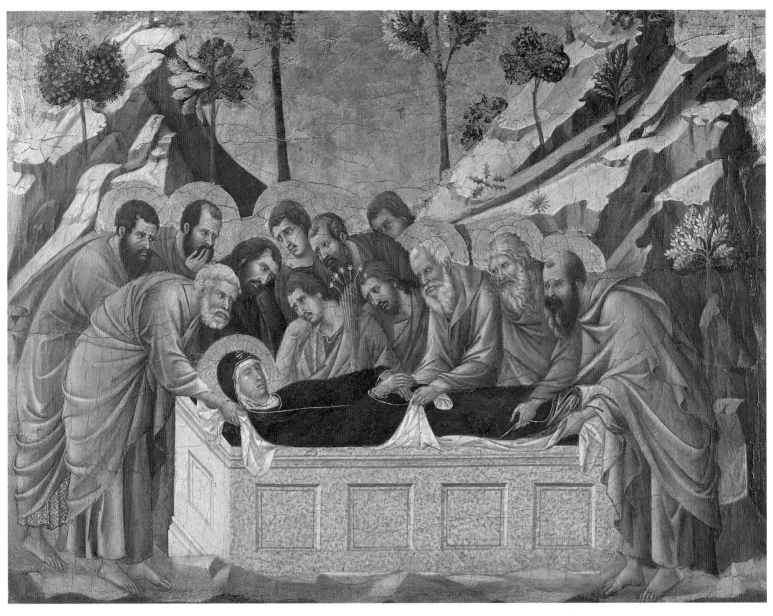

47. Duccio, *The Entombment of the Virgin*, one of the front pinnacle panels of the *Maestà*, c. 1308–11. Siena, Museo dell'Opera del Duomo.

and richness of materials comparable to that of early Christian mosaics, the *Maestà* presented an imposing image of the Virgin as both tender mother and queen of heaven. Moreover, the very act of furnishing the high altar of the cathedral with a painting of this quality, allowed the Sienese to hope for a reciprocal gift from the Virgin, namely, the continued expression and demonstration of her favour and protection.

In addition to this powerful visualisation of the Virgin, however, Duccio added a further significant layer of imagery – that of the four patron saints of Siena. These saints were visualised as a more immediate rank of mediators, petitioning the Virgin on behalf of the Sienese. In addition to this important and central civic icon on the front face of the altarpiece, moreover, Duccio also extended the sheer range of the repertoire of imagery upon the high altarpiece. Thus he emphasised Mary's role in the Incarnation and the exceptional circumstances of her death. If the powerful image of the Virgin's court on the front of the altarpiece was indeed once crowned by an image of the Virgin of the Assumption, then the link between the symbolic acts of fealty on the part of the Sienese and their subjects which took place annually in the cathedral on the vigil and feast of the Assumption could not have been more clearly stated. Finally, the function of the high altar as a place where all

48 (facing page) *The Dormition, Assumption and Coronation of the Virgin*, detail of Pl. 43.

the feasts of the Virgin were marked by the celebration of mass, itself a symbolic commemoration of the redemptive act of Christ's death upon the cross, was fully acknowledged by specifically eucharistic themes upon both the back and front of this remarkable double-sided altarpiece.

In short, in Duccio's *Maestà*, the Sienese obtained, for the high altar of their principal church, a resounding visual affirmation of many of their most highly cherished civic myths. Moreover, as subsequent chapters will demonstrate, this altarpiece was to become highly influential as an example for other commissions for key civic and religious sites both within Siena itself and in its subject territories. Duccio's powerful pictorial celebration of the key religious figures at the centre of Siena's civic cult thus assisted successive Sienese governments in their efforts to promote a particular civic ideology and spread its influence well beyond the confines of the city itself.

3

The Town Hall

The high esteem in which Duccio's *Maestà* was held by the Sienese is perhaps nowhere better demonstrated than in the influence it exerted, within a remarkably short space of time, upon other Marian images in early fourteenth-century Siena. Such influence was expressed both in the renovation of existing – and often highly revered – Marian paintings dating from the previous century and also in the style and iconography of an entirely new and strikingly ambitious Marian image painted in the decades following the installation of the *Maestà* in the cathedral. The present chapter will therefore begin by noting, briefly, the apparent impact of the *Maestà* upon the renovation and repainting of two thirteenth-century Marian panel paintings, and will then examine in more detail the development of key elements in the iconography of Duccio's *Maestà* in Simone Martini's exploration of this subject in the Sala del Consiglio of the Palazzo Pubblico (Pl. 50).

It is generally assumed that the large panel painting known as the *Madonna del bordone* and now placed over a side altar in Santa Maria dei Servi – one of Siena's principal mendicant churches – once functioned as the high altarpiece of that church (Pl. 51).[1] Signed by Coppo di Marcovaldo (a Florentine painter who possibly served as a soldier in the Florentine army at Montaperti),[2] and dated 1261, it portrays the familiar subject of the enthroned Virgin with the Christ Child and accompanying angels.[3] Given the commitment of the Servite Order to the veneration of the Virgin and also the fact that between 1259 and 1263 the Servite community were establishing themselves on the south-eastern outskirts of Siena in an ancient church dedicated to San Clemente, the commissioning of a large panel of the Virgin for the high altar of their church would be appropriate.[4] Modern technical investigation has confirmed, however, that the faces and hands of the two principal figures have been repainted, the original paint still being visible under x-radiography. An underveil has also been added to soften the contours between the edge of the Virgin's face and the outline of the head-dress.[5] This renovation probably took place around 1315 and thus shortly after the completion of Duccio's *Maestà*.[6]

Although it is by no means certain, it appears that the large panel of *The Virgin and Child Enthroned with Angels* – recently reinstated within a chapel in San Domenico and previously located in the Palazzo Pubblico – once functioned as the high altarpiece of Siena's principal Dominican church (Pl. 52).[7] Signed by Guido da Siena, it

49. (facing page) Simone Martini, *The Virgin and Child*, detail of Pl. 54.

50. The Palazzo Pubblico, Siena.

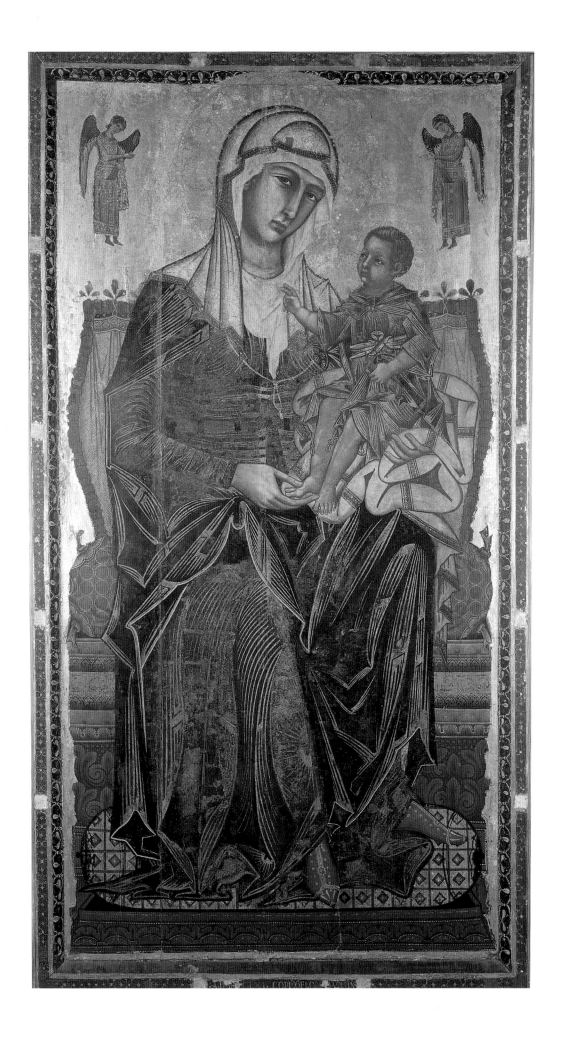

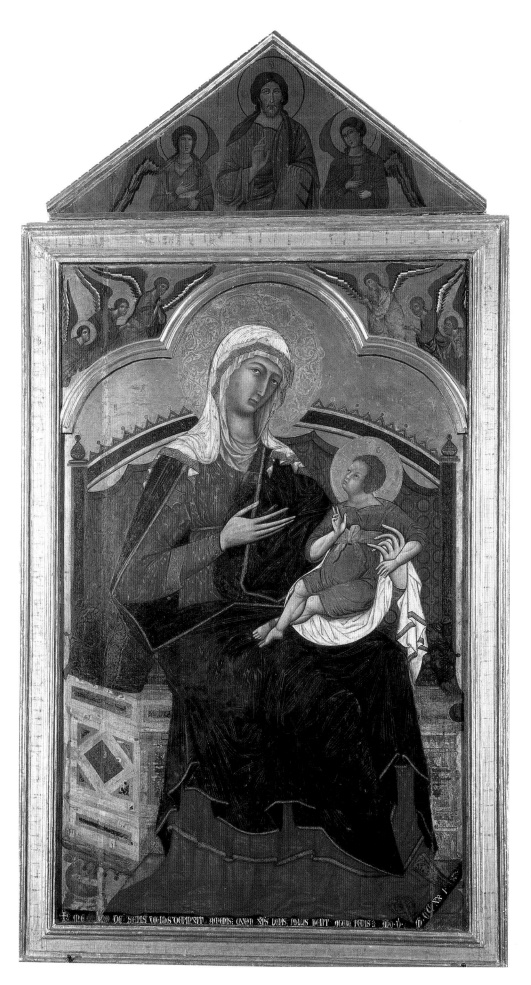

51. (facing page) Coppo di Marcovaldo, *The Virgin and Child with Angels*, known popularly as the 'Madonna del Bordone', 1261. Siena, Santa Maria dei Servi.

52. Guido da Siena, *The Virgin and Child with Angels (and Christ Blessing)*, *c*. 1275–80. Siena, San Domenico.

too shows the standard Marian iconography for large altar panels of this type. In terms of its stylistic conventions, the painting has been dated to the 1270s and was thus executed at approximately the same time as Guido's altarpiece for the high altar of the cathedral (see Pl. 38).[8] Like Coppo's earlier painting for the Servites, Guido's painting was also the subject of renovation. In this case, the face and hands of the Virgin, the flesh areas of the Christ Child, the faces of two of the angels in the spandrels, and the lower part of the throne have all been repainted by a painter who was clearly familiar with Duccio's technical and stylistic repertoire. The later painter also added a new and more transparent underveil to the Virgin's head-dress.[9] The reasons for this 'renovation' of the panel are by no means clear. It is possible, however, as several scholars have suggested, that since the date of 1221 on the lower border of the painting probably refers to the year of the death of Saint Dominic, the repainting took place in 1321 in honour of the centenary of the saint's death.[10]

As has recently been observed, these two examples of renovation of Marian paintings – both of which were located in important religious sites within the city – provide evidence not only of the impact of Duccio's style of painting but also recognition of the devotional efficacy of the *Maestà*.[11] It is significant, moreover, that in both cases, the faces and hands of the two most holy figures have been selected for repainting. In respect of human representation, it is these parts of the body which in psychological terms are the most affective for the potential devotee.

If the influence of Duccio's *Maestà* is thus discernible in the renovation of two of the city's oldest altarpieces, it is even more clear that this painting also provided significant inspiration for Simone Martini's treatment of this theme in the Sala del Consiglio of the Palazzo Pubblico (see Pl. 50). Executed in fresco, this monumental painting exercises an imposing presence within the large room then known as the Sala del Consiglio and now known as the Sala del Mappamondo (Pl. 53).[12] Once

53. Siena, Palazzo Pubblico, Sala del Consiglio (also known as the Sala del Mappamondo).

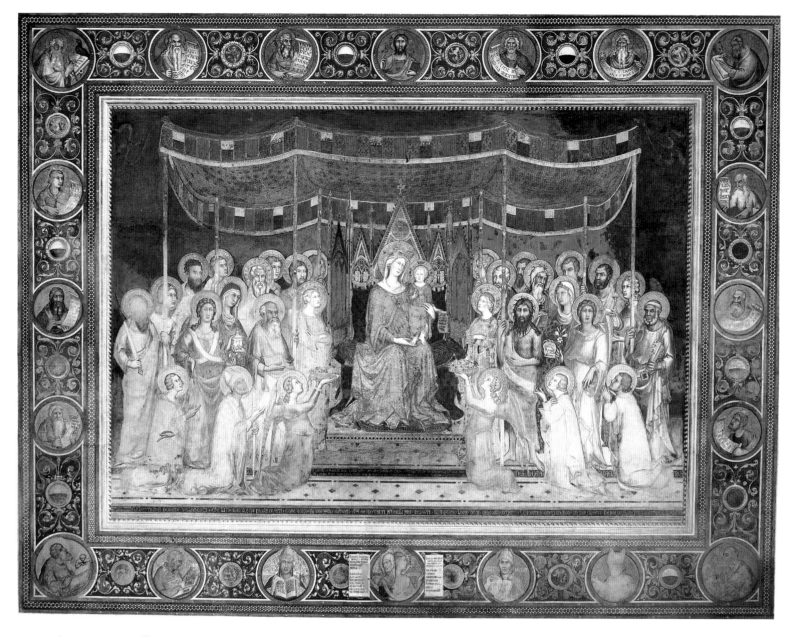

again the painting offers an impressive representation of the *Maestà* theme (Pl. 54). The Virgin appears seated upon an elaborate throne with the Christ Child upon her knee. Her status as queen of heaven is further amplified by the presence of numerous other saints and angels on either side of her. As in Duccio's earlier painting, the four patron saints of Siena – Ansanus, Savinus, Crescentius and Victor – are portrayed as supplicants kneeling before her. Reflecting its site and function as a mural, the principal painting is not framed by a series of subsidiary images executed on separate predella and pinnacle panels but by a broad border which includes a series of medallions which contain either busts of saints or other images. Although the surface of the painting has suffered extensive damage from the effects of damp and mineral deposits in the wall,[13] it is still possible to appreciate something of the original richness of the materials used upon this painting. Many of the haloes have been executed in relief with a variety of decorative motifs imprinted on the plaster like the matrix of a seal on soft wax.[14] It is also apparent that the painter employed expensive pigments such as lapis lazuli, azurite and malachite and metals such as gold and tin (now greatly tarnished, but originally gilded or glazed).[15] Select areas of the painting have been emphasised by the use of painted, gilded and coloured glass, and mock

54. Simone Martini, *The Maestà*, c. 1315–21. Siena, Palazzo Pubblico, Sala del Consiglio.

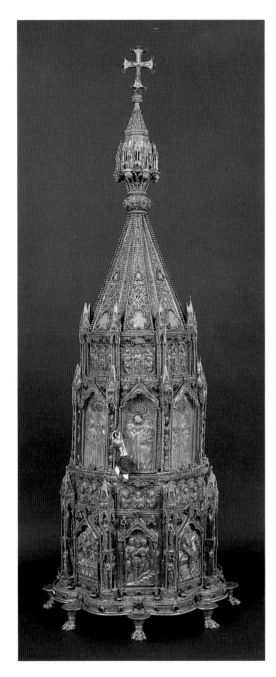

55. Reliquary of Saint Galgano, late thirteenth or early fourteenth century. Siena, Museo dell'Opera del Duomo.

gemstones which have been set into the surface of the wall itself. Thus the brooch on the Virgin's mantle is actually a piece of glass and the cruciform halo of the Christ Child is rendered the more distinctive by the insertion of lozenges of painted glass (see Pl. 49). The impression must once have been of a glittering, textured surface comparable to that of the work of contemporary goldsmiths and textile-workers (Pl. 55).[16]

Somewhat surprisingly for a commission of this size and status, there are very few contemporary records which throw light on the date and precise origins of the commission. Unlike Duccio's *Maestà*, local Sienese chroniclers remain curiously silent about the existence of this painting and contemporary reactions to it. Indeed, it is not until Ghiberti, writing in the mid-fifteenth century, that any reference to it appears. Significantly, however, Ghiberti attributes it to the Sienese painter, Simone Martini, and describes it approvingly as, 'a Madonna with the Child at her neck with many other figures, marvellously coloured in the upper hall of the Palazzo Pubblico'.[17] Although the commission itself is not specifically documented, records of 20 October and 12 December 1315, in which Simone is debited 46 *lire*, 8 *soldi*, against a credit account with the government, have been associated with this painting.[18] Below the wide lower border of the painting is another narrower frieze which contains a series of six roundels. Set slightly left of centre and inscribed into the surface of the wall itself is a cryptic fragment of a verse. The verse apparently describes the passing of 1315 and the arrival of spring and the month of June. Since the Sienese year began on 25 March, it has been suggested that the painting was completed in 1316 (but may well have been started earlier).[19] Directly below this verse and again inscribed into the plaster of the wall is the name 'Symone' which would suggest that Ghiberti's attribution is correct. It appears, however, from a payment of 27 *lire* by the Biccherna on 30 December 1321 to 'master Simon Martini' and his assistants that a mere five years later the painter was paid for gold, other materials and repairs (*raconciatura* or *reactatione*) to the painting.[20] Since there is clear technical evidence that the heads and/or hands of nine of the principal figures within the painting were replaced and made more distinctive in tone, colour and outline, it is generally agreed that part of this sum was for this reworking (Pl. 56).[21] It may be that the condition of the painting had deteriorated very early in its history, necessitating this intervention. Alternatively, however, it may be that the painter and his government patrons decided that the painting needed further enrichment and embellishment.[22]

The Sala del Consiglio is located on the first floor or *piano nobile* of the central section of the Palazzo Pubblico (Pl. 57). It is also situated at the back of the building and thus overlooks the present Piazza del Mercato. The initiation of the Palazzo Pubblico, as we see it today, is generally dated to circa 1297–8 with the completion of the part of the building containing the Sala del Consiglio occurring in the first decade of the fourteenth century.[23] It also appears from both structural evidence within the building itself and from references within contemporary government records that the Sala del Consiglio was part of an extension built at the rear of a much older building.[24] Some seven years before the construction of the Sala del Consiglio was begun, the Biccherna accounts record a payment made on 12 August 1289, to a master painter, Mino, for a painting of 'the Virgin Mary and other saints in the council chamber of the Palazzo Comunale'.[25] Two years later, on 17 June 1291, another painter, Dietisalvi, was paid by the Biccherna for painting 'gold letters below the *Maestà* of Saint Mary in the Palazzo Comunale'.[26] These payments offer important evidence that Simone Martini had a thirteenth-century precedent for his later painting and that the earlier painting apparently shared a similar subject and religio-political function. The reference to gold lettering also suggests that the early *Maestà*

The City

56. Simone Martini, *Saint Ansanus*, detail of Pl. 54.

had a didactic, exhortatory aspect to it – a feature which Simone Martini's *Maestà* also shared.

Simone Martini's *Maestà* was painted on the short east wall of the new Sala del Consiglio,[27] and thus became the focal point of a large rectangular space which runs the entire length of the south side of the central section of the Palazzo Pubblico (Pls 53, 57).[28] This space is demarcated by walls on the south, east and west sides of the room and by a series of imposing round-headed arches set on sturdy piers on its north side. The sense of an enclosed space is partly dictated by the Cappella dei Signori which lies just beyond the arches to the north-east of the Sala del Consiglio. As we shall see in a later chapter, this chapel and the Sala di Balìa situated beyond it are early fifteenth-century modifications to the first floor.[29] Originally it appears that this floor once constituted a much more open architectural structure subdivided by a series of piers and arches.[30] The council hall would have been lit, therefore, not only by four imposing triforate windows on its south wall but also by a more diffused light source emanating from the four windows facing onto the Campo on the north side of the building. There may also have been another meeting room situated on the north-west side of the building and at right angles to the relatively open and accessible Sala del Consiglio. A plan of the first floor of the building made before the modifications which took place in the last decades of the seventeenth century shows such a room and designates it '*concisto*' (Pl. 58).[31] This would suggest that this was the meeting-room of the Consistory – an important and powerful magistracy which, in the early fourteenth century, comprised the Nine and other key magistrates[32] and was

1 Sala del Consiglio (Sala del Mappamondo)
2 Sala dei Nove (Sala della Pace)
3 Cappella dei Signori
4 Anticappella
5 Sala di Balìa
A Cortile del Podestà

57. Plan of the first floor of the Palazzo Pubblico.

58. Plan of the first floor of the Palazzo Pubblico, c. 1658. Rome, Biblioteca Apostolica Vaticana, Archivio Chigi.

responsible for initiating much of the business of the council which met in the Sala del Consiglio just beyond. Evidence that this room existed in the fourteenth century is supplied by two Biccherna payments dated 1319 and 1330, which refer to paintings just outside or within 'the Consistory of the Nine'.[33]

It is generally agreed that Simone Martini's painting – in contrast to Duccio's *Maestà* – never functioned as the painted embellishment for an altar.[34] Instead, it acted as a backdrop to a raised platform on which would have been placed seating for the Podestà and the other officials who presided over meetings of the Consiglio Generale which took place within this room.[35] Also known as the Consiglio della Campana ('of the bell') – a reference to the fact that councillors were summoned to its meetings by the tolling of a bell – the Consiglio Generale comprised 300 councillors, a hundred elected from each of the city's *terzi*. Elected by the Consistory, councillors were required to be tax-paying citizens who had been resident in the city for at least ten years and were at least twenty-five years old. Another body, the *radota*, comprising 150 members (fifty from each *terzo*), was routinely added to the Consiglio Generale to swell the number of its voting members. Technically brothers could not serve concurrently, nor could members of noble families, but, as surviving membership lists reveal, such proscriptions were not always strictly applied. To these two councils were added, *ex officio*, the consuls of the Mercanzia and of the cloth guild. Presiding over the meetings of the council was the Podestà who, as a non-Sienese with a proven experience in law, was deemed capable of acting as an impartial chairman of the proceedings. He would be accompanied by two other judges who read the city statutes on his behalf. Also present was the Capitano del Popolo who, like the Podestà, was a foreign employee and had special jurisdiction over the city's military companies and the *contado* vicariates. In attendance also were the Consistory and other important non-Sienese officials such as the *maggior sindaco* whose task was to express opposition to any proposed constitutional innovation and the notary of the *riformagioni* who took the minutes of the meetings and then abstracted them in order to make an official record of the council's deliberations.[36]

The Podestà was responsible for presenting legislation for consideration at the meeting of the Consiglio Generale, but not for preparing it. Most business was forwarded to the Consiglio Generale by other bodies such as the Nine, the Biccherna and the Mercanzia. Like all such legislative bodies, it was the task of the

Consiglio Generale to approve, reject or order the revision of such business. A typical range of topics over a two month period might include the formal readings of the city's statutes, discussion of the city's walls, the paving of the streets, the fabric of the cathedral, the misbehaviour of the city's butchers, the danger of fires in bakers' shops, the election of a rector for Chiusdino in the *contado*, the need to encourage people to settle in the castle of Monteriggioni (see Pl. 8), and a dispute with Bologna over commercial reprisals.[37] The number of items of business per meeting would generally be restricted to no more than eight and the number of speakers for each item would be strictly limited to four or five. It was routinely normal to refer matters back to another council, office or *ad hoc* committee (*balìa*). A typical example of this occurred in 1297 when the council deliberated upon the construction of the Palazzo Pubblico itself. On this occasion, the councillors decided that the Nine should elect twelve 'good men', four from each *terzo*, who would decide when the building work should begin, and in what place, for the 'honour of the Sienese Commune'.[38] Decisions were made by a system of voting which involved the placing of a lead ball in either a white (yes) or black (no) box.[39] Certain types of decision required a two-thirds majority but routine or minor matters were decided by a simple majority.

The original audience of the *Maestà* would therefore have been a gathering of, at the most, some 500, and, at the very least, some 200 men.[40] This company would also have included many of the city's leading officials. Although these gatherings must have been crowded and physically uncomfortable and much of the debate often tedious, one should not doubt the ideological importance of this council and the solemnity of these occasions. Despite the fact that much of the government's policy and decision-making took place at meetings of smaller oligarchical councils and *ad hoc* committees, the Consiglio Generale represented the supreme legislative body of the Sienese state. It thus had considerable symbolic status far exceeding its actual political power and effectiveness. Moreover, certain crucial political decisions such as the alienation of territory and the making of war and of peace could only be legislated for by the council. This is particularly significant since, as noted earlier, the walls of the Sala del Consiglio were decorated with paintings of castles which had been consigned to Siena in the early decades of the fourteenth century (Pl. 10). Indeed the painting of the castle of Giuncarico was itself deemed a fitting matter for debate by the Consiglio Generale at its meeting of 31 March 1314.[41] Clearly, therefore, such topographical images would have served as worthy and inspiring subject matter for the councillors during their deliberations. But what of the *Maestà*? How might this painting also have fulfilled such an overtly political function?

At first sight, Simone Martini's *Maestà* has the appearance of an entirely conventional representation of the Virgin as the Mother of God and Queen of Heaven (see Pl. 54). Thus she appears as the largest and most significant figure at the centre of the painting. Her intimate and maternal relationship with the Christ Child is emphasised not only by the child being held close to her body but also in such well-observed details as the Virgin delicately supporting and steadying her infant with her right hand (see Pl. 49). Her regal status as Queen of Heaven is tellingly conveyed by her richly embroidered mantle and robe, the coronet on her head, her elaborately decorated throne and the ceremonial canopy of honour held over her and her son. As in Duccio's *Maestà*, the sense of her presiding over a heavenly court is further suggested by the large company of saints and angels surrounding her throne, six of whom kneel in homage before it (see Pl. 54, cf. Pl. 23).

In Siena, however, the Virgin also had another important role directly arising from her revered status as Divine Mediatrix. At least since Montaperti, the Virgin had been venerated as the city's principal guardian and protector, and as noted in the analysis

of Duccio's *Maestà* in the previous chapter, an important element of this essentially civic devotion was the role accorded to the four lesser patron saints of the city (Ansanus, Savinus, Crescentius and Victor) who were portrayed upon the high altar-piece as petitioners before the Virgin and her son. The nature of their role – it was also noted – was further emphasised through a written text on the painting, the content of which demonstrated the intense belief of the Sienese in the intimate and reciprocal nature of the relationship between the Virgin and themselves. Both these features of Duccio's *Maestà* are also strikingly present in Simone Martini's later painting. Indeed, it is apparent from the order in which the four patron saints appear, from their kneeling pose and their sequence of gesturing hands that Simone Martini wished to emulate Duccio's earlier representation of these saints. In Simone Martini's painting, however, the four patron saints are accompanied by two additional figures, namely two angels portrayed kneeling and presenting the Virgin with bowls filled with flowers – a painted detail which relates directly to painted texts which occur along the edges of the steps leading up to the Virgin's throne. This written embellishment also once extended to scrolls held by the four kneeling patron saints (whose faint outline is just visible in the hands of Ansanus, Savinus and Crescentius). Although the writing on these scrolls is now completely lost, it appears that it was once part of a dialogue between the Virgin and the four patron saints. This dialogue apparently began with some kind of collective petition on the part of the four patron saints which was written on their scrolls. This petition was followed by a response from the Virgin herself, inscribed first along the edge of a lower step, and second along a higher step, and saying:[42]

The reply of the Virgin to the said saints:

> My beloved bear it in mind
> When your devotees make honest petitions
> I will make them content as you desire,
> But if the powerful do harm to the weak
> Weighing them down with shame or hurt
> Your prayers are not for these
> Nor for whoever deceives my land.
>
> The angelic flowers, the rose and lily
> With which the heavenly field is adorned
> Do not delight me more than good counsel
> But some I see who for their own estate
> Despise me and deceive my land
> And are most praised when they speak the worst.
> Whoever is condemned by this speech take heed.

This written text is remarkable on a number of counts. Firstly, it clearly demonstrates the ideal of the Virgin as a person to whom lesser saints make petitions on behalf of their devotees. Secondly, it underlines the ideal of reciprocal responsibility which not only fuelled Christian belief in the intercession of saints but was also an indispensable aspect of late medieval Italian social organisation which relied heavily on the notion of a 'patron' and his or her 'client' co-operating with one another to their mutual benefit.[43] It also clearly signifies that the role of Ansanus and his three companions was to present such petitions to the Virgin on behalf of the Sienese. More telling still are the concerns that the Virgin expresses. Her role according to these words is that of a ruler, delighted by good counsel, attentive to petitions from her subordinates, but concerned to protect her land (*terra*) from those who wish to oppress it. Indeed, at the end of the speech, the Virgin goes beyond addressing the saints and gives a direct warning to such persons. At one level these texts portray the

Virgin as the queen of heaven – the 'heavenly field' of the opening lines to the second verse. At another level, however, they express a familiar concern of all medieval Italian communes, namely that their collective political stability should not be jeopardised by individuals pursuing political power for their own ends. That this was an enduring concern of the Sienese government is amply demonstrated by the content of the extensive painted texts which embellish Ambrogio Lorenzetti's paintings in the adjacent Sala dei Nove, painted some twenty-five years after Simone Martini's *Maestà*.[44]

The sense of the Virgin as Queen presiding over the court of heaven is also conveyed by the impressive number of saints and angels who surround her. Based on Duccio's compelling prototype, it is significant that Simone Martini chose to integrate the apostles with the other holy figures thereby increasing the illusion of a single gathering of the court of heaven. The marked increase in the number of saints compared to the number of angels also diminishes the much more iconic, Byzantine appearance of the earlier *Maestà*.[45] The representation of women saints is also increased from two to four in the later painting and, whereas Duccio placed his Saints Catherine of Alexandria and Agnes on the outer edges of the figural composition, Simone Martini placed his four female saints on either side of the Virgin. The effect is one of a queen attended by her maids-of-honour, themselves of high estate.

This imposing gathering of holy figures is further supplemented by the sequence of half-length figures portrayed in the twenty roundels placed symmetrically around the wide painted border of the painting. Encompassing representations of God the Father, Old Testament prophets, the four Evangelists and the four Doctors of the Church, they perform a similar function to the sequence of roundels on the painted border of Duccio's *Rucellai Madonna*, namely that of enriching and amplifying the figural content of the painting.[46] On this occasion, however, they provide a much more confident approach to the potential of painterly illusionism – best seen in the figure of Saint Gregory who appears to lean out of his frame while propping up his book upon its lower edge and allowing its bookmarks to drop over the edge of the painted border itself (Pl. 59). More intriguing still is the complex allegorical figure which features prominently in the central roundel of the lower border. It shows a two-headed figure, the left profile of which is that of an old woman with a veil and wimple and the right that of a young woman with a short, transparent veil and a gold coronet (Pl. 60). The religious significance of this complex figure is signalled by the titles 'old law' and 'new law' on the background of the roundel itself and by an inscription around the edges of the figure's octagonal halo which gives the names of the seven Christian virtues. The specific nature of this allegorical figure is further elaborated by two painted tablets on either side of the roundel which on the side of the Old Law provide an abbreviated summary of the Ten Commandments and on the side of the New Law a list of the seven sacraments.[47]

The painting's overtly religious imagery, notwithstanding, it is also apparent that this imposing treatment of the *Maestà* theme has been adapted for its specifically secular setting. Thus, the Virgin is seated upon an elaborately worked throne which, while displaying the sophisticated architectural vocabulary of contemporary work within the cathedral itself,[48] must also have provided a more immediate echo of the Podestà's ceremonial chair set at the centre of the platform directly below the painting. Similarly, the tenor of the dialogue inscribed on the edge of the steps is that of a person giving judgement in respect of a petition which corresponded to the role that, at least in theory, the Podestà performed at the meetings of the Consiglio Generale. The Christ Child appears not as a baby but as an infant standing on his mother's lap and thus adopting the guise of a child who is both mature and wise (see Pl. 49). While making the traditional blessing gesture with his right hand he also

59. Simone Martini, *Saint Gregory*, detail of Pl. 54.

60. Simone Martini, *The Two Laws*, detail of Pl. 54.

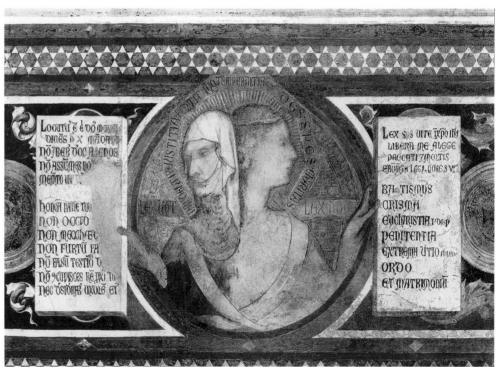

displays a scroll in his left hand on which is written in clearly decipherable letters the injunction, 'love justice, you who judge the earth', a verse from the apocryphal Book of Wisdom. Much favoured by late medieval scholars discoursing on the definition of good government, the direct and forthright appeal of the text to the practice of justice made it a highly appropriate text for paintings designed to embellish council rooms where legislative matters were constantly debated and decided upon.[49] Indeed, by placing it within the hand of Christ himself, it gave what in any case was believed to be a divinely inspired text still greater significance and authority. Moreover, this detail of the painting comprises an actual piece of paper, with writing upon it, attached to the surface of the wall.[50] The scroll is thus similar to the scrolls upon which many of the most important transactions of Siena's government were made – a use of 'real' written material similar to that of actual, legal documents that is indicative of a notable faith in the power of the written word and an atavistic belief in the magical properties of material objects themselves.

Simone Martini's *Maestà* is, indeed, in general, remarkable for its sheer emphasis upon written text. In addition to the extensive dialogue already discussed above, it is possible to identify specific biblical texts held by all but three of the prophets. The evangelists and the church fathers are also all shown either writing or displaying texts, two of which are recognisable as key texts associated with the writers in question.[51] Taken in conjunction with the allegorical figure of the Two Laws and its texts, the clear message for Siena's counsellors is that they should take inspiration from God's word and laws as recorded by the prophets and evangelists and interpreted by the later theologians of the Church. It also suggests a respect for the written word *per se*. Siena's government, like many other communal governments, placed great reliance on written records both as a way of effecting an efficient administration and also as a means of validating its political actions[52] – as the richness of the holdings of Siena's state archive make abundantly apparent.

The close and deliberate identification of Simone Martini's *Maestà* with Siena and its government becomes even more specific in other more peripheral areas of the painting. The striking canopy supported by eight of the saints obviously performs an important formal and iconographic function, providing – as it does – a relatively open but unified environment in which to situate the accompanying saints (see Pl. 54). It also offers a further indication of the regal status of the Virgin and Christ. Medieval images of secular and religious rulers frequently portrayed them seated beneath canopies of various sorts. In addition, canopies – be they constructed in stone, metal or material – were also utilised to bestow honour upon sacred objects such as the eucharist, a holy relic or a sacred image. Indeed it appears from the cathedral inventory of 1423 that by the early fifteenth century, if not earlier, Duccio's *Maestà* was itself given further prominence by being covered by a vaulted structure supported on four iron poles.[53]

While Simone Martini's painted canopy is represented as a ceremonial awning of red material embellished with a chequered pattern, its wide borders provide space for an alternating sequence of armorial devices. Now appearing as a pattern of black and white, red and undifferentiated blue, the last restoration campaign has enabled scholars to reconstruct the precise identity of this intricate heraldic detail. It portrays the city's emblems of the *balzana* and the lion of the Popolo, alternating with the coats-of-arms of the royal houses of both Angevin France and Angevin Naples. Like the rest of the painting, this heraldry was once exquisitely worked. Thus the simple black and white scheme of Siena's *balzana* was originally decorated with ornate flourishes in silver and the fleur-de-lis of the Angevin coat of arms was carefully picked out in gold. The embellishment of the painting by specifically Sienese civic insignia is continued within the border where roundels containing depictions of the

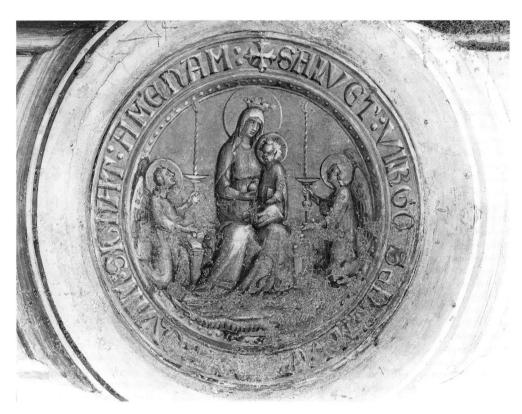

61. Simone Martini, *The City Seal*, detail of Pl. 54.

balzana, the she-wolf and the lion of the Popolo alternate with the roundels containing the prophets and saints. Framing the *Two Laws*, meanwhile, are two roundels which depict, respectively, the obverse and reverse of Siena's contemporary coinage.[54] Below the lower border, and thus in close proximity to where Siena's principal magistrates would have gathered together to preside over meetings of the Sala del Consiglio, is a second sequence of six smaller roundels which continue this theme of civic identity and authority. The outer four of these simulate the semi-precious and highly valued materials of serpentine and porphyry. The inner two present on the left, a detailed replica of the communal seal of Siena with its striking image of the Virgin and Child and its motto: 'May the Virgin preserve Siena, the ancient, whose loveliness may she seal' (Pl. 61)[55] and on the right, a faithful replica of the seal of the Capitano del Popolo with its heraldic emblem of the lion and an inscription identifying it as such.[56] At its most simple, this proliferation of emblems advertises the identity and authority of Siena and its communal government. At the same time, however, it also advertises the close diplomatic relations between the current political regime and the Angevin monarchs of both France and Naples. Thus whilst the inclusion of the Angevin coat of arms could be taken as a general token of the Nine's pragmatic preference for the Guelph cause at that time, the inclusion of the Neapolitan royal coat of arms would suggest that the painting was intended to advertise Siena's more specific political association with the royal house of Naples.[57]

Just as Duccio's *Maestà* exercised a remarkably rapid influence upon Simone Martini's treatment of the same theme in the Sala del Consiglio, so Simone Martini's *Maestà* in its turn proved similarly influential within a correspondingly short timespan. Thus, by 1317, a virtual copy of the basic design of the *Maestà* in the Sala del Consiglio had been executed for the council hall of San Gimignano (see Pl. 64). San Gimignano was never part of the Sienese *contado*, despite its relatively close proximity to Siena. Instead it functioned as an independent commune with its own political institutions.[58] By the early fourteenth century, however, San Gimignano's political fortunes were closely allied with the Guelph league of Tuscany and more particularly with Florence, under whose political control the town eventually fell in 1353.

Nevertheless, San Gimignano also had close political links with Siena during the early fourteenth century and, in particular, Siena frequently provided the town with a Podestà recruited from the city's leading families.[59] Also, from the late thirteenth century onwards, many of the town's most prestigious artistic commissions were assigned to Sienese artists.[60]

The council room of San Gimignano's Palazzo Comunale is located at the front of the *piano nobile* of a building begun in 1288 (Pl. 62) and still contains extensive remains of a late thirteenth-century pictorial scheme thus providing a rare glimpse of the kind of decoration favoured for such civic and secular settings.[61] At the top of the walls is a series of coats of arms of San Gimignanese families and other communes, as well as those of the papacy and the Angevin monarchy. Together these form a kind of heraldic frieze around the room as a whole. In the central section of the east wall is a painting of an enthroned male figure surrounded by attendant figures who, from their style of dress, appear to be men of noble status (Pl. 63). Given the prominence of the Angevin coats of arms in the upper frieze, it has plausibly been suggested that this figure represents Charles I of Anjou who visited San Gimignano in 1267.[62] In the corresponding sections on the other walls is a variety of heraldic and secular imagery including striking depictions of knights jousting. On the west wall, meanwhile, is an imposing painting of Saint Christopher and the Christ Child. In the lowest sections of this painted scheme are further illustrations of secular themes – most notably vignettes of men hunting on foot with dogs. Thus, as in the case of the Palazzo Pubblico *Maestà*, the painted decoration of this council room made specific allusion to the Angevin royal house and the current governing regime's Guelph sympathies. It is also striking that, apart from the image of Saint Christopher, the room's earlier decoration draws predominantly on strictly secular themes particularly those associated with the social pastimes of late medieval aristocracy.[63]

The introduction of the *Maestà* on the long south wall of the room disrupted this scheme and introduced a markedly religious note to its predominantly secular imagery (Pl. 64). The appearance of the painting today is, however, very different from its original appearance. During the 1460s two new doorways were inserted into the

62. Palazzo Comunale, San Gimignano.

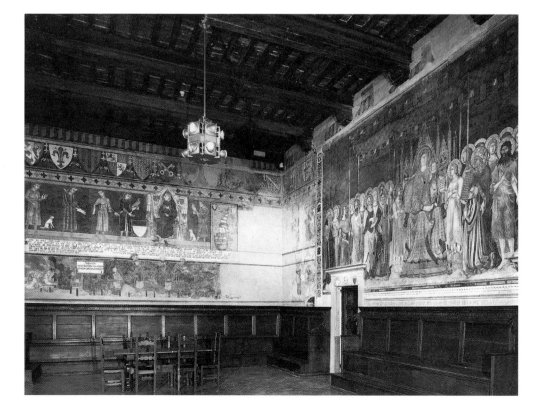

63. View of the east and south walls of the Sala del Consiglio (also known as the Sala di Dante), Palazzo Comunale, San Gimignano.

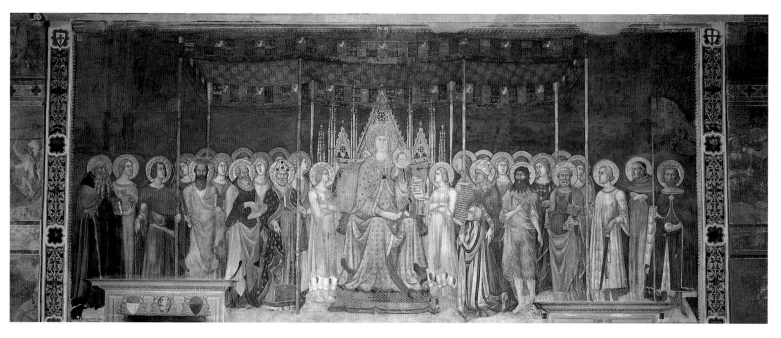

64. Lippo Memmi, *The Maestà*, 1317. San Gimignano, Palazzo Comunale, Sala del Consiglio.

67. (facing page) Lippo Memmi, *The Virgin and Child with Saints*, detail of Pl. 64.

65. (left) Diagram by Leonetto Tintori of the original patches of plaster on the *Maestà* and of the later layers of plaster executed in the fourteenth and fifteenth centuries.

66. (right) Reconstruction by Mauro Repetti of the *Maestà* without the later fourteenth- and fifteenth-century additions.

wall, the frames of which cut into the lower part of the painted composition. In 1466 the Florentine painter Benozzo Gozzoli was hired to repair the fresco and make good the damage caused by this structural alteration.[64] Modern restorers have also discovered that the four figures on the outermost edges of the painting representing Saint Anthony Abbot and Saint Fina on the left and the *Beato* Bartolo and Saint Louis IX on the right are additions made in the second half of the fourteenth century probably by the Sienese painter Bartolo di Fredi (Pls 65, 66).[65] A document of 1317 associates the Sienese painter Memmo di Filippuccio and his son, Lippo, with painted figures in the council room of the main civic palace of San Gimignano.[66] However, at the centre of the lower inner border of the painting is a painted inscription which records only Lippo Memmo as the painter.[67] Below, and to the right, as if inscribed into the surface of the cornice of the painted frame of the painting is the date 1317. It appears, therefore, that Lippo Memmi was primarily responsible for this mural, probably heading a workshop established by his father but now under his direction.[68] Although, by this date, Simone Martini had not yet married Lippo's sister, Giovanna, it is clear from the San Gimignanese painting that Lippo Memmi was aware of the earlier version of this theme by his future brother-in-law.[69] Indeed, he may even have worked with Simone on the Palazzo Pubblico painting. Although, such collaboration between the two painters on the Palazzo Pubblico *Maestà* is difficult to establish conclusively, there are a number of technical grounds which support the hypothesis. Moreover, in the present context, what is strikingly evident from Lippo's painting is

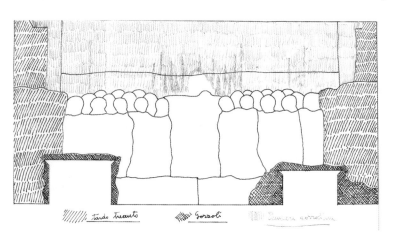

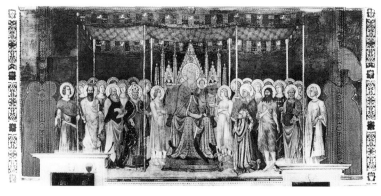

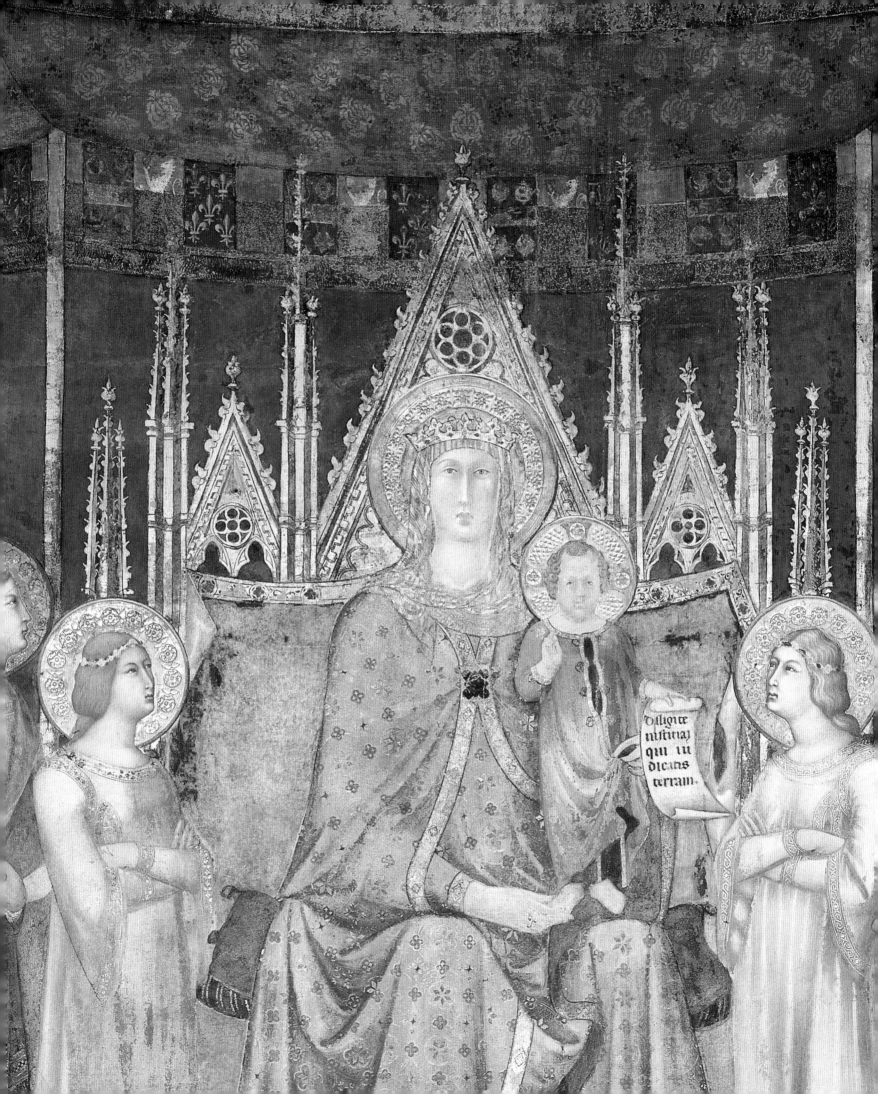

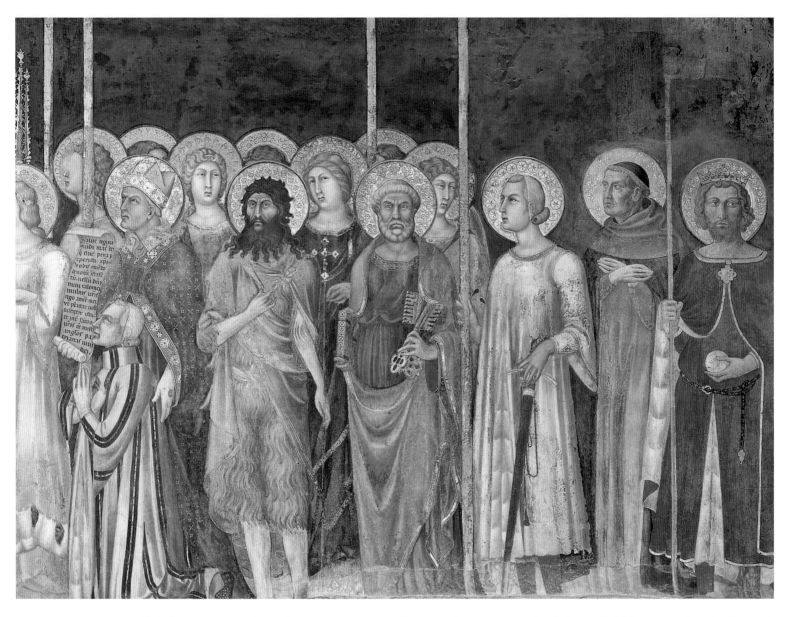

68. Lippo Memmi, *Nello Tolomei, Saints and Angels*, detail of Pl. 64.

that Simone Martini's original painting in the Palazzo Pubblico was already deemed worthy of emulation so soon after its execution.[70]

Other inscriptions within the San Gimignanese *Maestà* provide further information on the date of the painting and the circumstances of its commission. Below the fictive cornice is a long inscription which states that the painting was executed at the time of Nello di Mino Tolomei's term of office as Podestà and Capitano del Comune and del Popolo. Since this prominent member of one of the most influential Sienese families is recorded as Podestà of San Gimignano for the last six months of 1317 and as Capitano del Popolo the first six months of 1318, there are good grounds for accepting 1317 as an authentic record for the painting's completion.[71] Nello, himself, is depicted in the painting, kneeling in the right-hand foreground and being presented to the Virgin by Saint Nicholas of Bari (Pl. 68). That this figure, made striking by his gown of red and black stripes embellished with lines of gilding, is indeed a representation of Nello is attested by the scroll which Saint Nicholas is portrayed as holding. On it is a painted text which addresses the Virgin as Queen and Mother of God and commends Nello to her, her son and the assembled saints.[72] The canopy, meanwhile, is edged with the coat of arms of the Tolomei and three different sets of coats of arms belonging to the Commune of San Gimignano.[73]

Although it appears that in the San Gimignanese *Maestà* Lippo Memmi

employed many of the materials and techniques previously used by Simone Martini in his earlier *Maestà*,[74] there are also striking and subtle differences both in style and iconography. These are worth examining in some detail because of the way in which such comparison reveals the distinctiveness of Simone Martini's painting of the *Maestà* theme for the Sala del Consiglio in Siena. The San Gimignanese *Maestà* shows a figural composition comprising twenty-four attendant saints and angels. Moreover, it is important to bear in mind that originally the outermost saints would have been the two youthful male saints who have plausibly been identified as the Sienese saints Ansanus and Crescentius (see Pls 64, 66). In marked contrast to Simone Martini's *Maestà*, with its four patron saints and two angels kneeling prominently in the foreground, the San Gimignano *Maestà* has no comparable figures in its foreground (see Pl. 64, cf. Pl. 54). The absence of such foreground figures has a major effect on the spatial composition of the San Gimignanese painting contributing to its frieze-like appearance. The intricate intercessory dialogue between the Virgin and the four patron saints is absent. Instead, the theme of intercession now focuses decisively upon one single votive figure – Nello Tolomei. The identities of the saints who have the honorific role of supporting the four front poles of the canopy are also different, thereby assigning greater status to different saints. In place of Saints Paul, John the Evangelist, John the Baptist and Saint Peter in Simone Martini's *Maestà*, Saints Ansanus, Geminianus, Nicholas of Bari and Crescentius perform this role in Lippo Memmi's version. The four saints of the Sienese painting are now grouped less conspicuously between the pole-bearers. Clearly this alteration was made in order to assign particular prominence to Saint Geminianus, as the eponymous patron saint of San Gimignano; to Nicholas of Bari, as another patron saint of the town;[75] and to Ansanus and Crescentius as patron saints of Siena – thereby advertising the Sienese origins of Nello Tolomei and San Gimignano's political links with that city. The figures in the two rows behind these saints meanwhile lack the presence and individuality of Simone Martini's painting. Instead they present two somewhat amorphous rows of angels only distinguishable by their overlapping haloes.

Whereas Simone Martini's *Maestà* is wholeheartedly committed to commemorating and celebrating Siena's traditional and primary allegiance to the Virgin, mediated through the petitions and intercession of the city's four patron saints, Ansanus, Savinus, Crescentius and Victor, Lippo Memmi's painting expresses the devotion of the San Gimignanese to the Virgin in a significantly more personalised way. Thus one modern scholar of Lippo Memmi has remarked that 'without any reference to civic history, the [San Gimignano] *Maestà* remains a personal monument to Nello de'Tolomei'.[76] It is certainly the case that Nello's own identity and devotional aspirations are given a prominent role within the San Gimignanese painting. There is, however, also, in fact, an appropriately civic dimension to this painting.[77] The town's patron saint is given a place of honour within the painting. In addition, the detail and variety of San Gimignano's civic heraldry is recorded on the border of the canopy. We may conclude, therefore, that the San Gimignanese well understood the powerful potential of the *Maestà* theme – as interpreted by Simone Martini – as an appropriate religio-political image for the walls of their council hall. While adopting elements of Simone Martini's traditional Sienese iconography, however, they also wished to pay due attention to their particular circumstances and loyalties – hence the inclusion of their patron saint and their civic arms and the absence of the four Sienese saints from the foreground of the painting. As we shall see in later chapters, such concern for local detail is also clearly evident in various Marian images produced during the fourteenth century for locations within Siena's *contado*.

By 1321, therefore, the Sienese not only had an imposing representation of the

69 Lippo Memmi, *Saints and Angels*, detail of Pl. 64.

71. (facing page) Simone Martini, *Saints*, detail of Pl. 54.

70. Reconstruction by Gert Kreytenberg of the tomb monument of Henry VII.

Maestà theme over the high altar of the city's cathedral but also an equally imposing painting of this subject on the wall of the city's principal council hall within the Palazzo Pubblico. The cult of the Virgin as the queen of Siena with Ansanus, Crescentius, Savinus and Victor as her spiritual ambassadors was thus prominently represented within two of Siena's most important civic locations. Comparing the two paintings, however, it is striking that Simone Martini's version offers a much more secular and courtly interpretation of the *Maestà* theme than Duccio's painting (see Pl. 54, cf. Pl. 23). At one level, this is hardly surprising: Duccio's *Maestà* was an altarpiece for the high altar of the cathedral; Simone Martini's was a fresco for the main hall of Siena's principal civic building. Yet the very appropriateness of the differing emphases of the two paintings to their respective contexts should not be allowed to obscure the boldness of Simone Martini's reworking of Duccio's original exploration of this theme.

The boldness of Simone Martini's version becomes clearer if his painting is compared to other examples of imagery specifically designed to honour secular rulers and monarchs. One local example of such iconography would have been the monumental tomb for the Holy Roman emperor, Henry VII, which, although now reduced to a few sculpted fragments, would then have exercised an imposing presence within the apse of the choir of Pisa cathedral (Pl. 70). Executed by the Sienese sculptor, Tino di Camaino, the upper part of the monument comprised a sculpted group of the emperor seated upon a throne under a capacious canopy of honour and accompanied by six standing counsellors.[78] This sculpted group would thus have offered a partial precedent for Simone Martini's figural composition for the *Maestà*.[79] The mid-thirteenth-century enthroned figure of the Hohenstaufen emperor, Frederick II, framed by other sculpted figures and set over the principal gateway of Capua, north of Naples, could have provided another, earlier, example. Like the *Maestà*, this sculpted ensemble was accompanied by an inscription containing an

address by the emperor to his subjects warning them of his power to punish traitors and enemies.[80] It is possible, therefore, that Simone Martini deliberately utilised imagery derived from such precedents, designed to honour representatives of monarchical government, in his interpretation of the *Maestà* theme.

At first sight, this would appear to rest uneasily with the communal nature of the contemporary Sienese political regime. On closer examination, however, this apparent ideological tension may be seen to be explicable. We have already noted that the display of Angevin heraldry within Simone Martini's *Maestà* can be accounted for by Siena's pragmatic allegiance with the Tuscan Guelph party and the Angevin monarchy of southern Italy. Moreover, within the iconography of the painting as a whole, Sienese civic concerns are by far the most prominently displayed. Thus, in addition to the predominant presence of the Virgin and the four lesser patron saints of Siena, the painting also includes a wealth of civic emblems – many of them carefully worked to render them as accurate and faithful reproductions of important artefacts alluding to the city's political authority and economic stability. Whilst such details affirmed the communal traditions of Siena, the courtly emphasis within Simone Martini's *Maestà* enhanced and emphasised the belief of the Sienese in the Virgin as their queen – a religio-political ideology which was so idealised that it presented no real or practical threat to their identity as an autonomous political state. On the contrary, it offered the Sienese a strong and abiding sense that they and their city were uniquely privileged by enjoying the benign protection of the Queen of Heaven who, together with her son, endorsed and upheld their commitment to the communal ideal and the exercise of just and stable government.

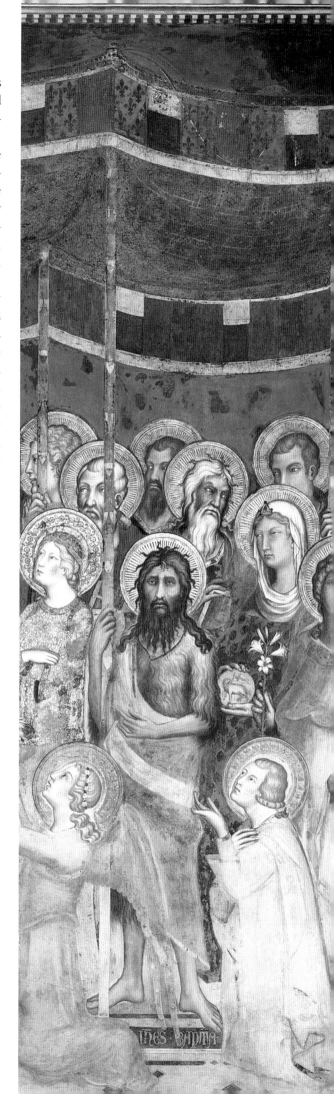

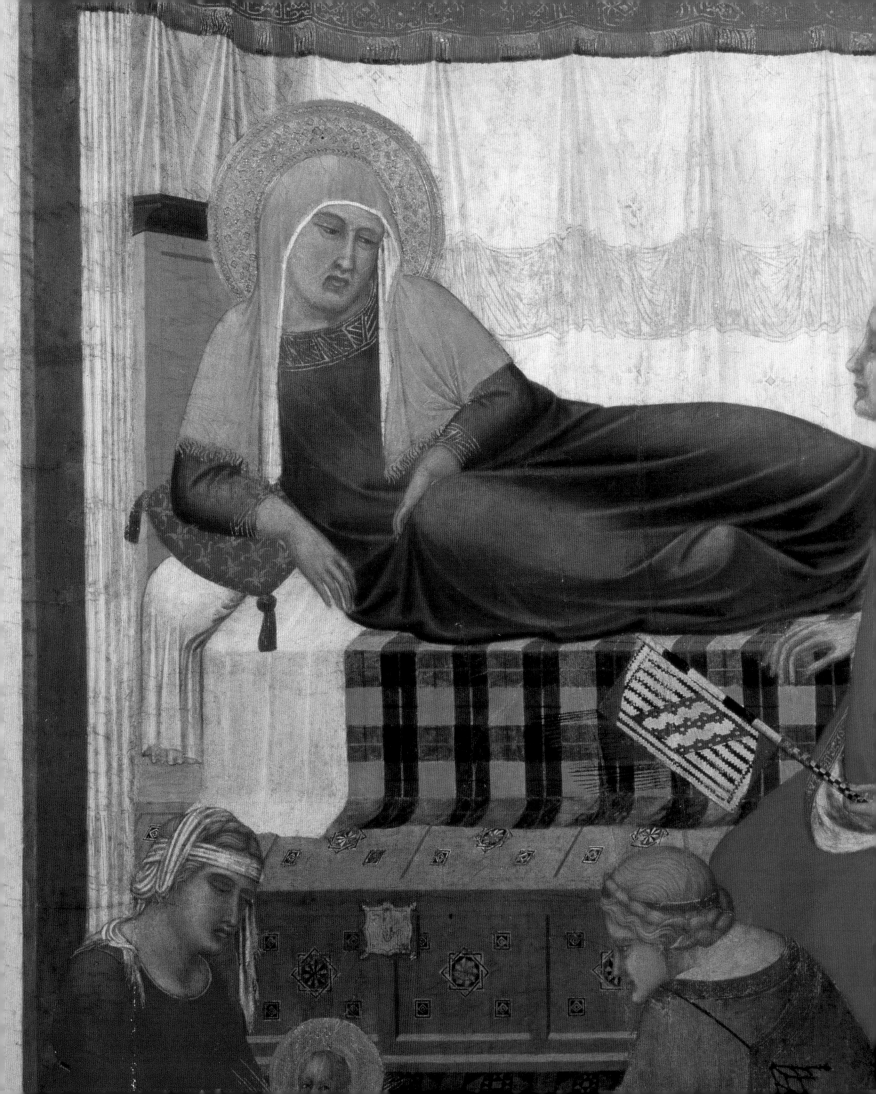

4

The Patronal Altars

During the years following the completion of Duccio's *Maestà* for the high altar of the cathedral and Simone Martini's *Maestà* for the Sala del Consiglio, the practice of celebrating the Virgin as Siena's principal protector received further impetus by the commissioning of two more major programmes of Marian imagery. Executed at roughly the same time and largely by the same painters, one comprised a series of altarpieces designed for altars at the east end of the cathedral, and the other, a series of mural paintings on the façade of the Spedale di Santa Maria della Scala, another of the city's most important civic institutions.

In their earlier paintings of the Virgin in majesty, Duccio and Simone Martini both focused upon the iconic theme of Mary as mother of God, queen of heaven and divine mediatrix. Within the complex pictorial scheme of the *Maestà*, Duccio also introduced a narrative element to the altarpiece's celebration of the divine status of the Virgin. Thus, in the predella paintings of the infancy of Christ due emphasis was placed upon the Virgin's role in these sacred events (see Pl. 46). The pinnacle panels, meanwhile, were devoted even more explicitly to honouring the Virgin herself, portraying the last days of her life (see Pl. 47). Both the painted programmes under discussion in this and the following chapter took up this narrative element and added to it further significant details and embellishments. The present chapter will examine the cycle of four altarpieces painted for Siena cathedral between, roughly, 1331 and 1351.

The fifteenth-century painting of *Saint Anthony Attending Mass*, discussed in an earlier chapter in relation to the location of Duccio's *Maestà* within Siena cathedral, also provides evidence for the presence of a side altar in the close vicinity of the high altar (see Pl. 26). It appears from this painting that such an altar was located in a vaulted space, a bay in width, lying north-west of the chancel and separated from it by a shallow flight of stairs. If one examines the plan of the present cathedral, a bay of this type occurs precisely between the chancel and north transept (see Pl. 30). The representation of this altar within a fifteenth-century painting ostensibly devoted to celebrating the cult of Saint Anthony, also suggests that the altar was of some devotional significance within the cathedral of Siena. Turning to the cathedral inventories, which survive from 1389 onwards, it appears that such an altar already existed and that it was dedicated to one of the city's patron saints, Ansanus. Indeed, it is clear from

72 (facing page) Pietro Lorenzetti, *Saint Anna*, detail of Pl. 74.

73. Plan of altars in the cathedral by the end of the fourteenth century (adapted from Aronow, 1990).

In the plan:
Door to sacristy
High altar
Screen
1 — 2
3 — 4
7
Porta del Perdono
8
Bell tower
9
5
6 10
no altar

1 Saint Ansanus
2 Saint Victor
3 Saint Savinus
4 Saint Crescentius
5 Shoemakers (Calzolai)
6 Magi
7 Crucifix
8 Santa Maria delle Grazie
9 Saint James Intercisus
10 Saint Boniface

these inventories that this altar was associated with three other altars, all also located close to the high altar and dedicated respectively to Saints Victor, Savinus and Crescentius.

From the short and often cryptic entries within the inventories, it is possible to reconstruct a plausible set of locations for these altars dedicated to Siena's patron saints.[1] Within the lateral extensions to the chancel were located on the left (or northern) side, an altar dedicated to Saint Ansanus and on the right (or southern) side, an altar dedicated to Saint Victor (Pl. 73).[2] From the painting of *Saint Anthony Attending Mass*, it appears that these altars were located on the eastern walls of the lateral extensions to the chancel and thus facing towards the body of the church (see Pl. 26). From the inventory of 1423, it also appears that these altars were separated from the rest of the church by a screen thereby enhancing their status.[3] Within the transept proper, meanwhile, were, on the left, the altar of Saint Savinus, and on the right, the altar of Saint Crescentius (Pl. 73). These probably faced one another across the transept.[4]

On the basis of the brief description of the altars given in the inventories together with other historical evidence, modern scholars have plausibly associated four fourteenth-century paintings with these altars.[5] Thus it appears that the *Birth of the Virgin*, signed by Pietro Lorenzetti, was once the centrepiece of the altarpiece for the altar of Saint Savinus (Pl. 74);[6] the *Annunciation with Saints Ansanus and Massima*, signed by Simone Martini and Lippo Memmi (Pl. 75),[7] the altarpiece for the altar of Saint Ansanus; the *Nativity and Adoration of the Shepherds*, attributed to Bartolommeo Bulgarini, the main painting for the altarpiece on the altar of Saint Victor (Pl. 76);[8] and the *Purification of the Virgin*, signed by Ambrogio Lorenzetti, the centre-piece of the altarpiece for the altar of Saint Crescentius (Pl. 77).[9]

From their subject matter it appears, therefore, that the four altarpieces once formed a logical narrative sequence, each depicting a key moment in the life of the Virgin, beginning with her birth and ending with her visit to the Temple with her new-born son. This, in itself, constituted an important milestone in the history of the altarpiece since it was one of the earliest uses of narrative imagery on religious paintings of this type.[10] If the sequence of altars described in the fifteenth-century inventories corresponds faithfully to that of the fourteenth century, the altarpiece paintings also followed a chronological progression around the east end of the cathedral with the two most sacred events associated most directly with the Incarnation of Christ – the Annunciation and the Nativity – set on either side of the high altar (see Pl. 73). It is also clear from early references that these altarpieces all had side panels depicting saints. Today, this feature of the altarpieces' design is only apparent in the case of the *Annunciation* where Saint Ansanus and his fellow convert and martyr, Saint Massima, appear on either side of the central painting (see Pl. 75).[11] Once, however, Pietro Lorenzetti's *Birth of the Virgin* was framed by Saint Savinus and Saint Bartholomew (an earlier patron saint of Siena), Bartolommeo Bulgarini's *Nativity* by Saint Victor and his wife and fellow martyr, Saint Corona (Pls 78, 79), and Ambrogio Lorenzetti's *Purification* by Saint Crescentius and the Archangel Michael.[12] In addition, all four altarpieces had predellas.[13] From the paintings that have been identified as part of these lost predellas, it seems that each had at its centre a painting whose subject matter related broadly to the theme of Christ's sacrifice for humanity upon the Cross (Pls 80, 81). On either side of these central paintings were four other paintings depicting incidents from the lives of the saints portrayed above (Pls 82, 83). From the paintings of this theme that survive, it appears that there was a particular emphasis upon the circumstances surrounding the saints' deaths as martyrs.[14] In addition, all four altarpieces were originally set in complex frames, little of which survives, but for which there are records of payment for elaborate woodwork.[15]

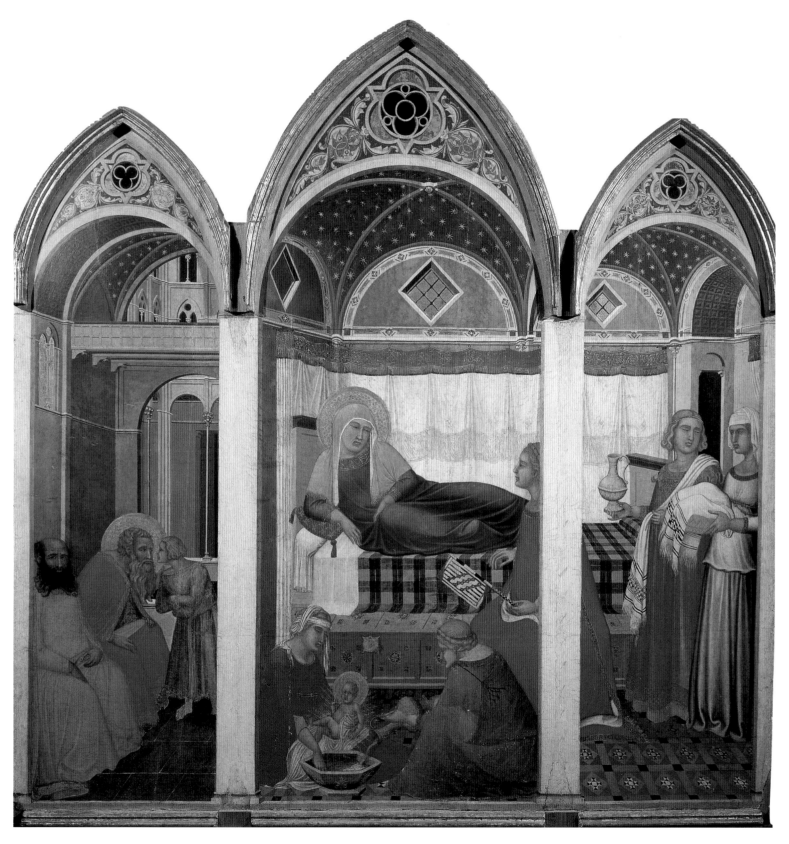

The execution of the four altarpieces did not, however, apparently follow the orderly sequence of their final arrangement within the east end of the cathedral, which suggests that the original project, although always conceived as a means of honouring the Virgin and the city's other patron saints, nevertheless progressed in a somewhat *ad hoc* manner. This, however, is not entirely surprising. From 1317

74. Pietro Lorenzetti, *The Birth of the Virgin*, 1342. Siena, Museo dell'Opera del Duomo.

75. Simone Martini and Lippo Memmi, *The Annunciation with Saints Ansanus and Massima*, 1333. Florence, Uffizi.

onwards, the east end of the cathedral became the site of an ambitious scheme to extend the fabric of the building southwards and eastwards (see Pl. 30). Although the more ambitious features of the project were abandoned in the 1350s, the scheme nevertheless resulted in a considerably larger chancel and transepts which, in turn, offered new sites for altars. It is also clear from the Customary of 1215 that, by that date, there were already at least two altars honouring the city's patron saints jointly within the cathedral. It has been suggested that these patronal altars were located in a subterranean crypt directly below the chancel of the twelfth-century building.[16] Accordingly, when the new project for extending the chancel eastwards and building a baptistery below it was initiated, it became necessary to dismantle most of the crypt and relocate the crypt altars with their precious relics of the city's patron saints to another part of the cathedral. Annotations on a mid-fourteenth-century drawing of a projected design for the Duomo Nuovo indicate clearly that one concern of the designers of this new building was that it should be provided with a number of altars around the east end (Pl. 84).[17] It seems, therefore, that at an undetermined point – but, in all likelihood, in the late 1320s – a decision had been made to honour the

four patron saints by dedicating a specific cathedral altar to each of them. Their status was, therefore, considerably enhanced by no longer sharing the dedication of an altar. The specificity of such dedications was further underlined by the commissioning of altarpieces whose imagery included representations of the four saints and their legends. Given the choice of subject matter for the principal paintings of these altarpieces it is also likely that, at their very inception, they were always intended for altars located close to the high altar, whose own dedication and painted imagery so decisively celebrated Siena's principal guardian and protector – the Virgin.

The earliest secure date in relation to the programme of altarpieces is 1333, the date given in the painted inscription along the lower edge of the *Annunciation* (see Pl. 75). In addition, a number of entries in an account book belonging to the Opera del Duomo for the year 1333 make extensive references to payment for the carpentry, painting and gilding of the altarpiece of Saint Ansanus. Since the last entries have the appearance of a final settlement of account and also make reference to the month

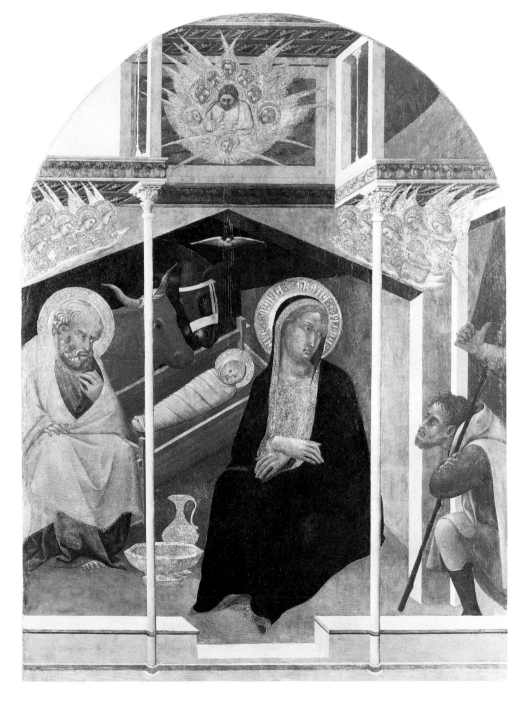

76. Bartolommeo Bulgarini, *The Nativity and Adoration of the Shepherds, c.* 1350. Cambridge, Massachusetts, Harvard University Art Museums.

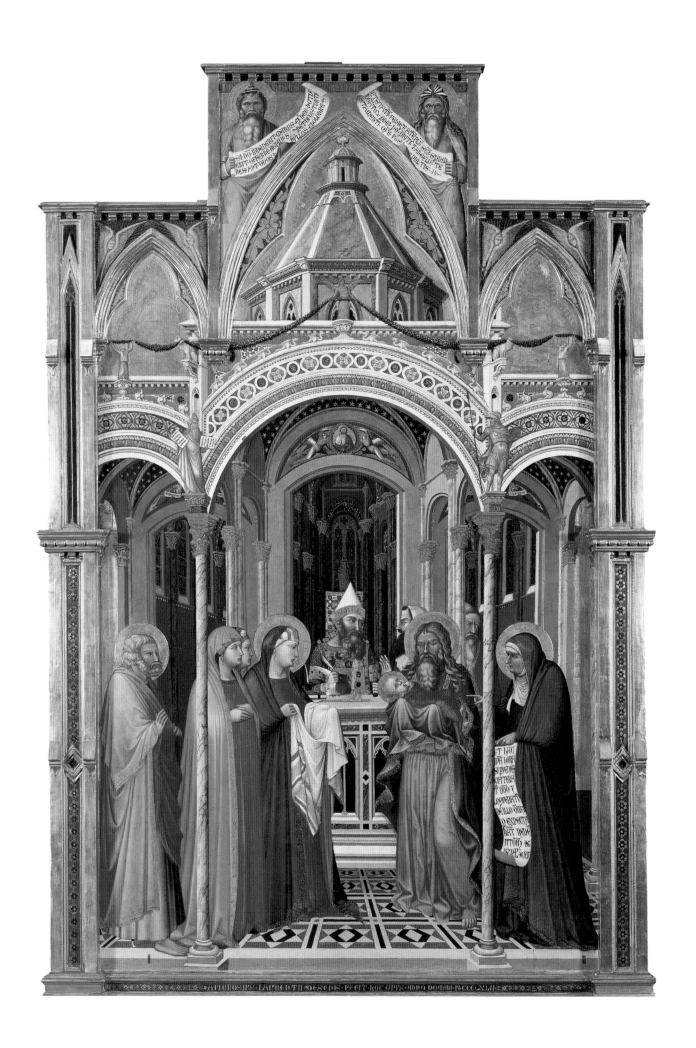

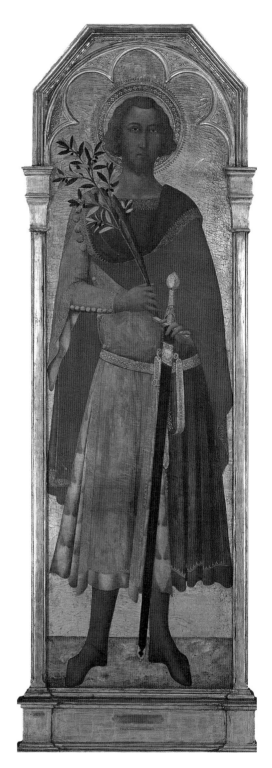

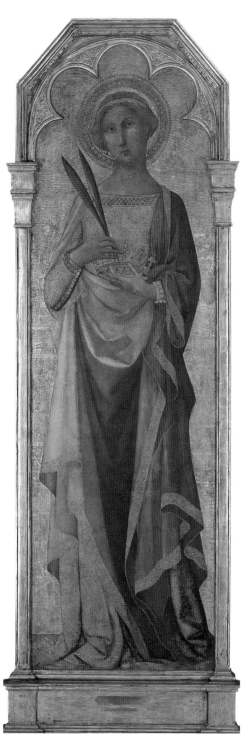

78. *Saint Victor*, *c.* 1350. Copenhagen, Statens Museum for Kunst.

79. *Saint Corona*, *c.* 1350. Copenhagen, Statens Museum for Kunst.

of December, it has plausibly been suggested that the altarpiece together with its wooden canopy was completed by 1 December 1333, for the feast of Saint Ansanus.[18] Given the relatively ambitious nature of this altarpiece painting, however, it may well have been commissioned some years earlier.[19]

Two years later in 1335, Pietro Lorenzetti received an initial payment of 30 gold florins for the Saint Savinus altarpiece, whilst a grammar teacher, one Maestro Ciecho, was also paid a *lira* for having translated the story of Saint Savinus from Latin into Italian for the painter.[20] In 1337, wood was acquired for the Saint Crescentius altarpiece and after a break of two years, Ambrogio Lorenzetti and the woodworker, Paolo di Bindo (who was also paid for carpentry on the Saint Ansanus altarpiece), received payments between June 1339 and May 1340 for their work upon the Saint

77. (facing page) Ambrogio Lorenzetti, *The Purification of the Virgin*, 1342. Florence, Uffizi.

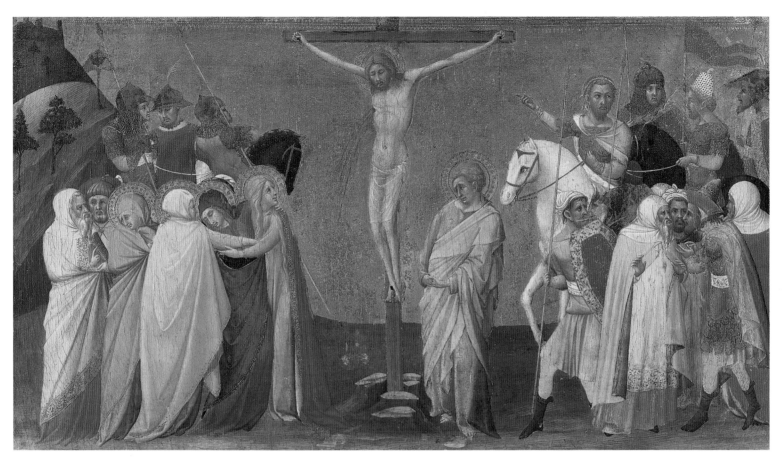

80. Bartolommeo Bulgarini, *The Crucifixion*, *c.* 1350. Paris, Musée du Louvre.

81. Ambrogio Lorenzetti, *Allegory of Redemption*, *c.* 1340. Siena, Pinacoteca.

Crescentius altarpiece.[21] According to the painted inscriptions on the *Birth of the Virgin* and the *Purification* these two altarpieces were completed by 1342 (see Pls 74, 77).[22] Nine years later, payments were made in 1351 for the final decorative details on the frame of the Saint Victor altarpiece – possibly in time for the feast day of the saint on 5 May 1351.[23] On stylistic grounds the *Nativity* (attributed to Bulgarini) and the *Saint Victor* and *Saint Corona* (attributed to another anonymous painter, dubbed

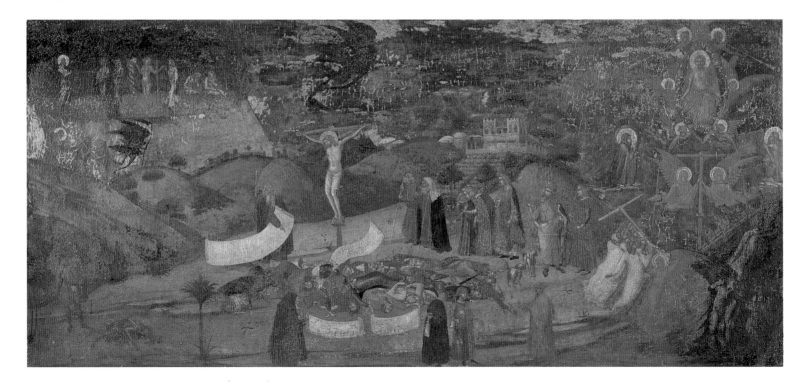

the Master of the Palazzo Venezia Madonna) have been dated to circa 1348–50 (see Pls 76, 78, 79).[24] The delay of eighteen years between the completion of the first and last altarpiece of this series can be accounted for by the uncertainties arising from the remodelling of the cathedral in the middle decades of the fourteenth century and also the huge social disruption caused by the outbreak of the Black Death in 1348. In addition, both Pietro and Ambrogio Lorenzetti were working on a number of other important civic commissions between 1335 and 1342.[25]

Despite the long-drawn-out nature of the project, however, it is nevertheless clear that the altarpieces were intended to function as a unified programme with a specific liturgical and devotional role within the fourteenth-century cathedral. Quite apart from the thematic nature of the subject matter of the four altarpieces, it appears that they once shared broad similarities in their overall design and format. Treating them in the order in which they were produced, it seems that the Saint Ansanus altarpiece by Simone Martini and Lippo Memmi originally comprised a triptych of three panels with the side panels divided from the central panel by twisted colonettes (see Pl. 75).[26] In place of the complex, florid contours of the nineteenth-century frame in which the painting is now placed, there would originally have been a series of five simple gables, each containing a tondo with a bust of a prophet or, in the case of the central tondo, a now lost God the Father (Pl. 85).[27] The entire altarpiece would have been framed by piers and a predella and sets of pinnacles would have given it

82. Pietro Lorenzetti, *Saint Savinus before Venustianus, Governor of Tuscany*, c. 1340. London, National Gallery.

83. Bartolommeo Bulgarini, *The Blinding of Saint Victor*, *c.* 1350. Frankfurt am Main, Städelschen Kunstinstituts.

84. Plan of the Duomo Nuovo, *c.* 1316–22. Siena, Museo dell'Opera del Duomo.

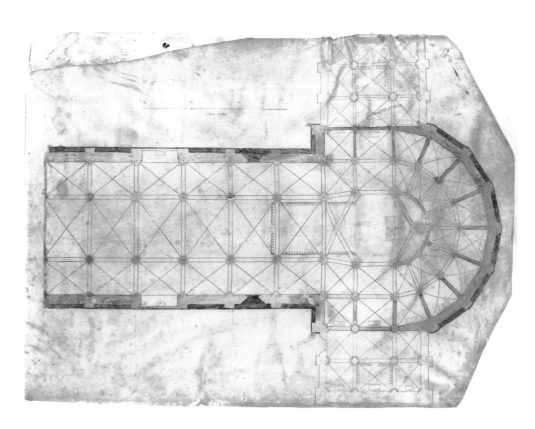

further height and decorative impact. Pietro Lorenzetti's Saint Savinus altarpiece would have shared broadly the same format and design with a series of five pointed arches, three of which still complement the intricate painted architecture of the painting itself (see Pl. 74).[28] These arches, in turn, would have been surmounted by triangular gables probably housing medallions containing heads of painted figures. Although the *Birth of the Virgin* by Paolo di Giovanni Fei is later in date and thus more complex in its design, it still offers a general sense of what the disposition of the upper part of the Saint Savinus altarpiece would once have been like (Pl. 86, cf. Pl. 87).[29]

Ambrogio Lorenzetti's Saint Crescentius altarpiece appears to represent a departure from the basic design of the first two altarpieces in the series. The surviving central painting is much taller thus providing the painter with the opportunity to represent the height and architectural complexity of his visualisation of the Temple of Jerusalem (see Pl. 77).[30] In addition, above the relatively narrow pointed arches of the upper frame are squared-off sections which house additional figures of cherubim and prophets. The presence of two dove-tailed cuts on the back of the upper central section of the panel suggests that it once supported a large pinnacle panel which would have been triangular in shape. It is likely that this would have been balanced by triangular gables over the flanking sections (Pl. 88).[31] In addition, the position of the battens on this part of the panel indicates that the side panels of *Saint Crescentius* and *Michael Archangel* reached the height of the corbels which mark the springing point of the series of arches framing the upper part of the painting. The side panels of the Saint Crescentius altarpiece would thus broadly have corresponded to those of the other altarpieces and, like the central panel, would also have been surmounted by triangular gables.[32] Although distinctively different in design from the first two altarpieces, the framework of the Saint Crescentius altarpiece (particularly when viewed in conjunction with the architecture of the painting itself) would have presented an appearance analogous to the façade of Siena cathedral where a similar interplay of rounded and pointed arches, set within rectangular sections and bounded by dentilled cornices, is apparent (see Pl. 21). Ambrogio Lorenzetti thus

85. Reconstruction of the Saint Ansanus altarpiece.

86. Reconstruction of the Saint Savinus altarpiece.

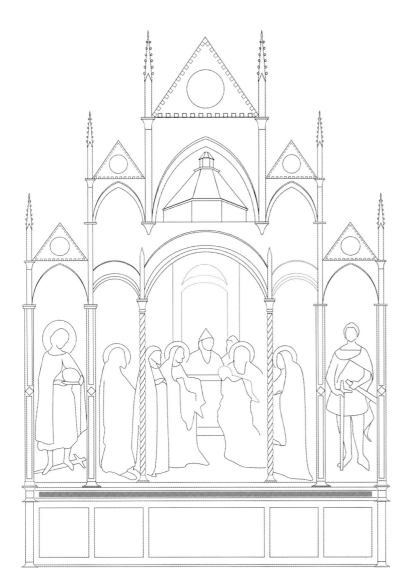

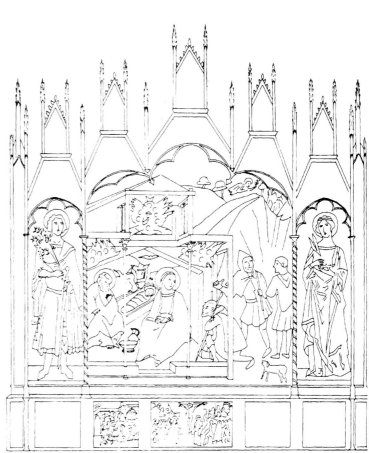

88. Reconstruction of the Saint Crescentius altarpiece.

89. Reconstruction by Norman Muller of the Saint Victor altarpiece.

created a bold analogy between the depiction of the façade of the Temple of Jerusalem in his altarpiece and the actual façade of Siena cathedral, the very building in which the altarpiece was located.[33]

Compared to the relatively simple design of the altarpieces of Saints Ansanus, Savinus and Crescentius, the original format of the Saint Victor altarpiece was probably more complex. It is clear that the painting of the *Nativity* which has been accepted by a majority of scholars as the surviving central panel of this altarpiece has been substantially cut down at some point in its history (see Pl. 76). On the basis of detailed examination of the painting itself and close comparison with a Florentine embroidery dating from the second half of the fourteenth century, it has plausibly been suggested that this painting has lost some 5 to 6 centimetres from its bottom and left-hand sides and a much more substantial 58 centimetres from its right-hand side and 42 centimetres from its top.[34] The right side of the painting would probably have shown the two shepherds adoring the Christ Child and, in the background, a vignette of the annunciation of the birth of Christ to the shepherds tending their flocks on the hillside. The original mouldings on the upper part of the *Saint Victor* and the *Saint Corona* paintings further suggest that the central painting was also surmounted by a series of cusped arches (see Pls 78, 79, 89).[35] The five upper arches of the painting were then, in turn, surmounted by five truncated gables and five pinnacle panels. The entire complex design would then also have been embellished with framing piers, pinnacles and finials.[36]

87. (facing page) Paolo di Giovanni Fei, *The Birth of the Virgin with Saints*, 1380s. Siena, Pinacoteca.

In short, the four altarpieces, once completed, would have presented a subtle and distinctive variety of formats and framing devices. Yet within this varied repertoire there were also important features in common. Thus the central painting on all four altarpieces had a strong tripartite division established either by the frame itself or by the frame in conjunction with the painted architecture. The effect of a common design governing all four altarpieces would arguably have been even stronger when the side panels and predellas were still present. From the surviving paintings of Saints Ansanus, Massima, Victor and Corona, it appears that on all the altarpieces, these subsidiary saints were represented full-length and on panels which were fairly narrow in width (see Pls 75, 78, 79). Similarly, the dimensions of the surviving predella paintings suggest that a common design was adopted for all the altarpieces, each predella accordingly comprising a wide central panel framed by four smaller paintings which were square in format (see Pls 80–3, 85, 86, 88, 89).[37]

The suggestion that these four altarpieces were intended as a unified programme is also supported by a consideration of the relationship between their subject matter and iconographical content and the liturgical setting and function for which they were designed. The choice of subject for the principal paintings could not have been an arbitrary one. The commissioners of the altarpieces – in all probability the Rector of the Opera del Duomo and his fellow counsellors[38] – had, after all, a rich variety of subjects associated with the Virgin and her hagiography upon which to draw. Thus, for example, narrative themes could have been selected from the hagiography relating to the Virgin's birth and youth – apocryphal accounts which emphasised the Virgin's exceptional status and suitability as the future mother of God. Indeed, such subjects had already been chosen for a series of early fourteenth-century relief sculptures ornamenting the architrave of the principal entrance to the cathedral (see Pl. 103). Alternatively, the focus of the altarpiece could have been upon the last days of the Virgin – a potentially appropriate choice given the cathedral's dedication to the Virgin of the Assumption. In fact, as the discussion of the narrative series depicted on Duccio's *Maestà* and the central section of the stained-glass oculus on the east wall of the chancel has already shown,[39] these themes were already represented within the decoration of the high altar and chancel of the cathedral (see Pls 43, 47). It was therefore logical that the four altarpieces should address other Marian subjects. At the same time, however, the specific choice of subjects for the four altarpieces was not merely the result of a desire to complement existing decorative schemes. It was also, in its own right, an additional and internally coherent contribution to the celebration of the Virgin and, in particular, four of the major annual festivals associated with her. Significantly, each scene chosen – one from the infancy of the Virgin and three from the gospel narrative of the circumstances relating to Christ's conception, birth and early life – depicted an event commemorated by a major feast of the church calendar: the Birth of the Virgin (8 September), the Annunciation (25 March), the Nativity (25 December) and the Purification of the Virgin (2 February). The introduction of these four altarpieces, therefore, allowed the liturgy of the cathedral to expand and extend from the high altar – where the feast of the Assumption (15 August) was celebrated with great pomp and civic ceremony annually over a number of days – outwards to other altars in the chancel and transepts.

In each altarpiece, the figure of the Virgin acts as a focal point of interest. Taking the paintings in their narrative order, in the *Birth of the Virgin* the majestic figure of Saint Anna, strikingly attired in a purple robe and yellow veil, initially draws the attention of the viewer (see Pls 72, 74). Nevertheless, by virtue of being placed in the immediate foreground of the scene and framed by two attentive women, the infant Mary also provides a strong counterpoint (Pl. 90). Similarly, despite the strong impulse given to the viewer to read the painting of the *Annunciation* from left to

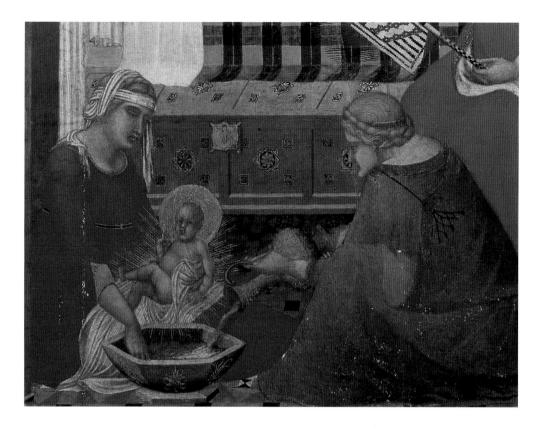

90. Pietro Lorenzetti, *The Washing of the New-born Virgin*, detail of Pl. 74.

right (and thus afford equal attention to the two principal protagonists), the Virgin makes the greatest impact upon the figural scheme – an effect partly achieved by the resonant colours of her ultramarine mantle and crimson robe and partly by her elegant and strikingly emotive pose (see Pl. 75). In the case of Bulgarini's *Nativity*, the focus of the painted composition upon the Virgin is now obscured by the cutting of the painting (see Pl. 76). From the reconstruction of the Saint Victor altarpiece, however, it is clear that the Virgin originally had a prominent and substantial presence within this painting (Pl. 89). Although, not centrally placed, she appears within the immediate foreground of the painting and on a considerably larger scale than the kneeling shepherd to the right of her. Her presence is also made more visually compelling by virtue of the architectural structure which acts as a framework associating her with the Christ Child and the heavenly host and separating her decisively from the mundane world of the shepherds and their flocks. Finally, as appropriate to its subject, the principal figures in the *Purification of the Virgin* are arranged so that attention is focused upon the Christ Child held in the arms of Simeon. Indeed, with the exception of two subsidiary figures in the background, all the figures are shown looking towards the Christ Child with the prophetess Anna also gesturing towards him (see Pl. 77).[40] But even in this figural composition, the Virgin is afforded a subtle prominence by virtue of her statuesque pose, the vivid hues of her traditional garb and the beautifully observed white linen cloth that she holds. What is striking about all four altarpieces, therefore, is that Mary is not only given a place of prominence within the figural scheme but is also consistently positioned off-centre.

Although in each case, this positioning can be accounted for by the narrative subjects portrayed, this particular feature of the paintings would also have presented a striking contrast to the placing of the Virgin within the traditional iconography of the *Maestà* theme (see Pl. 23). Indeed, it appears that the painters were taking account of the spatial relationship of these altarpieces to Duccio's *Maestà* over the high altar. Thus, it is striking that the infant Virgin in the *Birth* would once have had a comparable relationship to the high altarpiece as that of the infant Christ in the *Purification*:

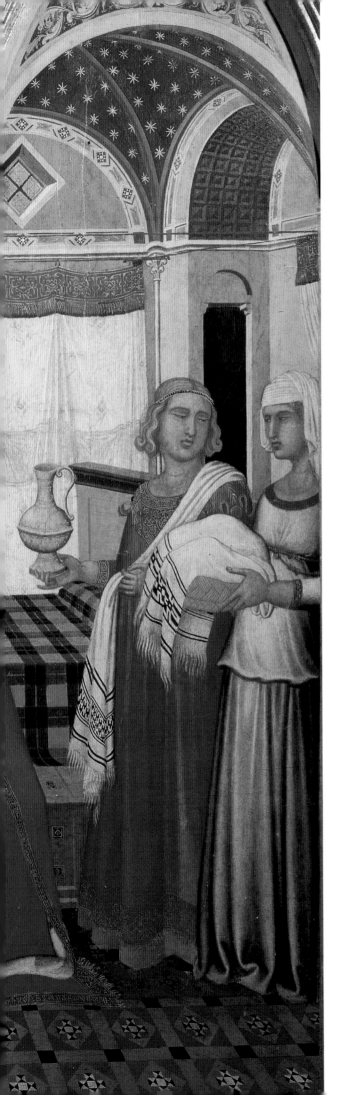

both holy infants would once have appeared looking in the general direction of the high altar (see Pls 73, 74, 77). Similarly, although both the Virgin of the *Annunciation* and the Virgin of the *Nativity* are shown as if looking away from the *Maestà*, yet, in both cases, there is a strong sense of the Virgin's body being oriented towards the high altar and its altarpiece (see Pls 73, 75, 76). On both iconographical and visual grounds, therefore, there is sound evidence for believing that the four altarpieces were consciously intended to complement the powerful Marian imagery of Duccio's *Maestà* upon the high altar.

There are also grounds for suggesting that a deliberate distinction was made between the altarpieces lying beyond the choir screen and thus framing the high altarpiece and those placed within the transepts. In Pietro and Ambrogio Lorenzetti's paintings, there is a marked concern to place the holy figures within a convincing architectural environment and also to furnish that environment with a detailed depiction of objects and materials (see Pls 74, 77). By comparison, Simone Martini and Lippo Memmi's painting is much more iconic, its narrative content and pictorial effect relying to a great extent on the disposition and poses of the holy figures themselves, with only a minimum description of other objects (see Pl. 75). The entire narrative event unfolds against an abstract, gold background, the surface of which is inscribed with the opening phrases of the angelic salutation as recorded in the gospel according to Luke.[41] The similarity between this painting and the principal painting on the front of the *Maestà* must have been striking. Similarly, although Bulgarini was apparently at some pains to establish an architectural setting (and presumably also a landscape background) for the *Nativity*, it is striking how relatively schematic it remains (see Pl. 76). In addition, the stable is set within an architectural structure that provides a framework in which to set God the Father surrounded by an aureole of seraphim.[42] In iconographic terms the inclusion of a representation of God the Father together with the dove of the Holy Spirit, introduces a relatively unusual Trinitarian theme to this depiction of the Nativity. This, in turn, would once have mirrored the *Annunciation*, where the Holy Spirit is depicted in an aureole just below the point where God the Father would have appeared in a tondo on the frame above. Such references to the Trinity serve to emphasise the theological complexity of the Incarnation – an important theme for the front face of the *Maestà* with its imposing image of the Christ Child on his mother's lap and its series of scenes depicting the events of Christ's birth and infancy (see Pls 23, 24). It is also striking how the act of reverence made to the Virgin by the Archangel Gabriel in the *Annunciation* and by the shepherds in the *Nativity* would have mirrored the kneeling poses of the four patron saints in the foreground of the *Maestà*. It is likely, therefore, that the unrealistic and schematic rendition of the architecture within Bulgarini's painting was intended to impart a more symbolic and iconic appearance to the Saint Victor altarpiece – thus relating it more closely to both Duccio's *Maestà* and Simone Martini and Lippo Memmi's *Annunciation*.

As well as the emphasis upon the person of Mary herself, the altarpieces also include other less obvious allusions to the Virgin and her status as the mother of God. Thus, in the *Birth of the Virgin*, the prominent appearance of Saint Anna serves as a reminder of the special circumstances of the Virgin's own birth – born, it was believed, immaculately, without taint of original sin (see Pls 72, 74). In addition, this altarpiece strongly emphasises the bathing of the new-born child and the prominent display of vessels of water and towels (Pl. 91). Although a common feature of such paintings, reflecting a number of well-established social rituals marking the birth of infants in fourteenth-century Italy, the prominence of these objects is striking. Similarly, it is notable that the vase filled with lilies in the *Annunciation*, although entirely traditional for this religious subject, is also given a highly prominent and

central position in the painting (see Pl. 75). The *Nativity*, meanwhile, contains a strikingly placed jug and ewer directly beside the seated Virgin (see Pl. 76).[43] In the *Purification* no such vessels are represented but the Virgin herself carries an immaculately laundered white towel, the design and weave of which echoes that of the attendant women in the *Birth of the Virgin* (Pl. 92).

These objects can be interpreted in a number of differing ways but their symbolism tends to coalesce upon the Virgin herself and her crucial significance for the miraculous process of the Incarnation. At its most straightforward, the gold vase containing three white lilies in the *Annunciation* acts both as a delicate allusion to the miraculous circumstances of the Virgin's conception and also to her status as a pure and sacred vessel of God's grace (see Pl. 93). In the *Birth*, the Virgin is actually being washed and thus surrounded by objects which associate her with the rituals of cleansing and purification (see Pl. 74). Indeed, it may be that this narrative detail was intended as a specific allusion to the Christian rite of baptism. If this was the case, then a telling parallel had been made between the Virgin herself and the sacrament of baptism. Significantly, both were regarded as essential tools for God's plan for securing the salvation of humanity. The presence of a basin and jug within the *Nativity* also associates the Virgin with a similar range of symbolic meanings (see Pl. 76). Finally, although the towel held by Mary in the *Purification* appears to be primarily a means by which to emphasise the sanctity and preciousness of the Christ Child himself, its whiteness also serves to reiterate the theme of the Virgin's purity and thus her suitability to be the mother of God (see Pl. 77).

Considering the four altarpieces in their original form, before their dismemberment in later centuries, it is also striking how many other important Christological and hagiographical themes once featured upon them. These, once again, complemented iconographical themes already established in Duccio's *Maestà*. It has already been suggested that the main subjects of the four altarpieces were chosen to demonstrate the importance of the Virgin for the Christological mystery of the

92. Ambrogio Lorenzetti, *The Virgin*, detail of Pl. 77.

93. Simone Martini and Lippo Memmi, *Vase with Lilies*, detail of Pl. 75.

91. (facing page) Pietro Lorenzetti, *Women Attendants*, detail of Pl. 74.

94. Simone Martini, *Saint Ansanus*, detail of Pl. 75.

95. (facing page) Paolo di Giovanni Fei, *The Birth of the Virgin*, detail of Pl. 87.

Incarnation. It appears that this Christological dimension was then made more explicit by the central predella paintings of the altarpieces, each of whose subject related broadly to Christ's death upon the Cross and the redemptive connotations of this sacrifice (see Pls 80, 81). The relevance of such imagery for the celebration of Mass, which regularly took place at each of the altars, is clear and unequivocal. Such imagery would also, however, have related closely to the extensive cycle of Passion imagery on the back face of the *Maestà* (see Pl. 44). Finally, it would have provided a prototype for the scenes of martyrdom that also apparently featured prominently on the predellas of the four altarpieces (see Pls 82, 83). The martyrdoms of saints were revered precisely because the saints' selfless act of dying for their faith mirrored that of Christ's sacrifice upon the Cross on behalf of humanity.

Turning to the two surviving paintings of the patron saints themselves, it appears that in terms of age and physiognomy the depictions here closely mirrored those of Duccio and Simone Martini in their earlier *Maestà* paintings (see Pls 75, 78, cf. Pls 23, 54). Far greater emphasis, however, is given to those attributes that identify them as martyrs and patron saints of Siena itself. Thus Saint Ansanus appears firmly grasping not only his palm of martyrdom with the fruit still attached to it, but also a flag with the civic colours of the *balzana* (Pl. 94).[44] Similarly, Saint Victor not only carries the palm of martyrdom but also wears a sword which both affirms his high social status and was also the instrument of his martyrdom (see Pl. 78). This figure also carries an olive branch, a well-established symbol of victory[45] and a punning reference to his name, Victor, and his personal victory over death. It was also, no doubt, intended to remind the Sienese of the reason for their particular devotion to this saint who, it was believed, assisted them in winning a decisive military victory over Montepulciano on his feast day in 1229. Given that each altar contained relics of the relevant saint,[46] the greater individual prominence given in the altarpieces of Saints Ansanus and Victor to the saints' status as martyrs and protector saints of Siena is readily explicable.

Although it is difficult to speculate on the appearance of the two lost saints, it is likely that Savinus would have been represented as a bishop and Crescentius as a youthful Christian martyr (see Pls 86, 88). On the evidence of Ansanus and Victor, both would also have carried attributes signifying their status both as martyrs and patron saints of Siena.[47] Finally, there remain the four figures that accompanied the patron saints. Although the precise identity of the saints now commonly named as Massima and Corona has been subject to debate, their respective ages and the aptness of their attributes make their identification as the godmother of Ansanus and the wife of Victor compelling. They also appear as representative types of late medieval womanhood – Massima, as an older matron or a woman in holy orders (see Pl. 75), Corona, as a young, recently married woman or a virgin (see Pl. 79) – as well as acting as graceful female companions to the Virgin, presiding over the court of heaven upon Duccio's *Maestà*. The inclusion of the now lost Saints Bartholomew and the Archangel Michael as the companions of, respectively, Savinus and Crescentius reflect important cults already established in the cathedral (see Pls 86, 88). Thus Saint Bartholomew had an altar dedicated to him in the thirteenth century and, for a time, was one of the four patron saints of Siena,[48] whilst the Archangel Michael, as the leader of heavenly hosts and weigher of souls at the day of judgement, would also have been a natural focus for a devotional cult.[49]

By 1351, when the last altarpiece was installed, the east end of the cathedral must have presented an extraordinary array of painted imagery devoted to the proclamation of the cult of the Virgin and its importance to the Sienese. Around the compelling and majestic portrayal of the Virgin as mother of God, queen of heaven and divine mediatrix on the front face of the high altarpiece, there would also have been

four other paintings, each of which vividly illustrated momentous events in the Virgin's life. Whilst the central panels of these four altarpieces thus enhanced the celebration of Siena's principal heavenly patron, the side panels presented full-length representations of the city's four lesser patron saints, themselves also already present on Duccio's *Maestà*. In their celebration of both the Virgin and the other patron saints of the city, these four altarpieces thus provided a further subtle consolidation of the cathedral's celebration of the civic cult of the Sienese community.

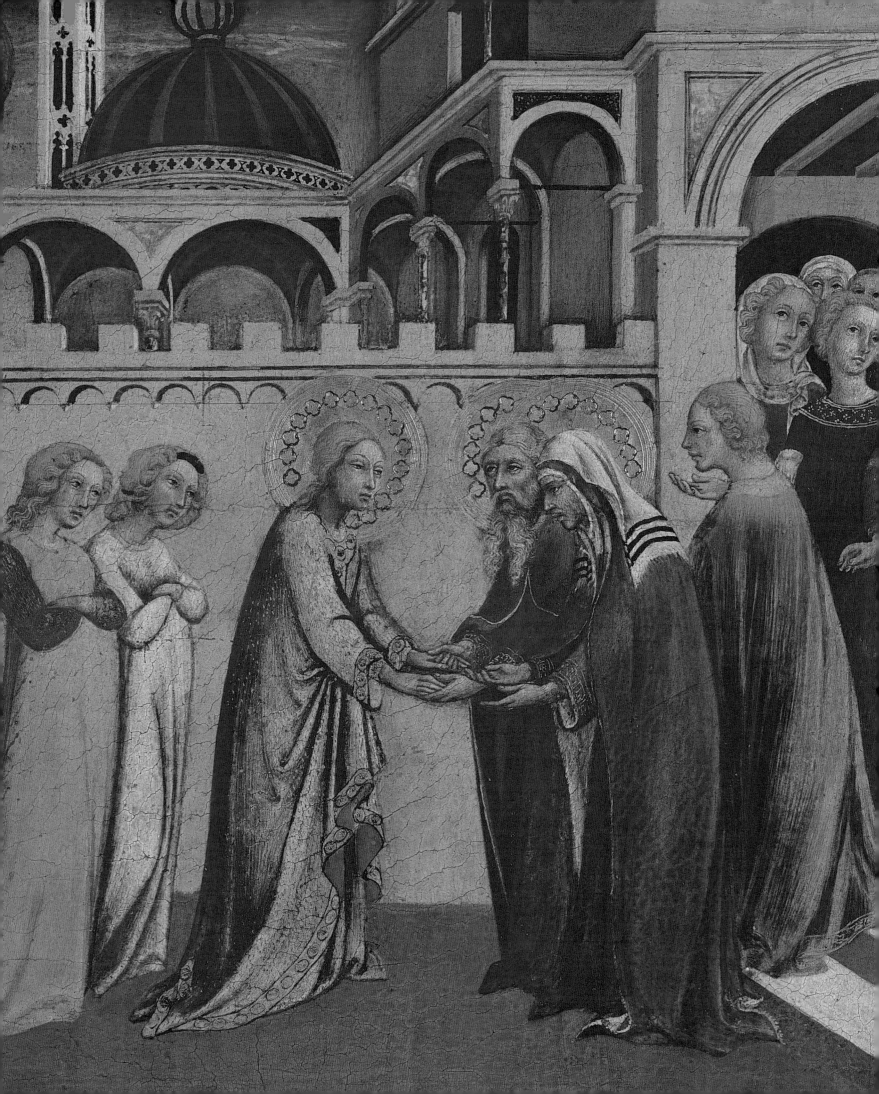

5

The Spedale

During the same period in which the ambitious series of Marian altarpieces for the east end of the cathedral were being painted, another series of fresco paintings celebrating the Virgin were also being executed in the close vicinity of the cathedral. Their location was even more public than that of the altarpieces, however, for these fresco paintings were situated on the exterior of buildings belonging to the Spedale di Santa Maria della Scala – buildings which faced onto the piazza fronting the entrance façade of the cathedral (Pls 97, 98). Unlike the programme of altarpieces, none of the series of frescoes survives. Due to their outdoor location, the paintings were under constant exposure to the elements and in a renovation of the exterior façade of the buildings between October 1720 and January 1721 that involved the scraping down of the surface of the wall, these early fourteenth-century frescoes were removed and lost to posterity.[1] Nevertheless, a number of historical sources dating from before their removal describe their subject matter and authorship – albeit in a sometimes confusing and contradictory manner.

The most useful body of evidence for the precise location and subject of the Spedale paintings occurs in a commission given to the painter, Sano di Pietro, by the government magistracy of the Consistory in 1448. In the commissioning document for a predella for an altarpiece for the Cappella dei Signori in the Palazzo Pubblico, the painter is instructed to paint: 'five stories of Our Lady like those that are above the doors of the Scala Hospital, placing in the middle the *Assumption* and on each side two stories'.[2] Although now dispersed in different art collections, the five panels of the predella survive and can be identified as the *Birth of the Virgin*, the *Presentation of the Virgin in the Temple*, the *Betrothal of the Virgin*, the *Return of the Virgin to the House of her Parents* and the *Virgin of the Assumption* (see Pls 105, 107, 108, 110, 112).[3]

Although the commission – and the resulting paintings – provide good circumstantial evidence of the location and subject matter of these fourteenth-century Marian paintings, they do not, however, make any reference to the identity of the painters responsible for them. A number of writers, writing before the destruction of the frescoes in the early eighteenth century, refer to Pietro and Ambrogio Lorenzetti and Simone Martini as all executing paintings on the façade of the Spedale. These sources, however, consistently refer only to paintings of the Virgin's early life and

96. Sano di Pietro, *The Virgin and Saints Anna and Joachim*, detail of Pl. 110.

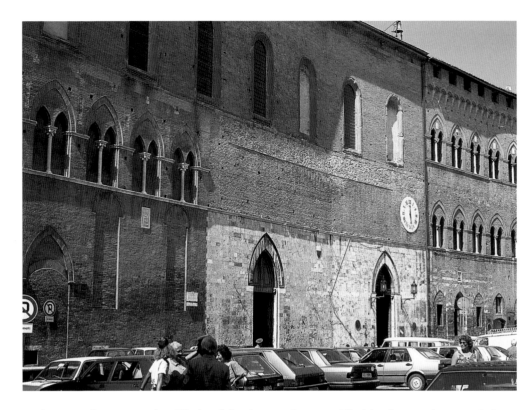

97. The principal façade of the Spedale di Santa Maria della Scala, Siena.

make no reference to the *Virgin of the Assumption,* specified in the 1448 commission. For the present, therefore, we will set aside this painting and its more iconic subject and return to it at a later point in the chapter.[4]

The history of the attribution of these mural paintings to painters also responsible for three of the cathedral altarpieces begins with Ghiberti's *Commentaries*. Although written in the late 1440s and early 1450s, the Florentine sculptor's apparently well–informed references to paintings by both Ambrogio Lorenzetti and Simone Martini were clearly based on experience of viewing the paintings, possibly during his documented visits to Siena in 1416 and 1417. His account of the Spedale paintings is brief and to the point, describing paintings of 'when our lady is born' and 'when she goes to the temple', attributing these to Ambrogio Lorenzetti, and paintings of 'when

98. Agostino Marcucci, *Procession in the Piazza del Duomo*, late sixteenth century. Siena, Palazzo Pubblico, Museo Civico.

99. Girolamo Macchi, annotated drawing of the façade of the Spedale before 1721. Siena, Archivio di Stato, MS D. 113, fols 59ᵛ–60ʳ.

our lady is betrothed' and 'when visited by many women and virgins', attributing these to Simone Martini.[5] Since we also know from a number of seventeenth- and eighteenth-century writers that there was once an inscription on the façade of the hospital recording the names of both Pietro and Ambrogio Lorenzetti and the date 1335,[6] it is surprising that Ghiberti did not also refer to Pietro Lorenzetti's participation in this scheme. However, Ghiberti makes no reference to the painter in the *Commentaries*, despite the fact that he was Ambrogio's brother and collaborated with him on at least one other major artistic scheme.[7] Vasari, writing in 1550 and 1568, was apparently aware of the inscription and accordingly divided all four paintings somewhat arbitrarily between the two painters.[8] Thereafter, local writers are more or less consistent in their references to the participation not only of Pietro and Ambrogio Lorenzetti but also Simone Martini in this painted scheme, although rarely identifying specifically who painted which painting.[9]

The early eighteenth-century archivist of the Spedale, Girolamo Macchi, gives the most detailed account of the precise location of this painted scheme which he described in his diary as located just below the 'roof', a structure built across the upper façade of the Spedale from the Rector's palace (located to the right of the present main entrance of the hospital) to what was, in his day, the 'convent of the girls' (located where the present Museo Archeologico stands).[10] This tiled structure is clearly visible in a drawing of the façade made by Macchi to accompany his history of the Spedale (Pl. 99).[11] Ugurgieri Azzolini, writing before the destruction of the paintings, refers to Pietro and Ambrogio Lorenzetti executing two paintings 'which are the first towards the Postierla' – the name of an important crossroads which lies beyond the Piazza del Duomo and to the left of the Spedale when facing it.[12] It seems, therefore, that the two Lorenzetti paintings were located towards the left-hand side of the façade of the Spedale. The order in which the names of the two painters are given on the inscription reported by the same writer and others, further suggests that Pietro Lorenzetti was responsible for the first of these two paintings and Ambrogio for the second. On the testimony of Ghiberti, it would appear that Simone Martini was responsible for the remaining two.[13] From the inscription

100. Reconstructions by Marco Parenti of the façade of the Spedale before and after the execution of the 1330s fresco scheme.

101. The Casa delle Gitatelle, Spedale di Santa Maria della Scala, Siena.

recorded by Ugurgieri Azzolini and others it also appears that the contribution by the Lorenzetti had been completed by 1335. Simone Martini, meanwhile, could presumably have been working on the scheme between 1333, when the Saint Ansanus altarpiece was completed (see Pl. 75), and 1336 when he probably left for Avignon.[14]

In 1335 the façade of the Spedale would, however, have had a very different aspect than it has today, or indeed in Macchi's time. It probably extended to its present length, but the hospital's thirteenth-century church would have been a much more modest edifice than today. Situated parallel to the Piazza del Duomo, it would have been distinguished from the hospital buildings on either side of it by a lower storey worked in travertine which still survives (see Pl. 97). Above this would have been an upper storey constructed in brick devoid of any windows (Pl. 100). The only light the church would have received would have been through two doors, one now acting as the principal door to the Spedale and the other now bricked up but still clearly visible on the wall outside. On either side of the church would have been two late thirteenth-century buildings: on the right, the palace of the Rector (see Pl. 97) and on the left, the Casa delle Gitatelle (Pl. 101). Both buildings would have been distinguished on their first floors by a series of imposing biforate windows.[15] Two phases of construction, one in the 1370s and the other between 1467 and 1471, resulted in the Casa delle Gitatelle becoming part of the newly extended church, thereby causing the enclosure of the Casa's first floor windows and the construction of a second floor with a series of tall lunette windows.[16] Given the appearance of the hospital façade prior to these radical adjustments of the fifteenth century, the only logical place for a series of frescoes would have been on the upper part of the church above the travertine facing of the lower storey. Although far less costly than the rich marble sculptures of the cathedral façade opposite, this series of frescoes would have enriched and enlivened an otherwise austere building frontage (Pl. 100).[17]

The date of 1335 places the execution of the scheme within the period of office of Giovanni di Tese Tolomei, Rector of the Spedale from 1314 to 1339.[18] In his account of the early eighteenth-century renovation of the Spedale façade, Macchi refers to the discovery of the Tolomei coat of arms just below one of the brackets supporting the roof on the façade and also states that it was during Giovanni

di Tese's rectorship that part of the roof structure was executed.[19] It is extremely plausible, therefore, that Giovanni di Tese was also primarily responsible for initiating the commission for the early fourteenth-century painted scheme and that the roof was erected precisely in order to protect the new paintings.[20] Other historical evidence lends support to this hypothesis. In an eighteenth-century record of the Spedale's obligations, detailed reference is made to a meeting of the chapter of the Spedale held on 28 March 1328, at which Giovanni and his wife, Andrea, requested that they be allowed to construct a chapel dedicated to the Virgin's parents, Saints Joachim and Anna, within the newly built Pellegrinaio – the large hospital ward for men, situated at right angles to the hospital church (Pl. 102).[21] That this chapel was in due course constructed is confirmed in the Spedale accounts where, on 27 June 1328, Giovanni di Tese is recorded as paying the Spedale 500 *lire* for the chapel in the Pellegrinaio.[22] From the eighteenth-century account, meanwhile, it appears that, in a later codicil to his will of 14 October 1325, Giovanni also specified that the hospital authorities were to celebrate the feast of Saints Joachim and Anna in this chapel.[23] On 20 August 1333, moreover, the Consiglio Generale debated and approved a petition from the Spedale authorities that this feast was to be celebrated within the hospital annually on 26 July.[24] From these sources it appears, therefore, that in the 1330s the rector and the hospital authorities wished to cultivate and promote a particular devotion towards the Virgin's parents. The four subjects chosen for the hospital façade, moreover, although primarily commemorating the childhood and early life of the Virgin, also by implication celebrated her parents Joachim and Anna. Indeed, the inclusion of the relatively rare scene of the Virgin's return to her parents' home provides a particularly striking ground for the proposal that the commission for this fresco scheme was closely related to Giovanni di Tese Tolomei's devotion to Saints Joachim and Anna.[25]

Given the loss of the frescoes themselves and the lack of any detailed description of them, beyond the identification of their subject matter, the question of their original appearance must remain largely a matter of informed speculation. Since the commissioning document of 1448 specified that Sano di Pietro should model his predella paintings on those of the Spedale façade, however, it is likely that this series of fifteenth-century paintings provides a reasonably faithful record – particularly since they were commissioned as part of a project to set an early fourteenth-century polyptych, probably by Simone Martini, within an elaborate, up-to-date frame.[26] It also remains possible, however, that Sano di Pietro introduced stylistic and iconographic elements which were inspired by his own preferred way of working and his knowledge of other, later representations of these Marian subjects.

The series of sculpted reliefs over the architrave of the central entrance doorway to the cathedral may also provide some evidence as to the appearance of the four lost frescoes. Part of the programme of sculpted decoration conducted by the cathedral workshop under the direction of Giovanni Pisano, these reliefs date to the first decade of the fourteenth century and would thus have provided a potential model for the hospital authorities and their painters in the 1330s. Although now very worn, the reliefs represent the expulsion of Joachim from the Temple, the dream of Joachim, the annunciation to Anna, the meeting at the Golden Gate, and the birth, presentation and betrothal of the Virgin – all subjects with an obvious relevance to the fresco scheme and the apparent devotion to Saints Joachim and Anna in the Spedale (Pl. 103).[27]

Other visual evidence for the possible appearance of the fresco paintings may be derived from two of the altarpieces for the patronal altars of the cathedral. Thus the *Birth of the Virgin* (see Pl. 74) would have duplicated the subject of one of the façade frescoes, while the architectural setting of the *Purification* (see Pl. 77) would have been

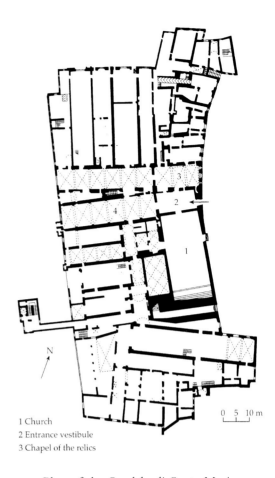

1 Church
2 Entrance vestibule
3 Chapel of the relics

102. Plan of the Spedale di Santa Maria della Scala.

103. *Scenes from the Early Life of the Virgin,*
c. 1300–10, architrave over the principal
doorway on the entrance façade. Siena,
cathedral.

appropriate for the paintings of the *Presentation* and the *Betrothal* since both events
were believed to have taken place within the Temple precincts. A number of other
Sienese altarpieces and fresco paintings similarly provide examples of later painters'
treatment of these Marian subjects.[28] Although in many cases removed from the
Spedale frescoes by considerable periods of time – indeed some by as much as a cen-
tury – it is well known that Sienese art exhibited a marked tendency to replicate, or
at least broadly emulate, earlier models and prototypes. Often discussed as simply a
mark of innate conservatism, a more positive and accurate construction of this char-
acteristic is that Sienese patrons and their artists valued continuity in their religious
art precisely because they believed that the 'newer' art would share the devotional
efficacy of the 'older' and by then much venerated early images.[29]

If it is clear that the fresco paintings were thus part of a long tradition of cele-
brating the Virgin in Sienese art, there yet remains the question of the significance
of the location of these particular paintings on the exterior wall of the Spedale. The
Spedale di Santa Maria della Scala was one of Siena's most important civic institu-
tions, competing in prestige and importance with the Palazzo Pubblico and the
cathedral.[30] By the end of the fourteenth century, the story of its foundation had
already taken on mythic proportions involving a legendary ninth-century founder,
Sorore, a humble cobbler, who, nevertheless, guided by God and the Virgin, was
inspired to found the hospital.[31] In fact, the Spedale probably began its existence as
a simple edifice built at the end of the twelfth century beside the cathedral as a place
where pilgrims could secure food and lodging and where the sick could be
nursed.[32] From these relatively humble origins, the Spedale grew into a major civic
and social institution housed in an expanding complex of buildings which finally
included a church, a number of chapels and confraternity oratories, hospital wards
for men and women, an orphanage, a palace for the Rector, accommodation for the
oblates, and numerous other rooms required for the practical day to day running
and administration of this extensive concern. Such was the extent of the building
that it even incorporated one of Siena's early medieval streets which became an
extensive subterranean corridor linking various parts of the hospital complex with

The City

one another.[33] Initially controlled by the bishop and canons of the cathedral, the Spedale's government and administration was subsequently placed in the hands of a lay order which recruited both men and women.[34] The city government, meanwhile, whilst affording the Spedale a significant degree of autonomy in its affairs, nevertheless, sought to increase its control over this important and wealthy institution, as charted by the various city statutes in which numerous provisions were made regarding the hospital and its administration.[35]

The Spedale's primary civic role was to perform various social and charitable functions.[36] It provided accommodation for pilgrims, dispensed medical care (particularly to the poor), and disbursed alms and food to the indigent. Another of its most important purposes was to act as an orphanage providing child care and education for foundlings and, once they were grown, finding work for the young men and providing dowries for the young women in order that they might marry or enter a convent.[37] These latter activities of the hospital were later graphically depicted in Domenico di Bartolo's fresco for the Pellegrinaio (Pl. 104). In this context it is significant that the *Birth of the Virgin* and the *Presentation in the Temple* appear to have been located towards the left-hand side of the church façade and thus directly adjacent to the late thirteenth-century building housing the female orphanage (see Pls 100, 101).[38] In general terms, moreover, the subject matter of three of these four paintings would have been directly relevant to the hospital's care of foundlings. The *Birth of the Virgin* furnishes the painter with the opportunity to depict women engaged in taking care of a new-born baby (Pl. 105). The subject of the *Presentation*, when the Virgin entered the temple to be educated with other young girls, provided a parallel to the hospital's role in the rearing of its foundlings (Pl. 107), whilst the *Betrothal* related to the hospital's function of providing dowries for its inmates (Pl. 108). The *Return* is of less specific relevance to the hospital's supervision of its foundlings, but its theme of filial obedience to elderly parents (Pl. 110) portrays the social values that the hospital authorities undoubtedly hoped to inculcate in its young protégés.[39]

If it is allowed that Sano di Pietro's predella panels may well constitute a reasonably accurate representation of the original fourteenth-century paintings, then it is striking that his narrative of the *Birth of the Virgin* affords equal interest to the Virgin and her parents Joachim and Anna (see Pl. 105). Thus, on the left, Joachim is portrayed hearing the news of his daughter's birth; in the centre, the new-born Virgin is rendered distinctive by the domestic activities of the women in attendance upon her; and on the right, Anna is portrayed, surrounded by women, all of whom are looking at the child. There are also a number of figures whose action provides a link from one point of the narrative to another. Thus the figure of a man carrying water into the house links the left-hand scene of Joachim and his companions with the principal action taking place within the birth chamber on the right. Such devices would have been entirely appropriate for a painting designed to relate a religious narrative rather than – as in the case of Pietro Lorenzetti's cathedral altarpiece – to provide a focus for religious veneration and worship (see Pl. 105, cf. Pl. 74). Later examples of paintings of this subject in which Anna's bed is portrayed as if from its foot also suggest that this may have been a feature of the original Spedale painting.[40] The striking domestic details of the well in an open courtyard and the fireplace only appear in another fifteenth-century painting of this subject, however, and may therefore be embellishments introduced by Sano di Pietro.[41] Nevertheless, this kind of well-observed genre detail was not without precedent in Pietro Lorenzetti's work as a painter (Pl. 106).[42] The domestic activities depicted by Sano in his predella painting of the *Birth of the Virgin* – the carrying of water, airing of cloths, nursing of the baby, preparing and bringing food to those in bed, and the making of the bed – were all

105. Sano di Pietro, *The Birth of the Virgin*, 1448–52. Ann Arbor, University of Michigan Museum of Art.

activities that would have been particularly relevant to the members of the Spedale, particularly those employed to care for the young orphans (see Pl. 105). It is quite possible, therefore, that in his painting Sano di Pietro carefully reported many of the details of Pietro Lorenzetti's original painting for the Spedale façade.

106. Pietro Lorenzetti, *The Last Supper*, c. 1315–19. Assisi, San Francesco, Lower Church.

104. (facing page) Domenico di Bartolo, *The Rearing and Education of Orphans and the Marriage of an Orphan*, c. 1441–2. Siena, Santa Maria della Scala, the Pellegrinaio.

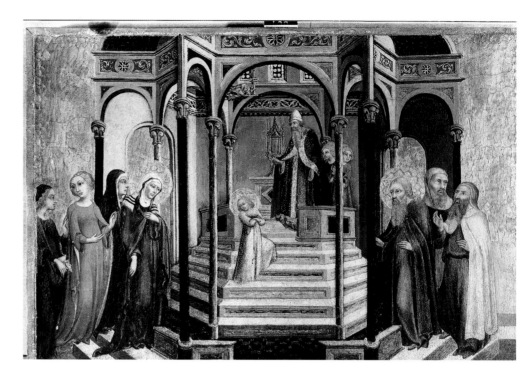

107. Sano di Pietro, *The Presentation of the Virgin in the Temple*, 1448–52. Vatican City, Pinacoteca.

Like the *Birth*, the figural composition in Sano's *Presentation in the Temple* appears to focus visual attention not only upon the Virgin herself who takes pride of place at the centre of the composition, but also on Anna and her companions on the left, and Joachim and his companions on the right (Pl. 107). There is also, again, a sense of the narrative unfolding from left to right with the Virgin, having just left her mother, turning back towards her as if unsure about the parting between herself and her parent. The viewpoint adopted by Sano in his predella panel for the architectonic structure of the Temple broadly corresponds to Ambrogio Lorenzetti's *Purification of the Virgin* (see Pl. 77) and a number of other later paintings commissioned for the cathedral.[43] In Sano's painting, however, it is significant that the portrayal of the Temple includes a very prominent series of steps (Pl. 107).[44] Although part of the descriptive account of the event given in the hagiographical sources, the prominence given to this architectural feature of the Temple would have afforded a graceful compliment to the name of the hospital itself – the Spedale di Santa Maria della *Scala* (the hospital of Saint Mary of the stairs).[45] Moreover, if Ambrogio Lorenzetti was the painter of the original fresco, then the relative complexity and sophistication of Sano's polygonal steps and colonnaded ambulatory would have been entirely typical of Ambrogio's skilful treatment of architecture and space in such paintings as the *Purification* altarpiece for the cathedral and the small *Maestà* now in the Pinacoteca of Siena.[46]

In principal, the portrayal of the *Betrothal of the Virgin* could have used the same architectural setting as the *Presentation*.[47] Instead, however, Sano di Pietro portrayed a rather curious double loggia with a vaulted building to the right (Pl. 108). Again the effect of this setting is that the narrative unfolds laterally from left to right as in the other two paintings, already discussed. In addition, the elegant pose of the musician on the right, with his head turned towards the event of the betrothal but his body aligned in the opposite direction, would have acted as a link between this painting and the final one on both the predella and the hospital façade – if Sano's paintings were, indeed, modelled closely upon the fresco cycle. The frequent appearance of musicians – particularly trumpeters – in other versions of this subject also suggests that this may well have been an important feature of the original fresco painting.[48] Significantly, moreover, the early fifteenth-century fresco of the *Betrothal*

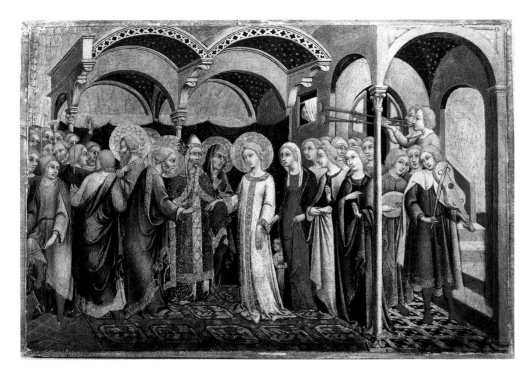

108. Sano di Pietro, *The Betrothal of the Virgin*, 1448–52. Vatican City, Pinacoteca.

in the sacristy of Siena cathedral – which apparently lacked any precedent in the cathedral altarpieces – not only includes musicians but also shows the unusual architectural setting of Sano di Pietro's painting.[49] Precedents for a number of specific details in Sano's painting can also be found in the work of Simone Martini to whom Ghiberti and later sources assigned the fresco of the *Betrothal* on the façade of the Spedale. Thus, for example, Simone Martini portrayed a luxuriously patterned carpet in his altarpiece of *Saint Louis of Toulouse*, and a vivacious group of musicians in the chapel of Cardinal Montefiore in the Lower Church at Assisi (Pl. 109) – both important motifs within Sano di Pietro's *Betrothal*.[50]

As a relatively unusual subject, the *Return of the Virgin to the House of her Parents* (Pl. 110) appears to have inspired far fewer later versions. In the two examples that survive, it is striking that – as in Sano's painting – the procession of the Virgin and her attendants appears silhouetted against a crenellated wall with her parents and their attendants issuing from an open portico on the right.[51] Sano di Pietro's portrayal of a domed building and a campanile beyond this wall does not appear in the other versions of this painting (Pl. 111). However, since such a building would have at once invoked an association with both the Temple of Jerusalem and with Siena cathedral itself, it is entirely plausible that it was also part of the original fresco painting. Moreover, Vasari's description of the Spedale frescoes offers strong circumstantial support for this hypothesis. Having briefly described the subjects of the first three frescoes, Vasari refers to a fourth as showing the Virgin going 'to the Temple in the company of other virgins'.[52] The traditional attribution of this fresco to Simone Martini by Ghiberti and other sources is also consistent with such a depiction of the Temple since further examples of this type of figural composition and of vignettes of buildings seen over city walls may be found in other paintings attributed to him.[53]

There are, therefore, good – albeit circumstantial – grounds for believing that each of the four scenes from the early life of the Virgin on Sano di Pietro's predella panels discussed above were, in fact, closely modelled on the four frescoes of the same subjects once on the façade of the Spedale. Or, conversely, we may plausibly argue that Sano's predella panels provide an at least tolerably accurate depiction of the now lost fresco paintings by Pietro and Ambrogio Lorenzetti and Simone Martini on the façade of the Spedale. There remains, however, the fifth and central image of Sano's

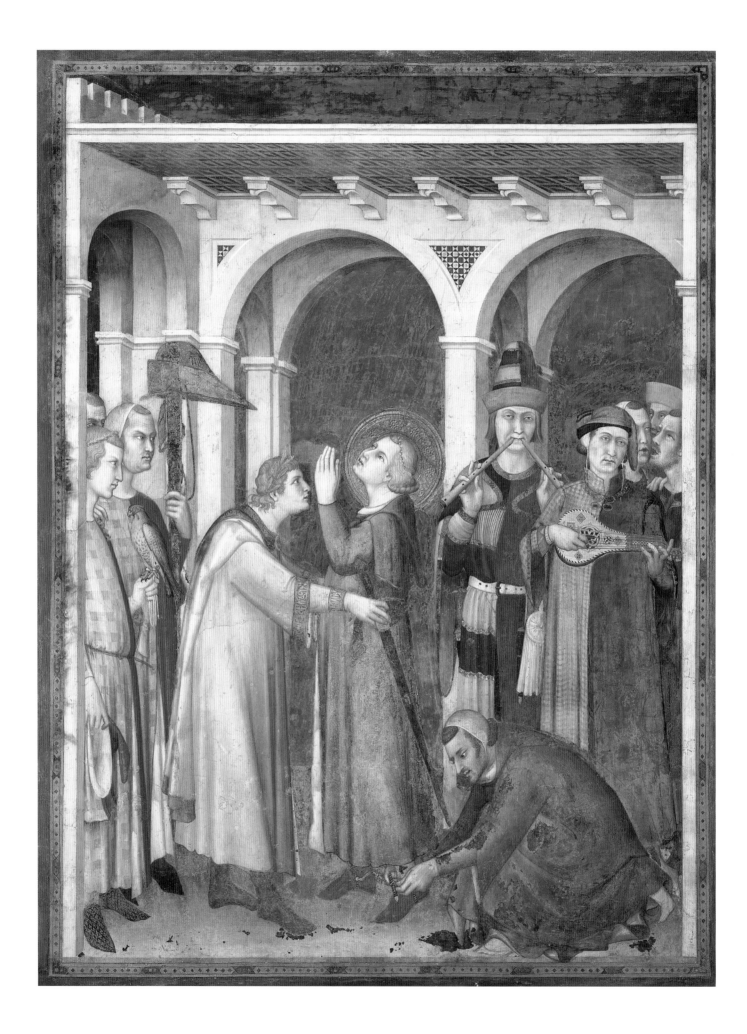

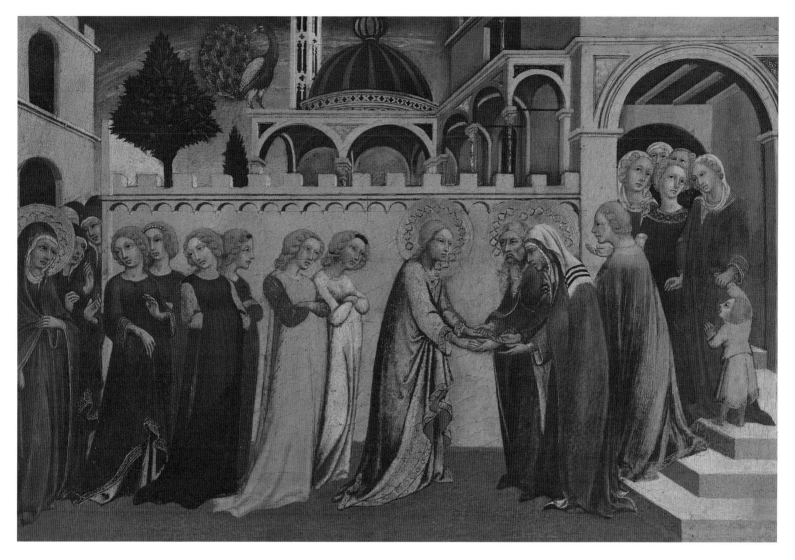

predella of 1448 (Pl. 112). The commissioning document specified that the central image of the predella was to be an *Assumption* and defined it and four other scenes to be painted as 'five stories of Our Lady like those that are above the doors of the Scala Hospital'. But neither Ghiberti nor Vasari mentions a fifth fresco of the *Assumption*, in their description of the Spedale paintings.

If a fresco of this subject had been at the centre of the sequence of paintings on the façade of the Spedale, the instruction in the 1448 document to make the *Assumption* the centrepiece of the predella would not have been strictly necessary. Neither is the subject of the *Assumption* of a piece with the other four paintings which portray events in the early life of the Virgin and follow a logical, sequential narrative order. Moreover, compared with his other predella paintings, Sano's *Assumption* shows a much more iconic image, focusing exclusively upon the Virgin of the Assumption and her act of dropping her girdle to Saint Thomas. Is it possible, therefore, to construct a plausible hypothesis for the existence of a fifth fresco on the hospital façade with this particular scene as its subject? In the singular absence of a detailed description of such a fresco, any proposal must remain highly speculative. However, aspects of the later fourteenth-century history of the Spedale do provide a potentially persuasive context for the addition of a painting of the *Assumption* to have been added to the hospital façade – especially one that included the detail of the Virgin dropping her girdle to Saint Thomas. In 1359 the Spedale acquired a rich collection of relics amongst which was a part of the Virgin's girdle. As a result, in the 1360s, a new chapel was installed on the ground floor of the Palace of the Rector,

110. Sano di Pietro, *The Virgin Returning to the House of her Parents*, 1448–52. Altenburg, Staatliches Lindenau-Museum.

109. (facing page) Simone Martini, *The Knighting of Saint Martin*, c. 1320–30. Assisi, San Francesco, Lower Church.

111. Sano di Pietro, *Architectural Vista*, detail of Pl. 110.

to the right of the hospital church on whose façade appeared the four scenes of the early life of the Virgin (see Pl. 102).[54] In order further to honour the newly-acquired relics, moreover, a new civic ceremony was instituted in which, each year, on the feast of the Annunciation, the precious objects were displayed to the populace from a specially constructed pulpit built on the façade of the hospital church, just below the early fourteenth-century fresco series (see Pl. 100).

Given that the Virgin's girdle was one of the most prestigious of the newly acquired relics, it is also entirely plausible that its acquisition should have been

112. Sano di Pietro, *The Assumption of the Virgin*, 1448–52. Altenburg, Staatliches Lindenau-Museum.

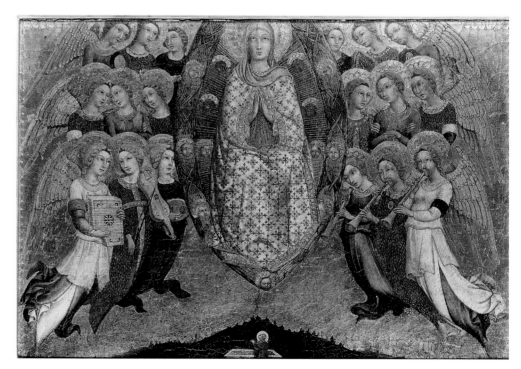

The City

celebrated by the addition of a painting of the Assumption – when the Virgin allegedly gave her girdle to Saint Thomas – to the façade of the Spedale. Where, then, might such a fresco of the *Assumption* have been placed? At first sight, the façade of the Spedale apparently offers little scope for such a painting. To the right of the church would have been the Rector's palace which, with its heavily fenestrated upper storeys, left no room for frescoed decoration (see Pl. 97). To the left, meanwhile, would have been the Casa delle Gittatelle with a series of arched windows on its upper floor (see Pl. 101). However, as noted earlier, the project to extend the church into this building began as early as the 1370s – a point at which the civic and hospital authorities were collaborating in the consolidation of a new annual civic festival in front of the hospital. If the extension of the church entailed not merely filling in the windows to form the blind arcade presently visible but, in addition, included plastering them over, then a suitable surface for further fresco painting would have been created. Significantly, in Macchi's eighteenth-century drawing of the hospital façade, the first floor of the former Casa delle Gittatelle is clearly completely plastered over (see Pl. 99), and indeed this also appears to be the case in other earlier representations of the Spedale and its façade (see Pl. 98). Also represented in these early images is a little roof running across the entire length of the façade linking the early church with the former Casa delle Gittatelle (see Pls 98, 99). It was the removal of this roof in 1720 that prompted Macchi to refer, in his diary, to five paintings on the façade of the Spedale.[55] Given that the 1448 commissioning document refers to the paintings as above the *doors* of the Spedale, a plausible position for the *Assumption* would have been over the door of the former Casa delle Gittatelle, which Macchi designates as the Portone del Comune and which is still distinguished by an inlaid *balzana* at its apex (Pl. 113). If this door was indeed under the patronage of the Commune in the late fourteenth century, a fresco of the *Assumption of the Virgin* – with all the civic associations that this subject carried for the communal authorities – would have constituted an extremely apposite embellishment.

If the reconstruction and interpretation of the frescoes on the façade of the Spedale di Santa Maria della Scala presented in this chapter is correct, then it provides a further striking demonstration of the determination with which the Sienese pursued their celebration of their principal patron saint – the Virgin – through the commissioning of a sequence of major Marian images, located in each of the three principal civic institutions of the city. In the cathedral, they had both Duccio's remarkable double-sided high altarpiece and the series of four subsequent altarpieces which, together with the earlier, late thirteenth-century stained-glass window, comprised a visually, theologically and liturgically complex celebration of the life and status of the Virgin, together with recognition of the role of Siena's four subsidiary patron saints, Ansanus, Savinus, Crescentius and Victor. In the Palazzo Pubblico, meanwhile, the same theme of the Virgin in majesty, accompanied by Siena's four patron saints, was rendered in fresco on the wall of the city's main council chamber. Finally, opposite the cathedral, on the façade of the third of the city's principal institutions, the Spedale di Santa Maria della Scala, a series of fresco paintings celebrated the early life of the Virgin, the cult of her parents Saints Joachim and Anna and very probably the legend of her assumption and the consequent origin of the relic of her girdle – which the Sienese believed they had obtained for the Spedale. Such a programme of interrelated Marian images would, in itself, have been a potent and effective means of proclaiming and reiterating the devotion of the Sienese to the Virgin. In addition, however, the Virgin was also celebrated on altarpieces on the altars of the most important churches within the city and in other public locations, including the city gates and a number of street tabernacles.[56]

113. The Portone del Comune, Spedale di Santa Maria della Scala, Siena.

114. (facing page) Simone Martini, *Musicians*, detail of Pl. 109.

As the first chapter of this study demonstrated, however, throughout the thirteenth and fourteenth centuries, the Sienese were also engaged in an ambitious programme of territorial expansion. The Marian images with which we have been concerned in the first chapters of this book were, in turn, a significant element within the moral and political endorsement of this process. Thus, for example, much of the political debate and legislation concerning such territorial expansion would have taken place in the Sala del Consiglio – that is to say, in a room dominated by Simone Martini's *Maestà*, itself, in turn, once surrounded by other paintings commemorating the recent submission of a variety of *contado* towns. And, as noted in chapter three, Simone Martini's image of the Virgin was itself a powerful form of visual propaganda for Siena's policy of territorial aggrandisement. After 1311 and the installation of Duccio's *Maestà* on the high altar of the cathedral, moreover, the annual celebration of the Feast of the Assumption – when representatives of Siena's subject towns and political allies processed to the cathedral and presented *ceri* and other tributes in a ritualised re-enactment of their original act of political submission and homage – was similarly centred upon an equally powerful Marian image. Whilst the government pursued the legislation of its official policies towards the submission and government of the *contado* under the gaze of the Virgin in Simone Martini's *Maestà*, the procession for the Assumption culminated in the cathedral in the presence of the Virgin of

Duccio's *Maestà* — in both cases supported and petitioned by Siena's four other patron saints. For the representatives from the *contado* the message was unequivocal. Siena was a city whose civic institutions and people were under the protection of the Virgin Mary and her saintly companions. But was this powerful body of Marian civic propaganda confined merely to the urban fabric of Siena itself? Or was it reiterated in the towns and religious communities of the *contado*? Did the Sienese government authorities responsible for commissioning these important civic images for Siena's major civic institutions also seek to ensure that similar images appeared in the city's subject territories, thus reaffirming their view of Siena's divinely sanctioned political control? And if so, what were the mechanisms that facilitated such a process of reaffirmation and what role, if any, did local factors within the *contado* also play?

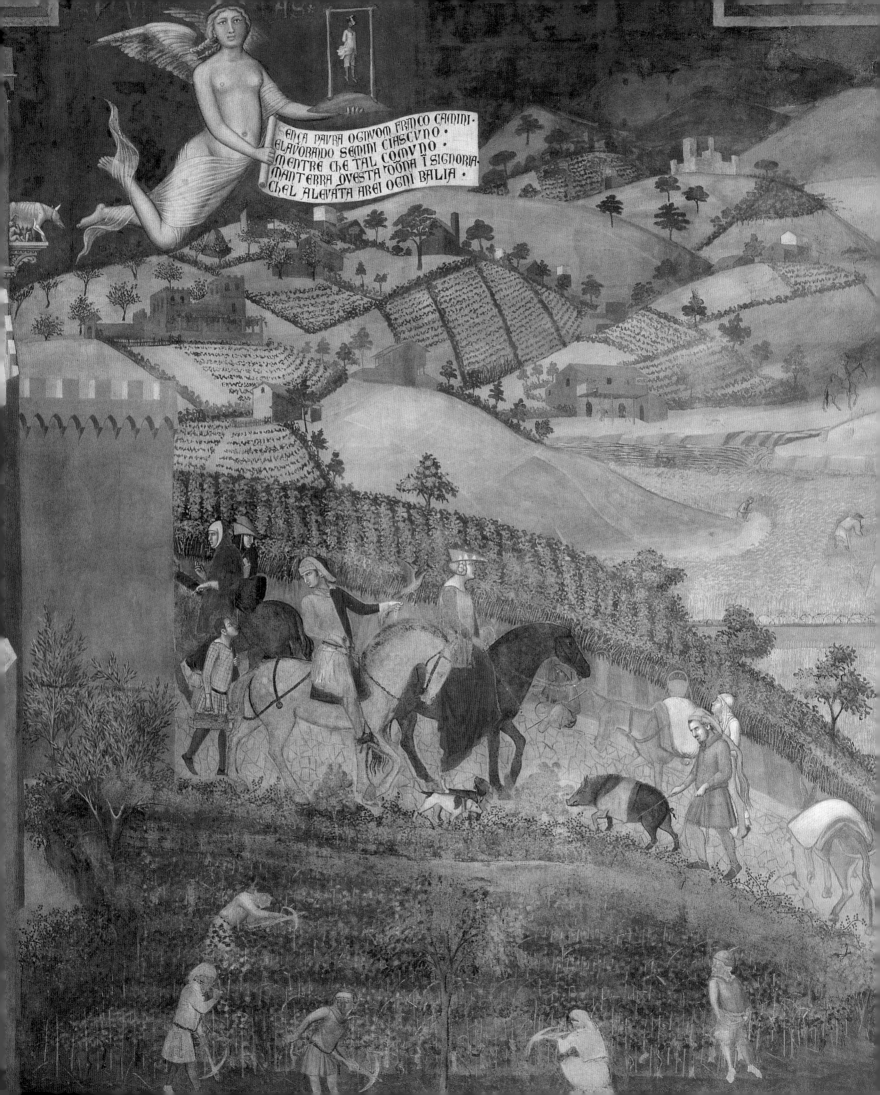

SENÇA PAVRA OGNVOM FRANCO CAMINI
ELAVORADO SEMINI CIASCVNO ·
MENTRE CHE TAL COMVNO ·
MANTERRA QVESTA DONNA I SIGNORIA.
CHEL ALEVATA AREI OGNI BALIA ·

PART III

THE CONTADO

6

Massa Marittima

In 1400, when the Sienese made a new register of the tributes owing to the city, those of the city of Massa Marittima to the south-west of Siena stand out as strikingly demanding (Pl. 117).[1] The first entry – recording an earlier agreement of 1361 – described an annual tribute of 2000 gold florins to be paid by the 'commune and men' of Massa Marittima for the Sienese garrison in their city. The second entry, composed in 1399, bound the Massetani to accept Sienese appointees as their principal judge and treasurer and to pay their salaries. By now the annual tribute was 800 gold florins. As these records show, the history of the political relations between Siena and Massa Marittima clearly involved a sustained attempt by the Sienese to establish their authority in Massa Marittima. This, in turn, was part of the Sienese enterprise, throughout the thirteenth and early part of the fourteenth centuries, to extend their territories south and west towards the sea and the mineral-bearing and rich agricultural lands of the Maremma. As they did so, however, the Sienese came into conflict not only with local families and cities but also with Pisa, another major Tuscan city intent upon territorial expansion into the Maremma. For both Siena and Pisa, however, the Maremma was difficult terrain over which to establish political control – combining mountain ranges and coastal plain, lying a considerable distance from both cities, and populated by noble families living in well-fortified castles and intent upon evading the control of either of the cities' governments. An important factor in both cities' campaigns to subdue the Maremma was, therefore, to secure the allegiance or outright submission of the region's most important communities, Massa Marittima being one of the most prestigious and strategic locations in this respect.[2]

In common with other Italian cities, Massa Marittima was first ruled by its bishops who, as early as the ninth century, had established their fortified residence overlooking the city. In the twelfth and thirteenth centuries, however, there was a gradual shift in political power away from the bishop to the citizens themselves. By the thirteenth century, Massa Marittima was a fully-fledged commune, governed by a magistracy of nine priors. As in other communes, the judicial processes were entrusted to a foreign Podestà, whilst attempts were constantly made to extend its territorial control over the surrounding countryside, often through strategic political allegiances with powerful, neighbouring communes.[3] Thus, for example, in 1226, Massa Marittima made its first major defensive alliance with Pisa, followed by

115. (previous pages) Ambrogio Lorenzetti, *The Well-governed Countryside*, detail of Pl. 16.

116. (facing page) Ambrogio Lorenzetti, *Saints Anthony Abbot, Augustine and Cerbone*, detail of Pl. 133.

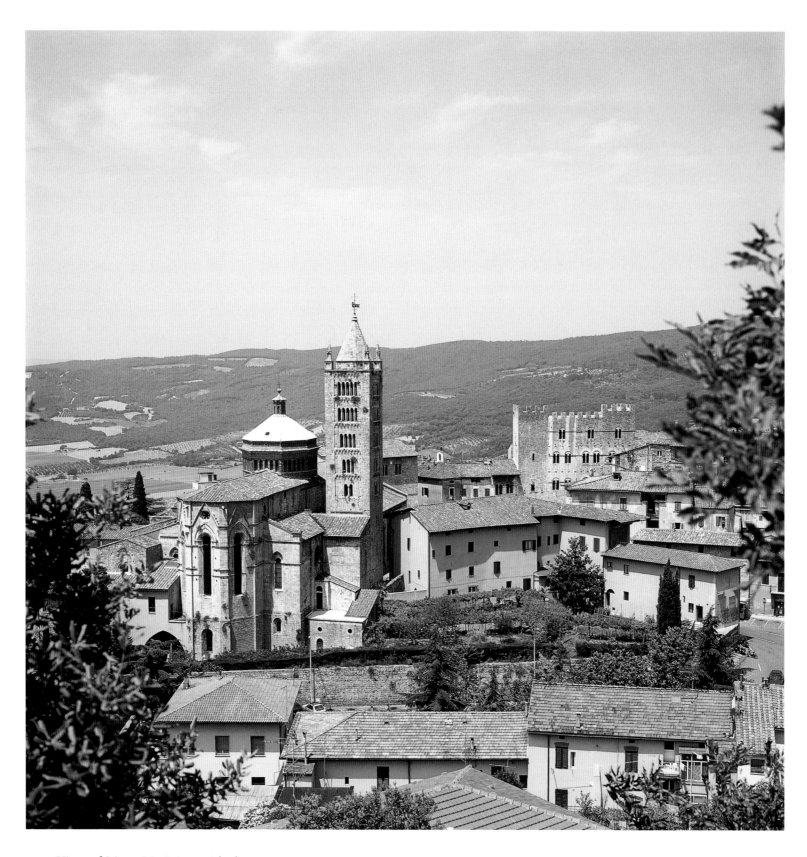

117. View of Massa Marittima with the cathedral on the left and the Palazzo Comunale on the right.

one with Siena in 1242, and another in 1276.[4] While pledging Massa Marittima to a variety of obligations, these treaties were, nevertheless, recognised as mutual agreements between two independent city-states.

In the early decades of the fourteenth century, however, the Sienese gradually extended their political influence in the immediate vicinity of Massa Marittima. The growing tensions caused by this expansion culminated in the 1330s in a full-scale

The Contado

military campaign between the two cities.[5] In December 1332, the Sienese inflicted a heavy military defeat on the Massetani and their Pisan allies at Giuncarico, lying south-east of Massa Marittima (see Pl. 7). Two months later, however, the Massetani, led by their new Capitano del Popolo, Ciupo Scolari, a Pisan appointee, laid waste to Sienese territory to within a few kilometres from the city walls. At this juncture, however, the Bishop of Florence, Francesco Salvestri, under instructions from Pope John XXII and his Guelph allies, intervened. In September 1333, it was agreed that Massa Marittima should be ruled for three years in the name of the Bishop of Florence and have a Florentine Podestà and judge. Within two years of thus losing control of Massa Marittima to Florence, however, Siena finally secured the city's effective political submission. While preparing a force to reoccupy Grosseto, the Sienese made a secret agreement with a pro-Sienese faction in Massa Marittima. On 13 August 1335, a force of Sienese cavalry were let into the city by members of this faction. On 21 August, the pro-Pisan faction in Massa Marittima also made terms with the Sienese. On 24 September the conditions of Massa Marittima's submission were ratified by the Sienese Consiglio Generale and the final treaty was drawn up on 5 October 1335.[6] Early in 1336, the Sienese ensured their continued political control over the city by building a fortress, the remains of which are still in evidence today in the upper part of the city (Pl. 118). Documents in the Sienese state archive detail the large amount of land purchased in order to construct this fortress.[7] According to the chronicle attributed to Agnolo di Tura, the main reason for this fortress was the ever present threat of Pisa.[8] Thus in 1338, and again in 1339, conspiracies to hand the city over to Pisa were uncovered and the conspirators summarily executed.

Military power and political domination were not, however, the only expressions of Sienese influence in Massa Marittima. The cultural influence of Siena is also to be seen in the presence in Massa Marittima of two striking early fourteenth-century images of the Virgin in majesty – a theme central to early fourteenth-century Sienese art and itself not without political significance. One of these images, moreover, predated the eventual Sienese domination of Massa Marittima by some two decades, thus highlighting the complexity of relationships between political power and cultural influence. The earlier painting, the so-called *Madonna delle Grazie*, although now cut down on all sides, is a strikingly close copy of the *Virgin Enthroned* from the front face of Duccio's *Maestà* (Pl. 120, cf. Pl. 23) and can be dated, on documentary grounds, to circa 1316 when Massa Marittima was still an independent city commune.[9] The second painting, securely attributed to Ambrogio Lorenzetti,[10] presents a highly imaginative and innovative reworking of both Duccio and Simone Martini's exploration of the *Maestà* theme (see Pl. 133, cf. Pls 23, 54). Although, the precise dating of Ambrogio Lorenzetti's *Maestà* is open to debate, there is a general consensus that it was produced between 1335 and 1337, and thus just at the point when Siena finally established firm political control over Massa Marittima.[11] What, therefore, were the circumstances surrounding the commissioning of these paintings and why were two paintings of such markedly Sienese character introduced into the city at these points in Massa Marittima's political history?

In respect of the earlier painting, a contemporary document throws some light on the circumstances of its commission. Dated 8 January 1316, it records a debate by Massa's Consiglio del Popolo as to how the 'new panel of the Blessed Virgin Mary' could be brought to completion. Stating that there was not sufficient money to pay the expenses of the project, and fearing that further delay might cause damage to what had already been completed, the city's principal magistrates strongly recommended that Master Peruccio, *operaio* of the Opera di San Cerbone – the body responsible for the cathedral fabric in Massa Marittima – should be allowed to lend

118. View of street leading up to the upper town of Massa Marittima.

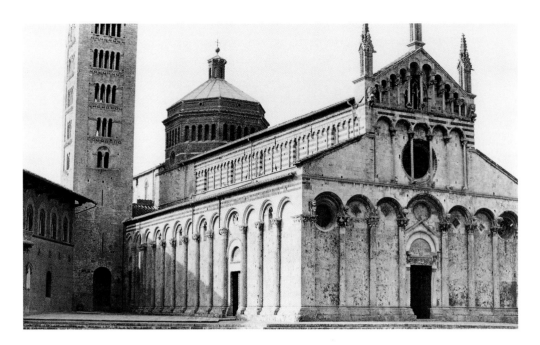

119. The cathedral, Massa Marittima.

the necessary money for making the panel. As a surety for his loan, all the wax offered on the feast of 'Saint Mary in August' would be pledged to Master Peruccio, until he had been paid back all of the money. The council duly agreed to this expedient – with a decisive vote of seventy-five to six.[12]

Although this document only refers to the painting in the most general terms, it is generally agreed that it must refer to the *Madonna delle Grazie* (Pl. 120) – a painting whose provenance, date, and imagery all suggest that it was once part of a double-sided altarpiece for the high altar of the cathedral of Massa Marittima (Pl. 119).[13] Although the commission was initiated by the Commune, its ambitious nature clearly led to the need for its completion by a private individual – albeit a leading member of the cathedral board of works. The motive for the commission is also implicit in the wording of the document. As in Siena, it appears that the annual celebration of the feast of the Assumption was marked at Massa Marittima by the presentation of wax candles to the cathedral. These celebrations undoubtedly involved both the citizens of Massa Marittima and representatives of the city's subject communities,[14] and thus would have closely mirrored the civic ceremonial of both Siena and Pisa.[15] Like Duccio's *Maestà* in Siena cathedral, a Marian altarpiece would have constituted a striking focal point for such civic celebration.

The present condition of this early fourteenth-century painting makes it extremely difficult to determine what the original appearance of the altarpiece would have been (Pl. 120). At some point in its history it was extensively cut down – probably as a result of the drastic remodelling of the high altar in the seventeenth century. Significantly, however, it survived as a cult object within the cathedral. Indeed, its present title – the *Madonna delle Grazie* – strongly suggests that its preservation was the result of its role as a votive object.[16] Much of the painted surface is now entirely lost. All that survives are the figures of the Virgin and Christ Child, together with portions of an elaborately patterned cloth of honour, a circular cushion and the panelling of a marble throne. Comparison between these painted details and those on Duccio's *Maestà* reveals that the Massa Marittima painting is closely modelled upon the Sienese painting (see Pl. 23). Although both figural groups share a common physiognomy, there are also subtle differences between them. Thus, the face of the Virgin on the *Madonna delle Grazie* is less delicately modelled than that of the *Maestà* and there is a marked variation in the relationship between the two figures signalled by the position of their right hands. Instead of grasping the delicate edge of the fabric

120. *The Virgin and Child*, known popularly as the 'Madonna delle Grazie', *c.* 1312–16. Massa Marittima, cathedral.

of his own mantle, as in Duccio's *Maestà*, in the *Madonna delle Grazie* the Christ Child is shown clutching a more clumsily conceived fold of material belonging to the Virgin's mantle. While the architecture of the marble throne appears substantially the same, on the *Maestà*, the Virgin's feet appear firmly placed upon a polygonal marble step, whereas on the *Madonna delle Grazie*, this appears merely as an area of pattern which does little to suggest that the Virgin is seated within a substantial architectonic structure. There are also striking contrasts between the patterns adopted for the cloth-of-honour behind the two cult figures. With its strongly stated contrasts of shape and colour, that of the *Madonna delle Grazie* is more reminiscent of the late thirteenth-century *Rucellai Madonna* than the *Maestà* with its delicate pattern of gilded tracery. Even allowing for the considerable damage done to the painting over the centuries, it is hard to avoid the conclusion that the *Madonna delle Grazie* constitutes a significantly less refined version of the *Maestà*.

That the Massa Marittima altarpiece closely emulated Duccio's *Maestà* is also apparent from the now fragmented Passion series on the rear face of the *Madonna delle Grazie* (Pl. 121). As in the case of the *Maestà*, the largest of these is the *Crucifixion*. Of the other surviving scenes – the majority of which have been extensively cut down – only five can certainly be identified as events immediately preceding or following the Crucifixion.[17] Although the narrative imagery is highly derivative of the *Maestà*, there are a number of subtle variations in terms of both composition and detail. The limitations of the *Madonna delle Grazie* series may best be seen in the *Christ in the House of Annas*. In place of the sophisticated representation of the high priest's palace with its upper audience chamber, staircase, and open courtyards, there is now only an awkwardly conceived architectural setting in which various parts of the building are clumsily juxtaposed.

Given the painting's present condition, reconstruction of the original design of this double-sided altarpiece is extremely difficult. An indication of its dimensions can be derived from the width of the original altar table which survives today as part of the seventeenth-century high altar.[18] This marble altar table measures approximately 300 centimetres and is therefore three times the width of the surviving panel. It would appear, therefore, that the painting has possibly been reduced to a third of its original width (see Pl. 120). Since Duccio's *Maestà* originally measured over 400 centimetres in width (see Pl. 24) this suggests that, even in its complete state, the Massa Marittima altarpiece was always a more modest version of its Sienese counterpart. In place of the twenty-two narrative scenes in the Passion series of the *Maestà*, it probably displayed only nineteen at the most – and quite possibly fewer (Pl. 121, cf. Pl. 44). It undoubtedly also had a predella and pinnacle panels but what their subjects were can only be a matter of speculation.[19]

The document of 1316 describing the difficulties surrounding the production of the *Madonna delle Grazie* remains silent as to the identity of the painter (or painters) working upon it. Given its close dependence upon Duccio's *Maestà*, there is a general consensus that it is a product of Sienese not Massetani workmanship. This is hardly surprising. Although there is abundant evidence of the presence in Massa Marittima of miners and skilled metal-workers,[20] there is little evidence of local painters in the early fourteenth century. Similarly, there is little evidence of local masons and stone-workers, the Massetani having employed Pisan stone-workers to execute much of the construction and embellishment of the cathedral in Massa Marittima.[21] The choice of Siena as a source for painters is entirely explicable. On the one hand, Duccio's *Maestà* provided an example of an altarpiece of unrivalled complexity and sophistication, whilst on the other hand, the political contacts between the city provided a ready means of facilitating such cultural interaction. In 1307, for example, the Massetani renewed their treaty of 1276 with Siena, undertaking to treat

121. (facing page) *Scenes from the Passion, c. 1312–16.* Massa Marittima, cathedral.

Siena's enemies as their enemies and to elect Sienese citizens as their Podestà and principal judge. Between 1308 and 1311, the Sienese acted as mediators between Massa Marittima and the powerful Pannocchieschi family in a territorial dispute, and in 1316, when the Massetani resolved to complete the painting of the *Madonna delle Grazie*, it was a member of one of Siena's leading families, Agnolino Salimbeni, who presided over the debate as Capitano del Popolo.[22]

As to the question of the identity of the painter who executed the *Madonna delle Grazie*, art historians remain divided – some wishing to attribute it to Duccio himself and others to members of his workshop.[23] In respect of the latter consideration, it has also been suggested that it may have been executed by Segna di Bonaventura, a close associate of Duccio. This suggestion receives support from the presence within the cathedral of another early fourteenth-century artefact – a painted crucifix which, in terms of its style, might well have been produced by Segna di Bonaventura.[24] Others see similarities between the painting and the style of Simone Martini.[25] What is apparent from the painting itself, however, is that its painter or painters had an extremely accurate knowledge of Duccio's stylistic and iconographic repertoire in his *Maestà*. Recent technical investigation of the *Maestà* suggests that its execution entailed collaboration between members of Duccio's workshop of an intricate kind, possibly involving as many as three painters working upon a single narrative scene.[26] This implies, therefore, that there were a number of painters in Siena capable of painting all or part of the Massa Marittima altarpiece. Indeed, it is even plausible that the civic authorities of Massa Marittima may have first approached Duccio to supply them with an altarpiece which represented a close, but more modestly conceived, version of his *Maestà*, and that he, while supervising the project – and possibly contributing to its initial design – then entrusted the major part of the work to one or more of his close associates who had themselves worked upon the *Maestà*.

There remains, however, the issue of the original location of the *Madonna delle Grazie* and the significance of this for the choice of imagery for the altarpiece. Given its principal subject and its association with the annual festivities of the feast of the Assumption, it is almost certain that this double-sided altarpiece was produced for the high altar of the cathedral in Massa Marittima. Although it appears that the high altar, like the cathedral itself, was also dedicated to Saint Cerbone, the cult of the Virgin was sufficiently strong within late medieval Italy to make the choice of the *Maestà* theme a popular choice for its embellishment.[27] But why was the double-sided aspect of Duccio's *Maestà* also adopted for the design of this high altarpiece? The east end of the cathedral of Massa Marittima has a spacious chancel which extends out over a steeply sloping site (Pls 122, 123).[28] Significantly, this chancel was not part of the original twelfth-century cathedral building,[29] but belonged to a phase of construction dating between 1287 and 1304 and thus only just over a decade before the probable date of the commission for the *Madonna delle Grazie*. It has also plausibly been suggested, on grounds of style, that this architectural project was completed by Sienese builders and stone-workers.[30] The new chancel provided a large and well-lit area within which the cathedral canons could meet, behind the high altar, to celebrate their daily offices. The similarities between the liturgical arrangements for the cathedrals of Siena and Massa Marittima are thus striking (Pl. 122, cf. Pl. 32).[31] As in the case of Duccio's *Maestà,* the Passion imagery on the rear face of the *Madonna delle Grazie* would once have provided a fitting programme of religious imagery for the cathedral canons (see Pl. 121).[32]

By the early 1320s, therefore, the high altar of the cathedral of Massa Marittima was embellished with an imposing Marian altarpiece which, although more modest in scale, closely resembled that of the high altar of the cathedral of Siena in

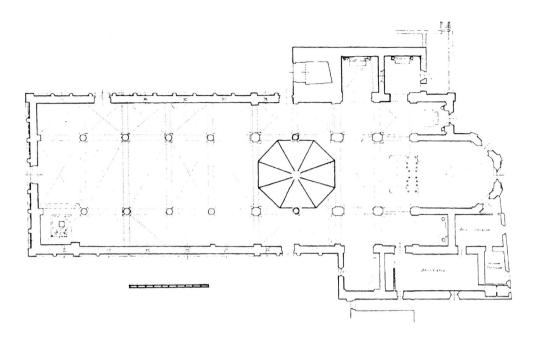

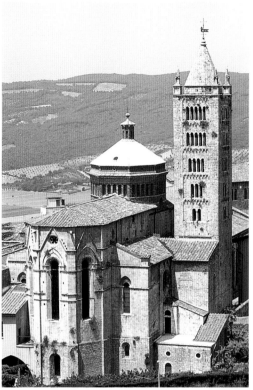

design, subject matter and function. There remains the further interesting question of whether – again like Duccio's *Maestà* – the front face of this altarpiece originally included representations of the city's locally revered saints, Cerbone, Agatha and Lucy.[33] Given the complete loss of the areas on either side of the centrally placed figures of the Virgin and Christ Child, this can only remain a matter of speculation. What is clear, however, is that by 1324 – and thus eight years after the civic authorities were endeavouring to complete this altarpiece – the cathedral was further embellished by a sculpted monument primarily designed to celebrate the identity of Saint Cerbone and the presence of his highly valued relics within the cathedral.

This monument took the form of marble tomb, or *arca*, which is presently housed in the chancel lying behind the high altar (Pl. 124).[34] As common to its sculpted type, the *arca* comprises a relatively simple design of a rectangular chest with a steeply-inclined gable lid. Its appearance, however, is rendered distinctive by an extensive

122. Plan of Massa Marittima cathedral.

123. Massa Marittima, cathedral, view of the exterior of the east end and chancel.

124. Goro di Gregorio, the *Arca* of Saint Cerbone, 1324. Massa Marittima, chancel of the cathedral.

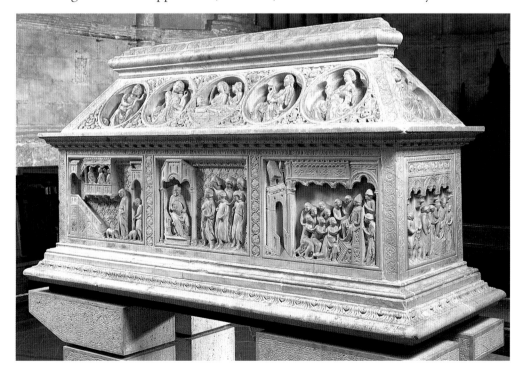

125. Goro di Gregorio, *The Virgin and Child*, roundel on the lid of the *Arca* of Saint Cerbone.

126. Goro di Gregorio, *Angels Mourning the Death of Saint Cerbone*, detail of Pl. 124.

127. Goro di Gregorio, *The Journey of Saint Cerbone to Rome*, reliefs on the *Arca* of Saint Cerbone.

series of carved reliefs, all of which are framed by decorative detail, giving it the appearance of an intricately worked reliquary, an impression which would also have been further enhanced by its original polychromy.[35] On the lid appear twelve carved roundels, ten of which house single angels, saints or prophets. On one side, the central roundel displays an image of the Virgin and Child (Pl. 125) and on the other, an image of Saint Cerbone lying on his bier with two mourning angels in attendance (Pl. 126). On the sides of the chest are a series of eight narrative reliefs. Beginning at the extreme left side of the *arca* over which the roundel of Saint Cerbone presides, a detailed narrative of the saint's legend unfolds in an anti-clockwise direction.[36] The first scene shows the sixth-century saint miraculously taming the bears to whom he had been thrown by the barbarian leader, Totila, the king of the Ostrogoths, as punishment for sheltering Roman soldiers. The next scene shows the saint, as Bishop of Populonia, seated in his *cathedra*, refusing the request of his congregation that he not celebrate mass before dawn. Thereafter follow scenes of the congregation's appeal to Pope Vigilio, the papal ambassadors requesting Cerbone that he go to Rome, two miraculous acts of charity performed by him on his journey there, his audience with

The Contado

the Pope, and his concelebration of mass with the Pope where the Pope has the same heavenly vision as the saint had been experiencing at his pre-dawn masses. Although, due to the exigencies of carving in relief, these narrative scenes are restricted to shallow architectural settings and the representation of a few key figures, they nevertheless display great ingenuity and imagination on the part of the sculptor (Pl. 127). It is also clear that the sculptor was at some pains to communicate significant points of hagiographic detail. Thus, in the scene of the saint's meeting with Pope Vigilio, not only is Cerbone's highly idiosyncratic gift of a flock of geese prominently portrayed (a gift which subsequently became the saint's principal emblem), but he also chose to represent Pope Vigilio as standing before his papal throne (Pl. 128). This detail corresponds closely to the saint's hagiography where the Pope's action is cited as a mark of respect for Cerbone's saintliness and as the origin of the tradition whereby later popes customarily stood when meeting the bishops of Populonia (of whom the bishops of Massa Marittima were direct successors).[37]

Unlike the early fourteenth-century high altarpiece, no contemporary document survives concerning the commissioning of the *arca*. An inscription, however, below the narrative scenes of Saint Cerbone's journey to Rome states that: 'In 1324, in the seventh interdict, Master Peruccio, *operaio* of the church, had this work made by Master Goro di Gregorio of Siena'.[38] This inscription, which would have been located on the front — and therefore most public face — of the *arca* indicates clearly that the same *operaio* who had offered to finance the completion of the high altarpiece also secured the execution of the sculpted monument.[39] Once again, therefore, a major commission for a work in the cathedral of Massa Marittima was given to a

128. Goro di Gregorio, *The Arrival of Saint Cerbone in Rome and the Saint's Audience with Pope Vigilio*, detail of Pl. 124.

129. Goro di Gregorio, the tomb monument of Guglielmo di Ciliano, 1320s. Siena, Università degli Studi, Cortile del Rettorato.

Sienese artist although in this case relatively little is known of Goro di Gregorio himself. In 1311–12, he is recorded as a property owner in Siena.[40] His father was probably Goro di Ciuccio Ciuti from Florence who, as a master-carver working for the Opera of Siena cathedral, applied for Sienese citizenship in 1272.[41] It is likely that his father's work for the cathedral of Siena was an influential factor in Goro being awarded a commission for the cathedral of Massa Marittima. Apart from Massa Marittima, his principal work appears to have been in Pisa, in 1326, and Sicily in the 1330s.[42] A sculpted relief in Siena, attributed to Goro di Gregorio and dated to the 1320s, provides an indication of the skills the commissioners for the *arca* were seeking to secure. Originally part of the funerary monument of Guglielmo di Ciliano, a celebrated jurist, Rector of Siena's university and ambassador to the Commune between 1318 and 1324, it depicts a medieval university lecturer (probably Guglielmo himself) teaching his pupils (Pl. 129).[43] As on the *arca* itself, the relief reveals both Goro's competence as a marble-carver and his lively approach to the portrayal of specific individuals grouped within generalised settings.

Until its removal in 1950, the *arca* was located on the pavement of the cathedral below the high altar table (Pl. 130).[44] Long before 1950, however, its original design and setting had been substantially altered. In order to support the weight of Flaminio del Turco's Baroque sculpted altarpiece of 1626–8, the back of the altar itself had to be closed. This meant that one side of the *arca* was no longer visible. It also appears that when the *arca* was installed under the newly fashioned high altar, the narrative reliefs at the foot and head of the *arca* were reversed, thus interrupting the logical flow of the narrative.[45] As early as 1904, the local historian, Luigi Petrocchi, was complaining about the difficulty of viewing the *arca* and its reliefs in such a location,[46] and in an earlier publication in 1900, he also claimed that the *arca*, supported on eight columns, originally stood on the high altar and was surrounded by twelve statues of apostles, eleven of which survive today.[47] Such an arrangement, however, would not

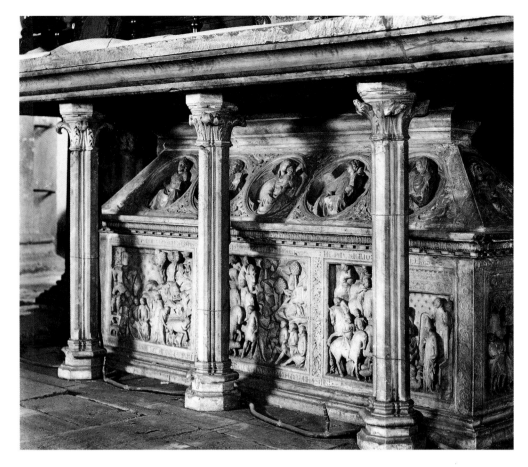

130. The *Arca* of Saint Cerbone in its position under the cathedral high altar prior to its removal in 1950.

only have been highly unorthodox but would also have obscured the recently completed high altarpiece. On these grounds, therefore, later art historians have suggested that the *arca* was always intended to be housed under an open-sided altar table,[48] and that the eleven statues should not be associated with the *arca* but rather with the newly completed canons' choir behind the high altar.[49] A location below the high altar would, however, have obscured the narrative reliefs on the *arca* and its intricate decorative detail, whereas it is clear that the *arca* was designed as a free-standing object intended to be seen from all four sides.[50] Indeed, the composition of the majority of the reliefs, with their lack of a central focus, would have encouraged the spectator to move around the *arca* viewing it in a circular, sequential order. A site under the high altar would have made such a process impossible and, moreover, such a sacrosanct location would also have made the *arca* less accessible to pilgrims, whose presence in Massa Marittima is amply attested by the existence, in the medieval period, of the Ospedale di San Cerbone, adjacent to the cathedral.[51]

Although monuments commemorating saints and *beati* represented a highly versatile sculptural type in late medieval art, the closest analogy to the *arca* of Saint Cerbone is that of the free-standing monument supported on piers or columns – the latter often embellished with caryatid figures (Pl. 131).[52] Such a design allowed for maximum visibility of the *arca* and also enabled devotees to touch it, thus benefiting from the supposed thaumaturgic properties of the relics contained within it (Pl. 132). A significant thirteenth-century precedent for an *arca* of this type was that containing the relics of Saint Dominic in San Domenico, Bologna, completed in 1267 to Nicola Pisano's design by members of his workshop.[53] If, like the Bolognese monument, the *arca* of Saint Cerbone was indeed a free-standing object supported on columns (such as those that currently support the high altar table[54]), where could it have been situated? One location which could easily have accommodated a free-standing monument would have been the newly-built crypt.[55] The crypt, however,

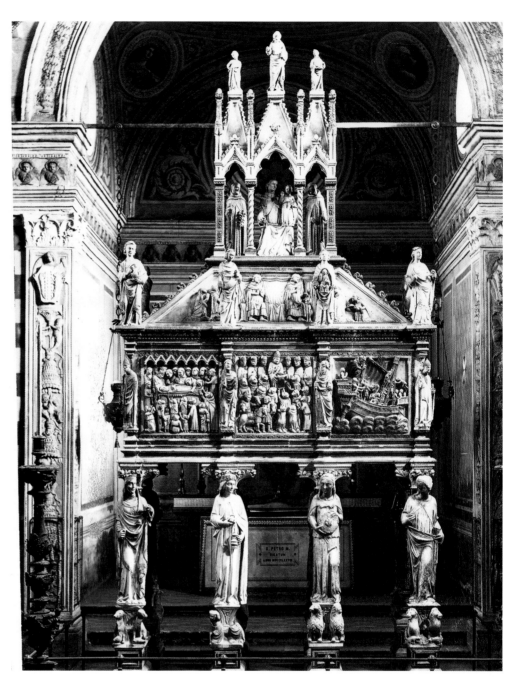

131. Giovanni di Balduccio, the *Arca* of Saint Peter Martyr, 1339. Milan, Sant'Eustorgio.

is only accessible by a narrow flight of stairs connecting it with the chancel above. It could not, therefore, easily have accommodated a steady flow of pilgrims in and out of it. It also appears from the *arca* itself that it was designed to facilitate two kinds of visual scrutiny. The first encourages the spectator to view the *arca* beginning at the left-hand corner of the side surmounted by the roundel of Saint Cerbone, and then proceed in an anti-clockwise direction, examining the reliefs in their correct narrative order. The second involves viewing the *arca* from the side surmounted by the roundel of the Virgin and Child and bearing the inscription indicating the sculptor, patron and date of execution – an inscription designed to draw attention to the monument itself and the circumstances of its commissioning. Given that the *arca* was thus apparently designed to be viewed from both sides and with access to its entire narrative sequence, it therefore seems likely that it was originally located somewhere in the body of the cathedral, in front of the choir screen, and in a space which would have allowed pilgrims and devotees to approach it without difficulty.

By the end of the 1320s, therefore, the cathedral of Massa Marittima had received two impressive additions to its fabric – a monumental, double-sided altarpiece and a tomb monument honouring the city's patron saint. For the civic and ecclesiastical authorities of Massa Marittima, these commissions must have represented a fitting conclusion to the extensive remodelling of the east end of their cathedral. More specifically the imposing image of the Virgin and her son accompanied by other holy figures would have provided a visually compelling focal point not merely for the celebration of masses that took place at the high altar on major feast days but also for the solemn civic celebration which marked the feast of the Assumption (see Pl. 120). The Marian imagery of the altarpiece was reiterated upon the front face of the *arca* of Saint Cerbone where the central roundel on the lid represents a particularly tender and evocative image of the Virgin's maternal role (see Pl. 125). Within the more exclusive area of the canons' choir, an intricate programme of eucharistic imagery relating to the Passion of Christ would also have been on display (see Pl. 121), whilst in the public area of the cathedral itself would have been the *arca* of Saint Cerbone, an artistic monument which commemorated the identity and sanctity of Massa Marittima's own patron saint and celebrated the presence of the saint's relics within the city's principal church (see Pl. 124).[56]

In the years immediately after the city's submission to Siena in 1335, another Sienese painter, Ambrogio Lorenzetti, also executed an altarpiece for Massa Marittima. Like the cathedral high altarpiece, it too depicted the *Maestà* theme (Pl. 133). Now housed in the city's municipal museum (itself the former palace of the

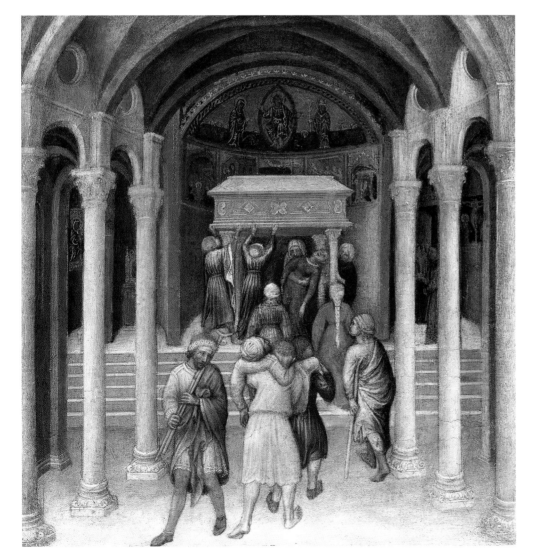

132. Gentile da Fabriano, *Pilgrims at the Arca of Saint Nicholas of Bari*, 1425. Washington D.C., National Gallery of Art, Samuel K. Kress Collection.

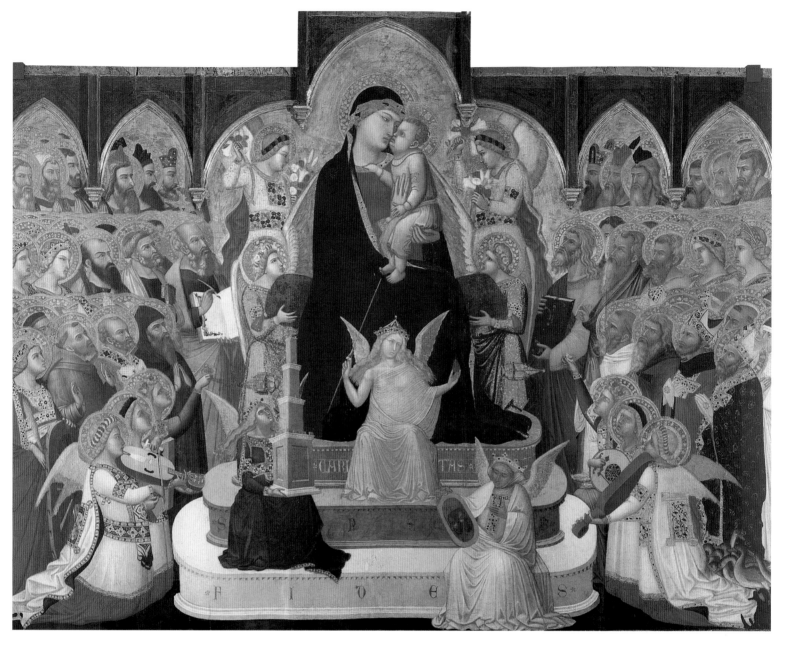

133. Ambrogio Lorenzetti, *The Maestà, c.*
1335–7. Massa Marittima, Palazzo Podestà,
Museo Civico.

Podestà), the circumstances of its original commission and location are by no means
secure. Accounts in early twentieth-century local histories describe the painting's dis-
covery in 1867 in the priory of the Augustinian Hermits in the upper city or *città
nuova*.[57] Although initially and mistakenly associated with the document of 1316
(now rightly associated with the *Madonna delle Grazie* and the high altarpiece of the
cathedral), it has been proposed that this painting was originally commissioned for
the Augustinian church of Sant'Agostino in Massa Marittima, specifically for the
high altar.[58] There is, however, an alternative interpretation of the available evidence.
Although the foundation stone for the church of Sant'Agostino was laid in 1300, a
surviving contract awarded to two stone-workers strongly implies that in 1348 the
east end of the church still had to be completed (Pl. 134).[59] It appears, therefore, that
the church of Sant'Agostino was then still a building site and, although it was not
unknown for altarpieces to be commissioned in such circumstances – the Marian
narrative altarpieces of Siena cathedral being a case in point – the 1330s would not
have been a propitious time for the painting of a new high altarpiece for the
church.[60] The historical circumstances surrounding this painting and its commission
require, therefore, further scrutiny and evaluation.

The earliest description of the painting occurs in Ghiberti's *Commentaries* where the Florentine sculptor, writing in the mid-fifteenth century, briefly refers to a '*tavola*' and 'chapel' painted by Ambrogio Lorenzetti in Massa Marittima. The reference to a 'chapel' strongly suggests that the painter executed not only a panel painting but also a series of frescoes within one of the city's churches. Vasari, in his 1550 and 1568 editions of the *Lives*, elaborated slightly on Ghiberti's information, claiming that Ambrogio – working with others – executed a chapel in fresco and a panel painting in tempera.[61] Thereafter, references to Ambrogio Lorenzetti's work in Massa Marittima apparently disappear from the records until the nineteenth century.

Turning to the painting itself and its present condition, it is clear that what survives is only the main panel of a multi-tiered composite structure (Pl. 133). Nothing now survives of its predella, pinnacle panels, framing piers and pinnacles.[62] Despite its reduced state, however, the painting still presents a remarkably powerful treatment of the *Maestà* theme and – although clearly owing a debt to both Duccio's and Simone Martini's treatments of this subject – includes many highly innovatory features within its pictorial design. Like its two prototypes, the central figure of the Virgin is portrayed as both a tender and loving mother and as a queen presiding over the celestial court.[63] Indeed, this *Maestà* is distinguished further by an even more impressive number of accompanying saints – anticipating later fourteenth-century paintings of the *Coronation of the Virgin*.[64] Within the tightly ranked tiers of figures appear the four evangelists, Saints Peter and Paul, other apostles, Old Testament prophets, the founders of religious orders – including Saints Francis and Benedict – and bishop saints, such as Saint Nicholas of Bari. On the outer edges of the painting appear a number of female saints representing either youthful Christian martyrs, for example Saint Catherine of Alexandria, or the founders of female religious orders such as Saint Claire of Assisi.[65]

Amongst this throng of saints, two stand out as of particular significance. In the right-hand foreground – and thus in a position of some prominence – is Massa Marittima's patron saint, Cerbone, with his flock of geese (see Pl. 116). The episcopal vestments of the figure beside him prompted earlier art historians to identify him as Saint Cerbone's companion, Saint Regolo.[66] However, since this bishop saint wears the black habit of the Augustinian Hermits beneath his cope, he is more likely to

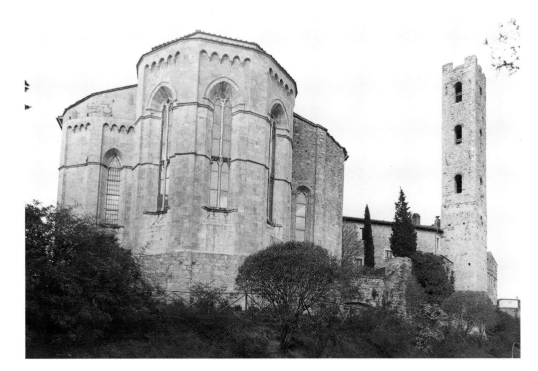

134. Massa Marittima, Sant'Agostino, view of exterior of the east end of the church.

represent Saint Augustine, the reputed founder of this mendicant order. To the left of this figure of Saint Augustine, appears Saint Anthony Abbot, an eremitical saint particularly venerated by the Augustinian Hermits. This group of figures therefore constitutes important visual evidence that the painting was executed not only for a church in Massa Marittima but also that it may, indeed, have been intended for an Augustinian church in that city.[67]

In the foreground of the painting appear three further female figures. Strikingly absent from both Duccio's and Simone Martini's treatment of this subject, the inclusion of these figures is a markedly novel feature of the painting's design and iconography. From the inscriptions written on each of the steps on which they are seated, they can be identified as the three theological virtues, Faith, Hope and Charity. The prominent position of Charity within the painting's design cleverly underlines and dramatises the Church's teaching on the supremacy of charity as endorsed by Saint Paul's canonical biblical text: 'And now abideth faith, hope, charity, these three, but the greatest of these is charity' (I Corinthians 13, 13). The figure, with her classicising robe of transparent texture and attributes of a javelin and burning heart, provides further compelling evidence of Ambrogio Lorenzetti's interest in classical art – an interest expressed in other examples of his work (Pl. 135). As one modern scholar of iconography has argued, by giving his figure of Charity a burning heart, Ambrogio Lorenzetti appears to be deliberately associating this Christian personification with the classical figure *Amor*/Love.[68] Given the painting's religious subject, such an association would have signified not secular love but rather the love of God. Hope, with her up-turned head, meanwhile, is portrayed in a characteristic pose of late thirteenth-century and early fourteenth-century representations of this figure (see Pl. 133). Her striking attribute of a tall, four-storied tower, is, however, much more unusual. Lacking obvious visual prototypes, the meaning and significance of this particular detail will be discussed in further detail below.[69] The figure of Faith, meanwhile, is shown pointing emphatically towards a mirror that she is holding (Pl. 136). Close examination of this painted detail reveals that originally its surface was covered in silver leaf. This has now oxidised with age leaving only the red bole ground onto which it was originally laid. The mirror still shows, however, a head painted in monochrome and shown with two profiles. It also reveals traces of a white dove once painted above this two-headed figure.[70] It appears, therefore, that on Faith's mirror would once have appeared an image of the complex theological concept of the Trinity. Furthermore the mirror, its burnished silver surface, and the image of the Trinity upon it would have provided a highly ingenious visualisation of another metaphor from Saint Paul's canonical text on the three theological virtues: 'for now we see through a glass, darkly, but then face to face' (I Corinthians 13, 12).[71]

As acknowledged above, the prominent presence of Saint Augustine amongst the company of saints might suggest that this *Maestà* was, indeed, executed for the church of the Augustinian Hermits in Massa Marittima, yet, as has also been noted, it appears that the church of Sant'Agostino was not completed at the time when the painting was executed. Sant'Agostino was not, however, the only church owned by the order in Massa Marittima.[72] The order also had control over a much earlier twelfth-century church located in close proximity to the priory and its fourteenth-century church (Pl. 137). Originally belonging to the bishop of Massa Marittima who, until 1336, resided in the castle of Monteregio in the *città nuova*,[73] the church was known as San Pietro all' Orto – presumably a reference to the bishop's gardens in its vicinity. In 1273, the current bishop of Massa Marittima donated the church to the Augustinian Hermits – an order then in the process of establishing itself within the city.[74] In the 1330s when the painting was commissioned and the priory's new church still incomplete, San Pietro all'Orto was probably still functioning as the

principal church of the Augustinian Hermits. Now the headquarters of the Terzo di Città Nuova, the interior of San Pietro all'Orto has been greatly altered over the centuries. A number of late thirteenth- and early fourteenth-century frescoes still survive, however, one of which is a remarkably early representation of Nicholas of Tolentino, an Augustinian Hermit who was not, in fact, canonised until 1446.[75] On stylistic grounds, none of these frescoes appear to be by Ambrogio Lorenzetti. It is significant, however, that both Ghiberti and Vasari stated that the Sienese painter executed frescoes in Massa Marittima. If the *Maestà* was commissioned for San Pietro all'Orto, the frescoes executed by Ambrogio and his associates may have been located in the east end of the church – the part of the building most extensively altered during its later history.[76]

As a panel painting, Ambrogio Lorenzetti's *Maestà* could have been brought to the priory at any date in its long history (see Pl. 133). The painting itself, however, provides strong circumstantial evidence that it was, in fact, originally painted for the church of San Pietro all'Orto.[77] Its dimensions would have made it an appropriate size for the main panel of an altarpiece for the high altar of San Pietro all'Orto – a church which was relatively modest in scale, when compared for example to Sant'Agostino. Its subject – the *Maestà* – was one generally favoured for high altarpieces at that date. More specifically, the choice of Saints Paul, Peter and John the Evangelist as the saints who take up the most prestigious position in relation to the Virgin and her son would have been particularly appropriate for an altarpiece over the principal altar of San Pietro all'Orto. An inscription set above the principal entrance of the church records the building's foundation in 1197 and its dedication to Saints Peter, Paul and John.[78] The painting's particular emphasis upon these three apostles thus complements the dedication of the church to these three saints. The order of Augustinian Hermits under whose care San Pietro all'Orto resided were, meanwhile, commemorated by their founder, Saint Augustine. In addition, the church's early ownership by the bishop of Massa Marittima and the debt of the Augustinian Hermits to the bishop for the donation of the church is commemorated by the twinning of Saint Augustine with Saint Cerbone, the titular saint of the bishop's cathedral.

A number of other iconographic details in the painting also make it particularly appropriate as an altarpiece for an Augustinian church. Saint John the Evangelist is shown with an open book and a dramatically poised pen thus underlining his role as the writer of the fourth gospel (Pl. 138). The ornament on the margin of the book constitutes a highly decorated 'I' executed in blue, pink and gold. 'I' is the first letter of the opening verse of John's Gospel which, in the original Latin of the Vulgate reads: 'In principio erat verbum' ('In the beginning was the Word'). This text is replete with theological significance, especially in relation to the doctrine of the Incarnation and the concept of Christ as the 'Logos' or word of God incarnate. Given the proximity of this text to the Christ Child within the painting, it appears that this initial was included not merely to identify Saint John the Evangelist but also to signify the crucial theological import of the biblical text to which it referred.[79] Although a preoccupation of most major theologians of the early Christian church, Saint Augustine, in particular, devoted a great deal of his writing to the complex theological issue of the Logos and its relationship to the Trinity. In so doing, he had frequent cause to analyse in detail the meaning and significance of the first verse of John's gospel.[80] The inclusion of Faith, Hope and Charity within the painting's design may also constitute a further pictorial reference to key texts in Augustine's theological work (see Pl. 133). It has been shown that Augustine's theological thought was arguably highly formative for the pictorial tradition of representing Charity as a personification of the love of God.[81] In addition, two key passages from

Following pages:

135. Ambrogio Lorenzetti, *Charity*, detail of Pl. 133.

136. Ambrogio Lorenzetti, *Faith*, detail of Pl. 133.

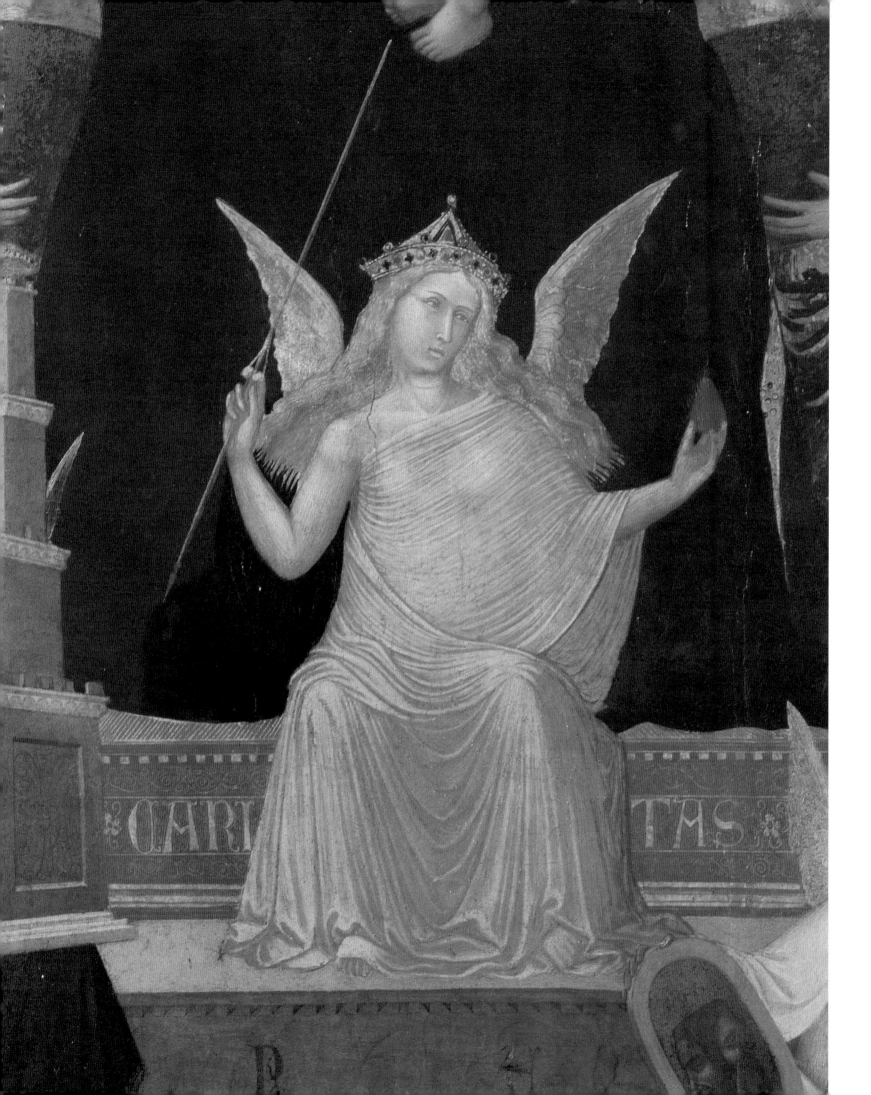

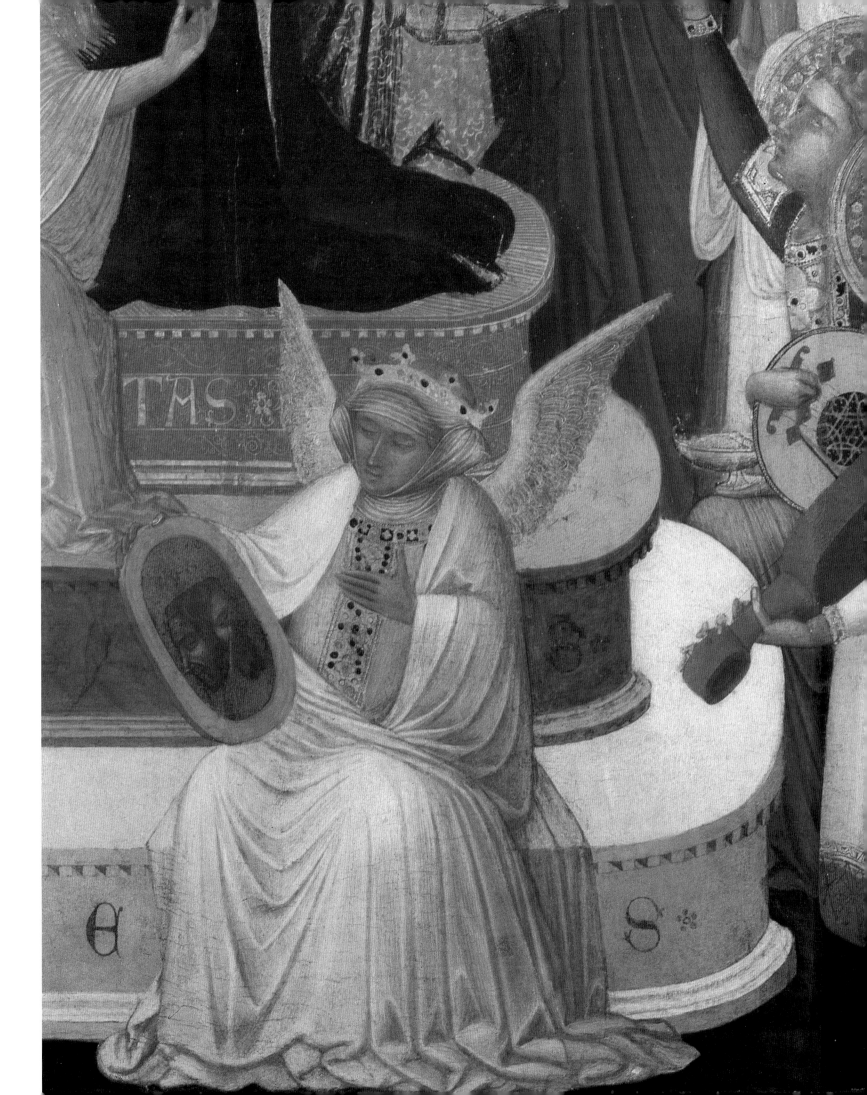

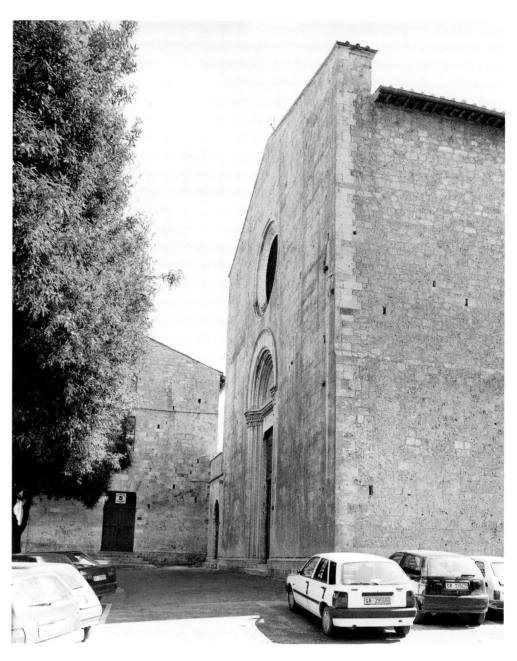

137. Massa Marittima, San Pietro all'Orto (on the left) and Sant'Agostino (on the right).

138. (facing page) Ambrogio Lorenzetti, *Saint John the Evangelist*, detail of Pl. 133.

Augustine's writings also furnish an explanation for the distinctive attributes given to Faith and Hope in the painting. In his treatise on the Trinity, where he is expounding on the significance of the first verse of John's gospel, Augustine uses the image of the mirror to convey to his readers how faith can assist in their comprehension of the divinity of Christ.[82] In his treatise on John's gospel, meanwhile, again when considering its first verse, Augustine makes an analogy between the Word of God and the design of a great building.[83] Finally, in a short didactic treatise entitled the *Enchiridion*, Augustine discusses Faith, Hope and Charity at length, linking these three virtues with both the first verse of John's gospel and his views on the Trinity.[84]

Although it is unwise to attempt to establish too specific a relationship between a number of comparatively simple and concrete pictorial details and the complex and varied body of Augustine's theological writing, there is also a compelling piece of local historical evidence to suggest that Augustinian learning may well have exerted a significant influence upon the iconography of this painting. In an inventory of the library of the priory of Sant'Agostino at Massa Marittima, compiled in 1317, one of the entries is for a copy of Augustine's *Enchiridion*, the work in which Augustine

The Contado

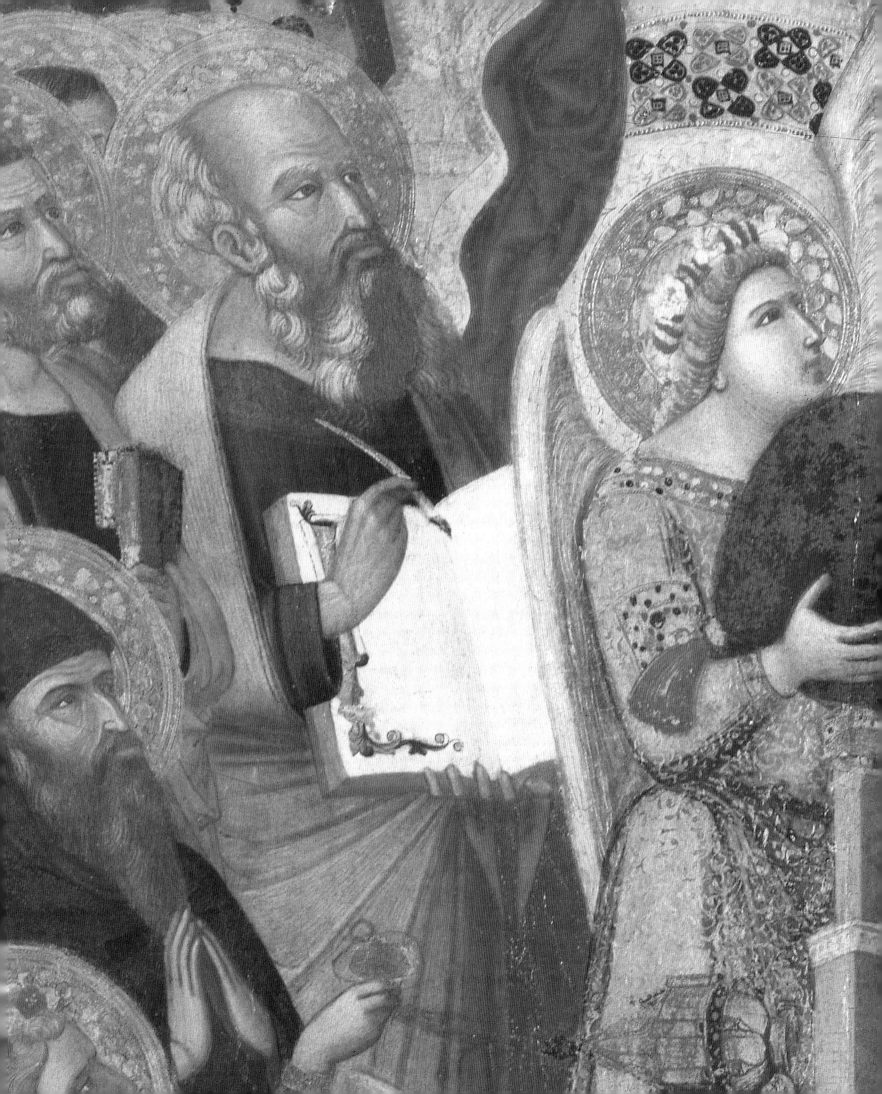

discusses in detail the religious significance of the three virtues who feature so prominently – and so uniquely – in this *Maestà* painting.[85] There is, therefore, a substantial cumulative case for the probability that Ambrogio Lorenzetti's Massa Marittima *Maestà* was for the original church of the Augustinian Hermits in that city and that it included innovative iconographic details precisely in order to address theological themes with which their Order and their own library were likely to have made them familiar.

By virtue of its emulation of two of Siena's most important civic Marian images, Ambrogio Lorenzetti's *Maestà* provides another striking example of Sienese artistic and cultural influences being imported into Massa Marittima. Although a common enough subject in late medieval religious art, the *Maestà* theme constituted a particularly 'Sienese' choice by virtue of the fact that the Sienese venerated the Virgin as their most revered saint. Moreover, by adopting her as their 'governor', the *Maestà* theme had taken on strong political overtones for the Sienese as well. The introduction of an altarpiece portraying the *Maestà* theme so soon after Massa Marittima's incorporation into the Sienese state, may, therefore, have constituted an example of self-conscious propaganda on behalf of the Sienese, as well as an innovative response to the specific interests of the Augustinian Hermits.[86] In the absence of documentary evidence on the matter, the financing of a new high altarpiece for San Pietro all'Orto must remain a matter of speculation. The cost may have been borne by a prominent Massetani family such as the Galliuti or Ghiozzi who, as adherents of the Sienese cause in Massa Marittima, wanted to endear themselves to the city's new governors.[87] Alternatively, it may have been the result of an initiative of one of the Sienese officials sent to police Massa Marittima from the newly constructed fortress.[88] There is considerable evidence, however, that the embellishment of a high altar was closely controlled and supervised by the religious order under whose care the church resided.[89] Given the intensely Augustinian nature of the painting's imagery, it seems highly likely, therefore, that the local community of Augustinian Hermits also played a seminal role in the history of this commission and its award to Ambrogio Lorenzetti.[90]

Between the second and fourth decades of the fourteenth century Massa Marittima thus received three impressive works of art all commissioned from Sienese artists. At one level, such a choice can be accounted for by the apparent lack of indigenous artistic skill. It was also undoubtedly a consequence of the reputation for artistic excellence that Sienese artists enjoyed in the early decades of the fourteenth century.[91] The three works of art also, however, constitute an index of Siena's increasing political and cultural control over Massa Marittima at this time. Even before Massa Marittima's act of submission to Siena in 1335, Sienese artists were given the highly prestigious commissions for the embellishment of the city's most sacred location, that of the high altar of the cathedral. After the submission of 1335, another Sienese painter, Ambrogio Lorenzetti, received a commission for an altarpiece of the *Maestà*, and possibly also for a series of frescoes. The choice of the *Maestà* theme, moreover, suggests that, by that date, Sienese cultural and political influence in Massa Marittima was sufficient to enable the commission of an altarpiece which, however adapted to the needs of the Augustinian Hermits of Massa Marittima, remained, nevertheless, a representation of a subject with strongly Sienese devotional and political connotations.

The fact that this altarpiece was, indeed, commissioned for the high altar of the church of the Augustinian Hermits in Massa Marittima is also of significance, however, for the Augustinian Hermits themselves provide another striking example of a further means by which Sienese art was disseminated from Siena to the city's subject territories. Organised in a pyramidal structure with a network of houses throughout

139. Goro di Gregorio, *Saint Cerbone's Geese and Travelling Companions*, detail of Pl. 128.

Tuscany, and with lesser houses such as the priory of Sant'Agostino in Massa Marittima owing their allegiance to major houses such as Sant'Agostino in Siena, the Augustinian Hermits provided an ideal conduit along which such cultural exchanges could be effected.

7

San Leonardo al Lago

Most of the cities and towns of the Sienese *contado* boasted the presence of church-
es belonging to one or other of the mendicant orders. Thus major towns such as
Massa Marittima, Montalcino and Montepulciano had at least two, if not more, such
houses belonging to the principal mendicant orders and even a relatively small vil-
lage, such as Corsignano, had a Franciscan church and friary (see Pl. 7). It appears,
however, that the Augustinian Hermits were particularly influential in Siena's *conta-
do* and thus, in the context of the present study, constitute an important case-study
in their own right. There had long been intense eremitical activity both within Siena
itself and the surrounding countryside. Hermits inhabited both the subterranean
grottoes which still honeycomb Siena's urban fabric and also cells attached to the
city's churches, monasteries, priories, convents and gateways. Their support by Siena's
citizens was actively encouraged by the government in the city statutes,[1] and hermits
were frequently the objects of testamentary bequests. Thus in 1307, the wealthy
Tavena di Deo Tolomei left a generous bequest of 100 *lire* to the male and female
hermits of the city and outskirts of Siena.[2] The *contado* proper, meanwhile, was popu-
lated by hermits who – following a long-established Christian tradition – sought to
withdraw from the distractions and temptations of urban life.

The expansion of the eremitical tradition in the Sienese territories can also be
identified closely with the history of the order of the hermit friars of Saint
Augustine. Thus, in an initiative to organise and regulate the myriad communities of
hermits within thirteenth-century Tuscany, in 1243 Pope Innocent IV directed that
all Tuscan hermits, with the exception of the Guglielmiti,[3] should group together
and, with a Prior General of their choice, adopt the rule of Saint Augustine. Between
1244 and 1250, sixty-one such hermitages united to form the order of the hermit
friars of Saint Augustine. This development was further consolidated when, in 1256,
Pope Alexander IV promulgated an act of General Union binding upon the new
order.[4] The Augustinian Hermits received the recognition and active support of the
Sienese government[5] who undoubtedly saw the order as a means by which they
could further control and administer their subject territories. Indeed, the predomi-
nantly south-westerly disposition of the order's principal rural hermitages corre-
sponded closely to the line of Siena's territorial expansion towards the Maremma
and the sea[6] – a campaign of expansion that included the political control and final
submission of Massa Marittima.

140. Lippo Vanni, *The Betrothal of the Virgin,*
c. 1360–70, south wall of the chancel, San
Leonardo al Lago.

141. Francesco Vanni, Sant'Agostino on the southern outskirts of Siena, detail of *Sena vetus civitas Virginis*, *c.* 1600. Siena, Archivio di Stato.

One of the principal acts of support by the Sienese Commune to the new order of the Augustinian Hermits was the aid given towards the construction of a new church and priory within Siena itself. Replacing a much smaller establishment near the Porta Laterina, the imposing church and priory of Sant'Agostino was founded in 1259 on the southern outskirts of Siena just outside the Porta all'Arco, a gateway belonging to the twelfth-century circle of city walls (Pl. 141). The church, finished circa 1310, became one of the city's principal churches, receiving financial subsidies from the communal authorities.[7] It also attracted the patronage of some of the city's leading families including that of both the Tolomei and the Pannocchieschi d'Elci – two families that enjoyed close contacts with Massa Marittima.[8] By 1312, the priory had also attained the status of being the seat of a *studium*,[9] and in 1338, it hosted the General Chapter of the order.[10]

As the principal house of the Augustinian Hermits in Siena, the priory of Sant'Agostino maintained close links with other houses in the surrounding countryside. Thus, in the case of Massa Marittima, for example, it appears that in 1317 the prior of Sant'Agostino in Massa was Fra Michele Nucci from Siena.[11] In 1327, another prior of the priory of Massa Marittima agreed to act as guardian of a considerable amount of money belonging to the Mariscotti family of Siena and earmarked for the purchase of the castle of Montalbano from Manuello, Gaddo and Guglielmo dei Pannocchieschi d'Elci.[12] The son of Gaddo dei Pannocchieschi d'Elci was later buried in the church of Sant'Agostino in Siena.[13] In 1337, a friar, Fra Pietro di Ciampoli from Massa Marittima made his profession to the Prior Provincial in the sacristy of Sant'Agostino in Siena.[14] Given such close contacts between the two priories, it is highly likely that the Augustinian Hermits of Siena were fully aware of the commission for an altarpiece awarded to Ambrogio Lorenzetti by their brother friars in Massa Marittima. Indeed, further circumstantial evidence of such awareness is provided by a frescoed *Maestà*, now attributed to the painter, which still survives today in Sant'Agostino, Siena (Pl. 142).[15]

Located within the former chapterhouse,[16] this frescoed *Maestà* was once part of a fresco scheme which, on the reliable testimony of Ghiberti, also included frescoes of the Crucifixion, Saint Catherine of Alexandria before the Emperor Maxentius in the temple, Saint Catherine disputing with the philosophers and, in the vault, the Apostles' Creed.[17] Although different in terms of their figural compositions, there are a number of striking iconographical similarities between the two *Maestà* (Pl. 142, cf. Pl. 133). Thus in both paintings, the Virgin is shown upon a throne made of seraphim, the highest order in the hierarchy of angels. As appropriate to their Augustinian contexts each painting includes amongst its company of saints, the order's founder, Saint Augustine, and the hermit saint, Anthony Abbot.[18] Saint Catherine of Alexandria also features in both paintings – in the Sienese painting, as the prominent figure in the left-hand foreground proffering her decapitated head to the startled Christ Child, and in the Massa Marittima painting, as one of the early Christian virgin martyrs on the left-hand side of the composition. Although her presence in the Siena painting can be accounted for by her status as the likely titular saint of the chapterhouse, this early Christian martyr was highly venerated by the Augustinian Hermits who valued her reputation as a saint who embraced both human and God-given wisdom.[19]

It has plausibly been argued that the fresco scheme for the chapterhouse was completed in time for the General Chapter of the order which was held there in 1338 and that, accordingly, its execution should be dated to between 1335 and 1338.[20] That being the case, it is highly likely, therefore, that Ambrogio Lorenzetti and his workshop were executing both Augustinian commissions at broadly the same time. One further piece of iconographical evidence links the two painting commissions together. As already indicated, the vault of the chapterhouse was once embellished with the

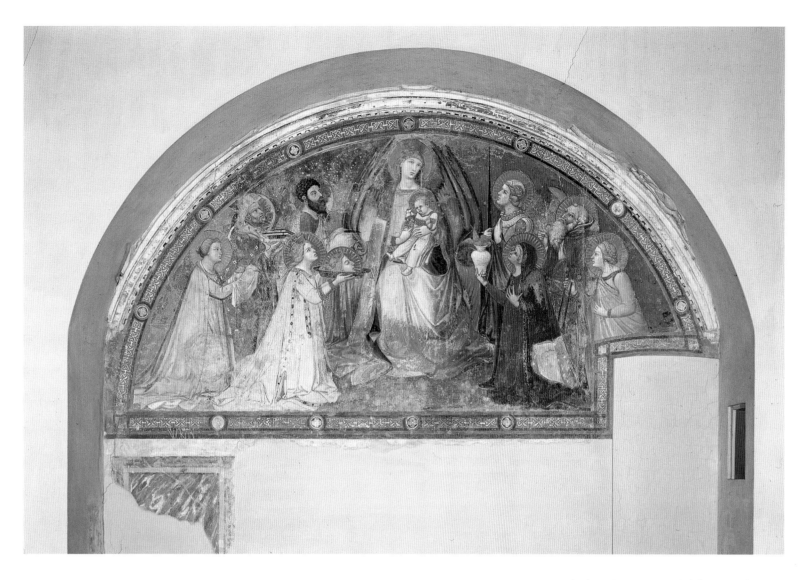

articles of the Creed.[21] Given its site within a chapterhouse such pictorial expression of the Church's definition of belief and doctrine would be entirely appropriate.[22] The Apostles' Creed also informs the iconography of the Massa Marittima altarpiece, however, albeit less explicitly. As already noted, an explanation for the prominent presence of the three theological virtues in the painting can be found in Saint Augustine's *Enchiridion*, a text in which he expounds at length on the significance of each of these virtues for the Christian believer. Significantly, in his long treatment of Faith, Augustine organises his material precisely around each of the articles of the Apostles' Creed.[23] This apparent preoccupation with the Creed, which finds pictorial expression in both chapterhouse and altarpiece, strongly suggests that, in the case of both commissions, Ambrogio Lorenzetti received instructions and advice from an Augustinian theologian, possibly one attached to the *studium* of Sant'Agostino in Siena.

Some thirty-five years after the commission to Ambrogio Lorenzetti for the Massa Marittima altarpiece, another church belonging to the Augustinian Hermits and situated within the Sienese *contado* was also embellished with a series of Marian paintings (Pl. 143). As in the Massa Marittima *Maestà*, at least two of these paintings closely emulated those belonging to a major civic scheme within Siena itself. Now, however, the images represented the lively, narrative themes of the early life of the Virgin – themes which Ambrogio Lorenzetti together with Pietro Lorenzetti and Simone Martini – had already portrayed on the façade of the hospital church of

142. Ambrogio Lorenzetti, *The Maestà, c.* 1335–8. Siena, Sant'Agostino.

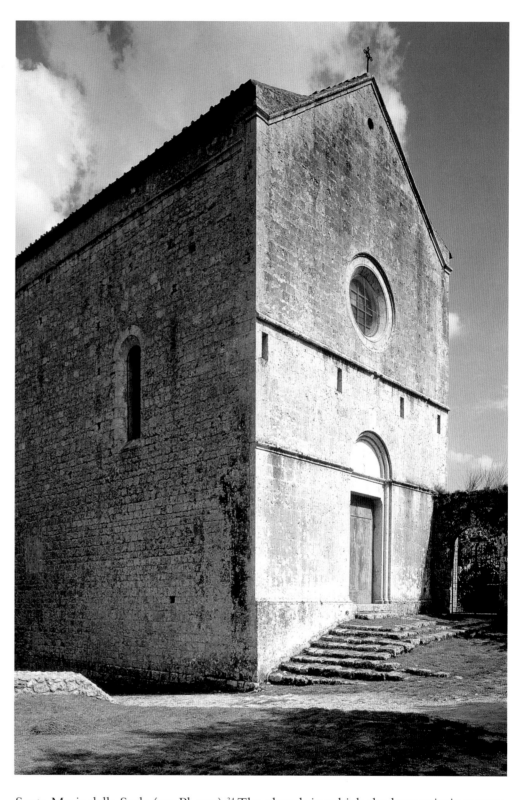

143. San Leonardo al Lago.

Santa Maria della Scala (see Pl. 100).[24] The church in which the later paintings were executed was not, however, situated within the urban setting of a *contado* city or town. Rather, it was attached to the hermitage of San Leonardo al Lago, 6 kilometres west of Siena (Pl. 144). Set beside a lake which, during the eighteenth-century, was drained to become the present Pian del Lago,[25] the hermitage was situated in an area of woodland and pasture, known as the Selva del Lago. Due to its plentiful supply of wood, game and fish, the Selva del Lago represented a valuable resource for the city government who drew up extensive legislation concerning it.[26] Like many such rural foundations, San Leonardo al Lago had a long and complex history.[27]

Archaeological investigation has revealed the presence of a natural subterranean cave which, by the tenth century, if not before, had been modelled into a simple chapel for religious observance.[28] During the twelfth and early thirteenth centuries, San Leonardo was given a number of designations including that of a hermitage and of a canonry. During this period – probably in the early twelfth century – a simple oratory was built over the grotto-chapel (Pl. 145).[29] In 1250, San Leonardo al Lago accepted the rule of Saint Augustine and a year later was formally united with San Salvatore at Lecceto, a union which lasted until 1516.[30] In 1277, however, San Leonardo regained the right to elect its own prior. The links between San Leonardo al Lago and Siena were very close, the Sienese government being anxious to exercise rights of patronage over the Augustinian hermitage as a means of controlling this valuable part of its territorial domain.[31] Thus, in the city statutes of 1309–10, the Commune signalled its commitment to the friars of San Leonardo al Lago by making them an annual grant of 10 *lire*.[32] In 1366, the Commune agreed to contribute to the expense of fortifying the hermitage with the proviso that the friars provide protection to the nearby inhabitants of Santa Colomba (Pl. 146).[33]

144. View of the hermitage of San Leonardo al Lago.

145. Plans by George Radan of the present church of San Leonardo with the twelfth-century oratory and earlier grotto superimposed on it.

146. Reconstruction by George Radan of the fortified hermitage of San Leonardo al Lago.

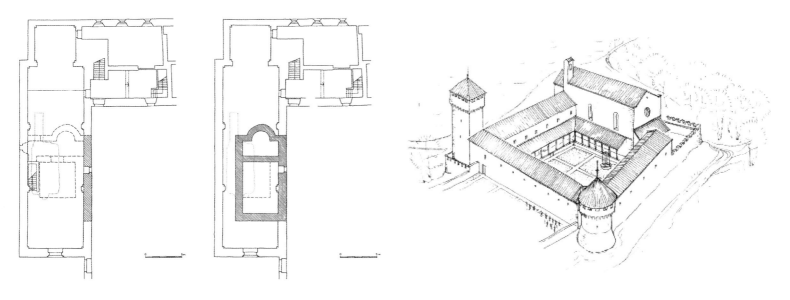

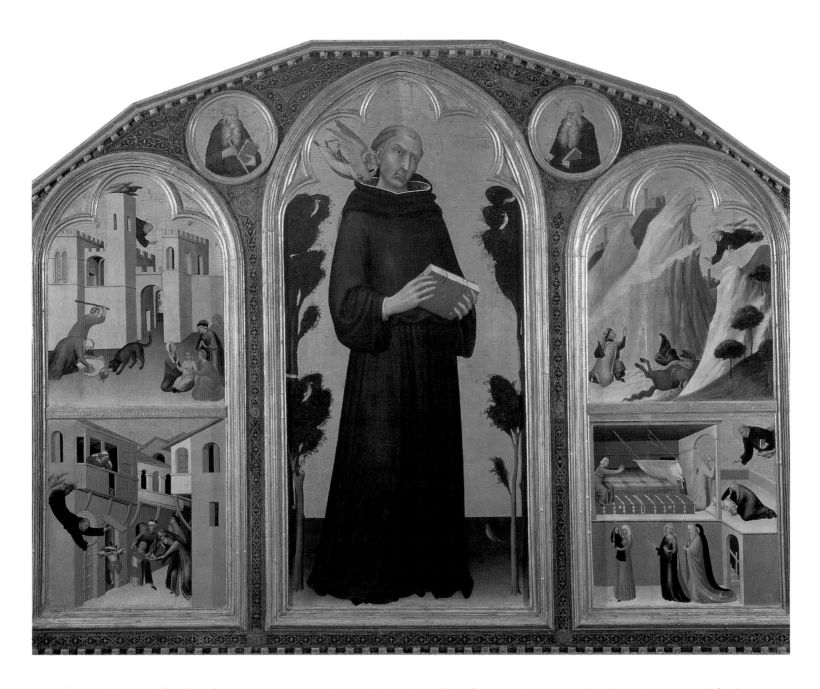

147. Simone Martini, *The Blessed Agostino Novello with Scenes of his Miracles*, 1320s. Siena, Pinacoteca.

In the early decades of the fourteenth century this hermitage gained further prestige when Agostino Novello, jurist, councillor to King Manfred of Sicily and Prior General of the Augustinian Hermits retired to San Leonardo al Lago in 1300.[34] After his death and burial there in 1309, it soon became apparent that the Augustinian Hermits were determined to honour the memory of their former Prior General by translating his remains to Siena and making him the centre of an intensely-observed local cult. Although it is not known precisely when the translation took place, two contemporary Augustinian writers claimed that the bishop of Siena sanctioned it because of the many posthumous miracles that had occurred shortly after Agostino Novello's death.[35] An entry in the chronicle attributed to Agnolo di Tura also suggests that the anniversary of his death was celebrated as a feast day in Siena as early as 1310.[36] By the 1320s, the Augustinian Hermits were petitioning the Consiglio Generale for financial support and official recognition for this annual celebration.[37] From such petitions, it is clear that the Augustinian Hermits were intent upon promoting the cult of Agostino Novello within the church of Sant'Agostino and – despite the fact that at that date he had been neither canonised nor beatified –

endeavoured to commemorate the day of his death both as a feast day within their liturgical calendar and a civic event attended by the city's major officials.

It has also plausibly been argued that the painting by Simone Martini depicting Agostino Novello and four of his miracles, originally from Sant'Agostino, but now in the Pinacoteca of Siena, was once located above the now lost wooden *arca* which housed the remains of this eminent Augustinian hermit (Pl. 147).[38] Situated, in all probability, just outside and to the left of the choir screen and thus in the public part of the church,[39] the shrine would have combined the *arca* and, above it, set in an arched recess, Simone Martini's painting. Portraying, on the front face of the lost *arca*, four scenes from the life of the *beato* and, on the surviving painting, four of his posthumous miracles together with the arresting image of Agostino Novello himself, the shrine would thus have once provided compelling testimony to the importance and perceived sanctity of this venerated member of the order.[40]

In the decades following the death of Agostino Novello, the hermitage of San Leonardo al Lago prospered precisely because of the alms it received from devotees coming to worship at the place where the *beato* had died.[41] The earlier twelfth-century oratory and the subterranean grotto-chapel were incorporated into a new church which although much larger, was still simple in design, comprising three vaulted bays and a chancel, but unembellished by transepts or chapels (Pls 145, 148).[42] In a verse description of the church, written in 1611 by an anonymous Augustinian friar, reference is made to two 'ancient' images of the *beato* which suggests that the memory of Agostino Novello was also honoured within the new church.[43] One is described as a mural painting within the church[44] and, although now lost, would probably have taken the form of a single standing figure – a very typical form of mural painting for churches within the Sienese *contado*, whose walls were characteristically lined with figures of standing saints. The other is described as an altarpiece which comprised a central image of the Virgin and Child framed by Saints John the Baptist, Augustine, Leonard and Agostino Novello – all represented as half-length figures. Above the main tier of panels were apparently pinnacle panels depicting figures of angels and, at the centre, Christ the Redeemer.[45] Two visitation reports, one dated 1638, and the other 1756, provide further confirmation of the presence of such an altarpiece which is described as 'ancient' and located in a subterranean chapel below the church – presumably referring to the twelfth-century chapel by then converted into the crypt of the later church.[46] The eighteenth-century visitor also attributes the altarpiece to Simone Martini or Lippo Memmi. Since the former had produced one of the earliest and most influential images of Agostino Novello (Pl. 147) and the latter was related by marriage to Simone and had worked closely with him on a number of projects, either attribution is entirely plausible.[47]

This campaign of embellishment of the new church of San Leonardo culminated in the execution of a fresco cycle within its chancel (Pl. 149). Partly covered by whitewash at some point in its history, the entire painted scheme was only brought to light in a restoration campaign executed between 1960 and 1963.[48] Each of the three walls of the chancel is devoted to a single narrative painting. On the altar wall is an *Annunciation* where the painter has skilfully incorporated the window of the chancel as part of the painting (Pl. 150). On the left wall is a *Presentation of the Virgin in the Temple* and on the right, a *Betrothal of the Virgin* (Pls 151, 140). Depicted in the four compartments of the vault are choirs of angels and seraphs, each group carefully distinguished from one another by the colour of their robes and the type of music that they are performing (Pl. 152). A sequence of busts of female saints – three for each painting – embellish the lower borders of the three narrative frescoes.[49] The outer surface of the pointed arch of the chancel facing out into the church proper is embellished with an *Assumption of the Virgin* – although much of

149. San Leonardo al Lago, view of the chancel.

the detail of the group of apostles to the right of the spectator has now been lost (Pl. 153).

The remaining surfaces of the archway are devoted to images relating more directly to the Augustinian Hermits themselves and to the commissioners of this fresco scheme (see Pl. 149). To the left appears an image of the titular saint of the church, Saint Leonard, together with, below it, four small narrative scenes of posthumous miracles from the saint's legend (Pl. 154). As the patron saint of prisoners, who secured the right from the sixth-century French king, Clovis, to free all prisoners that he encountered, it is appropriate that Leonard is represented holding a pair of manacles and that in one of the scenes he is shown liberating a prisoner.[50] More strikingly, however, he is also depicted in the black habit of the Augustinian Hermits – a graceful compliment to the religious order under whose care the church resided.[51] On the right appears an image of Saint Augustine, revered by the Augustinian Hermits as the saint whose name they adopted and whose supposed

148. (facing page) San Leonardo al Lago, interior of the church.

150. Lippo Vanni, *The Annunciation, c.* 1360–70. east wall of the chancel, San Leonardo al Lago.

rule they followed (see Pl. 149). Beneath Augustine appears a narrative scene where the saint's mother, Monica, prays for her young son's conversion to Christianity (Pl. 155).[52] On the inner surface of the left-hand entrance pier appears an image of Saint Catherine of Alexandria with, below her, a kneeling figure of a middle-aged, bearded male votary set in a simple, panelled enclosure (Pl. 156). Opposite this pair of figures – and on the inner surface of the right-hand entrance pier – is the figure of Saint Monica with the kneeling figure of an older male votary below her (Pl. 157).[53]

On the intrados of the arch, meanwhile, is a sequence of six medallions, four of which contain a bust of one of the four cardinal virtues (Fortitude, Justice, Prudence and Temperance) and two of which contain a bust of Constancy or Humility. While the Marian narrative paintings of the *Presentation in the Temple* and the *Betrothal* remain unimbellished with any painted inscription, the *Annunciation* portrays Gabriel holding a long scroll on which is written the verses which end the gospel account of the Annunciation (see Pl. 150). The Virgin, meanwhile, is shown with a caption which records the words of her acceptance, as given in the same source.[54] All the saints and the cardinal virtues are identified by painted titles executed in fourteenth-century cursive script. The *Miracles of Saint Leonard* were also once embellished with texts around the borders of each painting but much of this written detail is now lost (see Pl. 154).

A very damaged painted inscription, beneath the painting of Saints Augustine and Monica and written in the same script as on the other paintings, offers fragmentary information regarding the dating and commission of this painted scheme (see Pl.

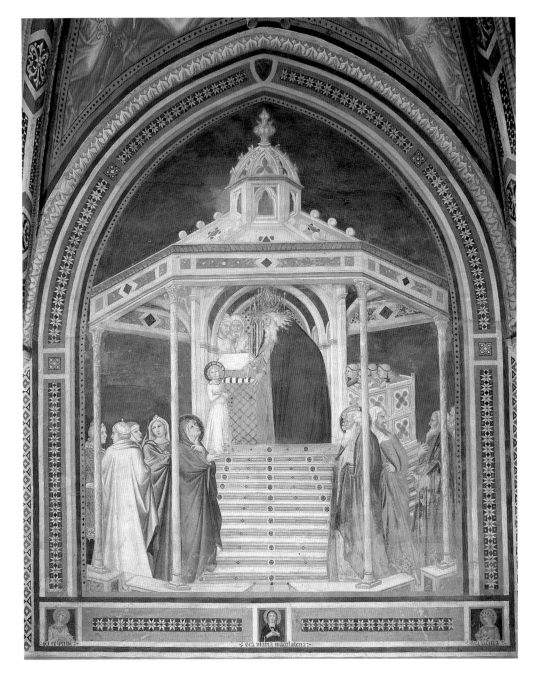

151. Lippo Vanni, *The Presentation of the Virgin in the Temple, c.* 1360–70, north wall of the chancel, San Leonardo al Lago.

152. (following page) Lippo Vanni, *Choirs of Angels, c.* 1360–70, vault of the chancel, San Leonardo al Lago.

155).[55] From what can be reconstructed of it, it appears that the embellishment of the chapel (that is the chancel) was begun in 1360 and brought to completion by someone from Siena in 1370. It is unclear, however, if this unnamed person was the commissioner or the painter. What it does indicate, however, is that the chancel and its frescoed decoration represents another striking example of Sienese intervention and influence within an artistic commission for the *contado*. In a brief description of San Leonardo al Lago, where he mentions the paintings in the chancel, the early nineteenth-century scholar, Enrico Romagnoli states that the cloister of San Leonardo was adorned by paintings in 1360 at the order of Giacomo di Vanni, Rector of the Spedale – the latter presumably being a reference to the Spedale di Santa Maria della Scala in Siena.[56] Although subsequent scholars have speculated that Romagnoli was, in fact, referring to the chancel scheme,[57] no rector of that name is listed in the documents of the Spedale for these years.[58] It may be, therefore, that Romagnoli was mistaken in his association of a mid-fourteenth-century artistic scheme at San Leonardo with a rector of the Spedale. There is, however, a body of evidence to suggest that the Spedale di Santa Maria della Scala may, indeed, have played an important role in the commission and design of the painted scheme for the chancel of the hermitage church.

The frescoes have plausibly been attributed to Lippo Vanni,[59] a Sienese painter active between 1344 and 1375 who – on the basis of surviving paintings in the Palazzo Pubblico, San Francesco and from the cloister of San Domenico – was clearly a painter skilled in the art of fresco and capable of securing commissions from both the government and the major religious orders.[60] More pertinently, it appears that in 1344 the painter also received a commission from the Spedale to execute illuminations for

153. Lippo Vanni, *The Virgin of the Assumption*, detail of Pl. 149.

154. Lippo Vanni, *The Miracles of Saint Leonard*, detail of Pl. 149.

155. Lippo Vanni, *Saint Monica Praying for her Son, Augustine*, detail of Pl. 149.

various liturgical books belonging to the Spedale.[61] On 18 October 1345, he received from the current treasurer of the Spedale, Jacomo di Chino, payment for his work on five narrative paintings (*storie*) for a choir book, described in the account book as an antiphonary.[62] The latter probably refers to a handsomely produced gradual or antiphonary currently housed in the Museo dell'Opera del Duomo of Siena. Among its copious illuminations, the first five – depicting a company of saints and the narrative subjects of the Annunciation, the Birth of the Virgin (Pl. 158), the Purification of the Virgin and the Assumption – stand out as distinctively typical of Lippo Vanni's work.[63] These initials thus provide compelling visual evidence of a painter at an earlier stage of his working practice approaching Marian subjects which he was later to treat on a more monumental scale.[64]

Turning to the frescoes themselves, it is significant that within a church ostensibly dedicated to Saint Leonard, the pictorial scheme for its chancel is devoted to celebrating the early life and the assumption of the Virgin – themes dear to the Sienese, in general, and to the hospital authorities, in particular. Moreover, while the identity and the concerns of the Augustinian community receive acknowledgement in the imagery on either side of the entrance, once within the chancel itself, the imagery is focused almost exclusively upon the representation of female saints – all the more remarkable in light of the fact that the chancel was the part of a mendicant church conventionally designated for the worship of the friars themselves.

As noted earlier, this fresco scheme has two subjects in common with that of the earlier scheme for the façade of the church of the Spedale. Indeed, the *Presentation of the Virgin in the Temple* and the *Betrothal of the Virgin* by Lippo Vanni at San Leonardo al Lago have been utilised by a number of scholars as a means of reconstructing how

156. Lippo Vanni, *Saint Catherine of Alexandria and a Votary*, c. 1360–70, inner face of the chancel arch, San Leonardo al Lago.

157. Lippo Vanni, *Saint Monica and an Elderly Votary*, c. 1360–70, inner face of the chancel arch, San Leonardo al Lago.

158. Lippo Vanni, illuminated initial of the *Birth of the Virgin*, 1345. Siena, Museo dell'Opera del Duomo, MS 98–4, fol. 14ʳ.

the earlier Spedale frescoes may once have appeared.[65] If, however, Sano di Pietro's fifteenth-century predella paintings are accepted as broadly representative of the earlier paintings, such a process of comparison can be reversed in order to assess the nature of Lippo Vanni's debt to the Spedale scheme. Like Sano di Pietro, Lippo Vanni portrayed the scene of the Presentation taking place in an open-sided edifice supported on slender colonettes whose bases rest on a low podium (see Pl. 151, cf. Pl. 107). But in order to exploit the full height of the chancel wall, he added a cupola to the building and simplified its structure by not giving it any kind of lateral extension. As their central feature, however, both paintings portray an imposing flight of steps which is hexagonal in design. The general disposition of the principal protagonists is also broadly similar. Thus, in both cases, the young Virgin is shown at the head of the stairs being received into the Temple by the High Priest. Below her, and to the left, appear her mother, Anna, and a number of elegantly-clothed female companions, and to the right, Joachim with three male companions.

There are also, however, a number of distinctive features within the San Leonardo *Presentation* which should probably be attributed to Lippo Vanni himself. Thus, while the presence of other young girls is a standard feature of paintings of this subject, Lippo Vanni has elaborated upon this detail by depicting five young girls peering curiously out of their enclosed choir to get a glimpse of the new arrival. The

striking physiognomy of the High Priest, with his rounded facial features and curly white hair and beard, also appears in other depictions of elderly patriarchs by Lippo Vanni and therefore probably constitutes another example of his distinctive contribution to the representation of this canonical Marian subject.[66]

In the case of the *Betrothal*, similarities between Lippo Vanni's and Sano di Pietro's versions of this subject suggest that they shared a common prototype – the *Betrothal* on the façade of the Spedale being a likely candidate (Pl. 140, cf. Pl. 108). The principal figures in both paintings are very similar, even to such striking details as Joachim, with his back to the betrothed couple, actively remonstrating with the angry suitors, and a young man, turned towards the spectator, breaking his rod beneath his right knee. Lippo Vanni's architectural setting is, however, very different from that of Sano di Pietro. In place of the latter's open-sided, vaulted loggia with its vestibule set to one side, Lippo Vanni presents a much more solidly-conceived structure with a barrel-vaulted space, fronting another covered by a coffered ceiling. This edifice is further distinguished by an upper storey of open tracery behind which appear a pair of twisted columns and two crenellated towers. As in the case of the *Presentation*, the decision to portray such an elaborate structure was undoubtedly influenced by the shape of the picture field available to him. It also enabled him to focus his figural composition more decisively on the sacerdotal figure of the High Priest.

As suggested in an earlier chapter, the subjects chosen for the Spedale façade in the 1330s would have been particularly pertinent to the Spedale authorities because of the devotion of the current rector and his wife to the cult of Saints Joachim and Anna and the Spedale's charitable activities of raising and dowering young orphan girls.[67] Similarly, the two particular subjects chosen for the chancel of San Leonardo al Lago also provided an opportunity to celebrate priesthood and the enclosed religious life – subjects of obvious relevance to the religious community there. The subject of the Presentation associates the High Priest with the sacred space of the Temple itself and also conveys the sense of a young acolyte entering the enclosed life of a religious community (see Pl. 151). In the *Betrothal*, meanwhile, the High Priest is shown as a cleric officiating at a marriage (see Pl. 140). Thus, it appears that whilst the influence of the Spedale and its charitable functions can still be seen in these paintings – in the presence of the young girls in the *Presentation* and the scene of marriage in the *Betrothal*, for example – the choice of these two subjects and their treatment also skilfully acknowledges the life of the religious community at San Leonardo al Lago.[68]

This clerical aspect of the paintings' iconography is further elaborated by the choirs of angels portrayed in the vault of the chapel (see Pl. 152). Over the *Annunciation*, angels, dressed in tunics of either pale blue or golden yellow, play a portable organ and a variety of stringed instruments. Over the *Presentation* and the *Betrothal*, further angels, now in pink, white or green, play a variety of brass, woodwind and percussion instruments.[69] Over the entrance itself, meanwhile, appear three angels singing polyphonically, accompanied by others carrying wax *ceri* or delicately-wrought thuribles with which they appears to cense the altar below. All of them are dressed in white tunics reminiscent of priestly surplices. In terms of the variety and range of the musical instruments, moreover, the angelic choir appears to be performing a full-scale concert of *ars nova* music incorporating both voices and orchestral instruments, a detail suggestive of a significant degree of musical sophistication on the part of the commissioners and the paintings' first audience.[70] The acts of singing, censing, and burning wax candles on the part of the angels would also once have closely replicated the sung devotions and liturgical rituals of the friars themselves.

The *Annunciation* on the altar wall was not a subject depicted in the Spedale scheme and thus introduces an independent feature to the frescoed cycle at San Leonardo al Lago (see Pl. 150). In place of the relatively logical treatment of space in the other two frescoes, the *Annunciation* displays a sharp disparity between the perspective of the pavement at the centre of the painting and that of the pavilions on either side. Despite this apparent lack of co-ordination, the painting is a striking one – particularly when viewed from within the body of the church where the boldness and ingenuity of utilising the window of the chancel within the design of the painting are most apparent (see Pl. 149). In terms of its subject, the light coming through the glass panes of the window would also have contributed dramatically to the religious meaning of the painting. A number of later medieval theologians, when seeking to elucidate the profound mystery of the concept of the virginal conception of the Son of God, evoked the metaphor of sunlight which can pass through the material substance of glass but leave it intact.[71] This particularly ingenious exploitation of the window of the church by Lippo Vanni to enhance and deepen the meaning of his painting of the *Annunciation* had already been anticipated some twenty-five years earlier in another rural oratory within the Sienese *contado* at Montesiepi. Within a chapel, probably built and endowed in the 1340s by the noble Sienese family of the Salimbeni, and attached to the twelfth-century oratory standing in close proximity to the Cistercian abbey and church of San Galgano, Ambrogio Lorenzetti had painted an extraordinarily emotive rendition of the Annunciation (Pl. 159).[72] Although what survives today is a later, more orthodox, reworking of this painting (Pl. 160), it is clear even from this – and also from other technical evidence – that Ambrogio Lorenzetti's original version of the Montesiepi *Annunciation* imaginatively exploited the presence of the chapel window in his composition.[73] It is also significant, moreover, that Lippo Vanni appears to have been highly receptive to the art of the Lorenzetti – as in the example of the probable influence upon him of the Spedale frescoes.

By the date of the execution of the San Leonardo scheme, the feast of the Annunciation had become a major liturgical event both for the Spedale itself and for the civic authorities of Siena. This new development was closely linked to the Spedale's purchase, on 28 May 1359,[74] of a collection of precious relics from the furnishings of Constantine's imperial chapel at Constantinople. These relics cost the impressive sum of 3000 gold florins, with the Sienese government also paying for the cost of their transport to Siena and the festivities marking their arrival in the city.[75] These relics, housed in exquisitely-worked reliquaries, became the focus of an annual ceremony on the feast of the Annunciation, the importance of which was signalled by the attendance of Siena's principal government officials.[76] Between 1360 and 1364, a special pulpit for exhibiting the relics was built just below the fresco paintings of the early life of the Virgin on the exterior façade of the Spedale church (see Pl. 100).[77] In order further to facilitate and dignify the staging of this event, the piazza in front of the Spedale was levelled in 1361 – and again in 1371 – and in 1379 a stone bench for the city's principal officials was built at the base of the façade of the hospital church.[78] Given this renewed focus upon the feast of the Annunciation within the public life of the Spedale and the Sienese government in the 1360s and the 1370s, it is, therefore, striking that this particular iconographic theme should have been included so prominently within the chancel frescoes at San Leonardo – particularly as this scheme was apparently executed within the same decades.

A similar preoccupation with themes dear to the Spedale may also have governed the choice of the *Assumption* for the subject of the chancel arch. As already indicated, the Virgin of the Assumption held a special significance for the Sienese[79] and indeed, Lippo Vanni had himself contributed to the propagation of this particular form of

159. Ambrogio Lorenzetti, underdrawing of the *Virgin of the Annunciation*, *c.* 1340–4. Montesiepi, Oratory of Saint Galgano.

Marian devotion by his illuminated initial for the Spedale's gradual.[80] The Virgin of the Assumption had also become particularly important for the Spedale, however, since amongst the relics acquired in 1359 was a piece of the girdle that the Virgin was believed to have dropped to Saint Thomas while she was being assumed into heaven.[81] It is striking that after the acquisition of this relic by the Spedale, a number of Sienese paintings of the Assumption conspicuously include the act of the Virgin bestowing the girdle upon the apostle Thomas. Thus, for example, Bartolommeo Bulgarini, most probably in the 1360s, produced a painting of the Virgin of the Assumption in which a diminutive figure of Thomas stretching up to receive the girdle is an eye-catching feature (Pl. 161). It has plausibly been suggested that this painting once formed the central part of a triptych framed by figures of saints[82] and that it was commissioned for the chapel of relics, converted in the 1360s out of the ground floor of the Rector's palace and thus directly adjacent to the hospital church (see Pl.

102).[83] Such a suggestion is supported by the materials used for the painting itself which incorporates gold leaf, sgraffito work, coloured glazes and, in the spandrels, pieces of coloured glass and pastiglia-work – all features which closely emulate those of contemporary reliquaries (Pls 162, 55).[84] It seems, therefore, that the Spedale itself was not only instrumental in further enhancing the already well-established cult of the Virgin of the Assumption within Siena but also commissioned a major altarpiece which provided a graphic visualisation of the Virgin on the occasion of her assumption. Since, in addition, there may have been an image of the Assumption of the Virgin portrayed on the façade of the Spedale,[85] it appears all the more significant that this particular Marian subject should also feature so prominently on the public face of the chancel entrance at San Leonardo al Lago (see Pls 149, 153).

There remains the question of the identity of the kneeling votaries portrayed at the entrance to the chancel (see Pls 156, 157). Although the patronage of the high altar within the chancel would certainly have been under the control of the Augustinian Hermits themselves, it is likely that these two figures represent the benefactors who provided the financial resources for the chancel's painted decoration and who, in return, were the recipients of masses sung by the friars themselves. The costume of the younger man suggests that he was a prosperous layman. It has been proposed that the figure could represent the painter himself.[86] If this is the case,

160. *The Annunciation*, mid to late fourteenth century. Montesiepi, Oratory of San Galgano.

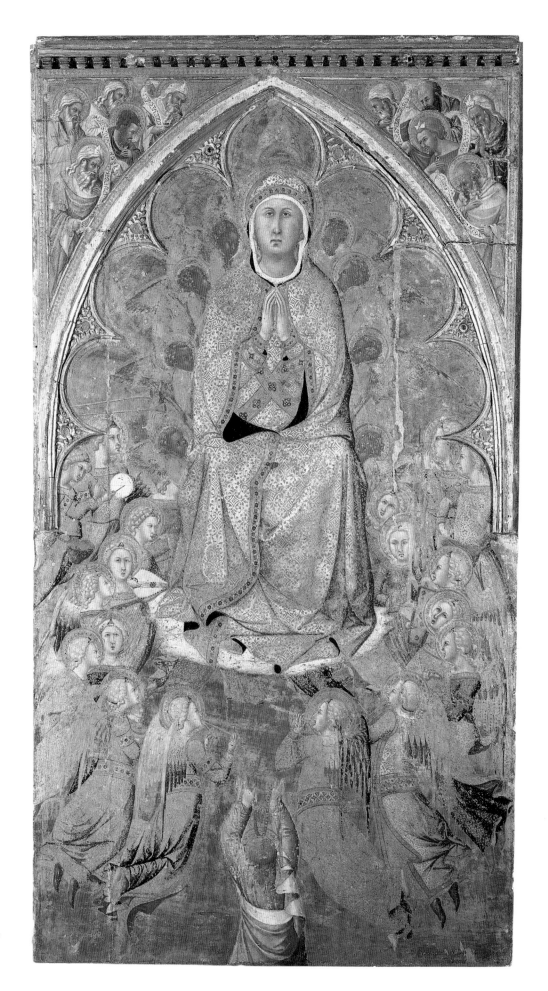

161 Bartolommeo Bulgarini, *The Virgin of the Assumption with Saint Thomas Receiving her Girdle*, *c.* 1365. Siena, Pinacoteca.

162. (facing page) Bartolommeo Bulgarini, *The Virgin of the Assumption*, detail of Pl. 161.

The Contado

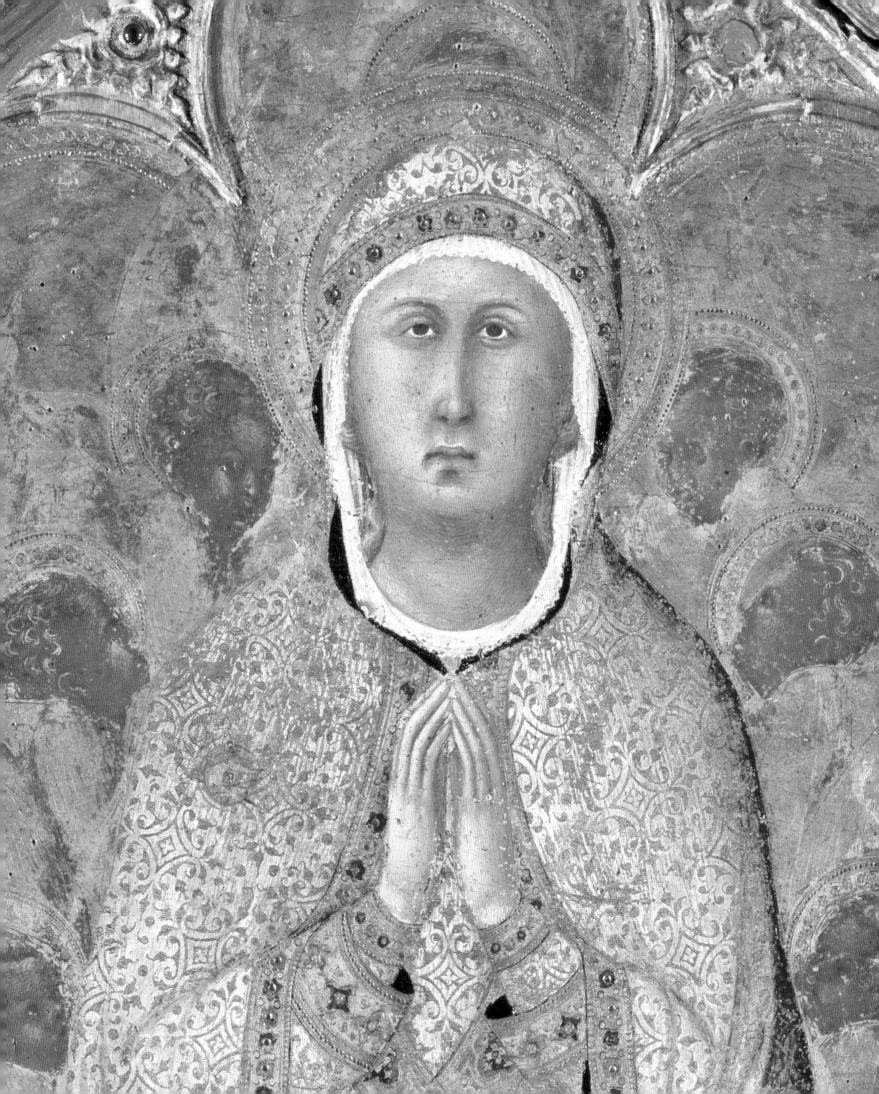

163. Lippo Vanni, *Elderly Votary*, detail of Pl. 157.

165 (facing page) Bartolommeo Bulgarini, *Saint Thomas Receiving the Virgin's Girdle*, detail of Pl. 161.

164. Lorenzo Vecchietta, *The Rector Receiving his Cloak of Office from the Blessed Agostino Novello*, panel from the exterior of the *Arliquiera*, 1445. Siena, Pinacoteca.

however, it would represent a remarkably self-confident statement of his identity and social standing by Lippo Vanni. Given the figure's rich clothing, it appears more likely that he represents one of the benefactors of the chapel and possibly a close relative of the second, older figure. In the 1611 verse description of the church, the author suggests that the older figure is the wife of the younger man.[87] It is clear, however, that the older figure represents an elderly man (Pl. 163). His distinctive white bonnet is also characteristic of that worn by the rector and brothers of the Spedale. Although only fifteenth-century representations of the rector and brothers survive, it appears from these that beneath their hats they wore a white cap or bonnet (Pl. 164).[88] This particular feature of their dress is also confirmed by the instruction given in the hospital statutes of 1322 that every brother was to have a bonnet (*cuffia*), hat and hood.[89] If this votive figure is, indeed, a portrait of a member of the Spedale community, it also appears that he has been portrayed divested of his hat as a sign of respect and reverence (Pl. 163).[90] It seems, therefore, that there is good circumstantial evidence for supposing that these two figures portray members of a Sienese family who had financed the painting of the chancel as an act of private benefaction, but that, in addition, the elder of the two was or had been a prominent member of the hospital community of Santa Maria della Scala. It is tempting to speculate further that he might represent a former rector of the Spedale.[91] However, until further supporting historical evidence is discovered, such a view can only remain within the realm of informed speculation.

The close associations between the Spedale and the order of the Augustinian Hermits does, however, provide further circumstantial evidence that the fresco cycle at San Leonardo al Lago may have been sponsored by a rector of the Spedale. The hospital had begun as a lay community, but in the early fourteenth century it formally became attached to the Augustinian Hermits as the tertiary order of Santa Maria.[92] In addition, it appears that the Blessed Agostino Novello had close contact with the Spedale in the years immediately prior to his death at San Leonardo al Lago. Early hagiographic sources for the *beato* describe how he frequented the Spedale between 1305 and 1309, and also claim that he wrote the monastic rule for the Spedale and devised the costume of the rector and the brothers.[93] So strong was this tradition that, in the fifteenth century, the event of the *beato* bestowing the cloak of office upon the rector of the Spedale was represented by Priamo della Quercia on the walls of the Pellegrinaio and by Vecchietta on the *Arliquiera* – the monumental and ornately decorated cupboard designed to house the Spedale's precious cache of relics within the newly fashioned sacristy of the hospital church (Pl. 164).[94]

Although it cannot be proved that this *contado* commission was the result of an act of patronage on the part of a rector of the Spedale or his family, the above discussion outlines a plausible context for just such an eventuality. The relationship between the hermitage of San Leonardo al Lago and the Spedale was clearly very close.[95] It is also striking that the scheme – while acknowledging the identity of the Augustinian Hermits through the representation of Saints Augustine, his mother, Monica, and Saint Leonard – is primarily focused upon the Marian images of the Virgin of the Annunciation and of the Assumption, two of the Virgin's titles which had a special resonance both for the Spedale itself and for Siena as a whole (see Pls 149, 150, 153) If a rector of the Spedale di Santa Maria della Scala did, indeed, play a role in the introduction of these Marian images within a *contado* church, it is highly unlikely that he and his family would have acted in isolation. Quite apart from the co-operation of the Augustinian Hermits themselves (at both San Leonardo and Sant'Agostino in Siena), it is likely that the civic authorities would also have been aware of this initiative in one of the churches within this highly valued part of their territories. It is significant, for example, that in the 1309–10 statutes of the city, the rector of the Spedale is granted half the straw harvested from the communal lands beside the lake of the Selva for bedding for the poor in the hospital.[96] When it is recalled that in the same city statutes, the Commune also committed itself to giving an annual grant to the hermit friars of San Leonardo al Lago,[97] the complexity of the network of contacts, influences and interrelationships becomes even more apparent. It is also significant that it was in the 1360s – precisely the time when the Commune was taking an active role in developing the civic festival of the exhibition of the relics at the hospital on the feast of the Annunciation – that the government also agreed to contribute to the fortification of this relatively isolated rural hermitage.[98] Such was the importance of this and other rural hermitages for the Sienese Commune, in their endeavour to control and administer the countryside and its smaller rural communities, that it is highly probable that the city authorities actively welcomed the initiative of a prominent member of a major civic institution such as the Spedale di Santa Maria della Scala to contribute to the embellishment of one of its more remote and isolated churches – especially when the initiative resulted in a pictorial scheme which honoured the Virgin, the protector and defender of both the city and its outlying territory.

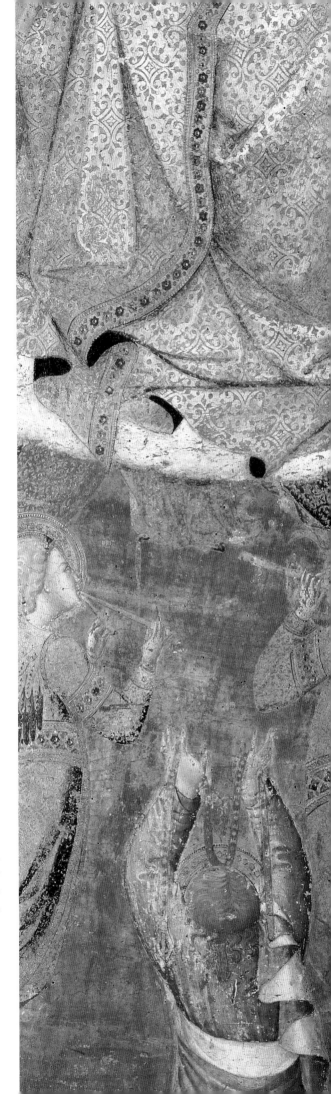

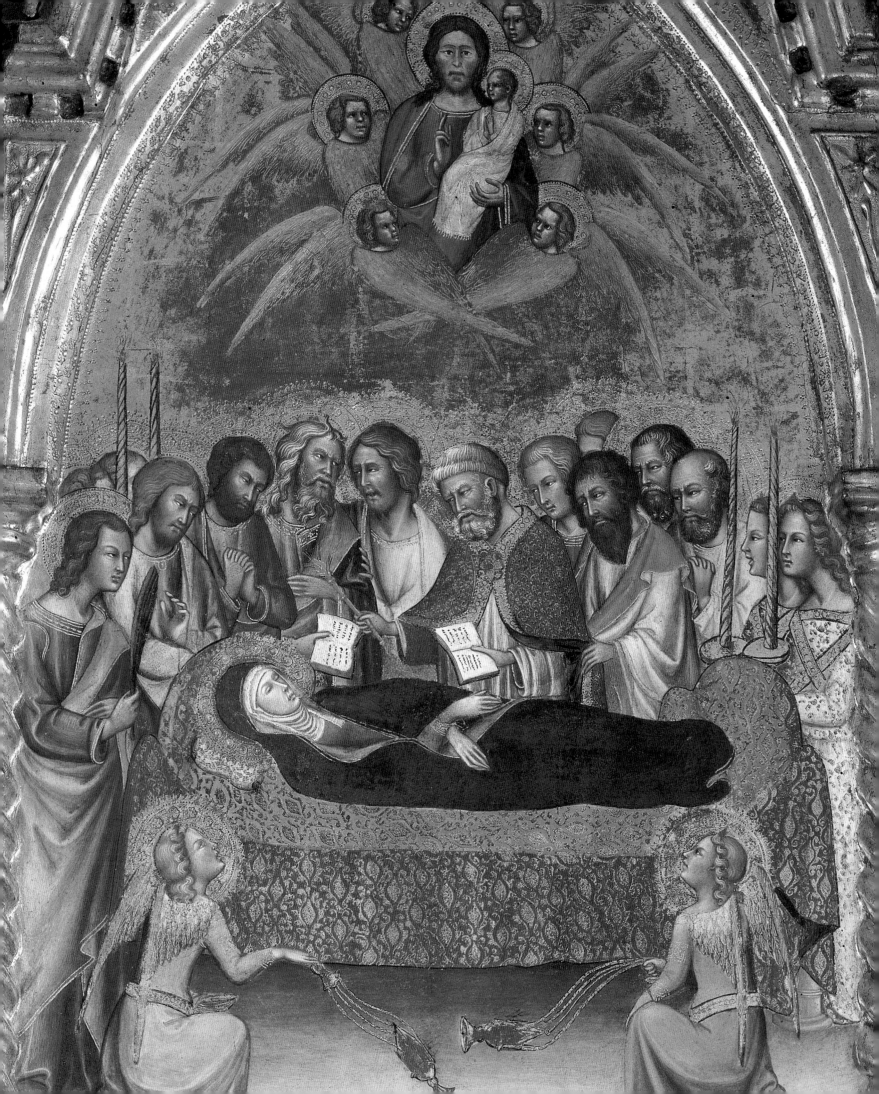

8

Montalcino

On 1 March 1307, a wealthy member of one of Siena's leading families made his last will and testament.[1] Lacking a surviving son, Tavena di Deo Tolomei made the Augustinian Hermits of Sant'Agostino in Siena his universal heir on the understanding that they construct a chapel and tomb for him in their church. Requiem masses were to be sung at the altar of the chapel for Tavena and members of his immediate family.[2] Although the Augustinian Hermits were the principal beneficiaries, Tavena Tolomei also left bequests to the Opera del Duomo, San Domenico and San Francesco, the hospitals of Santa Maria della Scala, Monna Agnese and the Misericordia, and to the hermits of the city and *borgo* of Siena.

In addition to the principal religious institutions of Siena, Tavena also made a number of further bequests to churches in Montalcino, an important town lying 30 kilometres south-east of Siena (Pl. 167). From these bequests, it appears that Tavena owned houses, courtyards, gardens and orchards in Montalcino – property with which he endowed an altar in Sant'Agostino, the local Augustinian church. Tavena further instructed that this altar was to be embellished with his coat of arms and that requiem masses were to be sung there for him and his family. In addition, the church of San Francesco in Montalcino was to receive a bequest of 50 *lire* for the singing of requiem masses – thus ensuring the continuance of an earlier bequest made by his father.

In general terms, this document was entirely typical of the will of a wealthy member of a powerful Sienese family, such as the Tolomei. In such wills, it was common to include bequests to churches, hospitals and hermits both in Siena itself and within those parts of the *contado* where the family owned property. From his bequest to the Franciscans of Montalcino, it is clear that Tavena Tolomei was continuing a tradition of patronage already established by his father. His family's ownership of property in Montalcino was probably part of the expansion of the Tolomei into this part of the Sienese *contado* whereby various branches of the family had gained control of a number of castles in the vicinity of the town.[3] Indeed, in 1297, Tavena himself had been appointed Sienese Podestà of Montalcino – an official role which further consolidated his and his family's links with the town.[4]

As in the case of Massa Marittima, Montalcino merited a detailed entry in the 'Libro dei Censi' of 1400.[5] This was due, in part, to the long and complex history of the relationship between Siena and this relatively small Tuscan town.[6] Situated on a

166. Bartolo di Fredi, *The Dormition of the Virgin*, detail of Pl. 177.

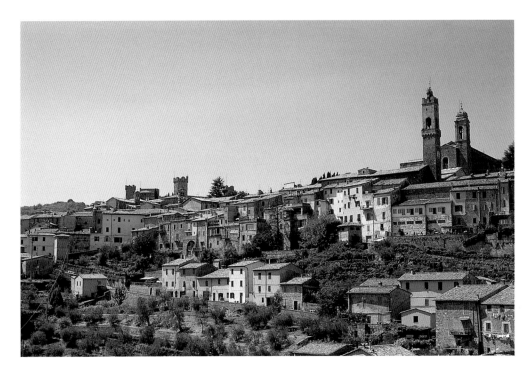

167. View of Montalcino with the Fortezza (on the left) and the Palazzo Comunale and Sant'Agostino (on the right).

hilltop site, it provided an excellent vantage point over the surrounding countryside – particularly the southern stretches of the Via Francigena linking Siena with Rome – and was, therefore, a site of considerable strategic significance for Siena. Already inhabited in the Etruscan and Roman periods, in the ninth century it came under the jurisdiction of the powerful Benedictine abbey of Sant'Antimo, lying 8 kilometres to the south-east of the town (Pl. 168). Due to the loss of the ancient archive of Sant'Antimo, Montalcino's evolution into an independent commune is obscure, but it is clear from other historical sources that it already had such status by the twelfth century. As a site of strategic importance for the control of the surrounding territory, its political control was strongly contested by the Sienese, the Florentines and the Orvietans. In 1212, the Sienese acquired quarter ownership of Montalcino from the abbot of Sant'Antimo, ownership which they duly ceded to the Montalcinesi themselves with the proviso that they offer an annual tribute of thirty wax candles to Siena cathedral on the feast of the Assumption and a sum of 30 *lire* to the Commune of Siena as acknowledgement of Siena's formal rights over the town. The

168. Sant'Antimo.

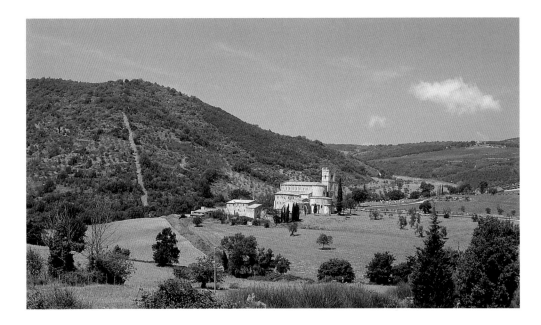

Montalcinesi also undertook to fight on behalf of the Sienese and to place the castle at their disposal. The importance of this early thirteenth-century treaty for the Sienese is signalled by its inclusion within both the 'Caleffo dell'Assunta', and the 'Libro dei Censi'.[7] The Montalcinesi were soon straining against the political control of their new allies, however, and the thirteenth century was marked by a series of renewed contests between Siena, Florence and Orvieto for control of the town. Indeed, the question of Montalcino and the support given to the town by the Florentines was an important factor in the war between Florence and Siena in 1260 which concluded with the celebrated victory of Montaperti that became such a crucial part of Sienese civic consciousness and ideology. After the victory and the peace treaty that assigned Montalcino firmly to Siena, the Sienese gave vent to their fury towards the town and its inhabitants by destroying its fortifications, defences, buildings and cultivated lands.[8]

With the subsequent Sienese defeat at Colle Val d'Elsa in 1269, Montalcino briefly regained its political autonomy, but with the advent of the rule of the Nine in Siena, and their pragmatic allegiance with Florence, the town once again became part of the Sienese state – albeit as a commune with a high degree of political independence. In the last decades of the thirteenth century and the early years of the fourteenth century, the Palazzo Comunale was built (Pl. 169) and the churches of San Francesco and Sant'Agostino, and their conventual buildings, were also constructed (Pl. 170, nos 8, 10).[9] In 1324, a pro-imperial conspiracy was suppressed by the communal authorities, and a year later, a new church, dedicated to Sant'Egidio and facing onto the public square behind the Palazzo Comunale, was built with the materials of an earlier church.[10] With the fall of the Nine in 1355, Montalcino – like other subject towns and castles – temporarily regained its independence but, in 1361, a series of new capitulations ratified the town's reintegration into the Sienese state.[11] The Montalcinesi were conceded the right to Sienese citizenship but – like the Massetani some twenty-five years earlier – also witnessed the construction of a fortress at the southern edge of the town (Pl. 170, no. 13). This imposing pentagonal fortification, which incorporated parts of the town's thirteenth-century defences, became the base of Siena's political control over the town (Pl. 171).[12]

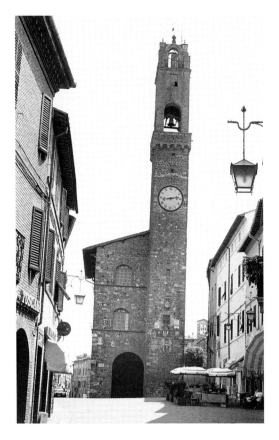

169. The Palazzo Comunale, Montalcino.

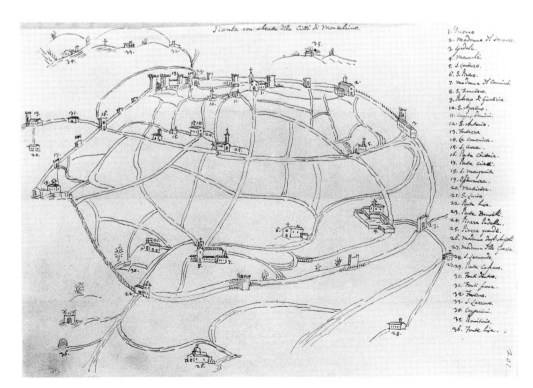

170. Giovanni Antonio Pecci, plan of Montalcino, c. 1760. Siena, Archivio di Stato, MS D 70, fol. 201[r].

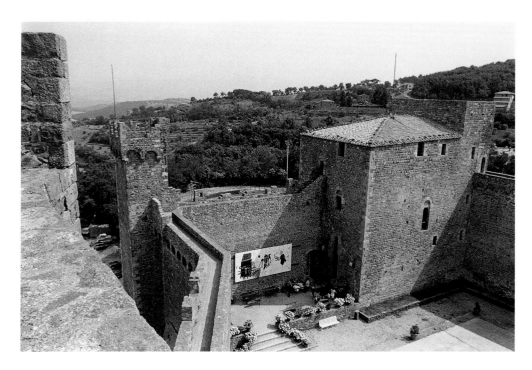

171. The Fortezza, Montalcino.

It is clear from Tavena Tolomei's will that, as early as 1307, the mendicant church-es of Sant'Agostino and San Francesco in Montalcino were the recipients of patron-age by the laity – on this occasion a Sienese whose principal power-base lay with-in Siena itself. Nothing apparently survives today in Sant'Agostino to indicate where the Tolomei altar might have been or what form it might have taken.[13] From the latter part of the fourteenth-century, however, there survive an impressive num-ber of paintings commissioned for both churches, all of which were produced by a single Sienese painter – Bartolo di Fredi – and his workshop. As in the case of Ambrogio Lorenzetti's commission for the Augustinian Hermits of Massa Marittima, some four or five decades earlier, Bartolo di Fredi's work in Montalcino furnishes a striking example of Sienese artistic skill and expertise being imported into a Sienese subject town. By virtue of their Marian subject matter, two altar-pieces are particularly pertinent to this study. Although commissioned by Montalcinese patrons – and thus subject to a number of local imperatives – both altarpieces show a marked indebtedness to earlier Sienese paintings produced for two of Siena's most prestigious buildings, namely the cathedral and the Spedale di Santa Maria della Scala.

The first of these two altarpiece commissions resulted in an ambitiously-conceived polyptych, the centre-piece of which was an imposing representation of the coronation of the Virgin by Christ – a triumphal event held to have taken place after her assumption into heaven (Pl. 172). Documentary evidence indicates that this complex altarpiece – which also incorporated numerous subsidiary paintings illus-trating other events in the Virgin's life – was completed between 1383 and 1388 and that it was intended for a chapel in San Francesco under the patronage of a local confraternity, the Compagnia di San Pietro (Pl. 173). By that date, it appears that Bartolo di Fredi had completed three other altarpieces for the same church, two of which portrayed the conventional subject of the Virgin and Christ Child with saints, and the third of which represented the narrative subject of the deposition from the Cross, together with subsidiary scenes from the early life of Saint John the Baptist and a local Franciscan *beato*, Filippo Ciardelli (Pl. 174). A variety of historical evi-dence lends support to the view that these altarpieces were executed in an orderly sequence between 1380 and 1383, the year in which the Compagnia di San Pietro contracted the *Coronation of the Virgin* from the painter.[14]

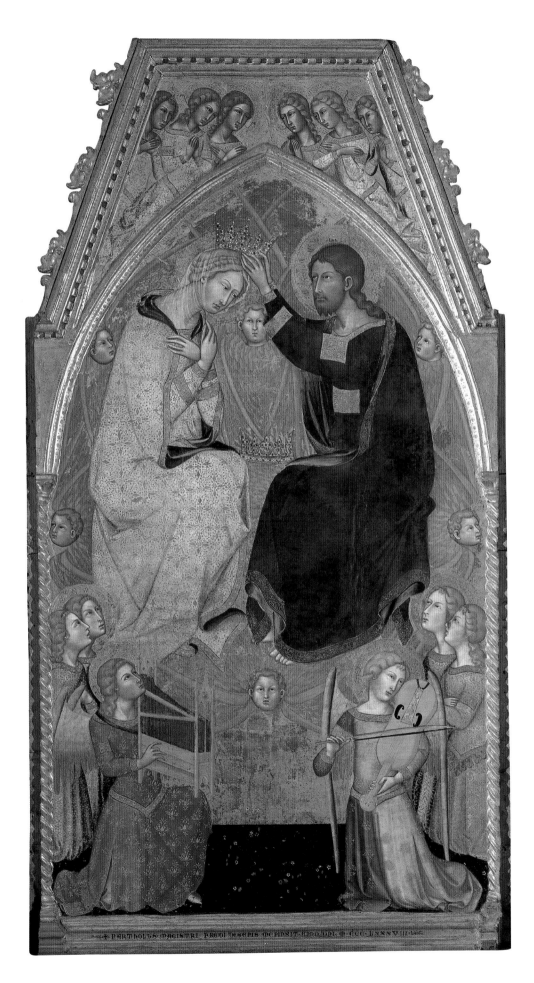

172. Bartolo di Fredi, *The Coronation of the Virgin*, 1388. Montalcino, Museo Civico e Diocesano d'Arte Sacra.

1 Chapel of the
 Virgin Annunciate

2 Chapel of Saint Peter

3 Chapel of Saint Blaise

4 Chapel of the *Beato*
 Filippino Ciardelli

173. Montalcino, plan of San Francesco and its chapels (adapted from Freuler, 1994).

By 1380 – when he clearly began a period of intensive work in Montalcino – Bartolo di Fredi was already a highly successful artist in Siena, a member of the city guild of painters,[15] and co-owner of a workshop with the painter, Andrea Vanni, near the Spedale della Misericordia.[16] He had secured commissions both from the government itself for work in the Sala del Consiglio of the Palazzo Pubblico and the Cappella di Piazza, and from the Opera del Duomo and the guild of stone-workers for work in the cathedral.[17] In addition, he had also worked extensively outside Siena – most notably at San Gimignano and Volterra.[18] While working in Montalcino in the 1380s, he also secured other important commissions in Siena: an altarpiece for San Domenico,[19] the painting of a statue of the Archangel Michael for the confraternity of the Virgin which met in an oratory in the vaults of the Spedale di Santa Maria della Scala,[20] and altarpieces for two adjacent altars in the north aisle of the cathedral.[21] During the same period, he also painted an altarpiece for the principal Augustinian church in San Gimignano and a reliquary bust of Saint Ursula.[22]

As well as his highly successful career as a painter, Bartolo di Fredi also had an impressive record of political service for the Sienese government. Thus from 1368 onwards there are regular records of his membership of both the Consiglio Generale and the more elite magistracy of the Consistory as well as his services on numerous other more *ad hoc* committees and appointments.[23] To some extent such frequent office-holding may have been the result of the more egalitarian face of Sienese government which, in the wake of the decimation of the population by successive outbreaks of the plague and the overthrow of the wealthy mercantile oligarchy of the Nine in 1355, had begun to recruit its members from amongst professional artisans and craftsmen. It remains striking, nevertheless, just how often Bartolo di Fredi features within such records.[24] Many of them refer, moreover, to the painter being engaged on official government business outside Siena with neighbouring cities and towns. Such business undoubtedly furnished him with an extensive network of personal contacts and must, therefore, have increased his chance of securing lucrative commissions for himself and his workshop. Most significantly, these contacts extended to Montalcino where, on 7 June 1375, Bartolo and two others were appointed by the Consistory to consult with the Montalcinesi in respect of levying an indirect tax, or *gabella*, of 200 gold florins per year upon the town.[25] Similarly, fifteen months later, he is referred to in Montalcino itself, assisting the Podestà in settling a dispute between two named individuals.[26] The varied and substantial nature of Bartolo di Fredi's political and professional commitments, notwithstanding, it is his two major Marian altarpieces for Montalcino that are of particular interest in the present context.

The *Coronation of the Virgin*, which carries on a moulding along its lower edge the name of the painter and the date 1388 (see Pl. 172),[27] was originally the centre-piece of a monumental polyptych of complex design. Although still standing in the Cappella dell'Annunziata in San Francesco in 1750 – where it was described in detail by the Franciscan, Pietro Bovini – by the nineteenth century it had been dismantled and its component parts dispersed to a number of different locations within Montalcino itself. Subsequently, many of these were incorporated into other collections housed in Siena or further afield.[28] Recent research has, however, resulted in a persuasive reconstruction of the original design of the altarpiece.[29] This, in turn, has led to the greater part of the polyptych being reassembled to act as one of the most impressive items on display in the newly opened Museo Civico e Diocesano d'Arte Sacra in Montalcino.[30] At its centre is the imposing *Coronation of the Virgin* which is framed by side panels depicting, somewhat unusually, four narrative paintings: two drawn from the hagiography of the Virgin's early life and two from her last days (Pls 176, 177). As in the case of Duccio's *Passion* series on the back of the *Maestà* (see Pl.

The Contado

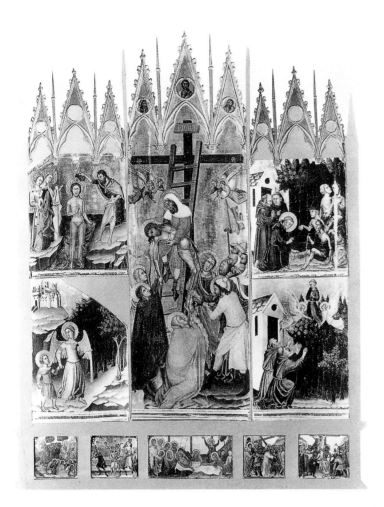

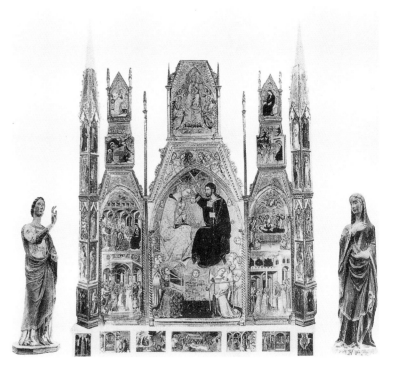

44), the narrative sequence of these scenes reads sequentially from left to right and from bottom to top. The lower sequence, consisting of the *Betrothal of the Virgin* and the *Virgin Returning to the House of her Parents*, once represented a logical sequel to four paintings on the predella which depicted the *Expulsion of Joachim from the Temple*, the *Annunciation to Joachim*, the *Birth of the Virgin* and the *Presentation of the Virgin* – scenes which preceded the two represented on the lower side panels of the altarpiece (Pl. 175). Similarly, the upper sequence of the *Gathering of the Apostles before the Virgin's Death* and the *Dormition of the Virgin* provided a prelude to the image of the Virgin being crowned in heaven on the central panel and the Virgin of the Assumption portrayed on the central pinnacle panel of the altarpiece.

The remaining component parts of the altarpiece were devoted to subjects from the biblical account of Christ's incarnation – but in each case ones in which the Virgin figured prominently – and to figures of saints of particular relevance to the Franciscan order and the Montalcinesi. Thus, two tiers of pinnacle panels depicted, on the left, the *Nativity and Adoration of the Shepherds* with, above it, an image of the Archangel Gabriel, and, on the right, the *Adoration of the Magi* with an image of the Annunciate Virgin above it. The centre of the predella, meanwhile, featured the *Lamentation over the Dead Christ*, with the Virgin at the centre cradling the body of her Son. The entire edifice was buttressed by tall piers, the faces of which displayed a series of twenty standing saints, amongst whom appeared the Franciscan saints, Francis and Louis of Toulouse, together with the local Franciscan *beato*, Filippo Ciardelli. Finally, at either end of the predella – acting as bases to the piers – were two further panel paintings depicting the eremitical saints, Anthony Abbot and Paul the Hermit.

Among the detailed records of the local confraternity, the Compagnia di San Pietro, is a record of a contract awarded by them to Bartolo di Fredi in May of 1383.[31]

174. Reconstruction by Gaudenz Freuler of the altarpiece of the Blessed Filippo Ciardelli.

175. Reconstruction by Gaudenz Freuler of the *Coronation of the Virgin* polyptych and the wooden figures framing it.

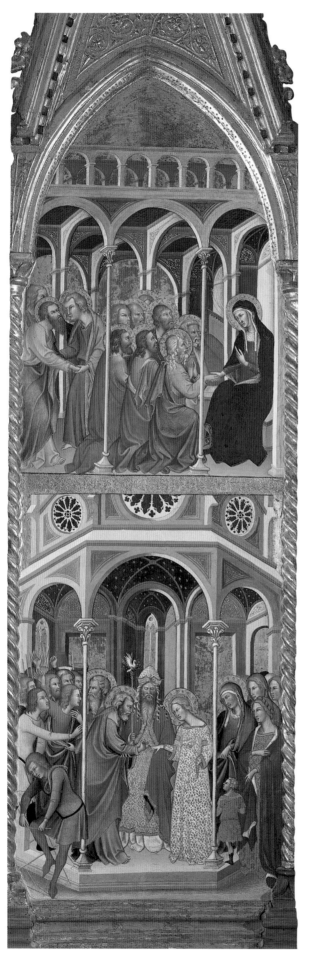
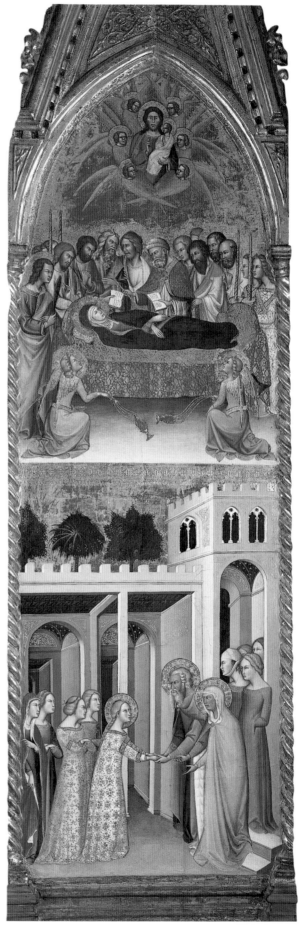

In it, Nuccio di Menchino, acting as procurator on behalf of the confraternity,[32] undertook to pay Bartolo di Fredi for gold leaf and ultramarine and for the painting of a *tavola* for the chapel of the Annunziata in the church of the friars minor in Montalcino.[33] The work was to be completed within a year. The contract gives the intended site of the panel painting as the chapel of the Virgin Annunciate in the church of San Francesco (see Pl. 173), and it was in this location that Bovini described the polyptych of the *Coronation of the Virgin* by Bartolo di Fredi in the mid-eighteenth century.[34] The chapel, which appears to have been the object of building work financed by the confraternity in the early 1360s, was situated in the south transept of the fourteenth-century church.[35] Clearly of some considerable size, the chapel owed its scale to the fact that it had once been the separate oratory of San Michele, ceded to the Franciscans by the abbot of Sant'Antimo in 1285.[36]

The re-dedication of the chapel to the Virgin Annunciate had also been celebrated by the commissioning of two finely polychromed wooden statues of the Archangel Gabriel and the Virgin Annunciate (Pls 178, 179).[37] Painted inscriptions on the bases of the statues indicate that the Virgin Annunciate was executed in 1369 at the behest of 'Agnolo, rector of the Arte dei Calzolai', and that the Archangel

176. (facing page, left) Bartolo di Fredi, *Scenes from the Life of the Virgin*, side panel of the *Coronation of the Virgin* polyptych, 1388. Montalcino, Museo Civico e Diocesano d'Arte Sacra.

177. (facing page, right) Bartolo di Fredi, *Scenes from the Life of the Virgin*, side panel of the *Coronation of the Virgin* polyptych, 1388. Montalcino, Museo Civico e Diocesano d'Arte Sacra.

178. Angelo di Nalduccio, *The Archangel Gabriel*, 1369/70. Montalcino, Museo Civico e Diocesano d'Arte Sacra.

179. Angelo di Nalduccio, *The Virgin of the Annunciation*, 1369/70. Montalcino, Museo Civico e Diocesano d'Arte Sacra.

Gabriel was completed in 1370 by one 'Angelo', at the behest of 'Tofo Bartolino, rector of the Arte dei Calzolai'. It has been suggested that the name 'Angelo' refers to Angelo di Nalduccio, a painter and sculptor who appears as a member of Siena's guild of painters in the records of 1356, 1363 and 1389.[38] It is also possible, however, that he was a member of the Compagnia di San Pietro and thus a Montalcinese since one 'Agniolo di Narduccio' features on a fourteenth-century list of confraternity members.[39] As for the commissioners of these two statues, the plentiful supply of game in the forests around Montalcino made tanning and leather work an important facet of the town's economy.[40] It is not surprising, therefore, that this particular guild had the finances to commission such sculptures. The commissions also imply that members of the guild worshipped in the chapel and indeed, according to the eighteenth-century Franciscan, Bovini, they visited the chapel on the feast day of Saint Nicholas.[41]

As modern reconstruction suggests, Bartolo di Fredi clearly provided the members of the Compagnia di San Pietro with an altarpiece which – in terms of its scale and ambitious programme of imagery – rivalled those painted for prestigious locations in Siena (see Pl. 175).[42] Moreover, much of its subject matter similarly evoked the imagery produced for the most sacrosanct and prestigious of Siena's civic locations. Thus, the central painting of the *Coronation of the Virgin* replicated an image that was prominent on the late thirteenth-century stained-glass oculus for the chancel of the cathedral (see Pl. 43).[43] The Coronation of the Virgin was also the subject of a large fresco, commissioned from Lippo Vanni in 1352 for the tribunal of the magistracy of the Biccherna which met on the ground floor of the Palazzo Pubblico (Pl. 180).[44] Extensively repainted in the mid-fifteenth century, it is difficult to assess the extent to which the present painting replicates the earlier one. It is likely, however, given the original painting's location, that Lippo Vanni's treatment of this subject would have combined religious and civic themes in a manner that would have required no explanation for its first audience, amongst whom would have been

180. Sano di Pietro (with Domenico di Bartolo), *The Coronation of the Virgin*, 1445, replacing an earlier version by Lippo Vanni, 1352. Siena, Palazzo Pubblico, Sala della Biccherna.

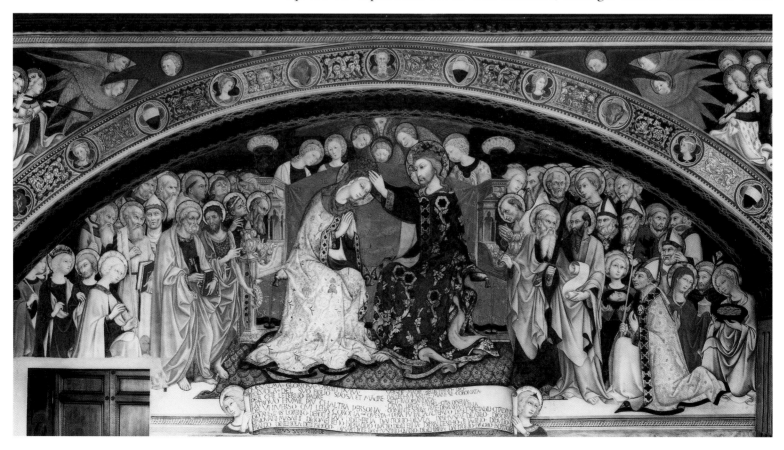

The Contado

181. Bartolo di Fredi, *The Virgin of the Assumption*, upper pinnacle panel of the *Coronation of the Virgin* polyptych, 1388. Montalcino, Museo Civico e Diocesano d'Arte Sacra.

Bartolo di Fredi himself, a frequent visitor to the Palazzo Pubblico, both as painter and government official.[45]

As well as the central panel of the *Coronation of the Virgin*, other aspects of the Marian imagery of Bartolo di Fredi's confraternity altarpiece also echoed key themes and images from the Sienese celebration of the Virgin and her combined religious and civic significance for Siena. Thus, the *Virgin of the Assumption* – represented on the altarpiece directly above the *Coronation of the Virgin* (Pl. 181) – also featured in the imagery of the stained-glass oculus in the cathedral (see Pls 43, 48) and also, probably, on Duccio's *Maestà* as well.[46] Moreover, given the prominent role that Montalcino played in the events surrounding Montaperti and the insistence in all the fourteenth-century *capitoli* that Montalcino should present *ceri* to the Sienese

182. Bartolo di Fredi, *The Archangel Gabriel*, upper pinnacle panel of the *Coronation of the Virgin* polyptych, 1388. Los Angeles, County Museum, Mr and Mrs C. Balch Collection.

183. Bartolo di Fredi, *The Virgin of the Annunciation*, upper pinnacle panel of the *Coronation of the Virgin* polyptych, 1388. Los Angeles, County Museum, Mr and Mrs C. Balch Collection.

authorities on the feast of the Assumption, the elevated position of the *Virgin of the Assumption* within the design of the altarpiece becomes, potentially, even more significant. As in the case of the mid-fourteenth-century illumination embellishing the collection of records of submissions to Siena in the 'Caleffo dell'Assunta' (see Pl. 2), the image of the *Virgin of the Assumption* might readily function as a visual endorsement of the political relationship between the two cities and the Virgin's endorsement of the political *status quo*.

Although the inclusion of paintings of the *Virgin Annunciate* and the *Archangel Gabriel*, framing the *Virgin of the Assumption*, can readily be accounted for by the dedication of the confraternity's chapel (Pls 182, 183), it is also significant that the feast of the Annunciation had become a major civic cult in the devotional life of the Sienese having been fostered especially by the Spedale di Santa Maria della Scala.[47] Moreover, four of the paintings on the altarpiece – two from the predella and two from the side panels (see Pls 175–7) – illustrate subjects which had already been depicted on the façade of the Spedale di Santa Maria della Scala in Siena.[48] If Sano di Pietro's later predella panels are regarded as relatively accurate copies of these fresco paintings, then it appears that in the *Birth of the Virgin* and the *Virgin*

Returning to the House of her Parents, Bartolo di Fredi, although reducing the number of protagonists, deliberately emulated much of the composition and pictorial detail of the Spedale paintings (see Pls 105, 110).[49] The *Betrothal* also apparently shared a similar compositional layout and cast of characters to the Spedale painting but, like Lippo Vanni's treatment of the subject at San Leonardo al Lago, Bartolo di Fredi radically redesigned the architectural setting of the event in order to accommodate his composition to the format available to him (see Pls 108, 140).[50] The *Presentation*, meanwhile, appears to have been more independently conceived – the probable reasons for which will be discussed shortly.

Other imagery on the altarpiece suggests that Bartolo di Fredi included Marian subjects already venerated as painted images within Siena cathedral. Thus, the two scenes from the last days of the Virgin on the upper part of the altarpiece had already featured amongst the pinnacle panels of Duccio's *Maestà* (see Pl. 24), while the *Dormition* had also appeared on the thirteenth-century stained-glass oculus as well (see Pls 166, 43). Finally, the two pinnacle panels of the *Adoration of the Shepherds* and the *Adoration of the Magi* (see Pl. 174) would each, in turn, have echoed aspects of major altarpieces for altars in Siena cathedral.[51]

Despite the very Sienese nature of much of its imagery, it is also apparent that the local patrons exerted an influence upon the iconographical programme of the altarpiece. The Franciscans had a profound devotion to the Virgin reflected in the policies of the order and the writings of their theologians.[52] The high altar of the Upper Church at Assisi was dedicated to the Virgin and its principal apse was embellished with late thirteenth-century frescoes by Cimabue which – like Bartolo di Fredi's altarpiece – combined events from the early life of the Virgin with those of her last days.[53] Most importantly, these frescoes provided an early prototype of a pictorial representation of the Virgin, enthroned with her son in heaven, and acting as a heavenly intercessor on behalf of a group of votaries. Such imagery was wholly appropriate to a Franciscan setting, for whilst on the one hand it provided a compelling illustration of the doctrine of the immaculate conception – a doctrine to which the Franciscans were particularly committed – on the other hand, it celebrated her status as Queen of Heaven through the depiction of her coronation, a subject represented on major altarpieces commissioned in the first half of the fourteenth century for the principal Franciscan churches in Florence and in Venice.[54]

It is also striking that, unlike earlier representations of the Coronation of the Virgin in which both the Virgin and Christ are represented seated on an architectonic throne, in this altarpiece the two figures are represented in a mandorla of red seraphim (see Pl. 172)[55] as are the figures of the Virgin in the *Assumption* and of Christ in the *Dormition* (see Pls 181, 166). It has been suggested that Bartolo di Fredi's adoption of this device was symptomatic of a new spiritual ethos prompted by the instability and insecurity of the plague-ridden decades of the second half of the fourteenth century.[56] Arguably, however, there is a more pertinent explanation. Seraphim had a particular resonance for the Franciscan Order precisely because it was believed that their founder, Saint Francis, received his stigmata from the crucified Christ who was himself enveloped by a winged seraph.[57] Given the location of the altarpiece, Bartolo di Fredi's adoption of a mandorla of seraphim for the coronation theme was, therefore, highly appropriate for the Franciscan context within which the altarpiece was to function.

The representation of Franciscan saints on the piers – including Saint Francis himself and the Blessed Filippo Ciardelli, a protégé of Saint Anthony of Padua, reputed to have been at Francis's funeral – provides further evidence of the influence of local Franciscan interests upon the design of this altarpiece. In the middle decades of the

184. Bartolo di Fredi, *The Expulsion of Joachim from the Temple*, panel from the front predella of the *Coronation of the Virgin* polyptych, 1388. Montalcino, Museo Civico e Diocesano d'Arte Sacra.

thirteenth century Fra Filippo established himself in a rural hermitage at Colombaio, on the slopes of Monte Amiata, south-west of Montalcino, where he secured for himself the reputation of a holy man capable of miraculous levitation.[58] As in the case of the Augustinian Hermits of Siena and the Blessed Agostino Novello (see Pl. 147), the Franciscans of Montalcino were anxious to promote the cult of this local holy man after his death circa 1290. At an unknown date, but certainly before 1369, they duly transferred his remains to Montalcino and established an altar in his honour in the north aisle of their church (see Pl. 173).[59] In 1382, six years prior to the completion of the *Coronation of the Virgin* polyptych, Bartolo di Fredi painted an altarpiece for that altar (see Pl. 174). Although primarily celebrating Christ's deposition from the Cross, it also included two prominently displayed narrative paintings commemorating the identity and perceived sanctity of this local *beato*.[60]

The Passion imagery of the Ciardelli altarpiece would also have been highly appropriate for the Franciscans of Montalcino, since the order had a marked devotion to the Passion because of their founder's experience of the stigmata. Significantly, the subject of the centre-piece of the predella for both the Ciardelli altarpiece and the *Coronation of the Virgin* polyptych was the *Lamentation over the Dead Christ* (see Pls 174, 175). Closely derivative of an earlier painting of this subject by Ambrogio Lorenzetti – possibly for an altarpiece for the church of a Franciscan convent[61] – the subject was also highly apposite for a predella which would stand on the altar table precisely at the point where the consecrated host was placed at the

celebration of mass. Moreover, in the *Coronation of the Virgin*, it is striking that the predella was once framed at either end by paintings showing almost identical representations of the Temple. Within the Temple, in each case, is an altar on which is prominently displayed an object similar in design to that of contemporary ciboria designed to house the consecrated host or Corpus Christi (Pl. 184).[62] Finally, the portrayal of various social classes venerating the 'body' of the young Christ Child in the two pinnacle scenes of the *Adoration of the Shepherds* and the *Adoration of the Magi* would also have had strongly eucharistic associations for those worshipping before the altarpiece (see Pl. 175).

As well as appealing to the Franciscans themselves, the eucharistic dimension to the iconographic programme of the altarpiece would also have supported and facilitated the devotional needs of members of the Compagnia di San Pietro who, in their confraternity statutes of 1330, were required to go daily to church to hear mass or, at least, view the Corpus Christi (Pl. 185).[63] In the early fourteenth century, the Compagnia appears to have been a typical flagellant or Disciplinati confraternity, committed to performing acts of collective penance in imitation of Christ's Passion. By the mid-fourteenth century, however, it appears that the Compagnia di San Pietro had become a fully-fledged Laudesi company whose primary function was the singing of *laude* or hymns in praise of the Virgin. The confraternity's commissions for the Cappella dell'Annunziata and its embellishment mark an important stage in this shift of emphasis.[64]

The 1330 statutes of the confraternity reveal that, in common with other late medieval confraternities, its members were expected to hear daily mass and to recite daily a number of Lord's Prayers and Ave Marias in honour of the Passion and the Holy Cross.[65] Twice weekly, on Friday and Sunday, they were also required to participate in penitential exercises and prayers.[66] From the account – given by Bovini in the eighteenth century – of a papal indulgence awarded to the confraternity in 1369, however, it appears that, by this date, it was customary to sing *laude* within the chapel.[67] Apart from such daily spiritual exercises, they also marked particular feast days with further ceremonies. Thus the statutes of 1330 instruct the *confratelli* to process to all the other churches of Montalcino on Good Friday and the first Sunday in Lent.[68] The 1369 papal indulgence further encouraged them to celebrate amongst other feasts, the feast days of Christmas and Epiphany and of the Franciscan saints

185. Bartolo di Fredi, *The Lamentation*, panel from the front predella of the *Coronation of the Virgin* polyptych, 1388. Montalcino, Museo Civico e Diocesano d'Arte Sacra.

Francis, Louis of Toulouse and the Blessed Filippo Ciardelli – all of which receive acknowledgement within the rich imagery of the altarpiece. A few months later, another indulgence, dated 9 March 1370, offered the *confratelli* strong spiritual incentives to mark the Marian feasts of the Birth, Annunciation, Purification and Assumption of the Virgin with particular devotion.[69] It is striking, therefore, that three of these Marian feasts – the Birth, the Annunciation and the Assumption of the Virgin – are all commemorated very prominently on the confraternity's altarpiece. The confraternity statutes further instruct its members not to visit public houses or indulge in card playing and bad language.[70]

Bartolo di Fredi's *Coronation of the Virgin* altarpiece would, therefore, have acted as a powerful and visually compelling focus for the devotional activities of the Compagnia di San Pietro (see Pl. 172). The triumphant and joyous nature of the subject of the Coronation of the Virgin itself would have emphatically endorsed and celebrated the confraternity's growing commitment to the cult of the Virgin and her Son. Furthermore, the detail in the foreground of the painting of two music-making angels, one playing a portable organ and the other, a viol, would have complemented the confraternity's practice of singing *laude* before the image.[71] Indeed, the surviving lyrics of contemporary *laude* provide strikingly close textual equivalents to the kinds of imagery evoked by Bartolo di Fredi's depiction of the Virgin as the embodiment of both queenliness and humility.[72] Similarly, the striking detail of the flowering lilies in the tomb below the Virgin of the Assumption finds a close parallel in the lyrics of contemporary sacred music in which floral metaphors for the Virgin were frequently evoked.[73]

The choice of the last days of the Virgin as the subject for the upper paintings on the side panels also allowed for the detailed depiction of the Virgin's funeral exequies – a significant theme since members of the Compagnia di San Pietro would regularly attend the funerary rites and commemorative masses of their deceased companions.[74] It is notable, therefore, that in the *Dormition*, Bartolo di Fredi took great care to portray the liturgical detail of such funerary rites (see Pl. 166). Thus, two angels in the foreground gracefully swing thuribles full of incense, whilst four others carry tall wax candles, a customary feature of fourteenth-century funerals. Further evidence that this scene would have had a particular relevance for the members of the Compagnia di San Pietro is provided by the relatively rare detail of Saint Peter, in priestly vestments, officiating at this event. Already included amongst the company of saints on the framing piers of the altarpiece, this distinctive portrayal of their titular saint participating in the Virgin's funeral rites would undoubtedly have had a particular resonance for Bartolo di Fredi's confraternity patrons.[75]

There also remains the intriguing question of why, on the side panels, the betrothal of the Virgin and the relatively rarely depicted scene of the Virgin returning to her parents' house were afforded greater importance on the altarpiece than the more canonic subject of the birth of the Virgin which appeared only on the predella, despite having a feast day dedicated to it (see Pls 175, 186). It has already been suggested that one factor that may well have influenced their inclusion was a desire to emulate the paintings on the façade of the Sienese Spedale di Santa Maria della Scala.[76] It is significant, therefore, that in the 1360s, the former Prior of the Compagnia di San Pietro, Ser Griffo di Ser Paolo, was also a member of the Compagnia degli Raccomandati di Giesù Christo Crocifisso attached to the Spedale in Siena.[77] The betrothal of the Virgin and her return to her parents' house were, as argued earlier, of particular relevance to the Spedale authorities because of the hospital's charitable activity of raising orphaned girls and then, subsequently, providing them with dowries.[78] A body of close-knit historical evidence indicates that the Compagnia di San Pietro had close relations with the two largest and most

186. (facing page) Bartolo di Fredi, *The Virgin Returning to the House of her Parents*, side panel of the *Coronation of the Virgin* polyptych, 1388. Montalcino, Museo Civico e Diocesano d'Arte Sacra.

The Contado

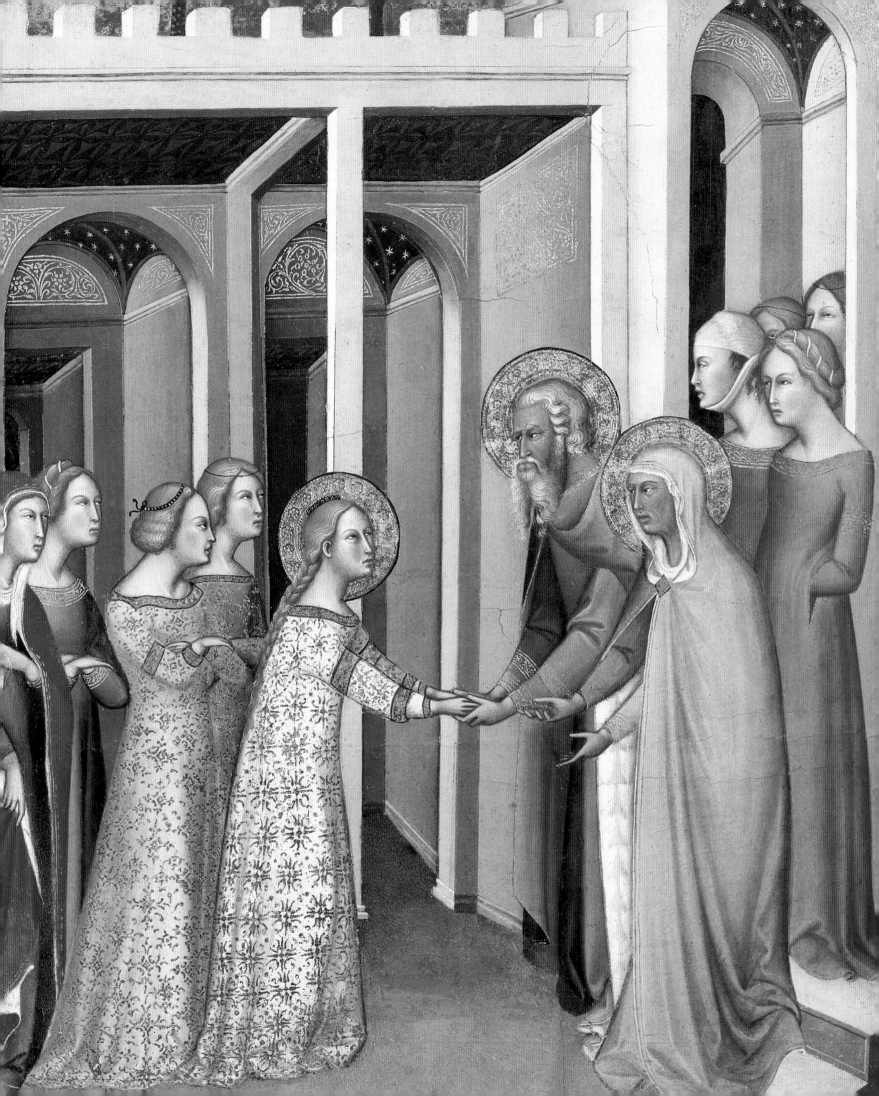

187. Bartolo di Fredi, *The Nativity and Adoration of the Shepherds and Saints*, late 1390s. Torrita di Siena, SS Fiora e Lucilla.

prosperous hospitals in Montalcino – the Spedale della Misericordia and the Spedale di Santa Maria della Croce (see Pl. 170, no. 3)[79] – both of which shared many of the functions of the Spedale di Santa Maria della Scala, caring for the sick, offering accommodation to travellers, distributing food to the poor, and, most importantly, rearing young orphan girls and furnishing them with dowries for marriage.[80] These charitable institutions also had close links with the Franciscan community at San Francesco.[81] Thus, as in the case of the *Dormition of the Virgin*, the two scenes from the early life of the Virgin enjoyed an additional significance. By

depicting events associated with the social rituals and practices of marriage, these two paintings further dignified the pious and charitable activities of the Compagnia di San Pietro which commissioned the altarpiece from Bartolo di Fredi (see Pls 176, 177, 186).

Some ten years after his completion of the *Coronation of the Virgin* polyptych for the confraternity of Saint Peter, Bartolo di Fredi was commissioned to produce another altarpiece with an ostensibly Marian theme for Montalcino.[82] Painted for a chapel in Sant'Agostino – the church of the Augustinian Hermits which, almost a century earlier, had been the recipient of a bequest from Tavena Tolomei – the circumstances of its commission have only recently been reconstructed. Now located over a side altar in the parish church of SS. Fiora e Lucilla in Torrita di Siena and securely attributed to Bartolo di Fredi,[83] the principal interest of the painting hitherto had been its possible significance as an indication of the original appearance of the mid-fourteenth-century altarpiece for the altar of Saint Victor in Siena cathedral (Pl. 187).[84] It had also been acknowledged, however, that the prominent appearance in the altarpiece of Saints Augustine and Anthony Abbot – two saints particularly revered by the Augustinian Hermits – strongly suggests that its original location was once a church belonging to that order. Moreover, Torrita di Siena – rebuilt by the Sienese in the mid-thirteenth century as a garrison town on their extreme southeast border – had no such church.[85]

It has, therefore, been argued that the most likely original location for this altarpiece was the church of Sant'Agostino in Montalcino,[86] and more specifically that it was commissioned for a chapel known as the Cappella del Parto – the chapel of the birth of Christ[87] – attached to the north wall of Sant'Agostino. Still visible in early photographs, the chapel was dismantled in 1937 in order to create the present side entrance to Sant'Agostino (Pl. 188).[88] It has further been suggested that the patronage of this chapel belonged to the confraternity of the Spedale di Santa Maria della Croce – a devotional body attached to the hospital of that name – and that its construction had been made possible by a generous bequest of land, made on 31 May 1388, to the rector of the hospital, by Petra Cacciati.[89] Petra's interest in this chapel was further confirmed by her decision to make the Spedale di Santa Maria della Croce her universal heir in December 1401.

There is much to commend the proposal that the *Nativity and Adoration of the Shepherds* was designed for the Cappella del Parto in Sant'Agostino and that the altarpiece was commissioned from Bartolo di Fredi by Petra Cacciati. Three unpublished documents in the Archivio Comunale of Montalcino, all dated to the first decade of the fifteenth century, link Petra to the foundation and endowment of a chapel in Sant'Agostino. On 7 September 1402, the Augustinian Hermits of Sant'Agostino, meeting in their chapter, agree to observe unspecified obligations placed on them by Lady Petra.[90] Another document – undated, but in a hand closely similar to that of the 1402 document – provides a detailed account of the expenditure by one Antonio[91] on the chapel of Santa Maria in Jesu in Sant'Agostino, built from a bequest made by Petra, widow of Bartolommeo Longarucci. This document further records the decision on the part of the *operai* of the church to use the remainder of Petra's bequest to fund the salaries of both Augustinian and Franciscan clergy to celebrate masses in the chapel on the feasts of the Nativity and the Birth of Saint John the Baptist. The *operai* also agreed that the rector of the Spedale di Santa Maria della Croce should institute a celebration of the feast of the Visitation in the new chapel.[92] The third document – also undated but closely related to the previous document – records an appeal from the *operai* to the rector of the Spedale that he provide the liturgical equipment necessary for the newly instituted celebration of the feast of the Visitation.[93] Although now referring to the chapel as the

188. Montalcino, exterior of Sant'Agostino before restoration in 1937.

189. Bartolo di Fredi, *Saint Augustine*, detail of Pl. 187.

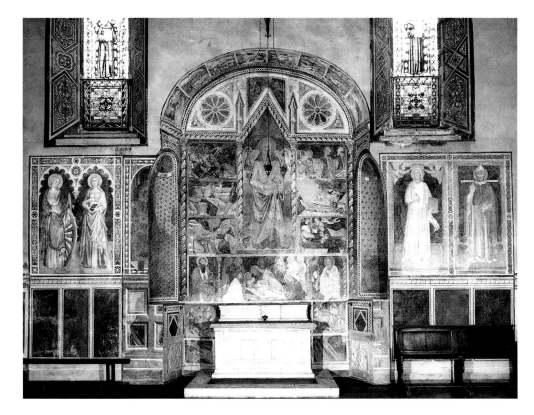

190. *Saint Anthony Abbot and Scenes of his Life (with the Lamentation and Saints),* late fourteenth century. Montalcino, Sant'Agostino.

chapel of Santa Maria in Jesu, these three documents make it clear that in the first decade of the fifteenth century the Spedale di Santa Maria della Croce enjoyed the patronage of an important new chapel in Sant'Agostino and that it had been funded by Petra's wealth and generosity.[94] It is also significant that the officials responsible for the new chapel singled out the Nativity as one of the chapel's principal liturgical feasts. The subject of the adoration of the shepherds would have been entirely apt for an altar in a chapel designed to celebrate annually the birth of Christ.

The Augustinian Hermits of Montalcino also had a particular devotion to the two saints – Augustine and Anthony Abbot – represented on the side panels of this altarpiece (Pls 187, 189). Further evidence for such veneration of these two saints occurs in the early frescoed decoration of the church. Thus the chancel still contains extensive remains of a frescoed scheme which combines paintings from the lives of Saints Phillip and James the Minor, with paintings celebrating the life and theology of Saint Augustine. This cycle has plausibly been attributed to Bartolo di Fredi himself and is generally given a date of circa 1388–90 – shortly after the completion of the *Coronation of the Virgin* polyptych.[95] The inclusion of Saints Phillip and James the Minor in this cycle may be explained by the fact that, although known as Sant'Agostino, the church was, in fact, dedicated to these two apostles.[96] On the south wall of the church, meanwhile (directly opposite the original entrance to the Cappella del Parto), is a large, frescoed altarpiece depicting Saint Anthony Abbot surrounded by six scenes from his legend (Pl. 190). Although the identity of the painter and the date of the commission are not known, it is likely that it was executed in the fourteenth century at the request of the local Compagnia di Sant' Antonio Abate, thus providing an imposing testimony of the veneration to which this eremitical saint was held within this particular church.[97]

Petra Cacciati, the proposed commissioner of the altarpiece, is known to have had a number of contacts with both the Augustinian Hermits of Montalcino and with Bartolo di Fredi himself. Highly committed to the Spedale di Santa Maria della Croce, she may herself have been an Augustinian tertiary.[98] An inscription in the chancel of

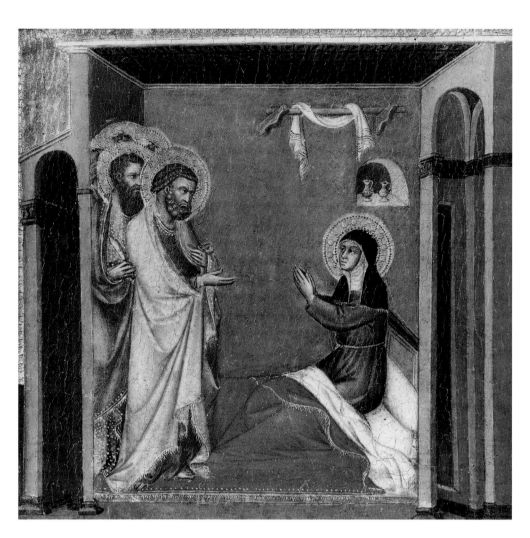

191. Bartolo di Fredi, *The Healing of Saint Petronilla*, c. 1380–3. Siena, Pinacoteca.

Sant'Agostino indicates that she was also responsible for the commissioning of the stained-glass which survives today in the window of the chancel and displays a series of saints, including Saint Augustine, and a representation of the Trinity – a theological doctrine on which the saint wrote a major work.[99] Some fifteen years earlier, Petra's sister, Lina Cacciati, had probably commissioned an altarpiece from Bartolo di Fredi for the altar of the family chapel in San Francesco. Now dismantled and located partly in Lucignano d'Asso, a former *contado* town on Siena's south-eastern border, and partly in the Pinacoteca in Siena, it appears that the choice of imagery was dictated by predominantly familial concerns.[100] Indeed, the inclusion in the predella of the altarpiece of the relatively unusual scene of Saint Peter healing Saint Petronilla may well have been intended as graceful tribute to Petra herself and a reference to the close involvement of the two sisters with the hospitals of the Misericordia and Santa Maria della Croce in Montalcino (Pl. 191).[101]

There is, therefore, a substantial and persuasive body of evidence to support the proposal that the *Adoration of the Shepherds* altarpiece from Torrita di Siena was originally painted for the Cappella del Parto in Sant'Agostino in Montalcino. What, then, may be said of the earlier suggestion, by a number of scholars, that this altarpiece offers an example of the likely appearance of the Saint Victor altarpiece for Siena cathedral, prior to its subsequent dismemberment (see Pls 76, 89)? The suggestion remains both plausible and intriguing. It remains plausible because, faced with a commission for an altarpiece that combined side panels depicting standing saints with a central narrative scene of the Adoration of the Shepherds, Bartolommeo Bulgarini's Saint Victor altarpiece would have provided Bartolo di Fredi with an obvious, but also highly prestigious, precedent – and one located, moreover, in a

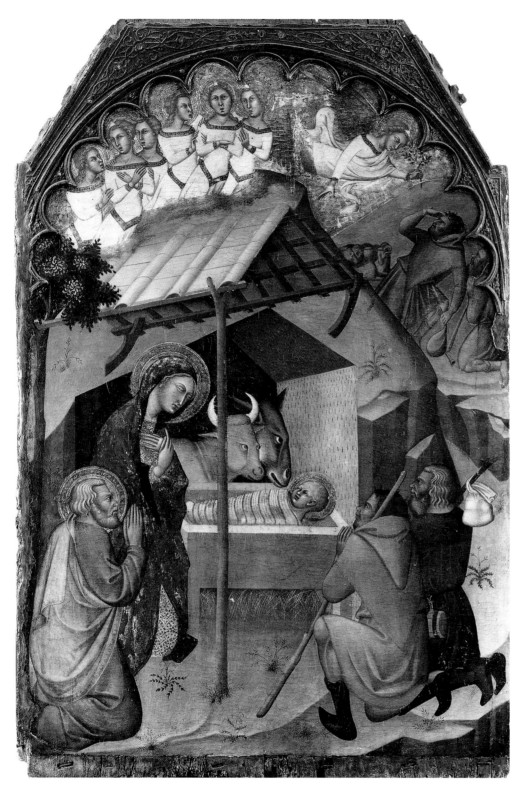

192. Bartolo di Fredi, *The Nativity and Adoration of the Shepherds,* 1374. New York, The Metropolitan Museum, The Cloisters Collection, 1925 (25.120.288).

church with which Bartolo was fully familiar, having worked in Siena cathedral extensively during previous decades.

The suggestion that the Adoration of the Shepherds may thus owe something to the Saint Victor altarpiece is also intriguing, however, not least because it demonstrates, once again, the way in which Bartolo di Fredi reworked the imagery of a prestigious model in order to fulfil the particular needs of an altarpiece embellishing an altar dedicated to the birth of Christ and located in an Augustinian church. Thus, as previously noted, the identities of the saints represented on the side panels were particularly relevant to the church of Sant'Agostino in Montalcino. The treatment of

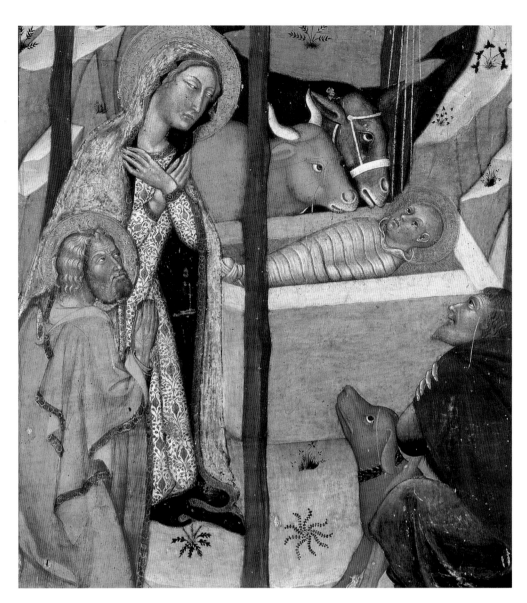

193. Bartolo di Fredi, *The Virgin Venerating the Christ Child*, detail of Pl. 187.

the central subject of the Adoration was also subtly different from that of Bulgarini in the Saint Victor altarpiece. Bulgarini's portrayal of the Virgin gave her a prominence and centrality appropriate to the Marian focus of the entire programme of four altarpieces designed for the east end of Siena cathedral. In his Montalcinese altarpiece, however, Bartolo di Fredi reduced the prominence and centrality of the Virgin, portraying her not seated upon the ground, but kneeling in veneration before her new-born son – an adaptation he had already used in earlier paintings of this subject (Pls 187, 192).[102] Possibly based on the influential account of the birth of Christ by the fourteenth-century visionary Bridget, who had died in Rome in 1373 and been canonised in 1391,[103] this pose for the Virgin replicates that of the shepherds and of Saint Joseph and, in so doing, renders the veneration of the Christ Child the central theme of the painting. Such a shift in emphasis is entirely apt for an altarpiece designed as the principal painted embellishment of a chapel dedicated to the birth of Christ.

Bartolo di Fredi's two late fourteenth-century Marian altarpieces for Montalcino thus provide further striking examples of the complexity of the cultural and artistic contacts that existed between fourteenth-century Siena and its *contado* towns – thereby continuing a pattern that had begun several decades earlier with Ambrogio Lorenzetti's *Maestà* for the Augustinian Hermits of Massa Marittima. Both the altarpieces examined in detail in this chapter provide evidence

194 (facing page) Bartolo di Fredi, *Music-making Angels*, detail of Pl. 172.

of their painter self-consciously introducing subject matter and imagery which emulated or evoked earlier prestigious paintings and images from the cathedral of Siena – and in the case of the complex *Coronation of the Virgin* polyptych, such emulation also extended to the façade paintings of the Spedale di Santa Maria della Scala as well. At the same time, however, Bartolo di Fredi also took care to introduce into his altarpiece paintings for Montalcino details and references with a specific, local and Montalcinese significance – as his patrons no doubt requested and required. The preservation of such a balance between 'Sienese' and 'local' interests and influences was, as seen in earlier chapters, entirely characteristic of the works of art produced by Sienese artists for locations within the Sienese *contado* and under the political control of the Sienese state.

It was also, however, a natural result of a variety of personal contacts which existed between individuals, organisations and institutions in Siena and Montalcino. Thus, for example, as well as working as a painter in Siena and serving on various Sienese government committees, Bartolo di Fredi also represented the Sienese government in Montalcino and worked as a painter there too. Conversely the painter and sculptor Angelo di Nalduccio, who appears to have been a member of the Montalcinese confraternity of San Pietro – and who may well, therefore, have been Montalcinese – was also a member of the Sienese Consiglio Generale.[104] Similarly, the prominent Montalcinese lawyer, Ser Griffo di Ser Paolo, had established an impressive network of political and religious contacts in Siena during the 1350s and 1360s – contacts subsequently maintained by his son Jacopo in the 1390s.[105] In addition to such individual contacts, moreover, the Franciscan and Augustinian orders in Montalcino must also have enjoyed significant contacts with their respective brother communities in Siena.[106] The richness and intricacy of such personal and institutional histories goes far towards explaining both the success of Bartolo di Fredi in securing commissions for work in Montalcino and also the subtle interplay of Sienese and Montalcinese themes within the resulting works of art.

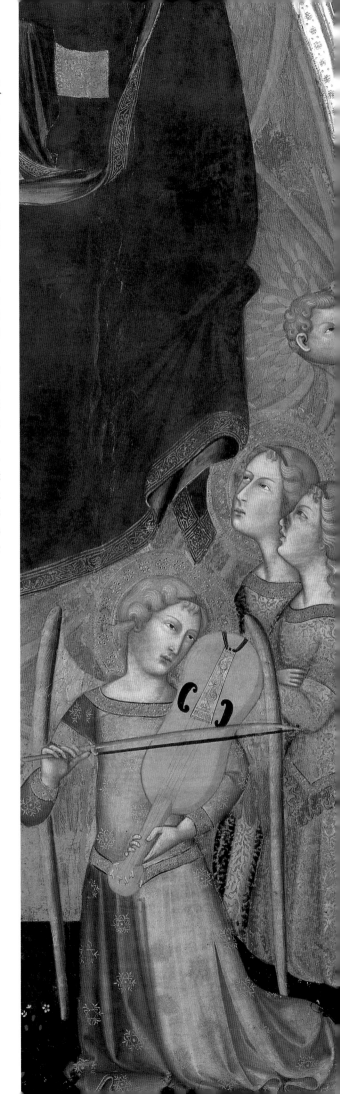

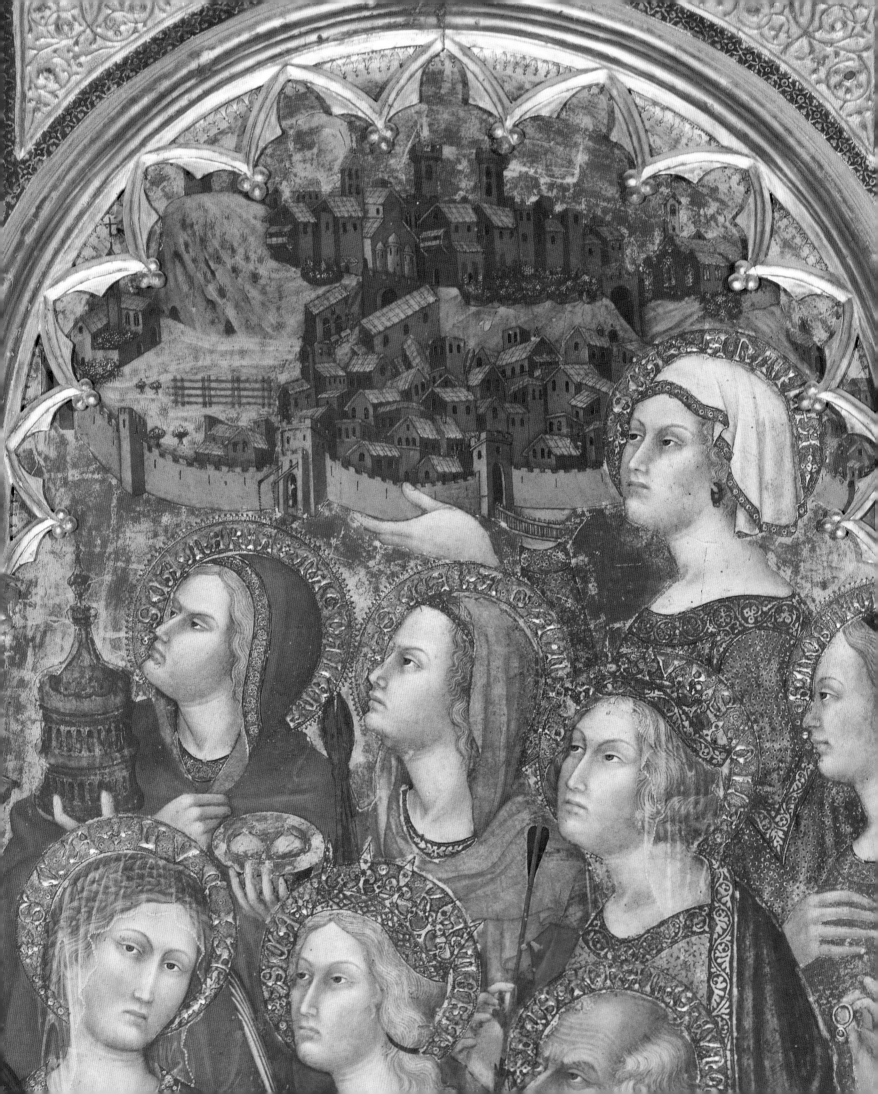

9

Montepulciano and Siena

Some thirty years before the production of the *Coronation of the Virgin* polyptych for San Francesco in Montalcino, another Sienese painter, Jacopo di Mino del Pelliccaio, painted the same subject for a church in Montepulciano (Pl. 196).[1] Now housed in the Museo Civico of the town, it was originally in the oratory of a local confraternity – the Compagnia dei Neri – which, until its suppression in the eighteenth century, was one of the wealthiest and most prestigious lay organisations in Montepulciano.[2] The commission for this particular Marian subject suggests that – like the Compagnia di San Pietro in Montalcino – the Compagnia dei Neri intended to use the painting as a focus for the singing of *laude* in honour of the Virgin. The specific circumstances surrounding this commission can no longer be determined precisely but the choice of Jacopo di Mino del Pelliccaio as the painter demonstrates once again the extent to which, during the fourteenth century, Sienese art and artists exerted a significant cultural influence upon the principal towns and cities located within the Sienese *contado* – even when, as in the case of Montepulciano, Sienese political control was far from secure or straightforward.

Lying 44 kilometres to the south-east of Siena and documented as a castle as early as the eighth century, by the beginning of the thirteenth century Montepulciano was an independent commune claiming political control over the surrounding countryside (see Pl. 7). It thus came into conflict with Siena, itself intent upon expanding its southern borders and incorporating into its territory lands and castles in the vicinity of Montepulciano.[3] Accordingly, as a means of resisting Siena's advance, the Montepulcianesi swore allegiance to Florence in 1202. Thereafter, the question of who controlled Montepulciano – Siena or Florence – became a crucial aspect of the town's political history. In 1232 the Sienese succeeded in conquering Montepulciano and razing its fortress, walls and towers. Three years later, however, Siena renounced its rights over Montepulciano and contributed 8000 *lire* for the reconstruction of the town's fortifications. In 1261, after the victory of Montaperti, Siena regained control of Montepulciano and a year later Siena's Consiglio Generale agreed to construct a fortress on the 'Sasso' – which marks the highest point of the town and also the site of its earliest habitation. In 1266, the Montepulcianesi again rebelled against the Sienese and joined the Guelph party of Tuscany under the leadership of Florence. With the advent of the pro-Guelph regime of the Nine in Siena in 1287, however,

195. Taddeo di Bartolo, *Saint Antilla Presenting Montepulciano to the Virgin*, detail of Pl. 198.

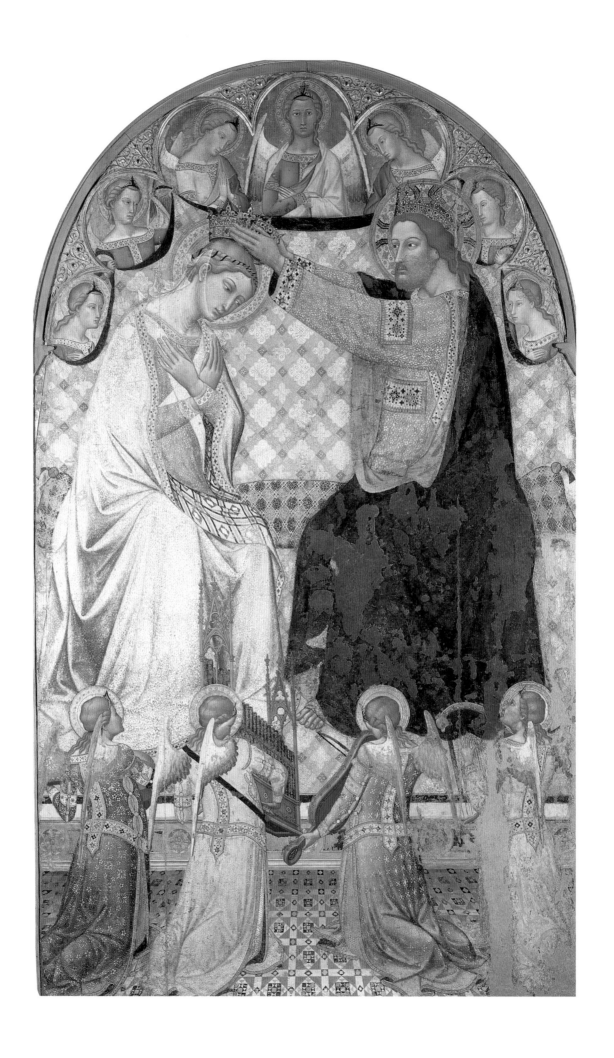

there began a long period of relative stability for Siena and Montepulciano with the Florentines giving their tacit support to Siena's claims over Montepulciano. Thus, on 13 June 1294, the Sienese signed a treaty with the Montepulcianesi where the latter were defined as 'the very devoted sons of the Commune and the Popolo of Siena'. The Montepulcianesi agreed to offer an annual tribute of a *cero*, fifty pounds in weight, on the feast of the Assumption; to accept Sienese appointees as their Podestà and Capitano; to participate in Sienese military enterprises; to grant citizenship to Sienese who purchased property in their town; and not to impose tolls on Siena's citizens and residents of Siena's *contado*. The enduring importance of the treaty of 1294 is signalled by its inclusion in the prestigious 'Caleffo dell'Assunta' and the 'Libro dei Censi' of 1400.[4]

From the mid-fourteenth century onwards, however, Montepulciano itself was dogged by civic unrest arising from the emergence of a single, dominant family, the Del Pecora. Political agitation fomented by one or other faction within the family was frequently supported by Siena or Florence – and also occasionally by Perugia to the east of Montepulciano whose government also wished to extend its political dominion in that region. As a result of such alliances, Sienese control of the city was less secure than the treaty of 1294 implied. Thus, in April 1353, a few months after an unsuccessful attempt by Iacopo del Pecora to make himself *signore*, the Commune of Montepulciano made a twenty year agreement with Siena reconfirming the political supremacy of the latter,[5] but only two years later, in 1355, as a result of the political crisis in Siena and the fall of the government of the Nine, Montepulciano again rebelled against Sienese dominion – a rebellion this time assisted by the support of the Perugians and a temporary accommodation within the Del Pecora family. Florentine and papal intervention once more secured the acceptance of Sienese rule by Montepulciano, although with an increased degree of political autonomy. Further factional disputes involving the Del Pecora occurred in 1364, 1368 and 1385, when Florentine mediation was again instrumental in securing an eventual agreement between Siena and Montepulciano in 1387. As this recurring pattern suggests, however, in reality, Siena's capacity to control the political situation in Montepulciano had progressively diminished from the mid-fourteenth century onwards while Florence, in its role as mediator and peacemaker, had steadily consolidated its own hold over the town. In 1390, the process moved a stage further when, threatened by the depredations of mercenary companies and the fear of political domination by Gian Galeazzo Visconti of Milan, Montepulciano formally accepted Florentine sovereignty, agreeing to have Florentine appointees as Podestà, Capitano del Popolo and castellan and to pay considerable financial tribute. A decade and a half later in 1404, with a change of government in their own city, the Sienese, in turn, signed a treaty with Florence recognising Florentine suzerainty over Montepulciano.

Despite its unstable political history, late medieval Montepulciano constituted a prosperous town graced by a number of imposing secular and ecclesiastical buildings (Pl. 195).[6] Located on the 'Sasso' were the principal civic buildings of the Palazzo Comunale (Pl. 197), the Palazzo del Capitano and the Pieve, together with, on the northern side, the fortress, an ancient edifice which had been successively re-fortified over the centuries. By the fourteenth century, the town also boasted churches and religious houses belonging to the principal mendicant orders.[7] Like Siena and Montalcino, Montepulciano also had a number of hospitals[8] whose charitable functions continued until well into the nineteenth century. Fragments of early fourteenth-century frescoes in the town's mendicant churches provide further circumstantial evidence that the Montepulcianesi tended to rely on Sienese expertise for the embellishment of their churches. It was not until the very end of the fourteenth century, however, that they commissioned a Marian altarpiece of comparable

197. Montepulciano, the Palazzo Comunale.

196. (facing page) Jacopo di Mino del Pelliccaio, *The Coronation of the Virgin*, 1350s. Montepulciano, Museo Civico.

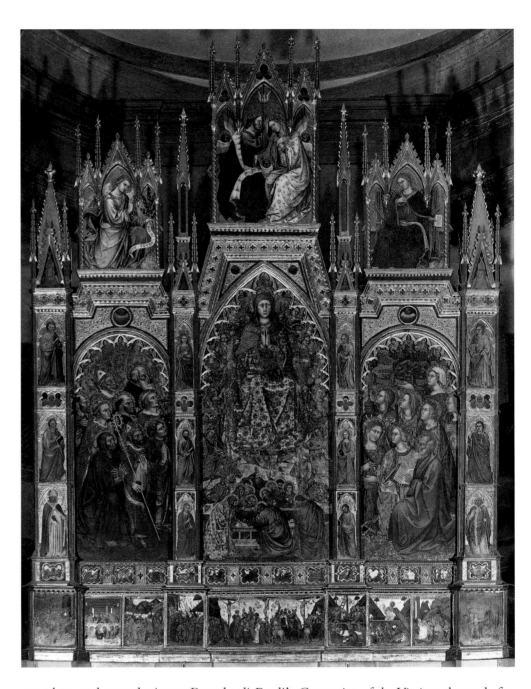

198. Taddeo di Bartolo, *The Virgin of the Assumption and Saints*, 1401. Montepulciano, cathedral.

grandeur and complexity to Bartolo di Fredi's *Coronation of the Virgin* polyptych for Montalcino. Ironically, therefore, as the date of the altarpiece attests, Taddeo di Bartolo – the Sienese painter responsible for the work – only completed the painting in 1401, by which time Montepulciano had effectively become a subject town of Florence, not Siena (Pl. 198).

The monumental altarpiece in question, which rivals Duccio's *Maestà* in scale, still functions as the high altarpiece of the cathedral in Montepulciano – although in a setting extensively remodelled in later centuries.[9] Although suffering from considerable wear and tear, it thus presents a rare example of a late medieval altarpiece continuing to perform the liturgical and devotional role for which it was originally intended.[10] Its principal panel depicts the Virgin's assumption into heaven, attended by the apostles whose expressions of wonder underline the extraordinary nature of this miraculous event (Pl. 199). On the side panels, meanwhile, appear male and female saints also witnessing the Virgin's triumphal ascent into heaven (Pl. 198). Above the main register are three pinnacle panels representing, respectively, the

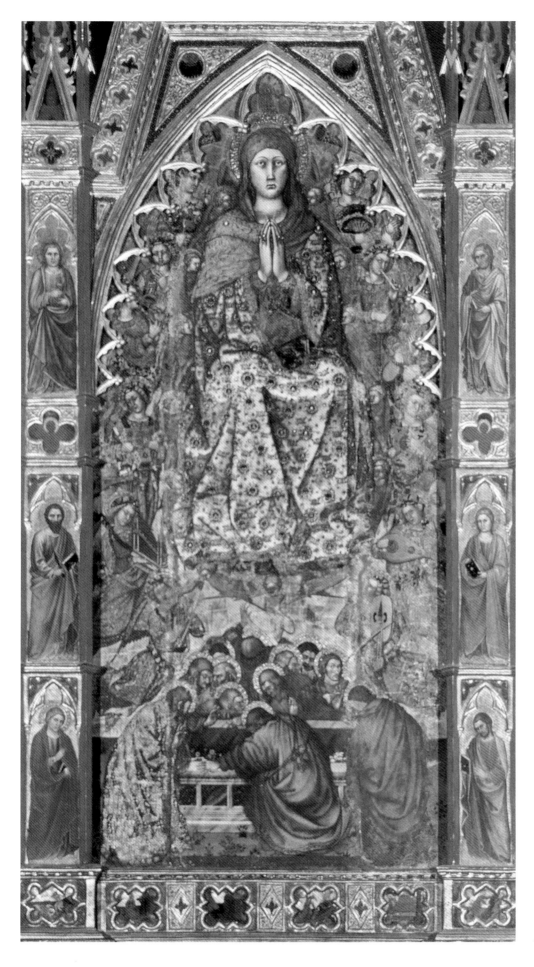

199. Taddeo di Bartolo, *The Virgin of the Assumption*, detail of Pl. 198.

Coronation of the Virgin, the Archangel Gabriel and the Virgin Annunciate. The subject matter of the predella, meanwhile, through a sequence of eleven scenes depicting the Passion of Christ, recalls the rear face of Duccio's *Maestà*. Finally, the Old Testament series which forms a historiated border between the lower edges of the main paintings and the predella,[11] and the series of twelve saints on the pilasters, further extend the extremely ambitious programme of religious imagery on this altarpiece.

The circumstances of the commissioning of this monumental altarpiece for the high altar of Montepulciano's principal church are relatively easy to reconstruct. An inscription below the tomb of the Virgin on the central painting names Taddeo di Bartolo as the painter, gives a truncated date of 1401, and associates the commission with one Jacopo di Bartolommeo, arch-priest of Montepulciano.[12] The Pieve had attained the status of being administered by an arch-priest in 1217 and by 1318 this official presided over a chapter of six canons.[13] Jacopo di Bartolommeo, the arch-priest at the time of Taddeo di Bartolo's commission, was a member of the Aragazzi, a local family of wealthy notaries and merchants. Jacopo's younger brother, Francesco, in whose house he chose to live and whose general heir he became, was one of Montepulciano's richest men, owning extensive properties in both the town and the *contado*.[14] On 9 April 1400, Jacopo further enhanced his status and that of his successors by obtaining, from Pope Boniface IX, the title of abbot, the right to wear a mitre and carry a crosier, and the power to ordain minor orders of clergy. The Pieve and its clergy were also removed from the jurisdiction of the Bishop of Arezzo and placed directly under papal control. It seems entirely plausible, therefore, that the imposing polyptych was commissioned specifically to celebrate Jacopo Aragazzi's newly-won ecclesiastical preferment and that it was probably installed on the high altar of the Pieve on the feast of the Assumption in 1401.[15]

The choice of Taddeo di Bartolo as painter certainly reflected his well-established status by the beginning of the fifteenth century. As well as having a workshop in Siena itself, Taddeo di Bartolo had also produced both altarpieces and fresco paintings for a number of locations outside his native city, including commissions in Pisa, Genoa and, perhaps, Padua.[16] In 1400 he secured an important commission in Siena for an altarpiece for the Compagnia di San Michele Arcangelo which met in the vaults of the Spedale di Santa Maria della Scala,[17] and subsequently in the first two decades of the fifteenth century he was to secure prestigious commissions in Siena as well as in Perugia, San Gimignano and Volterra.[18] It is also possible, however, that the commission for the altarpiece in Montepulciano resulted, in part, from Sienese contacts of the Aragazzi family. Francesco Aragazzi owned agricultural land a few kilometres outside Siena and also had the right of inheritance to a house, belonging to his cousin, located in the *terzo* of San Martino, the part of Siena in which Taddeo himself lived and where he had his workshop.[19]

The choice of principal subject for the Montepulciano altarpiece was undoubtedly determined primarily by the dedication of the Pieve to the Virgin – a dedication which probably dated back to the eighth century.[20] Moreover, it may also have been the case that the high altar was specifically dedicated to *Maria Assunta*.[21] The subject also, of course, carried political connotations for Montepulciano and the history of its relationship with Siena, although by this date the obligation to send a wax candle to Siena on the feast of the Assumption may well have fallen into abeyance.[22] Even if this was, indeed, the case, however, the new altarpiece remained, in many respects, a distinctively Sienese rendition of this Marian subject. As in many prestigious thirteenth- and fourteenth-century Sienese images, the Virgin appears as a seated figure, enclosed in a mandorla, facing outwards towards the spectator, with her hands clasped in prayer (Pl. 199). Possibly inspired by Bartolommeo Bulgarini's use

200. Taddeo di Bartolo, *The Apostles around the Tomb of the Virgin*, detail of Pl. 199.

of *pastiglia* work and inset stones on the *Assumption of the Virgin* for the Spedale di Santa Maria della Scala (see Pl. 161), Taddeo di Bartolo further dignified the Virgin's status as queen of heaven by portraying her in a white mantle embellished both with the words 'Ave', worked in gold leaf, and coloured crystals, embedded in gilt pastiglia stars. Her pink veil, meanwhile, displays a fine network of golden lines reminiscent of the Byzantine technique of crystallography.[23] Like both Bulgarini's and Bartolo di Fredi's versions of this subject, the Virgin's triumphant ascent into heaven is accompanied by a host of musician angels, to which Taddeo di Bartolo added the further detail of two angels carrying baskets filled with flowers (Pl. 199, cf. Pls 161, 181). The iconic treatment of the subject of the Assumption also includes certain original features. In place of the solitary figure of Saint Thomas represented by Bulgarini on his Spedale altarpiece, all twelve apostles surround the tomb of the Virgin in a variety of dramatic, emotive poses. Figures such as Saint Thaddeus – portrayed as if directly engaging with the spectator – and Saints Bartholomew, Matthew and Matthias, in the immediate foreground of the painting, peering intently into the empty flower-filled tomb, act as powerful visual prompts inviting the viewer to become involved in the event and to share the sense of wonder and emotion experienced by the apostles themselves (Pl. 200).

Moreover, in Taddeo's altarpiece, it is not only the apostles who act as witnesses to the Virgin's assumption, but also the company of saints represented on the side panels (see Pl. 198). Although separated from the scene of the Virgin's assumption by the wide pilasters of the frame, the pattern incised on the red-glazed gilt surface on which the saints kneel suggests that the two groups coexist in the same environment as that of the Virgin and apostles. Duccio's *Maestà* provided Taddeo di Bartolo with an important and highly venerated precedent for the portrayal of the Virgin surrounded on either side by the celestial court – a compositional arrangement then repeated by Ambrogio Lorenzetti in his *Maestà* in Massa Marittima (see Pls 23, 133). Significantly, both these early fourteenth-century versions of the *Maestà* were also

designed as high altarpieces and in each case the choice of saints depicted on them was largely determined by this role and location.[24] As we shall see shortly, precisely similar considerations influenced the choice of saints represented on the side panels of the Montepulciano altarpiece.

The particular combination of a central painting of a Marian subject with subsidiary paintings of tiered ranks of saints is also reminiscent of a number of important fourteenth-century Florentine altarpieces, beginning with Giotto's *Coronation of the Virgin* polyptych of circa 1328 for the Baroncelli chapel and culminating in Jacopo di Cione's *Coronation of the Virgin* polyptych of circa 1370 for the high altar of San Pier Maggior in Florence.[25] In his earlier altarpieces for churches in and near Pisa, Taddeo di Bartolo had already shown a marked awareness of Florentine precedents for the arrangement and treatment of the Virgin and Child accompanied by saints – a familiarity facilitated by the presence of altarpieces by Florentine painters in the Pisan region and also, in all probability, by visiting Florence, whilst travelling to Padua to work for the Carrara in the 1390s.[26] Additionally, it is possible that the 'Florentine' dimension of the altarpiece's design would have appealed to his patron, Jacopo Aragazzi who undoubtedly had important and influential contacts with Florence through his merchant brother, Francesco.[27]

The remaining paintings which ornament the summit and base of the altarpiece offer further evidence of the painter being both acutely aware of Sienese tradition and precedent, and yet also utilising his own experience of travelling widely and working farther afield. The placing of an image of the Coronation over the Assumption had already occurred within the late thirteenth- and early fourteenth-century embellishment of the chancel and high altar of Siena cathedral (see Pl. 198, cf. Pl. 43). Similarly, the placing of images of the Archangel Gabriel and the Virgin Annunciate on either side of a central pinnacle panel had also been a feature of the design of Bartolo di Fredi's *Coronation of the Virgin* polyptych for Montalcino (see Pl. 175). Yet within these conventional arrangements of Marian subjects, Taddeo di Bartolo also included original elements. Thus, in the *Coronation*, the Virgin again appears arrayed in her strikingly ornate pink veil and white mantle, whilst above the two central figures hovers the dove of the Holy Spirit, thus alluding to the Trinity and thereby adding a further layer of spiritual significance to the event depicted (Pl. 201).[28] The Passion cycle of the predella similarly recalls many of the paintings depicted upon the rear face of Duccio's *Maestà* (see Pl. 44) and, in the case of the painting that begins the series – the *Raising of Lazarus* – the predella as well. Nevertheless, Taddeo di Bartolo again added innumerable details of his own to the vivid characterisation of the events and persons portrayed.[29] Thus, for example, in the *Entry into Jerusalem* a youth is conventionally shown, on the right-hand side of the composition, climbing a tree in order to cut down a branch to carry in the triumphal procession into the city (Pl. 202). In this tiny vignette, however, Taddeo included the original detail of a black belt which the youth is using as a means of support in climbing up the trunk of the tree.

The choice of scenes for the predella undoubtedly related to their proximity to the high altar and the celebration of high mass that regularly took place upon it. Thus it was highly appropriate that the scene of the Crucifixion appeared at the very centre of the predella where the chalice would have been placed on the altar at mass (see Pl. 198). Additionally, the width of this predella painting broadly corresponds to that of the central panel of the Assumption directly above it.[30] It is striking, therefore, that the scene of Christ's death on the Cross is in line with the Virgin's empty tomb and her triumphal ascent from it – thereby underlining the message that heavenly redemption had only been made possible by Christ's sacrifice upon the Cross.[31] Like the early fourteenth-century high altarpieces for the cathedrals of Siena and Massa

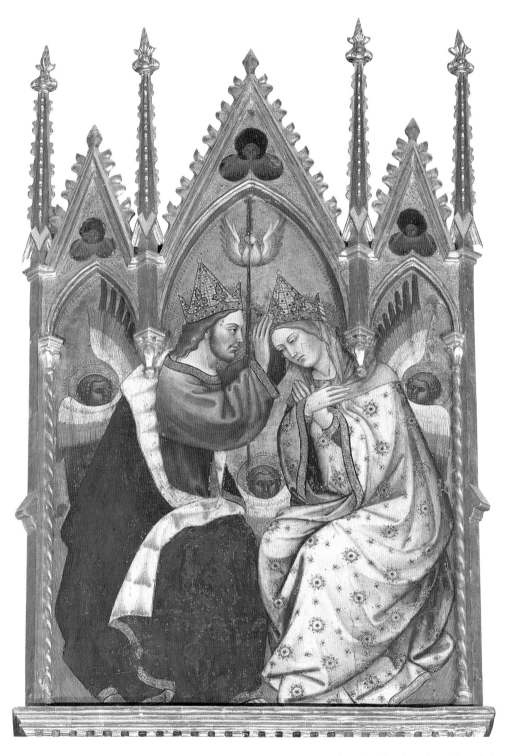

201. Taddeo di Bartolo, *The Coronation of the Virgin*, detail of Pl. 198.

Marittima, it is also likely that this theme was chosen for the further benefit of the canons who administered the Pieve. Due to the radical refashioning of the church in later centuries, it is now impossible to know where, precisely, the canons gathered to perform their collective devotions. Given that the altarpiece is not double-sided, however, it is likely that it was in a choir set just in front of the high altar.[32] The Passion series would thus have endorsed the canons' role as celebrants of masses held in the Pieve, whilst the rich detail of both Old and New Testament scenes would have provided intriguing subjects for contemplation and meditation.

Turning to the identities of the saints portrayed on this altarpiece, it appears that the selection was motivated firstly by civic concerns, secondly by the personal concerns of the arch-priest, Jacopo Aragazzi, and thirdly, in one particular case, by the

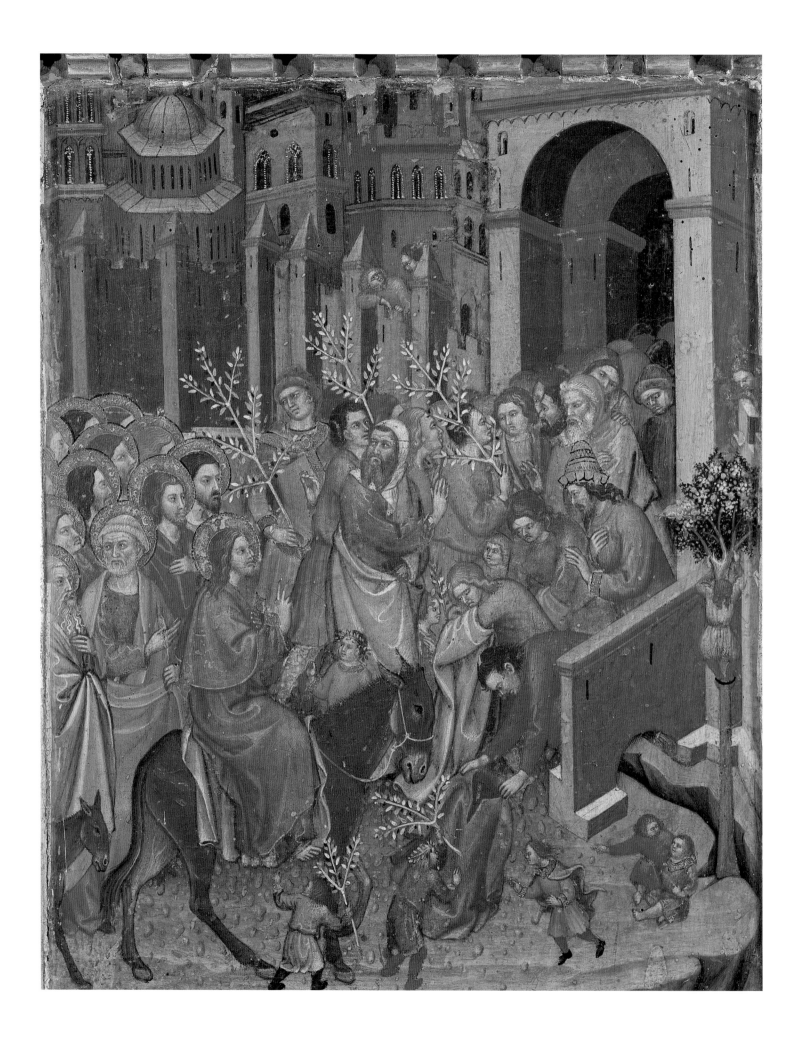

203. Taddeo di Bartolo, *Female Saints*, detail of Pl. 198.

personal interest of Taddeo di Bartolo himself. The essentially civic nature of the choice of saints on the side panels is nowhere more obvious than on the right-hand panel where the figural composition of seven female saints, accompanied by Saint John the Evangelist, is dominated by the figure of Saint Antilla, the fourth-century patron saint of Montepulciano, presenting a large model of Montepulciano to the Virgin of the Assumption (Pls 195, 203). Showing a high degree of topographical accuracy — whereby the Pieve and the Palazzo Comunale are accurately portrayed upon the high 'Sasso', together with the suburban churches of Santa Maria dei Servi (on the extreme left) and San Francesco (upper right) encircled by the town's thirteenth-century walls and principal gateways[33] — this representation of Montepulciano carries a great significance for the altarpiece as a whole. As patron saint of the town, Saint Antilla represents here the collective wishes of the Montepulcianesi who wished to place their town under the protection of the Virgin — just as the Sienese had done on the eve of the battle of Montaperti. It may well be significant, moreover, that this remarkably striking depiction of Saint Antilla presenting Montepulciano to the Virgin was painted just at the point at which Montepulciano had decisively reduced its own subservience to Siena. The portrayal of Saint Antilla and her presentation of the city may thus be seen as, at once, an echo of Sienese artistic and political precedents, and yet also an assertion of Montepulciano's increasing independence from Siena.

The other female figures, each of whom can be identified by their names worked in gilded relief on their haloes, represent Saints Mary Magdalen, Agatha, Ursula, Mustiola, Lucy and Catherine of Alexandria (Pl. 203). As virgin saints they all act as a graceful compliment to the Virgin herself. In addition, at least two of these saints had a special significance for Montepulciano. Saint Lucy, represented on the extreme

202. (facing page) Taddeo di Bartolo, *The Entry into Jerusalem*, part of the front predella, detail of Pl. 198.

left-hand side of the first row, was the titular saint of one of the town's parish church-es recorded in the 1270s.[34] The third-century saint Mustiola, meanwhile, shown in profile on the extreme right, was particularly venerated as one of the patron saints of Chiusi, lying approximately 15 kilometres to the south-east of Montepulciano and closely associated with the town. Mustiola is shown prominently displaying the Virgin's wedding ring, a greatly revered relic then housed in the church of Santa Mustiola outside the walls of Chiusi. Like Lucy, Mustiola also had a parish church dedicated to her in Montepulciano.[35] The prominent appearance of Saint John the Evangelist amongst a company of otherwise exclusively female saints can be accounted for by the fact that the saint was evoked as the patron saint of virgins and widows.[36] In the context of this essentially civic altarpiece, therefore, he thus also rep-resented a powerful advocate and protector of the female population of Montepulciano. His status as one of the four evangelists is further highlighted and dignified by the detail of his open book which has the opening verses of his gospel clearly inscribed on its gleaming white pages. Viewing the altarpiece, as a whole, John the Evangelist also acts as a striking counterpart to John the Baptist, who is portrayed kneeling in an identical position on the outer edge of the left-hand side panel (Pls 198, 204). A patron saint of Montepulciano whose feast day on 29 August is still com-memorated annually by a popular festival,[37] this saint would also have acted as a reminder that the Pieve was the church in which all the inhabitants of Montepulciano were baptised.

Of the remaining eight saints – all clearly identified by name on their haloes – five can be linked clearly to Montepulciano and its ecclesiastical history. Beside Saint John the Baptist kneels Saint Donatus, patron saint of Arezzo, in whose bishopric Montepulciano lay. More pertinently, it was believed that it was this fourth-century saint who brought Christianity to Montepulciano itself.[38] The four remaining beard-ed saints represent, respectively, Saints Francis, Dominic, Augustine and Anthony Abbot (the latter arrayed in the black habit of the Augustinian Hermits). Of these Saints Francis and Augustine represent the titular saints of late thirteenth-century mendicant churches and friaries in the town as well as the names of two of the town's *terzi*.[39] Saint Dominic, meanwhile, represents the founder saint of the order under whose rule the nuns of the convent of Sant'Agnese placed themselves. Saint Anthony Abbot, while alluding in general terms to the eremitical origins of the Augustinian Hermit community at Sant'Agostino, may also have been included as an advocate for the town's hospitals which, like the hospital of Santa Maria della Scala in Siena, were administered by lay organisations closely associated with the Augustinian order.[40]

The altarpiece as a whole thus offered an impressive reminder to the citizens of Montepulciano of the various saints to whom they owed special affection and alle-giance. In addition, the personal devotional preoccupations of the arch-priest Jacopo Aragazzi were also commemorated on the altarpiece.[41] Amongst the male saints on the left-hand side panel, Saint Donatus is a particularly eye-catching figure – large-ly due to the magnificence of his episcopal vestments (Pl. 204). Given that only a year before the painting's completion, Jacopo had received papal permission to wear just such accoutrements, the prominence of this saint and the detailed portrayal of his vestments can plausibly be accounted for by Jacopo's recent ecclesiastical preferment. In addition, behind Saint Donatus appear Saints Stephen and Laurence whose status as deacons is signalled by the vestments that they wear. As such, their presence recalls another of the arch-priest's new privileges, namely the right to ordain minor orders of clerics, such as deacons.[42] Similarly, the two saints who frame Saint Donatus – John the Baptist and the Archangel Michael – could conceivably personify the remit of Jacopo's priestly responsibility for the inhabitants of Montepulciano, ensuring that

204. Taddeo di Bartolo, *Male Saints*, detail of Pl. 198.

they be baptised and make a good death in preparation for the final day of judgement when Michael would preside over the weighing of souls.[43]

Turning to the central scene of the Assumption itself, it is also the case that the name-saints of Jacopo himself and his close male relatives are given a number of distinctive visual features (see Pl. 199). Thus Saint Bartholomew, the name-saint of Jacopo's father and nephew (and incidentally the name-saint of the painter's father as well) is conspicuous by his placement in the foreground and his gilded brocade mantle (see Pl. 200).[44] Directly behind him, on the other side of the tomb, appear Jacopo's name-saints, Saints James the Major and Minor, with the latter in conversation with Saint Peter. Finally, the inclusion of personal name-saints was also given striking expression in the portrayal of Taddeo di Bartolo's own name-saint, Thaddeus, who appears as a youthful figure looking towards the spectator (Pl. 205). In place of Duccio's written appeal to the Virgin on the lower edge of the *Maestà*, Taddeo di Bartolo alluded to his role in creating this magnificent altarpiece for Montepulciano in an entirely pictorial way – by giving his personal name-saint the scrutinising, observant expression appropriate to a painter and his calling.[45]

Five years after he completed his altarpiece for the high altar of the Pieve in Montepulciano, Taddeo di Bartolo was commissioned to paint another series of paintings celebrating the Virgin's death and assumption. Commissioned for a new chapel which was created in the first decade of the fifteenth century on the upper floor of the Palazzo Pubblico in Siena, directly adjacent to the Sala del Consiglio and Simone Martini's *Maestà* (see Pl. 57),[46] it comprised a frescoed scheme depicting narrative scenes from the Last Days of the Virgin together with other images of the Virgin, prophets, saints, angels and the civic emblems of Siena (Pl. 206). A painted inscription on the left edge of the entrance arch to the chapel records that Taddeo

205. Taddeo di Bartolo, *Saint Thaddeus*, detail of Pl. 198.

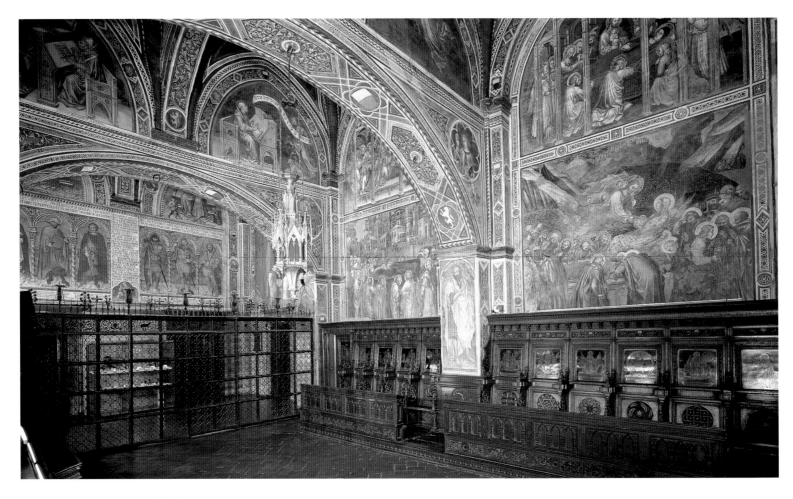

206. View of the Cappella dei Signori towards the entrance. Siena, Palazzo Pubblico.

di Bartolo painted the chapel in 1407.[47] This date is borne out by surviving documentation for the chapel. On 25 August 1406, the painter was entrusted by the Consistory to paint the chapel of the palace 'with figures, ornament and gold in the manner and dignified form as he saw fit for the adornment of the said chapel and the honour of the Commune'.[48] On 30 June 1407, he was given permission to destroy an earlier *Coronation of the Virgin* already painted above the altar of the chapel and replace it with 'new paintings'.[49] Several months later, in November 1407, Taddeo was threatened first with a fine of 25 florins and then confinement in the palace at his own expense until he had completed his work on the chapel.[50] On 23 December, however, appraisers were selected[51] and on 25 April 1408, the painter and his apprentices received a final payment for their work in the chapel.[52]

For all the obvious differences between the two commissions, in at least one important respect, the commission for the new chapel in the Palazzo Pubblico provides an intriguing parallel with that for the Montepulciano altarpiece. In each case Taddeo di Bartolo drew upon and developed well-established precedents for the portrayal of Marian themes in fourteenth-century Sienese art. In each case, also, it is possible to argue that both the commissions themselves and Taddeo's responses to them were significantly influenced by political events which reflected Siena's subtly changing status at the close of the fourteenth century and the opening of the fifteenth.

In the Montepulciano altarpiece Taddeo deployed traditional Sienese motifs – such as the dedication of a city to the Virgin, herself displayed in majesty and as Queen of Heaven, and the inclusion of local patron saints – and clearly drew upon influential precedents such as Duccio's *Maestà* and Ambrogio Lorenzetti's *Maestà* for Massa Marittima (see Pl. 198, cf. Pls 23, 133). Yet the Montepulciano altarpiece was

The Contado

produced as Montepulciano secured a new independence from Siena and included a most striking dedication of Montepulciano itself to the Virgin of the Assumption (see Pl. 195). The creation of the new chapel in the Palazzo Pubblico and its decoration may similarly be read, in part, as a response, this time by the Sienese themselves, to their changing political circumstances at the beginning of the fifteenth century – but a response which, once again, affirmed and drew heavily upon dominant themes in the Sienese portrayal of Marian subjects in the preceding century (Pl. 206).

The prominent presence within the chapel scheme of the relatively obscure saint, Peter of Alexandria, provides an important clue to the political context which prompted Siena's governors to create a new chapel – known as the Cappella dei Signori – within the Palazzo Pubblico and furnish it with a complex pictorial scheme (Pl. 208). In the years preceding the commissioning of Taddeo di Bartolo to decorate the new chapel, two particular political processes had exercised the Sienese. First, in 1399, the Sienese had been obliged to cede political control of their city to Gian Galeazzo Visconti of Milan who was then intent on extending his influence in Tuscany. A Milanese lieutenant duly took up residence in the Palazzo Pubblico in 1400. In 1403, following the death of Gian Galeazzo Visconti the previous September, one faction within the Sienese government – the Twelve – sought to oust the Milanese lieutenant still resident in Siena. The attempt failed, however, and it was the Twelve themselves who were excluded from the Sienese government, a coalition of other parties and allegiances forming a new regime. A year later, however, in 1404, the Milanese then formally renounced their control over Siena and their lieutenant left the city voluntarily.[53] At the same time, however, the Sienese government became involved in the complex political and diplomatic campaign to resolve the ongoing problem of the Great Schism in which several rival contenders claimed the title of Pope. For a short time, therefore, between September 1407 and January 1408, Siena became the location of the court of Gregory XII, the Rome-based papal claimant, during his negotiations with his Avignon-based rival Benedict XIII[54] – a tortuous process which eventually resulted in the Council of Pisa in 1409 and the election of Alexander V as pope.

A fine drawing by Taddeo di Bartolo of Gregory XII seated on a faldstool, which decorates the cover of a book containing consistorial records for September and October 1407, provides evidence both of Gregory's presence in Siena and of the importance of his visit to the Sienese (Pl. 207).[55] Further evidence of the Sienese wish to commemorate this event – and their role in seeking to resolve the Great Schism – is provided by the fresco cycle in another of the rooms on the upper floor of the Palazzo Pubblico. Commissioned on 30 June 1407, but not painted until 1408, the paintings were primarily the work of Spinello Aretino. Originally designated the Saletta Nuova, but later named the Sala di Balìa after the magistracy that met there, its painted decoration portrays scenes from the life of Alexander III, a twelfth-century pope who – like Gregory XII – was also involved in papal schism and an epic struggle against the Holy Roman Emperor, Frederick Barbarossa.[56]

Viewed within the context of these two works, the decoration of the new chapel in the Palazzo Pubblico may also be interpreted as a further example of the celebration of the achievements of the new regime which took power in Siena in 1403 – an interpretation that is given particular force by virtue of certain details in the portrayal of Saint Peter of Alexandria (Pl. 208). An obscure and rarely portrayed saint, the feast day of Saint Peter of Alexandria fell on 26 November – the very day on which the Twelve were excluded from government in Siena in 1403 after their failed attempt to oust the Milanese lieutenant from the city. It would have been highly appropriate, therefore, for the new regime in Siena thus to commemorate the saint

207. Taddeo di Bartolo, drawing of Pope Gregory XII, 1407. Siena, Archivio di Stato, Concistoro 250.

208. Taddeo di Bartolo, *Saint Peter of Alexandria*, 1406–7. Siena, Palazzo Pubblico, Cappella dei Signori.

209. Pisa, San Francesco, the Cappella Sardi Campiglia, view of the painted vault and below, *The Arrival of the Apostles*, painted by Taddeo di Bartolo, 1395–7.

upon whose feast day it had come to power. In addition, however, Peter of Alexandria is shown wearing a papal tiara and seated on a faldstool, whilst also holding a banner bearing both the *balzana* and the lion of the Popolo.

Taddeo di Bartolo was an obvious choice for such a prestigious commission. In 1406, he had himself served a two month term in July and August on the Consistory as a member for the *terzo* of San Martino.[57] It is likely, therefore, that he was aware of the debates and discussions that attended the Sienese government's negotiations with Gregory XII and his court. Furthermore, between 1401, when he signed the altarpiece for Montepulciano, and 1406, when he received the commission for the chapel frescoes, he had also worked in the cathedral and elsewhere in the Palazzo Pubblico.[58] A decade earlier, meanwhile, he completed a cycle of Marian paintings for the chapel of the Sardi Campiglia family in the sacristy of San Francesco in Pisa (Pl. 209).[59] Although a private, familial commission rather than a public and civic one, it included four impressively conceived narrative paintings depicting the last days of the Virgin – subjects also chosen by Siena's governors as the principal iconographic theme for their new chapel.

The choice of a Marian programme for the new chapel was undoubtedly governed, primarily, by the fact that the Virgin was Siena's principal patron saint and it can therefore be assumed that all the principal Marian feasts were celebrated annually in the chapel including the feast of the Assumption.[60] Indeed, the four narrative events depicted on the north wall all had a particular relevance to the feast of the Assumption.[61] The cycle begins in the upper lunette of the north wall of the entrance bay with the *Arrival of the Apostles at the Virgin's Bedside*, follows with the *Dormition* in the upper lunette of the altar bay, then proceeds to the lower wall of the entrance bay with the *Funeral Procession of the Virgin*, and ends with *Christ Raising the Virgin from her Tomb* on the lower wall of the altar bay (Pls 210–13).[62] Although the upper pinnacle panels of Duccio's *Maestà* and the side panels of Bartolo di Fredi's *Coronation of the*

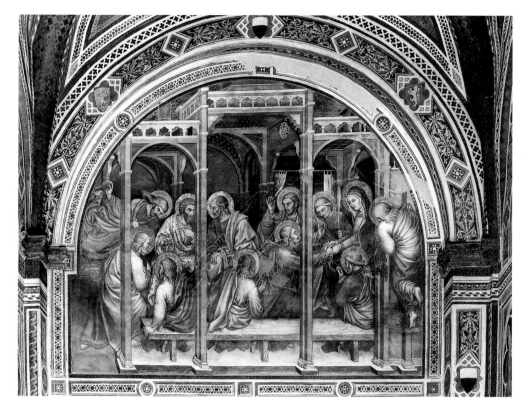

210. Taddeo di Bartolo, *The Arrival of the Apostles*, 1406–7. Siena, Palazzo Pubblico, Cappella dei Signori.

Virgin both provided precedents for the essential components of these subjects (see Pls 176, 177), Taddeo also had to adapt his paintings to a greatly enlarged scale and a horizontal format – an exercise in which he had already engaged in his scheme for San Francesco in Pisa (see Pl. 209).[63] Nowhere is this more obvious than in the final scene of the narrative cycle on the north wall. In place of the conventional *Assumption of the Virgin* – the very nature of which demands a vertical emphasis – Taddeo di Bartolo offered a highly original representation of this subject (Pl. 213). As in the case of the *Dormition*, Christ is represented, but instead of merely standing

211. Taddeo di Bartolo, *The Dormition*, 1406–7. Siena, Palazzo Pubblico, Cappella dei Signori.

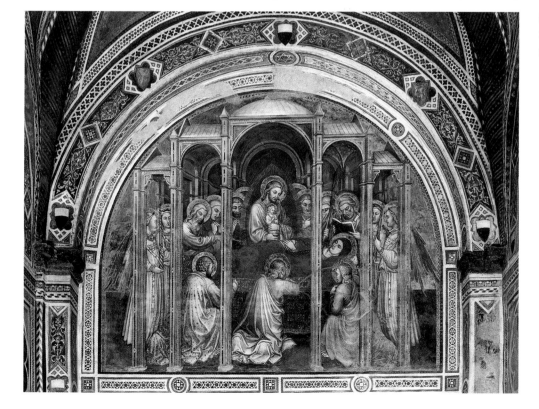

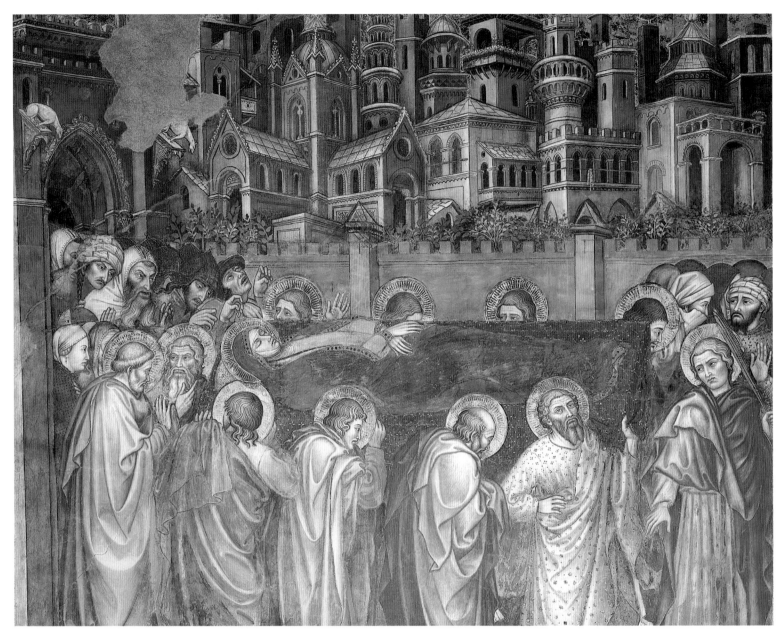

212. Taddeo di Bartolo, *The Funeral Procession*, 1406–7. Siena, Palazzo Pubblico, Cappella dei Signori.

behind the Virgin's bier, he now appears as a heavenly apparition actively assisting his mother in her ascent from the tomb. The wide picture fields of the chapel also allowed Taddeo to depict the events surrounding the Virgin's death in impressively-conceived spatial settings: an open-sided architectural pavilion for the *Arrival* (Pl. 210), a grandiose hall with three cross-vaulted bays for the *Dormition* (Pl. 211), a detailed cityscape for the *Funeral Procession* (Pl. 212), and an extensive landscape for the *Raising of the Virgin from her Tomb* (Pl. 213).

The earlier representation of Montepulciano itself on the *Assumption of the Virgin* polyptych (see Pl. 195) had already demonstrated Taddeo di Bartolo's abilities as a topographer, a skill which he also utilised within the chapel frescoes.[64] The background to the *Funeral Procession* offers an assured representation of a walled city containing a rich variety of buildings and other detail reminiscent of Ambrogio Lorenzetti's *Well-governed City* in the nearby Sala dei Nove (Pl. 212, cf. Pl. 15).[65] It appears that Taddeo wished to associate his representation of Jerusalem with Siena itself and its principal public buildings. Thus the detail of two crouching animals on the mensoles of the entrance gate recalls the wolves on the principal entrance door to the Palazzo Pubblico. Similarly, in terms of architectural style and decorative

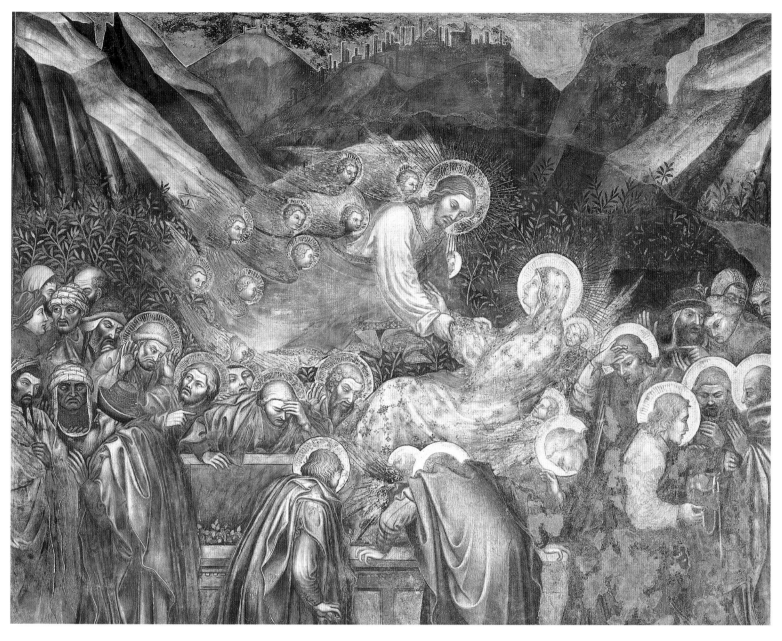

detail, the building to the right of centre – with its ground floor arcade, arched windows on the *piano nobile*, crenellations, tall tower and neighbouring loggia – is broadly reminiscent of the Palazzo Pubblico, the Torre del Mangia and the Cappella di Piazza. On the left, meanwhile, the church, with its tall drum and long transepts, similarly evokes the scale and design of Siena cathedral.[66] Such self-conscious association between Jerusalem – the City of God – and Siena itself is further consolidated in *Christ Raising the Virgin from her Tomb* where a distant city, silhouetted against the gold background, may plausibly be regarded as an evocation of the skyline of medieval Siena viewed from the south (Pl. 213).[67]

The four paintings also include striking examples of thoughtful and imaginative representations of the principal characters involved. A particularly dynamic example occurs in the *Arrival*, where two of the apostles are represented flying into the scene (see Pl. 210). Elsewhere, it appears from the treatment of the figural composition that Taddeo di Bartolo was particularly aware of the religious and liturgical functions of the chapel. Thus, in the *Funeral Procession*, the Virgin appears lying on her bier and being carried in the direction of the chapel altar where the clergy and civic dignitaries would themselves process on designated feast days (see Pl. 212).[68] In the

213. Taddeo di Bartolo, *Christ Raising the Virgin from her Tomb*, 1406–7. Siena, Palazzo Pubblico, Cappella dei Signori.

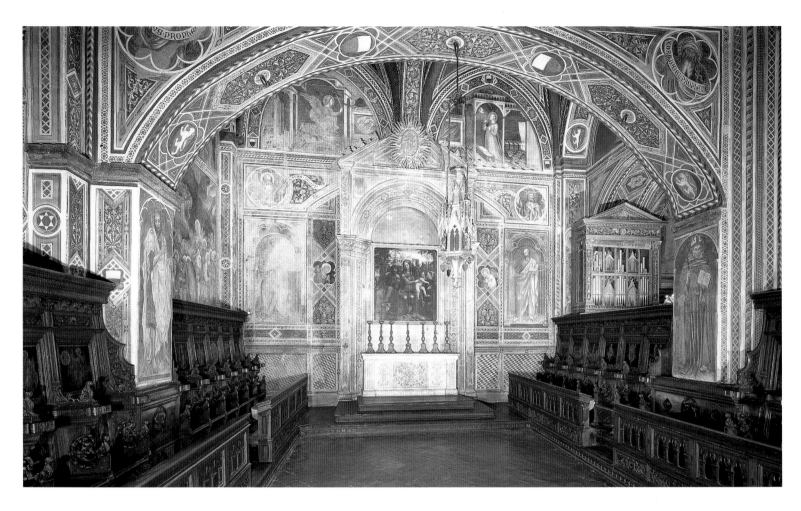

214. View of the altar wall, Cappella dei Signori. Siena, Palazzo Pubblico.

Dormition, meanwhile, her bier is represented as oriented towards the chapel entrance with Saint Peter, portrayed reading the funeral office, facing in the direction of the congregation – just as the priest officiating in the chapel would have done (see Pl. 211).[69]

The Marian nature of the chapel's painted imagery also originally extended to the altarpiece and altar wall of the chapel, although, due to later renovation, this is no longer fully apparent (Pl. 214). Frescoed images of the Virgin Annunciate and the Archangel Gabriel still survive and, given the civic ceremonies held in Siena to celebrate the feast of the Annunciation and the fact that the official year of the Sienese government began on that day, such a subject was highly appropriate for the new Cappella dei Signori. It also continued an earlier tradition already established in the Cappella dei Nove, the ground floor chapel of the Palazzo Pubblico that the new chapel was designed to replace.[70] The remaining surface of the wall is taken up with half-length figures of the prophets Isaiah and Jeremiah, each displaying banners with their names written on them; full-length figures of Saint Peter (very badly damaged) and Saint Paul and – in narrow bands of decoration framing the present altarpiece – two half-length figures of angels. In the case of the prophets, both relate to the Annunciation theme since both Isaiah and Jeremiah were deemed to have predicted the Virgin birth. In the case of the two saints, their prominent presence on the altar wall can be accounted for both by their status as the principal founders of the Catholic Church and also by the government's preoccupation with the papacy at the time of the chapel's commission.[71] The two angels, meanwhile, although extensively repainted, appear to belong to the decoration framing the chapel's original altarpiece. This has now been lost – having been replaced in the seventeenth-century by a *Holy Family with Saint Leonard* by the sixteenth-century painter, Sodoma. A substantial

body of historical evidence – beginning with the commission of 1448 to the painter Sano di Pietro and the woodworker Giovanni da Magno to furnish the chapel altarpiece with a new painted predella and wooden framework – suggests, however, that the original altarpiece for the chapel was a highly venerated fourteenth-century polyptych by Simone Martini, depicting the Virgin and Christ Child surrounded by half-length figures of saints.[72] Although the precise format and subject of this altarpiece is now difficult to establish,[73] it is possible that it was originally executed for the Cappella dei Nove which, with the construction of the new chapel, had by this time been converted to other uses.[74] It is also possible, however, that the altarpiece was always intended for an earlier altar on the site of the new chapel.[75] It has also been argued convincingly that the shallow lunette over the altar – now partially obscured by Sodoma's altarpiece – once housed a fresco by Taddeo di Bartolo depicting the *Coronation of the Virgin*, thus replacing the older painting he had been allowed to destroy in June 1407.[76] Moreover, if such a scene was once in the lunette, then the exuberant figures of dancing and music-making angels in the vaults of the chapel would have further extended the theme of celebration established by this image of the Virgin's final triumph as queen of heaven. Thus, the painted embellishment of the altar wall of the chapel would not only have continued the Marian themes of the north wall, but would also have shifted the emphasis from the story of the Virgin's death and assumption to her role as the Mother of God and Divine Mediatrix. Such imagery would have constituted a highly appropriate framework for the altar of the chapel where masses were regularly celebrated.

The three remaining lunettes surrounding the altar bay of the chapel are devoted to depictions of the three Theological Virtues, Faith, Hope and Charity. The four Cardinal Virtues then appear in roundels placed in the spandrels below Charity and Hope and below the lunettes on the west side of the entrance bay. Although initially appearing random in their placement, it is arguable that, in fact, these four medallions depicting the practical virtues of Fortitude, Prudence, Justice and Temperance were very precisely located so as to be readily visible to the city magistrates as they left the chapel to pursue the business of government.[77] Such a reference to the civic significance of the Cardinal Virtues echoed the earlier precedent of Ambrogio Lorenzetti's allegorical painting of *Good Government* in the Sala dei Nove in which the Cardinal Virtues – together with Peace and Magnanimity – appear as *Ben Comune*'s principal companions and thus as exemplars of qualities that Siena's rulers should strive to emulate (see Pl. 12). Moreover, although he represented both the Cardinal and Theological Virtues in an inventive and original manner,[78] it is clear that Taddeo di Bartolo had studied closely Ambrogio Lorenzetti's paintings in the Sala dei Nove – as demonstrated by his representation of Charity, where he adopts the transparent drapery, rosy skin, burning heart and javelin of Ambrogio Lorenzetti's earlier portrayal of this subject (Pl. 215).[79]

Four of the lunettes in the entrance bays are devoted to the portrayal of the four Evangelists and their role in communicating divine wisdom to the Church Fathers – a theme already established in the portrayal of the same figures in the borders of Simone Martini's *Maestà* in the adjacent Sala del Consiglio (Pl. 216, cf. Pl. 54).[80] In the chapel scheme, John is twinned with Augustine, Matthew with Gregory, Mark with Ambrose and Luke with Jerome. In each case, the Evangelist appears as a heavenly vision, hovering above his symbol, and carrying a scroll on which is written a number of Hebrew letters.[81] All four Church Fathers appear as scholars, seated at their desks and writing. On each of their books are the opening words, in Latin, of the relevant gospel. The theme of sacred learning is further developed in the roundels depicting Elijah, beneath *Saints John the Evangelist and Augustine*, and Zorobabel, beneath *Saints Matthew and Gregory*. The two prophets – together with

215. Taddeo di Bartolo, *Charity*, 1406–7. Siena, Palazzo Pubblico, Cappella dei Signori.

the depictions of Isaiah and Jeremiah on the altar wall – would thus have presented the city governors with an orderly sequence of exemplary figures from the Old Testament on which to focus when they entered the chapel to worship.[82]

The figures of Saints Peter and Paul on the altar wall – portrayed to resemble statues within niches – are accompanied by paintings of seven other saints and the Jewish hero, Judas Maccabaeus, all of whom are disposed around the chapel on the faces of the piers (see Pls 206, 214). Thus, in an almost literal sense, these holy figures appear to support the chapel's structure, just as the saints were believed to consolidate and support the faith and authority of the Church. Framing the central arch

216. Taddeo di Bartolo, *Saints John the Evangelist and Augustine*, 1406–7. Siena, Palazzo Pubblico, Cappella dei Signori.

The Contado

of the chapel are Saints John the Baptist and Augustine (see Pl. 206). The former is shown pointing in the direction of the altar and thus in his traditional guise of the precursor of Christ. When the altar was embellished with the early fourteenth-century altarpiece showing the Christ Child in his mother's arms, this aspect of the chapel's painted programme would have been even more apparent.[83] The prominence of Augustine at the heart of the chapel scheme may be accounted for by the fact that this early theologian dealt extensively in his writings with the mystery of Christ's Incarnation. In addition, in the *Golden Legend*, Jacobus de Voragine ends his influential account of the feast of the Assumption with an extensive quotation from a sermon by Augustine on the theme of the Assumption, thus suggesting that Augustine and his work were readily associated with the narratives of the last days of the Virgin portrayed on the wall opposite the painted figure of Augustine himself.[84] The figure of Augustine also connects with the series of four other saints represented on the broad piers of the two arches which separate the chapel from the Sala del Consiglio. Together with Augustine, these saints represent the five major mendicant orders present in Siena: Saint Augustine for the Augustinian Hermits, Saint Dominic for the Dominicans (now obscured by the sixteenth-century organ), Saint Albert Siculus for the Carmelites, Saint Francis showing his stigmata for the Franciscans (Pl. 217), and the fourteenth-century Sienese *beato* Giovacchino Piccolomini for the Servites.[85] If the practice, described in the early eighteenth century, of each of these orders officiating for a two-month period in the chapel dated back to the chapel's foundation, then the relevance and significance of these figures to the chapel and its painted programme would require no further explanation.[86]

217. Taddeo di Bartolo, *Saint Francis*, 1406–7. Siena, Palazzo Pubblico, Cappella dei Signori.

The celebration of the mendicant communities of Siena itself is also taken further by the striking representation of the thirteenth-century Dominican *beato*, Ambrogio Sansedoni, which appears to the right of the entrance to the chapel. This figure – represented with his traditional attribute of the dove of the Holy Spirit at his right ear, inspiring his thoughts and actions – also carries a strikingly detailed model of Siena (Pl. 218). Executed with great skill and fluency in various shades of brown pigment, the contours of the Palazzo Pubblico, the Torre del Mangia and the cathedral are instantly recognisable. The association of the chapel and its paintings with the civic identity of Siena and one of its most popular local *beati* could therefore not be made more explicit. Furthermore, it is highly likely that the inclusion of this particular figure was again prompted by the preoccupation of the Sienese government in 1406 with Pope Gregory XII's mission to resolve the papal schism. Located on the same side of the chapel as the lunettes representing both his illustrious predecessor, Pope Gregory the Great, and the government's newly adopted patron saint, Peter of Alexandria (see Pl. 208), this image would have served as an elegant reminder of an earlier diplomatic campaign, of the late thirteenth century, in which Ambrogio Sansedoni interceded with Pope Gregory X in 1273 to lift the papal interdict imposed on Siena at that time.[87] His companion on the opposite side of the chapel entrance, the Jewish leader, Judas Maccabaeus, acts, meanwhile, as a representative of political action under the Old Law. Celebrated as a liberator of the Jews from the political and religious oppression of the Assyrians, Judas Maccabaeus also belonged to the iconographic tradition of the Nine Worthies, pagan and biblical figures deemed particularly worthy of emulation by public figures such as rulers and governors.[88]

According to the eighteenth-century Sienese historian, Girolamo Gigli, after the tumultuous political events at the end of 1403, the civic authorities ordered that a solemn mass be celebrated in the cathedral every year, on the feast of Saint Peter of Alexandria. The mass was to be attended by the clergy of the city and at least two members of each religious order, together with the city magistrates – the latter pre-

218. Taddeo di Bartolo, *The Blessed Ambrogio Sansedoni with the City of Siena*, 1406–7. Siena, Palazzo Pubblico, Cappella dei Signori.

219 (facing page) Taddeo di Bartolo, *Funeral Procession*, detail of Pl. 212.

The Contado

senting wax candles as offerings.[89] Four years later, a similar desire to celebrate and consolidate the political legitimacy of the new regime and its involvement in negotiations over the papal schism found expression in the painted embellishment of the new Cappella dei Signori at the heart of the Palazzo Pubblico. The result was a sophisticated and intricate painted programme which drew upon and restated a variety of central themes in the civic art and Marian imagery of fourteenth-century Siena. In continuity with the deeply revered images of the Virgin by Duccio and Simone Martini, and incorporating details and ideas from painters such as Ambrogio Lorenzetti and Bartoli di Fredi, the chapel provided a compelling representation of the events commemorated in the office of the feast of the Assumption – the very day on which Siena's subject cities and communities traditionally brought their annual tributes to the cathedral. Siena's civic identity was further celebrated in the very accurate image of the city itself held by Ambrogio Sansedoni (Pl. 218), and by the similarities evoked between it and the representations of Jerusalem in the *Funeral Procession* and *Christ Raising the Virgin from her Tomb* (see Pls 212, 213). The chapel's imagery acted as a powerful reminder to the city's governors that if Siena, the city of the Virgin, was truly to emulate Jerusalem, the city of God, then they must take account of the accumulated wisdom of the prophets, evangelists and fathers of the Church, pay due honour to the founders of the Church, follow the precepts of the Christian virtues and aspire to emulate the practical political achievements of such figures as the ancient hero, Judas Maccabaeus, and the more recent Sienese *beato*, Ambrogio Sansedoni. Thus, Taddeo di Bartolo's paintings for the Cappella dei Signori provide a suitable and fitting climax to the late medieval Sienese celebration of the cult of the Virgin as principal protector and defender of their city and its territory.

EPILOGUE

Under the Sway of the Virgin

The works of art examined in this study constitute a compelling demonstration of how central the Virgin was, not only to late medieval Sienese art, but also to the very fabric of the political and cultural life of the city itself. The reasons for such fervent and ongoing commitment to the celebration of the Virgin and her life go beyond the pervasive influence of the cult of the Virgin in late medieval society in general and must be sought, rather, in the history and civic ideology of the Sienese Commune itself. Thus, in addition to the ancient dedication of the city's cathedral and its principal altar to the Virgin, when Siena's political independence and institutions were under threat from Florence and its allies in 1260, the city and its *contado* were specifically dedicated to the Virgin as defender, protector and principal patron saint. This act of dedication thereafter became the focus of a powerful civic ideology that was reinforced and embellished over the centuries by subsequent acts of rededication, the most recent occurring in June 1944 when the city faced the threat of bombardment and destruction as the allied armies advanced northwards through Tuscany.[1]

A key factor in sustaining devotion to the Virgin as protector and defender of Siena was the scrupulous annual observance of a variety of civic festivities to mark the feast of the Assumption. As well as the participation of representatives of all sections of the city in these events, the celebration of the feast of the Assumption also included an important ceremony, replete with political symbolism, in which representatives of Siena's subject territories re-enacted their submission to Siena by presenting tributes at the cathedral, as if to the Virgin herself in her role as queen and patron of the city. The appeal of such religio-political events to the city authorities, focusing upon the Virgin on one of her major feast days, is further demonstrated by the introduction in the 1360s, of a further civic celebration marking the Feast of the Annunciation and centred upon the Spedale di Santa Maria della Scala and its collection of precious relics.

As this study has demonstrated, art played a crucial role in the articulation of this powerful civic ideology of the Virgin as protector and defender of Siena. Within Siena itself, this is particularly apparent in the first half of the fourteenth century where four important civic projects were commissioned for the three most important civic sites of Siena: the Duomo, the Palazzo Pubblico and the Spedale di

220. (facing page) Jacopo di Mino del Pellicciaio, *Coronation of the Virgin*, detail of Pl. 196.

Santa Maria della Scala. Thus, Duccio's *Maestà* for the high altar of the cathedral continued – but also raised to a new level of sophistication – a long-established and venerated tradition of celebrating the Virgin by means of painted imagery over the high altar. In his complex and ambitious design for this double-sided altarpiece, Duccio elaborated and developed a well-established iconographic type for images of the Virgin, not least by representing her being actively petitioned by the four other patron saints of Siena, Ansanus, Savinus, Crescentius and Victor – an innovation which was imbued with explicitly civic associations and significance (see Pl. 23). As part of the crowning embellishment of the front face of the altarpiece, meanwhile, he also included a series of narrative scenes depicting the Last Days of the Virgin – a subject which was to provide inspiration for later Sienese painters working on major commissions in the second half of the fourteenth century (see Pls 24, 47).

Within four or five years of Duccio's altarpiece being installed over the high altar, Simone Martini painted his frescoed treatment of the *Maestà* theme in the Sala del Consiglio of the Palazzo Pubblico (see Pl. 54). In so doing he continued a tradition already established by earlier thirteenth-century painters employed to decorate this important government building. Adopting Duccio's precedent of portraying the four early Christian patron saints of the city as votive figures before the enthroned Virgin, in his treatment of the *Maestà* theme, Simone Martini emphasised even more strongly the Virgin's status as both Queen of Heaven and governor of Siena and its lands – an apt approach for a painting designed as the principal embellishment of the Sala del Consiglio where the city's principal legislative council regularly met to pass laws on matters concerning the government of both city and *contado*.

Having furnished both cathedral and town hall with monumental paintings which exulted the Virgin as heavenly ruler of Siena, the city authorities then turned their attention once again to the cathedral where, as part of the ambitious reconstruction of the east end of the building, four new altars and altarpieces were installed in close proximity to the high altar. Although not finally completed until 1351, these four altarpieces were conceived during the 1330s and 1340s as a unified programme of imagery which not only commemorated major religious feasts (such as the Annunciation and the Birth of the Virgin) but also, by its very nature, served further to illustrate the unique status of the Virgin (see Pls 74–7). In addition to this elaboration of Marian iconography within the painted embellishment of the cathedral, moreover, these four altarpieces also further celebrated the four patron saints of Siena – and the presence of their relics within the cathedral – by portraying them both on the side panels of the altarpieces as independent, standing figures, and also on the predellas as Christian martyrs (see Pls 85, 86, 88, 89).

While this programme of altarpieces for the cathedral was being completed by the city's leading painters, a frescoed scheme was also commissioned in the close vicinity of the cathedral for the façade of the Spedale di Santa Maria della Scala (see Pl. 100). The choice of site for this scheme, on the exterior of this prestigious civic building, made it easily visible to the public, whilst its subject matter of the early life of the Virgin again extended the pictorial celebration of the Virgin's life begun in Duccio's *Maestà* and continued in the patronal altarpieces in the cathedral. In this instance, however, the choice of subject matter also offered possibilities for the painters and their patrons to advertise the charitable activities of the Spedale itself.

This triumphant celebration of the Virgin in the three most important civic institutions in Siena continued throughout the remainder of the fourteenth century despite the major political upheavals and the changes to the social and economic fabric of the city that occurred during this period. Thus, in 1352, Lippo Vanni was commissioned to paint a fresco for a meeting-room on the ground floor of the Palazzo

Pubblico which depicted the Virgin being crowned Queen of Heaven in the company of the saints, including the four patron saints of Siena, thereby reinforcing, even more strongly than Simone Martini, the Sienese belief in the Virgin as their supreme governor, queen and advocate (see Pl. 180). Then in the Spedale, probably in the 1360s, Bartolommeo Bulgarini executed an elaborately worked altarpiece of the Virgin of the Assumption with saints for the new chapel of relics on the ground floor of the Rector's palace (see Pl. 161). In the 1380s and 1390s the sequence of narrative altarpieces for side altars in the cathedral was further extended by commissions awarded to painters such as Bartolo di Fredi and Paolo di Giovanni Fei. From the paintings themselves and from written sources relating to them it appears that, like their earlier counterparts, these later altarpieces followed a common design with a central painting commemorating a particular aspect of the life and cult of the Virgin – be it her Assumption into heaven, her presentation in the Temple, or her presence at the Epiphany. Such narrative subjects were then framed by standing figures of particular saints to whom the Sienese had a special devotion. Finally, in the opening decades of the fifteenth century, two further artistic initiatives continued this strikingly consistent pattern of commissions. A series of frescoes for one of the chapels in the newly constructed sacristy of the cathedral appears to have closely resembled – in terms of subject matter and pictorial treatment – the earlier series of frescoes on the façade of the Spedale di Santa Maria della Scala. In the Palazzo Pubblico, meanwhile, Taddeo di Bartolo's fresco cycle in the Cappella dei Signori again presented a series of Marian narrative subjects together with representations of saints and *beati* particularly revered by Siena's current governing regime (see Pls 206, 214).

It is clear, therefore, that in late medieval Siena images of the Virgin were not only part of a carefully cultivated and assiduously maintained civic ideology, but were also part of a highly self-conscious process of artistic representation and reformulation in which Sienese artists simultaneously echoed and yet also elaborated upon well-established Marian images and cycles. Thus, the *Maestà* theme itself, the close association of the Virgin with the other Sienese patron saints, and the depiction of key scenes from the life of the Virgin were all evident in prestigious works dating from the first half of the fourteenth century and located in the cathedral, the Palazzo Pubblico or the Spedale. In the second half of the fourteenth century and the early decades of the fifteenth century, these prestigious precedents were then taken up by later artists who both adopted and emulated key aspects of the work of their early fourteenth-century predecessors and also explored new combinations and elaborations of the Marian themes of the *Maestà* and the life of the Virgin and the depiction of Siena's other patron saints. As has often been observed, fourteenth-century Sienese art does indeed, therefore, exhibit a certain kind of 'conservatism';[2] but such 'conservatism' was intimately and primarily connected with the ongoing expression of a deeply-rooted civic ideology in which highly esteemed works and themes from the first half of the century continued to provide later artists with both inspiration and the opportunity to develop alternative or more intricate versions of their early fourteenth-century forerunners.

It was not only in Siena itself, however, that this group of major early fourteenth-century Marian works of art exercised a decisive and enduring influence. As the second half of this study has shown, they also had a significant impact upon prominent artistic commissions within the Sienese *contado*. Thus, leading Sienese artists were commissioned to execute prestigious works of art in Massa Marittima, Montalcino and Montepulciano – the three most significant subject towns within the Sienese *contado* – and also at the important Augustinian Hermitage of San Leonardo al Lago. The precise reasons for the commissioning of Sienese artists for these projects frequently remain a matter of speculation, but clearly, the

sheer prestige of Sienese artists such as Duccio, Ambrogio Lorenzetti, Bartolo di Fredi and Taddeo di Bartolo was itself a major factor. In addition, however, in many cases more specific – but also strikingly varied – local factors can be suggested as possible explanations for the commissioning of prominent Sienese artists. In the case of Massa Marittima, for example, a Sienese Capitano del Popolo was in office when the commission of the near replica of Duccio's *Maestà* (see Pl. 120) for the high altar of the cathedral of Massa Marittima was being debated by the city authorities. Similarly, but even more directly, in San Gimignano, a Sienese Podestà, Nello di Mino Tolomei, commissioned a near replica of Simone Martini's *Maestà* from Lippo Memmi (see Pl. 64). It is also quite possible that the sequence of Sienese Bishops of Massa Marittima – in office both before and at the time of the city's submission to Siena in 1335 – were influential in securing the commissioning of Sienese artists such as Goro di Gregorio and Ambrogio Lorenzetti (see Pls 124, 133). In Montalcino, meanwhile, it was undoubtedly Bartolo di Fredi's own position as a representative of the Sienese government there that assisted him in obtaining at least six commissions in that town, including the two Marian altarpieces for San Francesco and Sant'Agostino, respectively (see Pls 172, 176, 177, 187).

Another important factor – as emphasised at numerous points in this study – was the highly structured organisation of the religious orders, with their system of major houses in Siena and lesser houses in the towns and rural parts of the *contado*. The interaction between these various houses, particularly at the time of provincial and general chapters, provided a further means of communication between Siena and the *contado*. Thus, for example, the documented presence, in the early decades of the fourteenth century, of a Sienese prior at Sant'Agostino in Massa Marittima, and conversely of a friar from Massa Marittima at Sant'Agostino in Siena, suggests that there were well-established links between the two houses which would have facilitated the commissioning of the Massa Marittima *Maestà* from Ambrogio Lorenzetti (see Pl. 133). It is also highly likely that similar contacts occurred between the Franciscan and Augustinian communities of Montalcino and Siena. In the case of the Augustinian Hermits, moreover, it is clear that the circumstances of the order's early history and development made it a particularly influential presence within the Sienese *contado* and that its close links with the great civic institution of the Spedale di Santa Maria della Scala – itself a considerable landowner in the *contado* – appear to have been particularly crucial for the commissioning of a Marian programme of frescoes for the chancel of the church attached to the rural hermitage of San Leonardo al Lago (see Pl. 149).

Finally, a further important link between Siena and the *contado* was through the agency of private individuals and their families. In the first chapter of this study, attention was drawn to the relatively high incidence of Sienese citizens owning land in the *contado*, particularly members of wealthy, well-established families such as the Tolomei, Salimbeni, Malavolti, Bonsignori, and Piccolomini. In Montalcino, for example, the property interests of one branch of the Tolomei family in that town were such that Tavena di Deo Tolomei made generous endowments in his last will and testament to the local churches of both San Francesco and Sant'Agostino. Similarly, where it is possible to establish the identities of the patrons of *contado* commissions – as, for example, in the case of Bartolo di Fredi's two Marian altarpieces for Montalcino or Taddeo di Bartolo's high altarpiece for Montepulciano – it is clear that such local patrons also had close contacts with Siena itself. In the case of the prior of the Compagnia di San Pietro, Ser Griffo di Ser Paolo, moreover, these contacts were not only of a political nature but also included membership of a confraternity that met within the vaults of the Spedale di Santa Maria della Scala. The prominent appearance on the altarpiece, commissioned for

Montalcino by Ser Griffo's confraternity, of two relatively unusual scenes from the early life of the Virgin (see Pls 176, 177, 186), which had also featured in the frescoed scheme on the façade of the Sienese hospital, provides a vivid example of how such contacts might well have influenced the subject matter and visual appearance of *contado*-based commissions.

Nor was the example of Ser Griffo's confraternity altarpiece an isolated one. Indeed, as this study has argued, the self-conscious emulation of major works of art in Siena was one of the distinguishing features of many of the most striking and prestigious Marian images produced in the Sienese *contado* throughout the fourteenth century and into the first years of the fifteenth century. In Massa Marittima, Montalcino and Montepulciano, and at San Leonardo al Lago, artists as varied as Ambrogio Lorenzetti, Lippo Vanni, Bartolo di Fredi and Taddeo di Bartolo chose to emulate and echo, and to adopt and adapt, aspects of Marian imagery already devised for altarpieces, frescoes, or stained-glass for the cathedral, Palazzo Pubblico and Spedale di Santa Maria della Scala in Siena. Such Marian works within the *contado* were, at one level, a straightforward response to the need of local communities and religious orders for altarpieces and frescoes that celebrated the Virgin, to whom frequently their own local churches, altars or confraternities were dedicated. At the same time, however, the self-conscious emulation of major Marian themes and images originally painted specifically for the three key civic sites of Siena itself also suggests an awareness and acceptance of their significance as expressions of Sienese civic identity and ideology.

In spite of this apparent wish on the part of *contado* patrons to obtain works of art which carried powerful associations with prestigious and highly venerated images located within Siena itself, it is evident from the surviving works of art themselves that both patrons and artists were also highly attuned to the particular local circumstances of these *contado* commissions. Thus, just as in Siena works of art for the major civic locations often combined the celebration of the Virgin with the representation of the other patron saints of Siena, so in the *contado* the emulation of Sienese images of the Virgin was frequently accompanied by the representation of local patron saints and *beati*. Although never totally eclipsing the focus upon the glorification of the Virgin herself, many of these relatively obscure saints featured prominently on altarpieces and other monuments executed for *contado* locations. Thus the embellishment of the cathedral of Massa Marittima in the second and third decades of the fourteenth century included not only a high altarpiece closely emulating Duccio's *Maestà* but also an ambitiously conceived reliquary shrine commemorating Saint Cerbone as patron saint of the city (see Pl. 124). Similarly, as appropriate to an altarpiece decorating the high altar of Massa Marittima's Augustinian church of San Pietro all'Orto, Saint Cerbone was also given a striking position within Ambrogio Lorenzetti's inventive reworking of the *Maestà* theme (see Pl. 116). In Montalcino, meanwhile, the local Beato Filippo Ciardelli features on one of the framing piers on the *Coronation of the Virgin* polyptych (see Pl. 175), whilst in Montepulciano, Saint Antilla, the patron saint of the city, appears as a very distinctive figure on Taddeo di Bartolo's altarpiece of the *Assumption of the Virgin* for the Pieve, her significance as advocate of the Montepulcianesi being emphasised by the highly precise model of the town which she presents to the Virgin (see Pl. 195). Moreover, the images on the side panels of this altarpiece represent an impressive array of other saints to whom the Montepulcianesi felt a special devotion because of their association with the town's churches and other civic institutions (see Pls 203, 204).

Late medieval Sienese devotion to the Virgin as the defender, protector and advocate of Siena was thus expressed not only in the art of the city's most important institutions and monuments, but also in the art of the *contado*. But, just as the

political, social, economic and cultural relations between Siena and the surrounding countryside were, in fact, extremely complex and varied at the local level, so also the relationship between the art of Siena itself and that of the *contado* was similarly complex and subtle. For both the Sienese themselves, however, and also for their subjects in the *contado*, devotion to the Virgin was a common focus of their most prestigious works of art. And in Siena and its subject territories, such devotion and celebration possessed both conventionally religious and also distinctively political significance. In their personal and communal religious devotions, and in their acceptance of the Virgin as their particular queen and patron, the Sienese and their subjects were, indeed, doubly under the sway of the Virgin.

NOTES

ABBREVIATIONS

AAS	Archivio Arcivescovile, Siena
ACM	Archivio Comunale, Montalcino
ACMM	Archivio Comunale, Massa Marittima
AOMC	Archivio Ospedale di Santa Maria della Croce, Montalcino
ASF	Archivio di Stato, Florence
ASS	Archivio di Stato, Siena
AVM	Archivio Vescovile, Montalcino
AOMS	Archivio dell'Opera Metropolitana, Siena
AOPA	Archivio dell'Opera del Duomo (old citation for AOMS)
BCS	Biblioteca Comunale, Siena
Con. Gen.	ASS, Consiglio Generale, Deliberazioni
Const. 1337–9	ASS, Statuti 26
MS	Manuscript Collection
PL	*Patrologiae cursus completus: series latina*, ed. J. P. Migne, 221 vols, Paris, 1841–64
PR	Patrimonio Resti Ecclesiastici
RIS	*Rerum Italicarum Scriptores*

I CIVIC RITUALS AND IMAGES

1. Const. 1337–9, dist. I, rubrics 7–18, fols 9ᵛ–11ʳ. The relevant rubrics are published in Cecchini (1958) ed. 1983, doc. VII, pp. 349–50. For the 1337–9 statutes as a whole, see Bowsky (1967), pp. 239–43.

2. Cecchini (1958) ed. 1983, pp. 311, 315, who also publishes the 1200 statute. See doc. I, p. 348. The original document (ASS, Opera Metropolitana, September 1200) is currently on display in the Archivio di Stato of Siena.

3. Three-quarters of this wax had to be in the form of *fogliati* – candles which had been moulded and embellished with painted flowers and foliage – and the remainder as simple candles, a pound in weight each.

4. This account of the day's festivities owes its detail to Cecchini (1958) ed. 1983, pp. 311–12.

5. The leading officials of the city treasury.

6. Const. 1337–9, dist. I, rubric 7, fol. 9ᵛ. The early inventories of the cathedral list, in some detail, various kinds of object that had been presented by local communities and noble families to the cathedral as a form of tribute. These primarily took the form of banners or *palii* which were stored by the Opera del Duomo. See, for example, the inventory of 1423 (ASS, Opera Metropolitana 29, fols 22ʳ–25ʳ).

7. For the historical evolution of the Palio, see Cecchini (1958) ed. 1983, pp. 309–58, Catoni and Falassi (1983). For the modern Palio, see Dundes and Falassi (1975).

8. Chittolini (1990), pp. 69–80, esp. pp. 70–3.

9. Van der Ploeg (1993), p. 66. As early as 913, there is a documentary reference to the church of the Virgin, a bishop's residence and a canonry on the site of the present cathedral. This early cathedral probably had a different orientation from the present one. By the twelfth century it had broadly taken its present form, but was extended in the thirteenth and fourteenth centuries. For further discussion of the complex history of this building, see Chapter 2, pp. 25–6.

10. 'Cronaca senese conosciuta sotto il nome di Paolo di Tommaso Montauri', in *Cronache senesi*, ed. 1931–9, pp. 200–3. The prologue to the extant fifteenth-century copy of this chronicle refers to Antonio di Martino copying it faithfully from an old book given to him by a metal-worker, Paolo di Tommaso Montauri. The latter could well be a Sienese metal-worker, of a similar name, who is documented working in Perugia and Siena in the late fourteenth century. See ibid., pp. xxv, 175–6. See also the less detailed, but possibly more accurate, account given in the 'Cronaca senese dei fatti riguardanti la città e il suo territorio', in ibid., p. 58. It is generally agreed that this chronicle – covering a time span of 1202–1362 and with later entries to 1391 by other writers – is an authentic record by an anonymous fourteenth-century chronicler. See ibid., p. xiii. For further discussion of these accounts of the dedication of the city to the Virgin, see Chapter 2, pp. 28–33.

11. *Cronache senesi*, ed. 1931–9, p. 202.

12. To be found in BCS, MS A IV 5, and published in 'La sconfitta di Montaperto' (1442–3) ed. 1844.

13. BCS, MS A IV 5, fol. 4ᵛ; 'La sconfitta di Montaperto' (1442–3) ed. 1844, pp. 43–4.

14. See, for example, Garrison (1960a & b); Webb (1996), pp. 251–75.

15. See Webb (1996), pp. 251–3.

16. The inscription reads: SALVET VIRGO SENAM VETEREM QUAM SIGNAT AMOENAM (may the Virgin preserve Siena, the ancient, whose loveliness may she seal). For examples of painted replicas of the seal appearing in important early fourteenth-century paintings, see p. 13, Chapter 3, p. 58, and Pls 12, 13, 54, 61.

17. *Il constituto* (1262), dist. 1, rubrics 2, 3, 14, ed. 1897, pp. 26, 29. See also Webb (1996), p. 257.

18. *Il Caleffo Vecchio*, ed. 1931–91, 2, pp. 846–52.

19. Webb (1996), p. 259. Webb also provides a number of other arguments in support of the view that the accounts of the events surrounding Montaperti reflect a genuine development in Sienese devotion to the Virgin in 1260, however much the details of the narrative may have been embellished by later authors, for which see pp. 259–68.

20. Cited in Ascheri (1985), pp. 12–13, n. 4.

21. ASS, Biccherna, 746, published in Nardi et al. (1986), pp. 91–249. This manuscript is currently on display in the Archivio di Stato, Siena.

22. Nardi et al. (1986), pp. 109–12, 116–26.

23. See Cecchini (1958), ed. 1983, p. 311.

24. For an account of conditions in Italy in general at that time, see Jones (1997), pp. 57–71.

25. Bortolotti (1987), pp. 4–5; Redon (1995a), pp. 30–9. See also the accounts given in the older but essentially reliable histories of the city by Douglas (1902), pp. 14–19, and Schevill (1909), pp. 10–45.

26. For the economic and social renaissance in Italy as a whole, see Hyde (1973), pp. 38–64, Waley (1988), pp. 4–8; Jones (1997), pp. 92–120.

27. For Siena's urban growth and development, see Balestracci and Piccinni (1977).

28. 'In arte Lane instructi sufficientius . . . [non] acti ad laborerium terre', cited in Piccinni (1975–6), p. 207.

29. Douglas (1902), pp. 19–27; Schevill (1909), pp. 45–71, 130–48. For comparable developments in other Italian cities, see Hyde (1973), pp. 38–64, Waley (1988), pp. 32–68.

30. See Cammarosano and Passeri (1985), 'Repertorio', 32.1.

31. In the 1309–10 statutes, the city officials accordingly pledge themselves: 'to augment the city and jurisdiction of Siena in the Maremma, the mountains [west of Siena] and elsewhere, by the purchase and acquisition of castles, entire or in part, and the acquisition of rights wherever possible', see *Il costituto* (1309–10), dist. VI, rubric 27, ed. 1903, 2, p. 503, trans. from Waley (1991), p. 106. For the economic importance of the Maremma for the Sienese, see Redon (1995a), p. 28.

32. For a detailed account of this process, see Chapter 6, pp. 107–9, and Norman (1997), pp. 331–7.

33. See the editorial introduction to *Il Caleffo Vecchio*, ed. 1931–91.

34. This frontispiece has now been removed from the manuscript and is on display in the Archivio di Stato, Siena. For further analysis and discussion of this illumination, see *L'art gothique* (1983), cat. no. 79.

35. See, for example, the treaty agreed between Siena and Massa Marittima on 5 October 1335, as recorded in the 'Caleffo dell'Assunta', ASS, Capitoli 2, fols 548ᵛ–553ᵛ.

36. Bowsky (1967), pp. 210–11; Waley (1991), pp. 72–4.

37. For example, on 4 December 1302, the Sienese painter, Duccio, was fined 19 *lire* and 10 *soldi* for not fulfilling his civic obligation of garrison duties with the civic militia at Monteano and Roccastrada in the southern *contado*. See ASS, Biccherna, 117, fol. 182ʳ, published in White (1979), doc. 24, who mistakenly gives the amount of the fine as 18, not 19 *lire*. For Roccastrada, see Cammarosano and Passeri (1985), 'Repertorio', 27.5. For Monteano, see Repetti (1833–45), 3, p. 563.

38. *Purgatory* (XIII, 151–4).

39. ASS, Capitoli 3, 'Caleffo Nero', fols 25ᵛ–26ʳ. See also Cammarosano and Passeri (1985), 'Repertorio', 38.13.

40. *Il costituto* (1309–10), dist. I, rubric 50, ed. 1903, 1, pp. 73–4. See also dist. I, rubric 549, ed. 1903, 1, pp. 342–3. For the significance of Talamone in Ambrogio Lorenzetti's frescoes in the Sala dei Nove, see p. 14, and Norman (1997), pp. 331–2, 337.

41. For examples of the former view, see Douglas (1902), ch. 4, 'Struggle with the feudal nobles', pp. 42–53, and also pp. 30–1; Schevill (1909), ch. 8, 'The contado', pp. 229–49. For examples of the latter view, see Bowsky (1981); Waley (1988), (1991); Redon (1995b), who also summarises the complexity of the social make-up within the Sienese *contado*.

42. For the Aldobrandeschi and their close associates, such as the Pannocchieschi, see the old but essentially reliable family history by Ciacci (1935).

43. ASS, Diplomatico, Archivio Generale Comunale, 6 February 1292 (1293, modern style of dating), cited in Waley (1991), p. 21.

44. Waley (1988), p. 83. See also Cherubini (1974), pp. 231–311, esp. pp. 249–51; Bowsky (1981), pp. 186–7. For the compilation of the 'Tavola delle Possessioni', see Bowsky (1970), pp. 87–97.

45. Waley (1991), pp. 35–9, esp. p. 37. For the Salimbeni family, see Salimei (1986) and Carniani (1995); for the Tolomei, see Mucciarelli (1995).

46. Bowsky (1981), pp. 10, 272–3.

47. For San Salvatore, see Kurze (1988), pp. 1–26. For Sant'Antimo, see Canestrelli (1910–12) ed. 1987, pp. 1–11; Kurze (1989), pp. 319–37.

48. Canestrelli (1895) ed. 1989.

49. See Chapter 7 pp. 133, 135–7.

50. Documents within the Archivio Diplomatico of the Archivio di Stato, Siena, record a number of these pious donations. See, for example, those cited by Cohn (1988), p. 21, n. 17.

51. Epstein (1986), provides a highly detailed account of the economic development of the Spedale in the *contado*. For a more succinct account of the Spedale's properties within the *contado* and the hospital's administration of them over the centuries, see Balestracci and Piccinni (1985), pp. 24–9. See also Chapter 7, p. 155.

52. For an analysis of the function and design of the *grance*, see Cecchini (1959), pp. 407, 408; Coscarella and Franchi (1983), and (1985). For Cuna and Spedaletto, see Cammarosano and Passeri (1985), 'Repertorio', 33.2, 40.4.

53. Epstein (1986), pp. 220–4, 289.

54. Const. 1337–9, dist. III, rubric 333, fol. 181ʳ, cited in Bowsky (1981), p. 4, who gives the rubric as 332. I have taken the rubric number from the original index given on fol. 13ʳ.

55. Ascheri (1994), pp. 170–82.

56. Bowsky (1967), pp. 227–30.

57. Const. 1337–9, dist. III, rubrics 384–93, fols 189ᵛ–193ʳ. See also, Bowsky (1964), pp. 8–9; (1971), pp. 87–8; (1981), p. 7.

58. Ascheri (1994), p. 180, see also p. 176.

59. Thus in 1324, the celebrated jurist, Cino da Pistoia, advised the Nine that a petitioner from Grosseto was not liable for taxation on his movable property because of the fact that: 'the city of Grosseto had some pacts with that city [Siena] *because it is not perpetually subject to the jurisdiction of Siena and its territory*, as is not the land of Montepulciano and other similar lands' [my italics] trans. from Bowsky (1967), p. 196. See also Ascheri (1994), p. 172. For further discussion of Massa Marittima, Montalcino and Montepulciano, see Chapters 6, 8 and 9.

60. Waley (1991), p. 108.

61. *Il costituto* (1309–10), dist. I, rubric 6, ed. 1903, 1, p. 48: 'Di mantenere e conservare la chiesa magiore di Siena, et lo vescovado e la calonaca di Siena, et lo spedale Sancte Marie, e tutti li venerevoli luoghi de la città e del *contado* di Siena . . .'. [my italics].

62. ASS, Biccherna, 165, fol. 31ᵛ: payment of 2 May 1330, for the paintings of Montemassi and Sassoforte; Biccherna, 171, fol. 81ᵛ; Biccherna, 397, fols 55ᵛ, 147ᵛ: payment of 14 December 1331, for the paintings of Arcidosso and Castel del Piano. On 6 September 1331, the same painter was paid 8 *lire* for visiting Arcidosso, Castel Piano and Scansano. See Biccherna, 171, fol. 35ʳ, Biccherna, 397, fol. 123ᵛ. All the relevant extracts from these Biccherna accounts have conveniently been published together in Maginnis (1988a), pp. 139–40 (although the archival citation for his doc. 9 should be Biccherna, 397, fol. 147ᵛ).

63. Seidel (1982), pp. 37–41, publishes the record of the submission of Montemassi presented to the Consiglio Generale in September 1328 and the *capitoli* in the 'Caleffo dell'Assunta' which detail the terms of submission for Arcidosso and the purchase of Castel del Piano from the Counts of Santa Fiora in November 1331. See also Bowsky (1970), pp. 28, 45, 249. On 27 February 1330, the Consiglio Generale also agreed to the purchase of Sassoforte from the Aldobrandeschi of Santa Fiora. See Bowsky (1970), pp. 28, 177.

64. For the discovery of this painting in 1980–1 and an account of its condition, see Seidel (1982), pp. 17, 21–5.

65. Tintori (1982), p. 95.

66. Mallory and Moran (1986), p. 255.

67. The painting has been attributed to a number of early fourteenth-century Sienese painters including Duccio (Seidel, 1982; Bellosi, 1982); Memmo di Filippuccio (Carli, 1981, pp. 258–61, with considerable caution); and Simone Martini (Mallory and Moran, 1986; Martindale, 1986 and 1988; De Wesselow, 1995). The castle has variously been identified as either Giuncarico (Seidel, 1982; Bellosi, 1982) or Arcidosso (Mallory and Moran, 1986; Martindale, 1986 and 1988; De Wesselow, 1995). Polzer (1985), meanwhile, prefers to leave open the question of specific identification and attribution.

68. Thus a major aspect of the case for identifying the scene as the submission of Arcidosso is the suggested similarity between the topographical details in the painting and the topography of Arcidosso itself. Similarly, if the painting depicts the submission of Giuncarico, a case may be made that the figure with the sword represents Nello di Paganello who swore submission to Siena on behalf of Giuncarico (see Seidel, 1982). If conversely, the painting indeed represents the submission of Arcidosso, then the figure with the

sword is likely to be a portrayal of Guidoriccio da Fogliano, the Sienese Capitano della Guerra who captured Arcidosso on 12 August 1331 (see Mallory and Moran, 1986).

69. For publication of the Biccherna payments to Ambrogio Lorenzetti for these murals which begin on 26 February 1337 (1338, modern style of dating) and end on 29 May 1339, see Maginnis (1989), 'appendice' nos 4–17. For a review and assessment of modern studies of this programme of frescoes, see Norman (1995c). For a more detailed statement of the argument in the paragraphs following, see Norman (1997). It is also possible that the famous painting in the Sala del Consiglio conventionally known as *Guidoriccio da Fogliano at the Siege of Montemassi* and traditionally attributed to Simone Martini, may also provide further striking evidence of the celebration and commemoration of their territorial expansion by the early fourteenth-century Sienese government. If the painting's traditional attribution to Simone Martini is correct, this would certainly be the case. Indeed, even if it were to be firmly established that this painting was only completed in the 1350s, as some scholars now argue (e.g. De Wesselow, 1995), it would still constitute evidence of a continuing concern among Siena's rulers to recall and affirm key moments in the early expansion of the city and its territory. Unless and until the controversies over the date and attribution of this painting are resolved, however, it would be imprudent to cite it as a key example of fourteenth-century Sienese celebration of their expansion into the *contado*. It is also unnecessary to do so, since the case may be made without appeal to the *Guidoriccio* fresco. For a measured and judicious survey of the controversy over the painting, see Maginnis (1988a).

70. For the location of the Sala dei Nove within the Palazzo Pubblico and the significance of that location, see Starn and Partridge (1992), pp. 13–14, 18–19.

71. For an exhaustive photographic survey of this painted scheme, see E. Castelnuovo et al. (1995).

72. As also represented within the lower border of Simone Martini's *Maestà* in the adjacent Sala del Consiglio. See Chapter 3, p. 58, and Pl. 61. No impressions survive of this particular communal seal but it is likely to represent an impression of the 'new seal for the Lords Nine' for which the goldsmith, Guccio di Mannaia, was paid 12 *lire* on 4 September 1298 (ASS, Biccherna, 114, fol. 159ᵛ). The iconography, however, belongs to an earlier period. It was created in 1252 to replace the existing seal which showed a formalised representation of the city of Siena. The new design, of which an impression survives from 1266, showed the Virgin seated with the Christ Child and flanked by angels bearing candles. The main difference lay in the presence of a rose in the right hand of the Virgin and a dragon beneath her feet. See Bascapé (1969–84), 1, p. 211.

73. This group has been identified as representing either the Council of Twenty Four, Siena's principal magistracy from 1236–70 (Frugoni, 1991, p. 136) or members of Siena's contemporary executive officials and magistracies (Kempers, 1992, p. 137).

74. Skinner (1986), p. 42, further suggested that they may be intended to represent the special force of the *contadini* recruited in 1302 by the Nine to keep peace in the countryside. For these troops, see Bowsky (1971), pp. 79–80.

75. See p. 8. As pointed out by Feldges (1980), pp. 60–1, we are dealing with an allegorical, synoptic representation of Siena's territory. Nevertheless, as she herself acknowledges, the inclusion of Talamone suggests that a strong association with the Maremma was intended for this painting.

76. For a detailed presentation of the case for this interpretation of the paintings of the Sala dei Nove, see Norman (1997).

2 THE CATHEDRAL

1. *Cronache senesi*, ed. 1931–9, p. 90. Trans. with amendments from White (1979), pp. 96–7.

2. White (1979), pp. 80–95, 201–8, and Gardner von Teuffel (1979), pp. 36–44, provide the most persuasive reconstructions. For discussion of other earlier and less convincing reconstructions, see Deuchler (1984), pp. 73–7.

3. White suggests that the central panel was divided into two parts depicting the Assumption of the Virgin and, above it, her Coronation. Above the central panel would have been a gable panel depicting Christ in majesty. Gardner von Teuffel has challenged this reconstruction preferring the single subject of the Coronation of the Virgin for the central panel. Above this, in her view, would have been a gable panel depicting the Virgin of the

Assumption. The attractiveness of her suggestion is that it corresponds to other examples, such as Pietro Lorenzetti's Arezzo polyptych of 1320. There is, however, an illogicality in having the Coronation of the Virgin below her Assumption – hence my suggestion that the Assumption of the Virgin was, indeed, the subject of the central pinnacle panel and that it was then topped by a gable panel of a bust of Christ shown in the act of receiving and welcoming the Virgin into heaven. Such a relationship is depicted on the upper part of a Sienese altarpiece dating to the 1360s, now in the Museum of Fine Arts, Boston. See Van Os (1984–90), 2, fig. 142.

4. White suggests for the lost central panel the Ascension with Christ in Majesty and in the gable panel above, God the Father. Gardner von Teuffel prefers the Resurrection with the Ascension above. In terms of narrative chronology, however, a Resurrection set in the midst of scenes of the post-resurrection appearances of Christ would be a less logical sequence, hence my preference for an amended version of White's proposal.

5. First noted by Schottmüller (1910), col. 147, and more recently and thoroughly by Van der Ploeg (1984), p. 147, (1993), pp. 49, 118. For the series of Antonine paintings, including discussion of their attribution and dating, see Christiansen et al. (1988), pp. 104–23.

6. Borgia et al. (1984), cat. no. 72. A number of scholars have discussed the significance of this panel for the *Maestà* and its setting. See, for example, White (1979), p. 91; Van der Ploeg (1993), pp. 90–1, 94–5; Kempers (1994), pp. 89–90, 92.

7. Presumably Francesco Todeschini Piccolomini who, at that date, was Bishop of Siena and Cardinal Deacon of Sant'Eustachio. See Strnad (1964–6), pp. 156, 177–8.

8. This is probably an accurate depiction of the Cappella delle Grazie whose foundation and civic functions we shall consider shortly, see pp. 31, 33.

9. The history of the alterations made to the cathedral during the fourteenth century is extremely complicated. See the useful longitudinal section in Benton (1995), Pl. 163, which, with its coloured key, illustrates the different stages of the building's construction. The most comprehensive accounts of the fourteenth-century building programme are given in Carli (1979), pp. 19–28; Pietramellara (1980); Middeldorf Kosegarten (1984), pp. 129–61; Van der Ploeg (1993), pp. 97–117.

10. The 1362 decision is published in Bacci (1927), pp. 58–61. See also, Lusini (1911–39), 1, p. 322, n. 82. For the re-siting of the high altar and the reinstatement of its altarpiece, see Lusini, 1, pp. 261–5, p. 322, n. 80, p. 323, n. 84, and Van der Ploeg (1993), p. 117.

11. Published in Milanesi (1854–6), 1, p. 140.

12. Milanesi (1854–6), 1, pp. 140–1: '. . . quod altare sancte Marie, et corum ipsius episcopatus fiant et construantur suptus metam majorem dicti episcopatus . . .'. See also the reconstructions of the high altar and choir in the vicinity of the crossing proposed by Middeldorf Kosegarten (1970), pp. 74–6, (1984), pp. 24–6, 52, and White (1979), pp. 99–100.

13. Milanesi (1854–6), 1, pp. 140–1: '. . . quod altare sancte Marie et chorus prefati episcopatus et que pertinent ad ipsum corum construantur et compleantur sicut ordinatirum est per dominos Canonicos dicti episcopatus et operarios hoperis sancte Marie . . .'.

14. Milanesi (1854–6), 1, p. 331: '. . . che 'l coro si murasse, secondo che va el vecchio a retta linea'. The commission for the new choir stalls was awarded to Francesco del Tonghio c. 1362–3. A second, larger order was awarded to Francesco and his son, Giovanni, in 1378. Other documents suggest that this project lasted until the end of the fourteenth century. See Milanesi (1854–6), 1, pp. 328–83; Bacci (1927), pp. 58–61. For a comprehensive analysis of this later project, see Carli (1978).

15. Van der Ploeg (1993) pp. 83–9. By the early fifteenth century, as we have noted, it appears that an ante-choir had been erected in front of the high altar as shown in the 1483 panel (Pl. 28). In addition, a number of the cathedral's fifteenth-century inventories make references to a choir in the middle of the church, the inventory of 1467–70 offering the most detailed description: See AOMS, 1492 (AOPA 867), fol. 401ᵛ: 'El choro dimezo del lengniame intarsiato bellissimo et difuore lavorato di marmo apiei detto coro due pareti di ferro con serratura'. The 1423 inventory (ASS, Opera Metropolitana 29, fol. 17ʳ), describe this ante-choir as the choir where the canons and priests sang the divine office. It is likely that this ante-choir was part of the long drawn out project executed by Francesco del Tonghio and others, referred to in the note above.

16. White (1979), p. 80, estimates that the original dimensions of the altarpiece were approximately 468 × 499 centimetres. In 1506 the *Maestà* was

removed from the high altar and replaced by Vecchietta's tabernacle. The present altar was executed by Baldassare Peruzzi in 1532. See Torriti (1988), p. 100.

17. For the fragment of sculpted relief with the veiled woman and symbols of the four evangelists, see Lusini (1911–39), 1, p. 95; Van der Ploeg (1993), pp. 91–2; cf. Middeldorf Kosegarten (1984), pp. 53–4, who suggests that it was once part of the choir enclosure. The woman has been identified as the Virgin or Ecclesia. In either case, such an image would have been appropriate for an altar dedicated to the Virgin, who in late medieval belief was frequently understood as an embodiment of the Church. For the panels which may have been part of the choir enclosure and have been linked to a payment, dated 29 September 1259, to three artists who were known associates of Nicola Pisano, see Pope-Hennessy and Lightbown (1964), 1, pp. 18–20, 3, fig. 34; Middeldorf Kosegarten (1984), pp. 52–9, 335–7; Van der Ploeg (1993), pp. 89–91.

18. See p. 21.

19. See Chapter 1, pp. 3–4.

20. *Cronache senesi*, ed. 1931–9, p. 58.

21. Trexler (1972), pp. 18–19.

22. A later venerated image of the Virgin and Child (Pl. 38) was also known by the title of the *Madonna degli occhi grossi*. For further discussion of this painting, see pp. 29–33.

23. Hager (1962), p. 62; Carli (1979), pp. 79–80; Van Os (1984–1990), 1, pp. 10–12. While acknowledging that this painting was the image to which the dedication of the city was addressed, Kempers (1994), proposes that this painting was always a single image of the Virgin and Child and that, like an icon, it could be easily moved from place to place in the service of the liturgy. In his view, therefore, on the day of the dedication this image was moved to a temporary site on the high altar and then subsequently carried in the intercessory procession which is an important feature of all the chronicle accounts of this event. This proposal is at odds with the physical evidence of the panel which shows clearly that it has been cut down at some point in its history. See Van Os (1984–90), 1, p. 12. In addition, Niccolò di Giovanni Ventura, (BCS, MS IV 5, fol. 5ʳ, 'La sconfitta di Montaperto', 1442–3, ed. 1844, p. 46), in an aside to the reader, makes it very clear that the image to which Siena was dedicated was carved in relief, that it stood on the high altar and that it also had figures painted on either side of it. On these grounds, therefore, it appears that this early thirteenth-century painting once functioned as an altarpiece over the high altar of the cathedral.

24. Hager (1962), pp. 83, 106–7; Stubblebine (1964), pp. 72–5; Carli (1979), p. 80; Van Os (1984–1990), 1, pp. 15–18. Kempers (1994) acknowledges that this painting may have been made for the high altar, but also makes the alternative proposal that it might have been made for a specially commissioned chapel whose existence is documented from, at least, the fifteenth century onwards. However, the early chronicle accounts all state very clearly that the painting, known as the *Madonna delle Grazie*, was taken from the high altar. See *Cronache senesi*, ed. 1931–9, pp. 90, 314; 'La sconfitta di Montaperto (1442–3) ed. 1844, p. 46.

25. This ancient icon which had been brought to Constantinople in 438 earned the name 'Hodegetria' ('she who shows the way') because it had been housed, for a time, in a sanctuary for the blind. I am grateful to Lyn Rodley for this information.

26. White (1979), pp. 66–9 and Van Os (1984–90), 1, pp. 18–19, discuss a number of these early gabled dossals.

27. BCS, MS IV 5, fol. 5ᵛ; 'La sconfitta di Montaperto (1442–3) ed. 1844, p. 46.

28. Described in the 1423 inventory, ASS, Opera Metropolitana, 29, fol. 18ᵛ: 'La cappella del Crocefixo rilievato . . . a d[i]c[t]o altare la figura di nostra donna e S[an]c[t]o Giovani da piei ala croce rilevata'. See also the briefer entry in the 1420 inventory (ASS, Opera Metropolitana, 28, fol. 14ᵛ).

29. A painted wooden crucifix, dated to the second half of the fourteenth century, and from the face of the Crucifix, is now on display in the Museo dell'Opera del Duomo, together with painted wooden statues of the Virgin Mary and Saint John the Evangelist which were commissioned in 1415. For the latter, see *Scultura dipinta* (1987), pp. 116–18. Given the apparent date of the crucifix, it cannot have featured in the rituals surrounding Montaperti, but it might have replaced an earlier amd much venerated prototype. Another wooden crucifix displayed on an altar in the north transept and known popularly, but incorrectly, as the Cross of Montaperti, also dates from the mid-fourteenth century. See Torriti

(1988), p. 107. For the chronicle accounts of the intercessory processions with the Crucifix, see *Cronache senesi*, ed. 1931–9, p. 202; BCS, MS IV 5, fols 5ʳ, 21ᵛ–22ʳ, 'La sconfitta di Montaperto' (1442–3) ed. 1844, pp. 44–5, 86–7.

30. For the original site of the Porta del Perdono, see Butzek (1980), pp. 20–2, Van der Ploeg (1993), pp. 85–8, 100. For pilgrims' use of the route from the Campo to the cathedral, see Braunfels (1979), p. 163.

31. ASS, Opera Metropolitana, 29, fol. 19ʳ: '. . . la quale fu la tavola antica e principale nela dicta chiesa . . .'. See also ASS, Opera Metropolitana, 28, fol. 15ʳ, and Aronow (1990), pp. 236–7.

32. Sixteen of these reliefs by Urbano and Bartolommeo da Cortona and depicting scenes from the life of the Virgin survive. Nine of them now decorate the inner face of the central western portal of the cathedral, six flank the tomb of Tommaso Piccolomini del Testa (1484/5) situated above the door of the Campanile and one is kept in the Museo dell'Opera del Duomo. See Carli (1979), pp. 108–9. For the later history of this chapel, see Kempers (1994), pp. 115–16.

33. *Il constituto* (1262), dist. 1. rubric 14, ed. 1897, p. 29. This new chapel was to be on the site of the chapel of Saint James Intercisus. An altar dedicated to Saint James Intercisus is named in the cathedral inventories from 1389 onwards. It appears to have been located on the south aisle directly in front of the entrance to the campanile. See Pl. 65 and Aronow (1990), pp. 236–7.

34. *Il constituto* (1262), dist. 1, rubric 2, ed. 1897, p. 26. The Commune also paid for a lamp to burn day and night beneath the *carroccio* – the city's ceremonial war chariot which took part in the battle of Montaperti. See dist. 1, rubric 3, ed. 1897, p. 26. The immensely long pieces of wood that purport to be the standard poles of the war chariot can still be seen running the entire height of the piers between the nave and the crossing of the cathedral. It appears from the inventory of 1423 that these were already located in the crossing at that date, if not earlier. See ASS, Opera Metropolitana 29, fol. 17ʳ.

35. ANNO DNI MILLESIMO.CCXV. MENSE NOVEMBRE. HEC TABULA FACTA EST. The provenance of this early painting is the church of SS Salvatore e Alessandro at Fontebuona della Badia Berardenga. It was, however, presented to this *contado* church by Cardinal Alessandro Chigi-Zondadori, Archbishop of Siena, who had this church rebuilt in 1720, thus establishing a connection with the cathedral. See Van Os (1984–90), 1, p. 100, n. 10.

36. On the left are three episodes from the legend of an Alexandrian Jew first abusing and then being converted by a crucifix, on the right, three episodes from the Legend of the True Cross.

37. Cited in the original Latin in Van der Ploeg (1993), p. 75, n. 70. BCS, MS G V 8, is a manuscript copy of the *Ordo officiorum ecclesiae Senensis*, and an annotated edition has been published by Trombelli, ed. 1766. It is interesting to note, in this context, that the 1215 panel painting shows physical evidence of use as both an antependium and an altarpiece. See Van Os (1984–90), 1, p. 12.

38. For the commissioning documents, see Carli (1943), pp. 41–8. For discussion of its original location, see Seidel (1970), pp. 56–7, 60 (with citations from the cathedral inventories of 1420, 1429, 1435); Carli (1979), pp. 33–5; Van der Ploeg (1993), pp. 94–5.

39. For the relevant documents, see Carli (1946b), pp. 12–14.

40. At the time of writing, the stained-glass had been removed from the cathedral in order to restore it. Sections of it were on public view in one of the rooms of the Spedale di Santa Maria della Scala, a building itself undergoing a period of remodelling to turn it into a major civic museum.

41. *Bibliotheca Sanctorum*, (Ansanus), 1, cols 1324–35; (Crescentius), 4, col 292; (Savinus), 11, cols 705–16.

42. Gigli (1723), ed. 1854, 2, pp. 355–6.

43. Carli (1979), p. 13. These altars were apparently under the patronage of respectively: the bishop, the chapter of canons and the Opera del Duomo.

44. BCS, MS G V 8, *Ordo* (1215), fol. 117ᵛ (Ansanus), fol. 147ᵛ (Savinus). See also Van der Ploeg (1993), p. 67. For more detailed discussion of these saints and their cult within Siena cathedral, see Chapter 4, pp. 68–71, 84.

45. BCS, MS G V 8, *Ordo* (1215), fol. 143ᵛ–144ʳ (Crescentius), fol. 141ᵛ–142ʳ (Bartholomew). See also Van der Ploeg (1993), pp. 64, 66–7.

46. The strongest proponent for the presence of a crypt in both the twelfth- and thirteenth-century cathedrals is Van der Ploeg (1984), (1993).

47. For the view that the stained-glass oculus should be attributed to Duccio, see Carli (1946b), pp. 29–44, (1981), pp. 35, 40–1; for the alternative view that it should, rather, be attributed to Cimabue, see White (1979), pp.

137–40, (1993), pp. 191–5. For an exposition of the complexity of the rear face of the *Maestà*, see Norman (1995b), pp. 73–4.

48. For example, the late thirteenth-century altarpieces for the high altars of the Lower Church, Assisi, and San Francesco, Perugia, and the early four-teenth-century altarpiece for the high altar of St Peter's, Rome. For these double-sided high altarpieces and the way their location determined their format, see Schultze (1961), Gardner (1974), and Gordon (1982).

49. See pp. 27–8.

50. See p. 21. See also the accounts given in the chronicle of Paolo di Tommaso Montauri and the chronicle attributed to Agnolo di Tura, *Cronache senesi*, ed. 1931–9, pp. 236, 313. The authorship and dating of the latter chronicle, which only survives as a fifteenth-century manuscript copy, remains a matter of debate. Lisini in his editorial introduction (pp. xiii–xx, xxxv), argues that it was a fifteenth-century compilation of earlier records extracted from diaries and public documents. Bowsky (1964), pp. 3–5, iden-tifies Agnolo di Tura as a member of the Biccherna for the years 1348 and 1355 and therefore argues that he was the author for the chronicle's entries dating between 1300 and 1355, a view in which Seidel (1982), p. 26, concurs. On balance, I am persuaded that this chronicle was written in the mid-fourteenth century by Agnolo di Tura and that the errors of fact that appear within it may plausibly be attributed to subsequent fifteenth-century copyists.

51. The choir screen introduced in 1367 was set on a marble base and was designed to close off the high altar and the choir stalls behind it from the rest of the cathedral. See Van der Ploeg (1993), pp. 118–19. In the 1380s a second screen was erected across the entrance of the chancel to close off both the chancel and the chapels of Saints Ansanus and Victor. See Chapter 4, p. 68, and Aronow (1990), p. 232. For the well-established practice of segregating men and women in different parts of the church building, see Ashton (1990).

52. MATER SCA DEI SIS CAUSA SENIS REQUIEI . SIS DUCIO VITA TE QUIA PINXIT. This translation has been adapted from White (1979), p. 100. For alternative translations of this important text, see Deuchler (1984), p. 195, n. 75.

53. See the examples given in Deuchler (1984), p. 58, and Riedl (1991), p. 22.

54. The three saints appear in simple versions of such attire in the illuminated initials of the 1215 Customary. See BCS, MS G V 8, fols 117ᵛ, 143ᵛ, 147ᵛ, illus. in Van der Ploeg (1993), figs 80, 83, 84.

55. Kaftal (1952), cols 1011–16. For further discussion of this saint's hagiogra-phy, see Chapter 4, p. 84.

56. See Carli (1946b), pp. 44–9. For the entry in the Customary, see BCS, MS G V 8, fol. 132ʳ. See also Van der Ploeg (1993), p. 152. For the victory against Montepulciano, see Tommasi (1625–6), ed. 1973, part I, bk 4, p. 231.

57. See Chapter 3, p. 54, and Chapter 4, p. 84. Another contemporary repre-sentation of Saint Victor as a dark-haired, bearded man occurs in two illu-minations in an early fourteenth-century Sienese hymnal. See BCS, MS G III 2, fols 1ʳ, 86ᵛ.

58. See, for example, the ninth-century mosaic in Santa Maria in Domnica, showing Pope Pasquale I kneeling at the foot of the Virgin and Child, illus. in Deuchler (1984) pl. 56, and the tenth-century mosaic in Hagia Sophia, Constantinople, showing the Emperors Justinian and Constantine present-ing models of the church and city to the Virgin and Child. I am grateful to Lyn Rodley for the latter reference.

59. The late thirteenth- and early fourteenth-century sculpted programme for the façade of the cathedral once included sculpted statues of the four patron saints and, according to Sigismondo Tizio, in his 'Historia Senensis' (1508–26), 2, pp. 61–2 (BCS, MS B III 7), and Pecci (1752), p. 26, a sculpted group representing Buonaguida as a votary offering the city to the Virgin and Child. The general disposition of the sculpted lunette can be seen as a background detail of Priamo della Quercia's fresco of *The Investiture of the Rector by the Blessed Agostino Novello* and Domenico di Bartolo's fresco, *The Giving of Alms*, in the Pellegrinaio of the Spedale di Santa Maria della Scala and also in a drawing of the cathedral façade of 1600, but it is impossible to make a secure identification of its subject mat-ter. See Gallavotti Cavallero (1985), pls 121, 124, and Middeldorf Kosegarten (1984), pls 264, 265. But, if such a subject was, indeed, part of the sculpted embellishment of the cathedral façade it would have provided Duccio with a partial precedent. Of the statues of the four patron saints which were probably once located on the upper part of the façade, only two survive, those of Saints Savinus and Victor. See Middeldorf Kosegarten,

cat. nos. XIV, 9 and 10, pp. 346–7, pls 152–7. For the sculpted programme of the façade, as a whole, see Middeldorf Kosegarten, pp. 74–99.

60. See Chapter 3, p. 54.

3 THE TOWN HALL

1. Hoeniger (1995), p. 38; Mina (1993), pp. 70–1, 76. Mina also offers a con-vincing explanation (pp. 69–75) for the painting's traditional title which she associates with the Italian word, *bordone* (meaning a type of melody), and the well-established Servite practice of singing *laude* before their images.

2. For documentary references to 'Coppo, painter' as a member of the Florentine army, see Coor-Achenbach (1946), pp. 234–5. The painted inscription on the lower frame of the painting giving Coppo's name and the date, 1261, was not visible when Coor-Achenbach wrote. For its recov-ery, see Brandi (1950), p. 168 and fig. 6.

3. Corrie (1990) proposes that a number of iconographic details in the painting (particularly the repeated motif of the imperial eagle on the Virgin's head-dress) are suggestive of a politically motivated commission in the wake of the Ghibelline victory of Montaperti. Mina (1993), pp. 78–81, 98–107, questions Corrie's interpretation, preferring to account for the painting's distinctive iconography in terms of the Servite Order and its special devotion to the Virgin as *Regina Coeli*.

4. Lusini (1908), pp. 2–3; Dal Pino (1977), pp. 749–55; Mina (1993), pp. 56–62.

5. Brandi (1950); Hoeniger (1995), pp. 21–2.

6. Mina (1993), pp. 66, 332–3, suggests that the updating could have taken place as early as 1304 in order to commemorate the Servite Order's defini-tive approval by the Holy See. However, the manner of painting the Virgin's underveil appears to derive closely from that of the *Maestà* which was only completed in 1311.

7. For a history of the early stages in the construction of this church, see Lusini (1906), pp. 263–95, esp. pp. 263–4, 271–4, and Liberati (1961), pp. 263–74, esp. pp. 263–5. For the association of this painting with the high altar of San Domenico, see Gardner (1979), p. 108, and Hoeniger (1995), p. 39, but see also p. 162, n. 46, where Hoeniger notes the confusing nature of the early sources on this point.

8. White (1993), pp. 172–3; Hoeniger (1995), pp. 22, 39.

9. Hoeniger (1995), pp. 22–4. See also Brandi and Carli (1951).

10. Stubblebine (1964), pp. 31, 39–41; Gardner (1979), pp. 107–8; Hoeniger (1995), pp. 38–9.

11. See Hoeniger (1995), pp. 21–42, who also examines other related examples of this phenomenon and plausibly relates it to the well-established Byzantine practice of repainting new images over old ones.

12. The later name of Mappamondo deriving from a large, circular map of the world painted by Ambrogio Lorenzetti and installed in the room in the 1340s. For a detailed discussion of this object, see Kupfer (1996).

13. For an account of the painting's condition prior to its last restoration (1982–93), see Tintori in *Simone Martini* (1988), pp. 99–101, and also Borsook (1980), pp. 21–3. It has generally been assumed that the poor con-dition of the painting was caused principally by the corrosive effects of chloride from salts rising in the wall from the subterranean vaults of the Palazzo Pubblico where the communal salt supplies were stored. It seems, however, that damp was the principal reason for the precarious state of the painting, for which see Bagnoli (1988), p. 109. Bagnoli's point receives sup-port from Consistory documents of 1484 and 1494, published in Bacci (1944), pp. 138–9, where the poor condition of the painting is attributed to dampness and humidity.

14. For discussion of the precise techniques used on the haloes, see Frinta in *Simone Martini* (1988), pp. 139–45. It is also significant that there appears to have been a change of direction in respect of the ornamentation of the haloes. The majority of the figures to the right of the Virgin in the painting and all the figures in the upper and side borders have haloes which have a simple linear design. By contrast, the haloes of the Virgin and Child, four of the figures to their right, and all of the figures to their left, as well as those in the lower border, are intricately patterned. For the bearing of this on the dating of the painting's execution, see n. 19, 21.

15. For description of the materials and techniques used on the painting, see Bagnoli in *Simone Martini* (1988), pp. 109–12; Hoeniger (1995), p. 131. For the use of tin on the painting, see Tintori (1982), pp. 94, 95.

16. For Simone Martini's apparent indebtedness to contemporary metal-work, see Bellosi in *Simone Martini* (1988) p. 45.

17. Ghiberti (*c.* 1447–55) ed. 1947, p. 38.

18. ASS, Biccherna 377, fol. 28ʳ, 139ᵛ, published in Bacci (1944), pp. 134–5. On 7 June 1315, Simone was also paid 34 *lire*, 16 *soldi* by the Biccherna for an unspecified painting in the Palazzo Pubblico (Biccherna, 376, fol. 13ʳ, published in Maginnis, 1989, p. 12). As pointed out in Maginnis, pp. 4–5, if this was another payment for the *Maestà*, Simone would have received a total of 81 *lire* 4 *soldi*. Although low for a mural painting of this size, the Commune may well have supplied the materials (unlike the later payment of 1321, for which see n. 20).

19. Martindale (1988), pp. 207–8. Other scholars prefer, however, to take the date of 1315 at face value. See, for example, Bagnoli (1988), p. 114, and Leone de Castris (1989), p. 28. The latest restoration campaign has revealed that there were clearly two stages in the fresco campaign, the first comprising approximately the upper three-quarters and the second the lower quarter of the painting. See *Simone Martini* (1988), fig. 1, p. 109. In Bagnoli's view (pp. 113–14), the first phase of work can be dated on stylistic grounds to *c.* 1312 and the second to *c.* 1315, after Simone Martini had returned from painting the chapel of Saint Martin in the Lower Church of San Francesco, Assisi. Frinta (p. 140) prefers to date this second stage of execution to 1321.

20. ASS, Biccherna, 142, fol. 154ʳ, Biccherna, 143, fol. 94ᵛ, published in Bacci (1944), p. 136 .

21. The following were replaced: the face, head-dress and hands of the Virgin, the face and hands of the Christ Child and a small area of his tunic beneath the Virgin's left hand, the face and hands of the two kneeling angels, Saints Ursula, Catherine and Crescentius, the face of Saint Ansanus and the right hand of Saint Paul. See the diagram by Leonetto Tintori in Borsook (1980), fig. 3, p. 19, and Bagnoli (1988), p. 116, n. 8. As pointed out by Gordon (1989), p. 371, the 1321 payment would be a reasonable sum for replacing these areas of the painting, particularly as the painter had to supply gold and other materials, cf. Frinta in *Simone Martini* (1988), pp. 140–2, and Martindale (1988), pp. 16–17, 208, who suggest that the sum of money involved is suggestive of a more extensive reworking of the painting.

22. For a more extensive discussion of the 'repairs' of 1321, including the suggestion that these were similar in aim to the 'restoration' of the Coppo di Marcovaldo and Guido da Siena panels, see Hoeniger (1995), pp. 133–5.

23. Debates on the desirability of a new Palazzo Comunale were already being held in the 1280s and in the early 1290s the government was buying properties in order to demolish existing buildings to provide space for the new building. In 1297 government records begin to make reference to the extensive disbursement of funds for this project of construction and renovation. For a comprehensive list of the relevant extracts from contemporary sources, see *Il Palazzo Pubblico* (ed. 1983), pp. 415–17.

24. See Cordaro (1983), pp. 36, 37, 56, and also the older, but well informed, Donati (1904), p. 330. Both authors cite as evidence for the extension, the record of a payment for construction work at the back of the Palazzo Comunale (agreed by the Consiglio Generale at a meeting of 28 May 1304, ASS, Consiglio Generale, 64, fol. 185ʳ/ᵛ, and published in *Il Palazzo Pubblico*, ed. 1983, no. 89, p. 418). It is likely that the earlier building began as a modest, single-storied edifice, situated on the south side of the Campo and referred to in the early sources as either the Palazzo del Dogano (the customs house) or the Palazzo del Bolgano (the mint) – a reflection of the varied commercial functions to which the building was then put. By the 1280s, it appears that it had a council chamber and acted as a place of residence for the Podestà (see Donati, 1904, pp. 315–18). This would suggest that by this date, it had at least one, if not two upper stories. It probably did not, however, extend in depth beyond the present Cappella dei Signori on the *piano nobile* of the Palazzo Pubblico (Pl. 57).

25. ASS, Biccherna, 101, fol. 74ᵛ (published in *Il Palazzo Pubblico*, ed. 1983, no. 45, p. 416), Biccherna, 102, fol. 71ᵛ. It is not certain where the council chamber in the early Palazzo Comunale was located. Southard in *Simone Martini* (1988), p. 106, suggests that it may have been on the ground floor next to the Cappella dei Nove. The initiation of the Palazzo Pubblico, as we see it today, is generally dated to *c.* 1296–7, with the completion of the central part of the building where the Sala del Consiglio is located occurring *c.* 1300–5. Cairola and Carli (1963), pp. 18–25; Cordaro (1983), pp. 37, 56.

26. ASS, Biccherna, 105, fol. 97ʳ, published in *Il Palazzo Pubblico* (ed. 1983), no. 50, p. 416.

27. On the wall on which the *Maestà* is painted, there is evidence of two bricked up doors (*Il Palazzo Pubblico*, ed. 1983, figs 43, 542, 544) which suggest that before the painting was executed the new Sala del Consiglio was accessible by two doors on its east side. Cordaro (1983), p. 56, has made the sensible suggestion that these doors once gave access to a bridge between the Sala del Consiglio and the Podestà's residential quarters. After the painting's execution, the Podestà's access to the Sala del Consiglio must have been by another doorway – a rearrangement closely linked to the construction of the east wing of the Palazzo Pubblico as the Podestà's residence.

28. Strictly speaking the Palazzo Pubblico faces north-north-west onto the Campo. For clarity, however, the front façade of the building is taken to be facing north, with the rear façade onto the Piazza del Mercato as facing south.

29. See Chapter 9, pp. 195, 197.

30. A further distinguishing feature between the Sala del Consiglio and the remaining space would have been the timbered roof of the former and the vaulting of the latter. See Cordaro (1983), p. 37.

31. Part of these modifications was the reorganisation of the rooms on the first floor of the Palazzo Pubblico so that another room (marked on the plan as the 'sala dipinta' and decorated in the sixteenth century with paintings by Beccafumi) became the new Sala del Concistoro. See Cordaro (1983), pp. 352, 361.

32. These were the four Provveditori of the Biccherna, the four consuls of the Mercanzia (the merchants' guild) and the three consuls of the Knights or the Guelph party.

33. In the first, the painter Segna di Bonaventura is paid on 8 November 1319, for repairing a painting of the Virgin Mary 'in front of the Consistory of the Nine'. In the second, Simone Martini himself is paid on 20 February 1329 (1330, modern style of dating) for painting a figure of Marcus Regulus in the 'Consistory of the Nine'. These payments are recorded in ASS, Biccherna, 139, fol. 125ʳ (published in Bacci, 1944, pp. 40–1), and 165, fol. 15ᵛ (published in *Il Palazzo Pubblico*, ed. 1983, no. 154, p. 421). It is generally believed that Segna di Bonaventura repaired Duccio's documented *Maestà* of 1302 for 'the altar of the house of the Nine'. See Stubblebine (1972).

34. For discussion of the presence of an altar on this floor of the building, see Chapter 9, pp. 202–3.

35. In 1426, Mattia di Bernacchino was paid for a wooden chair for the Podestà which was set below the *Maestà* . This chair had intarsia work on it which included a figure of Justice and the Virgin commending the city of Siena to a kneeling Podestà. See Southard (1980), 1, pp. 266–7. This fifteenth-century chair undoubtedly replaced an earlier chair of similar design.

36. This account of the Consiglio Generale and its function is indebted to Bowsky (1981) and Waley (1991).

37. All topics discussed at four of the meetings of the Consiglio Generale held between 10 December 1294, and 22 January 1295 (recorded in, ASS, Con. Gen., 47, fols 27ʳ–43ᵛ) and noted by Waley (1991), p. 54.

38. ASS, Con. Gen., 52, fol. 27ʳ (4 July 1297).

39. In 1339 these were replaced by white and black beans which were placed in an urn. See Bowsky (1981), p. 94.

40. Although a full meeting of the Council could thus comprise some 500 members, it is apparent from the records of numerous fines for non-attendance that many councillors found their six-month term with its weekly meetings at best tedious and at worst highly inconvenient. Many of these meetings, therefore, probably only numbered some 200 members which occasionally had to be supplemented by representatives of other city bodies such as the Consiglio del Popolo and the military societies of the city.

41. See Chapter 1, p. 11.

42. Taken (with a number of minor changes to reflect the sense of the original more closely) from the translation given in White (1979), p. 96. For the original text, see Martindale (1988), p. 207.

43. It remains an interesting and tantalising question whether such social organisation owes its origins to Italy's classical past or to the influence of medieval feudalism where such relationships were also crucial. See the discussion of this issue in Weissman (1987), pp. 25–45.

44. These texts are published with an English translation by Roberto Stefanini in Starn and Partridge (1992), Appendix 1, pp. 261–6.

45. Duccio's *Maestà* portrays thirty figures (discounting the ten apostles in the upper arcade) ten of which are saints and twenty angels. Simone Martini's *Maestà* portrays thirty figures (discounting the figures in the border) twen-

ty-two of which are saints and eight angels. It is interesting to note that in the latter painting the Archangel Michael appears beside Saint John the Evangelist and – despite the misleading inscription of MICAEL – the Archangel Gabriel beside Saint John the Baptist. The pairing of these figures probably relates to the role of both Gabriel and John the Baptist as divine messengers and the association of Michael and John the Evangelist with the Day of Judgement. For a plausible scheme of identification of all the figures in this part of the painting, see Martindale (1988), diagram B on p. 206.

46. A perceptive point made by Martindale (1988), p. 14.

47. For the painted texts around this allegorical figure, see Martindale (1988), p. 204.

48. In terms of its ornate decorative detail, it is similar to the drawing of c. 1317 of the façade of the new baptistery and also to the late thirteenth-century windows of the triforium of the cathedral nave. See Middeldorf Kosegarten in *Simone Martini* (1988), p. 197.

49. Significantly, this sacred text also features prominently in Ambrogio Lorenzetti's painting of *The Good Government* in the adjacent Sala dei Nove (Pl. 12).

50. The written pages of the book of Saint Jerome in the lower border are also real pieces of paper attached to the surface of the wall. See Bagnoli (1988), p. 106, fig. 13, p. 115. According to Bagnoli, (pp. 109, 112, 116, n. 5), paper was used for these details, not parchment (cf. Borsook, 1980, pp. 20, 21).

51. Thus the text on the book of Saint John the Evangelist displays the opening line to his gospel and the text on the book of Saint Gregory an extract from Gregory's *Commentary on Job*. For a transcription of these texts, see Martindale (1988), p. 205.

52. For a thought-provoking discussion of this aspect of late medieval Sienese culture and its importance for the paintings of the Sala dei Nove, see Starn and Partridge (1992), pp. 30–4.

53. ASS, Opera Metropolitana, 29, fol. 16ʳ. This item also features in the inventory of 1420 (ASS, Opera Metropolitana, 28, fol. 13ᵛ), where it is described as a 'sopracielo dornato'. Both inventory entries are published in Van der Ploeg (1993), p. 114.

54. According to Borsook (1980), p. 20, this coin once showed on its obverse, SENA VETUS CIVITAS VERGINIS ('ancient Siena, city of the Virgin') and on its reverse, ALFA ET Ω PRINCIPIUM ET FINIS (the first and last letters of the Greek alphabet and Latin for 'the beginning and the end'). These inscriptions are no longer visible.

55. +SALVET VIRGO SEN(AM) VE(TEREM) QUA(M) SIGNAT AME-NAM.

56. +SIGILLUM: CAPITANEI: POPULI: SENENSIS.

57. Gabriele Borghini in *Il Palazzo Pubblico* (ed. 1983), p. 268, makes the pertinent point that Phillip of Anjou, prince of Taranto and Vicar of Robert of Anjou, visited Siena in 1315 and was received with much honour. See also Malavolti (1599), ed. 1982, part 2, bk 4, pp. 75ᵛ–76ʳ, who describes the prince visiting Siena twice in 1315 – the first visit taking place between 26 July and 6 August and the second in December.

58. See the highly informative account given in Pecori (1853), ed. 1975, ch. 3, pp. 36–179.

59. For a list of the Podestà of San Gimignano from 1199 until 1530, see Pecori (1853), ed. 1975, pp. 742–51. From this list, it is possible to ascertain that during the thirteenth and fourteenth centuries members of the Malavolti, Tolomei, Saracini and Salimbeni families all acted in this capacity.

60. For documentary references to Sienese painters working in San Gimignano during the 1270s and 1290s , see Previtali (1962), pp. 10–11, n. 5; Carli and Cecchini (1962), p. 70; Riedl (1991), p. 51.

61. These frescoes have plausibly been attributed to the painter 'Azzo' who was paid for work in a 'new room of the Palazzo Comunale' in July and August 1291. See Carli and Cecchini (1962), p. 70; Bennett (1979), pp. 29–30. In 1466, Benozzo Gozzoli was called upon to 'refresh and repair' the *Maestà* and also whitewash the earlier paintings in the room. See the document cited by Pecori (1853), ed. 1975, pp. 650–1. This whitewash was subsequently removed. For the history of the construction of the Palazzo Comunale (also known as the Palazzo del Popolo and the Palazzo Nuovo del Podestà), see Ceccarini (1983), pp. 3–41.

62. Carli (1963), p. 28; Riedl (1991), p. 51.

63. For discussion of this and other examples of secular decoration in thirteenth- and fourteenth-century Italy, see Martindale (1981), pp. 109–12.

64. A painted inscription beside the right-hand doorway gives the name of the painter and the date, 1467. See *Mostra di opere d'arte restaurate* (1979–83), 2, p. 30. For the contract of 22 April 1466, where Benozzo Gozzoli was instructed to restore the *Maestà*, see Pecori (1853) ed. 1975, pp. 650–1. See also Pecori, p. 567, where reference is made to the vote of December 1461, when San Gimignano's town council agreed to construct two new rooms adjacent to the Sala del Consiglio.

65. *Mostra di opere d'arte restaurate* (1979–83), 2, pp. 28–31; Hoeniger (1995), pp. 136–9, 142–7. Freuler (1994), pp. 21, 32, cat. 2, p. 435, places this renovation of Lippo Memmi's painting in the late 1350s and thus early in Bartolo di Fredi's career as a painter. For photographs of fragments of the original painted frame surrounding the painting, see Riedl (1991), fig. 158.

66. The relevant extract is published in Davidsohn (1896–1908), 2, p. 213.

67. LIPPUS MEM[M]I DE SENIS ME PINSIT. The 'de Senis' is barely legible but can be reconstructed from other signed works by Lippo Memmi. See Riedl (1991), p. 52.

68. See Bennett (1979), p. 62; *Mostra di opere d'arte restaurate* (1979–83), 2, pp. 24–5; Hoeniger (1995), p. 135.

69. In 1324, Simone Martini married Giovanna, daughter of Memmo di Filippuccio. See Martindale (1988), pp. 6–7.

70. On a number of technical grounds, Tintori (1982), pp. 94–5, argues for Lippo Memmi's participation in the Palazzo Pubblico *Maestà*. Martindale (1988), p. 17, concurs with this view – but on the basis of a number of stylistic similarities between the two paintings.

71. For a transcription of this painted text, see *Mostra di opere d'arte restaurate* (1979–83), 2, p. 25. Pecori (1853), ed. 1975, pp. 744, 751, lists Nello Tolomei as respectively, Podestà of San Gimignano in 1317 (July–December), and Capitano del Popolo in 1318 (January–June). Mucciarelli (1995), p. 244, details Nello's extensive career as Podestà and Capitano del Popolo for various Tuscan and Umbrian city communes. She, however, dates his term of office as Capitano del Popolo of San Gimignano to July–December, 1318. This would appear to be at variance with the painted text of Lippo Memmi's painting. Bennett (1979), pp. 59, 85, n. 32, 34, and Riedl (1991), pp. 523, accept that Nello's terms of office as Podestà and Capitano del Popolo ran concurrently from July 1317 to June 1318.

72. For a transcription of this painted text, see Southard (1980), 2, p. 517. For a photograph of it, see Riedl (1991), Pl. V.

73. For the identification of these civic coats of arms, see Pecori (1853) ed. 1975, pp. 566–7. For photographs of this detail of the painting, see Riedl (1991), Pls 175, 176.

74. Modern technical investigation has found, for example, evidence of extensive use of various kinds of metal leaf which in certain areas, such as the haloes, has been moulded into elaborate decorative patterns and in other areas glazed to simulate gem stones or enamels. See *Mostra di opere d'arte restaurate* (1979–83), 2, pp. 27–8 and Hoeniger (1995), pp. 137–8, citing an unpublished technical report by Leonetto Tintori.

75. Pecori (1853), ed. 1975, pp. 386–7, refers to Saint Nicholas as the titular saint of the first Pieve of San Gimignano. Hoeniger (1995), p. 136, however, calls this saint Nello Tolomei's patron saint. This seems unlikely as 'Nello' is not a diminutive of Niccolò, but of Antonello. Nicholas would, therefore, be an unlikely choice unless there were some, as yet undisclosed, connection between Nello and the saint. It seems more likely that Nicholas was chosen for the painting because of his episcopal status which mirrored that of Saint Geminianus and because he enjoyed a long-established cult within San Gimignano.

76. Bennett (1979), p. 61. Bennett's point is reiterated by Perrig (1981), pp. 227, 237, and Martindale (1988), p. 17.

77. As noted in *Mostra di opere d'arte restaurate* (1979–83), 2, pp. 25–6 and Hoeniger (1995). p. 142. Riedl (1991), p. 66, astutely remarks, 'Die *Maestà* des Palazzo Comunale in San Gimignano erscheint als Kompromiss der ikonographischen Bedürfnisse der Kommune wie Nello de'Tolomeis'.

78. For illustration of the surviving parts of this once impressive tomb monument and a plausible reconstruction of its original design, see Kreytenberg (1984).

79. Given the bad political relations between Siena and Pisa at that time, it is probably unlikely that Simone Martini would have seen the monument at first hand. Tino di Camaino, however, as a Sienese sculptor could well have been the painter's source for knowledge of this monumental figural composition. For the strained relations between Siena and Pisa, see Norman (1997), pp. 325–30.

80. For a detailed analysis of the original design of the gateway and its sculptures, see Shearer (1935), pp. 67–111, 113–29, 178, fig. 58. For the content of the inscription, see ibid., pp. 16–17, 19, 22, 127–9, fig. 60. Contacts between the kingdom of Naples and Siena in the early fourteenth century were close and Simone Martini himself executed, at some date between 1316 and 1319, a prestigious altarpiece commission for the Angevin rulers of Naples, for which see Martindale (1988), pp. 18, 192–4.

4 THE PATRONAL ALTARS

1. Although the inventory of 1389 (15 March 1388, Sienese style) makes reference to these four altars, it offers no sense of where they were located. See AOMS 1489 (AOPA 864), fols 12$^{r/v}$, and Aronow (1990), pp. 229–30. Throughout I cite the old folio numbers in these inventories. The inventories of 1420 and 1423 are much more helpful in this respect, see ASS, Opera Metropolitana, 28, fols 14r, and 29, fols 16v, 17r, 18r. See also Aronow (1990), pp. 230–52.

2. The altar of Saint Ansanus would have stood where the altar with *Saint Ansanus Baptising the Sienese* by Francesco Vanni (1596) stands today. The altar of Saint Victor would have stood where the altar of the Blessed Sacrament stands today with its altarpiece of *The Adoration of the Shepherds* by Alessandro Casolani (1594).

3. ASS, Opera Metropolitana 29, fol. 17r: 'quattro peci grandi di graticola a poporelle di ferro stagnate, le quali chiudano il coro dele due cappelle di sopra scripte [i.e. the chapels of Saints Ansanus and Victor], a uscia e chiavi'. For other historical evidence for the existence of this screen, see Aronow (1990), p. 232.

4. The altar of Saint Savinus would have stood where the present altar with the *Virgin in Glory with Saints Peter and Paul* by Salvatore Fontana and Raffaello Vanni (1583) stands today. The altar of Saint Crescentius would have stood where the present altar with the *Preaching of Saint Bernardino* by Matteo Preti (1670) stands today. See Bacci (1931); Frederick (1983), p. 33, and fig. 7, (1989b), pp. 128–9; Beatson et al. (1986), pp. 611, 614; Aronow (1990), diagram, p. 226. Van der Ploeg (1984), fig. 16, p. 144, (1993), pl. 59; and Frederick (1989b), pp. 128–31, and fig. 1, suggest, however, that the altars of Savinus and Crescentius were located on the short eastern walls of the north and south transepts. Frederick, in my view, places too great a reliance on Alfonso Landi's description of 1655 which was written after the reconstruction of the transept altars which took place in 1651. Moreover, the inventory of 1446 (ASS, Opera Metropolitana, Inventarii 31, fol. 27v) refers to ten choir stalls on the right-hand side of the chapel of Saint Savinus. The most logical place for these stalls would have been against the short eastern wall of the north transept. The close association made in the early inventories between these two altars and the other altars within the body of the cathedral also suggest that they were all set flush to the walls of the transepts and aisles.

5. The existence of this series of altarpieces glorifying the Virgin and the events of her life was first proposed in Van Os (1969), pp. 3–11. For further refinements on his initial proposal, see Frederick (1983), (1985); Van Os (1984–90), 1, pp. 77–89, 143–7; Beatson et al. (1986).

6. PETRUS LAURENTII DE SENIS ME PINXIT A. MCCCXLII. In 1655 Alfonso Landi made a record of the painting and its text, and associated it with the altar of Saint Savinus. At that time the painting was no longer on the altar of Saint Savinus (which had been demolished in 1651 and replaced by another). It was described, instead, as at the top of the stairs of the writing room of the Opera. In nineteenth-century sources, it is described in the sacristy of the cathedral from where it was taken to the present Museo dell'Opera del Duomo. See Volpe, ed. 1989, cat. no. 123, p. 152.

7. SYMON MARTINI ET LIPPUS DE SENIS ME PINXERUNT ANNO DOMINI MCCCXXXIII. The painted inscription is on a narrow piece of wood from the original frame which has been inserted into the present nineteenth-century frame. Simone Martini (but not Lippo Memmi) is first named as the painter of the altarpiece of the altar of Saint Ansanus in the cathedral inventories of 1591 and 1596. Marginal notes to these inventory entries also record that the painting (at an unspecified date) had been sent to the church of Sant'Ansano in Castelvecchio. The removal of the painting from its original site was undoubtedly connected with the elaborate refashioning of the altar of Saint Ansanus which took place between 1585 and 1596. The painting is recorded in Sant'Ansano from 1620 until 1799, at which point it entered the Uffizi, Florence. See Beatson et al. (1986), pp.

612; 614, n. 35; Martindale (1988), cat. no. 12, p. 189; Frederick (1989b), pp. 129–30.

8. Bartolommeo Bulgarini is first named as the painter of the altarpiece of the altar of Saint Victor in the cathedral inventories for 1591 and 1596. Marginal notes to these inventory entries also record that the painting (at an unspecified date) had been sold to the Compagnia di Stigliano and that it was in the Opera. The removal of the painting from its original site was undoubtedly connected with the elaborate refashioning of the altar of Saint Victor which took place between 1585 and 1594. It was subsequently recorded on the altar of Saint Crescentius in 1610, 1620 and 1639. Thereafter it disappears from the records until its sale on the art market in 1915 and its acquisition by the Fogg Art Museum in 1917. Its removal from the cathedral was probably linked to the destruction of the altar of Saint Crescentius in 1651. See Beatson et al. (1986), pp. 611–14; Steinhoff-Morrison (1989); pp. 67–76; and Frederick (1989b), pp. 129–30. It should be noted that the Fogg *Nativity* is not accepted by all scholars as the central panel of the Saint Victor altarpiece. See, for example, Frederick (1985), pp. 61–3, (1989b), pp. 130–1, who proposes a lost painting by Bulgarini for the Saint Victor altarpiece, the only evidence for which we now have, is a number of later derivations (e.g. Pl. 187). While accepting that there may have been such an influential prototype, I am persuaded by the historical evidence that links the Fogg *Nativity* with both Bulgarini and the Saint Victor altarpiece. For the history of the attribution of this painting to Bulgarini, a fourteenth-century painter whose work has only recently been systematically identified, see Steinhoff-Morrison (1989), pp. 6–11, 79.

9. AMBROSIUS LAURENTII DE SENIS FECIT OPUS ANNO DOMINI MCCCXLII. The earliest identification of a painting by Ambrogio Lorenzetti on the altar of Saint Crescentius was made by Fabio Chigi in 1625–6, an identification subsequently confirmed by Landi in 1655 who records the painting's inscription in full. In 1651, the altar of Saint Crescentius had been demolished and Landi makes no specific reference to where Ambrogio's painting was in 1655. Della Valle (1785) 2, pp. 225–6, locates it as in the Spedale di Monna Agnese from where it went to the Accademia, Florence, in 1822. See, Frederick (1989b), pp. 128–9, Maginnis (1991), p. 34. The painting's subject has been identified as both the presentation of Christ in the Temple and the Virgin's purification – both of which were described as part of the same event in Luke 2: 22–38. Since this event was commemorated in the late medieval liturgical calendar as the feast of the Purification and the painting was part of a series of altarpieces designed to honour the Virgin, it seems more appropriate to refer to it as the *Purification of the Virgin*.

10. Van Os (1984–90), 1, p. 79; see also, Martindale (1988), for two other early examples of this type of altarpiece.

11. Saint Ansanus' companion is named as Giulitta on the nineteenth-century frame and as Margaret in the inventory of 1458. See AOMS, 1492 (AOPA, 867) Inv. 1458, fol. 361r, published in Bacci, 1944, pp. 166–7. The latter identification is accepted by some modern scholars (e.g. Martindale, 1988, p. 188). For the more plausible identification of Ansanus' companion as Massima, who acted as the saint's godmother and was martyred on the same day, see Beatson et al. (1986), p. 619.

12. Saints Savinus and Bartholomew are named in the inventory of 1429 (AOMS, 1492, AOPA, 867, Inv. 1429, fol. 17r, published in Bacci, 1931, p. 1, n.1; 1939, p. 91); and Saints Crescentius and Michael in the inventory of 1458 (AOMS, 1492, AOPA, 867, Inv. 1458, fol. 26$^{r/v}$, published in Bacci, 1931, pp. 2–3, n. 2). None of the fifteenth-century inventories identify the flanking saints on the Saint Victor altarpiece, only describing it as a Nativity flanked by two figures (see, for example, AOMS, 1492, AOPA 867, Inv. 1458, fol. 25r, and also Beatson et al., 1986, pp. 610, 611). For the plausible identification of the two paintings in Copenhagen as belonging to this altarpiece, see Frederick (1983); Van Os (1984–90), 1, pp. 85–7 and Beatson et al. (1986), pp. 617–19. Van Os identifies the female saint as Saint Catherine of Alexandria. However, the saint's attributes of a crown and two palms make Beatson's identification of Corona, Victor's wife and fellow martyr, more likely – particularly since both altarpieces within the lateral extension of the chancel would then have shown pairs of saints martyred on the same day.

13. An inventory of 1594, when the altarpieces were still all in place, states that each one had a predella. See AOMS, 1498 (AOPA, 871), inv. 1594, fol. 3v, and Beatson et al. (1986), p. 621.

14. A small panel painting, attributed to Pietro Lorenzetti, now in the National Gallery, London, whose subject has been identified as *Saint Savinus before Venustianus, Governor of Tuscany*, probably featured as the outermost right-hand panel on the predella of the Saint Savinus altarpiece. See Davies, ed. Gordon (1988) pp. 60–3. Two other panels, one in the Louvre, Paris, and the other in the Städelschen Kunstinstituts, Frankfurt, both attributed to Bulgarini, and depicting respectively the *Crucifixion* and the *Blinding of Saint Victor* have been identified as the third and fourth panels on the predella of the Saint Victor altarpiece. See Beatson et al. (1986), pp. 619–21; Steinhoff-Morrison (1989), pp. 95–7, and pp. 149–56, cat. nos 21, 22, pp. 427–37, for a detailed descriptive and stylistic analysis of the two paintings. In addition, it has been suggested in Beatson, p. 621, n. 67, and Maginnis (1991), p. 35, and (1997), p. 139, that the *Allegory of Redemption* attributed to Ambrogio Lorenzetti and now in the Pinacoteca, Siena, could have formed part of the predella for the Saint Crescentius altarpiece. Since this painting shares the same provenance as the *Purification of the Virgin*, i.e. the Spedale di Monna Agnese (see Torriti, 1990, p. 73), this is an attractive idea.

15. The Saint Ansanus altarpiece is now housed in a nineteenth-century Gothic style frame. For a photograph of the back of the painting which indicates very clearly what remains of the original panels, see Beatson et al. (1986), pl. 13. Lusini (1911–39) 1, p. 237, n. 5, published a payment for woodwork for the Saint Ansanus altarpiece dated to July 1329. No record of this now apparently survives (see Beatson et al., 1986, p. 614, n. 39). In July and November 1333, a woodworker, Maestro Duccio, received payment for the 'tavola di Santo Sano'. In December 1333, another woodworker, Maestro Paolo, received payment for his manufacture of 'civori', 'cholone' and 'caercini' (pinnacles, columns and circular ornaments) for the panel and Lippo Memmi received payment for the 'adornment' of these decorative features. Payments were also made at this date for a wooden canopy for the altarpiece, ironwork and porterage. See AOMS, 174 (AOPA, 329 bis), fol. 20ᵛ, 44ʳ, 49ʳ, 49ᵛ, 54ʳ, published in Bacci (1944), pp. 168–71. In June 1337, wood was acquired for the 'tavola', 'civori' and 'predella' of the Saint Crescentius altarpiece; in July 1339 and May 1340, Paolo di Bindo was paid for work on the 'predella' and 'colonne'; and in January 1340, a supplier was paid for battens for the panel. See AOMS, 177 (AOPA 330), fol. 49ʳ, AOMS, 178 (AOPA, 331) loose-leaf file, and fols 97ʳ, 122ʳ, published in Maginnis (1991), 'Appendice', nos 3, 20, 21, 23. On 28 May 1351, Giovanni di Goro was paid for 'civori' (pinnacles), 'cercini' (circular ornaments) and 'colonne di legname' (columns) for the 'tavola di Santo Vittorio'. See AOMS, 180 (AOPA 333), fol. 87ᵛ, published in Frederick (1983), p. 32.

16. Van der Ploeg (1993), pp. 66–7. For the references in the 1215 Customary to the altars and relics of these patron saints, see Chapter 2, pp. 35–7, 40.

17. For further analysis of this drawing in relationship to the projected Duomo Nuovo, see Van der Ploeg (1993), pp. 107–9.

18. Bacci (1944), p. 166; Beatson et al. (1986), p. 615.

19. It appears from an anonymous modern transcription, inserted into the relevant folio of AOMS, 176 (AOPA, 329 ter), fol. 54ʳ, that the first entry of the final account of December 1333, now badly damaged by damp, makes a reference to the two painters receiving payments for the 'tavola di Santo Sano', in 1331 and 1332. See also Frederick (1989a), pp. 468–9, who prefers a date of 1330 rather than 1331.

20. In November and December, 1335, respectively. See AOMS, 176 (AOPA, 329 ter), fol. 52ᵛ, 58ᵛ, published in Milanesi (1854–6), 1, p. 194, Bacci (1939), pp. 90–1.

21. For the payments to Ambrogio Lorenzetti in July 1339 and January 1340, see AOMS, 178 (AOPA, 331), loose-leaf folder, and fol. 97ʳ, published in Maginnis (1989), 'Appendice', nos 20, 22. For the payments for wood and carpentry of the altarpiece, see n. 15.

22. See n. 6 and 9.

23. Beatson et al. (1986), p. 615.

24. Steinhoff-Morrison (1989), pp. 77–8. For the attribution of the two Copenhagen paintings to the Master of the Palazzo Venezia Madonna, see Van Os (1984–90), 1, pp. 85–7.

25. Thus both painters worked on an extensive cycle of frescoes for the chapterhouse and cloister of San Francesco which has been plausibly dated to 1336. Ambrogio Lorenzetti also executed another series of frescoes for the chapterhouse of Sant'Agostino which were probably executed in time for the General Chapter of 1338. For further discussion of the latter commission, see Chapter 7, pp. 134–5. Payments for the Sala dei Nove indicate that Ambrogio was engaged in another major commission between February 1338 and May 1339 (see, Chapter 1, n. 69).

26. Martindale (1988), pp. 42, 188, proposes more solid framing elements which would have disguised better the marked discrepancy between the floor level of the central painting and that of the side paintings. The 1333 payment for 'cholone' (see n. 15) suggests, however, that the present twisted colonettes are a fair reflection of the original frame.

27. This reconstruction of the Saint Ansanus altarpiece is based upon that of Cämmerer-George (1966), pp. 153–5, fig. 14. Circumstantial evidence for the triangular gable panels is provided by Della Valle (1785), 2, pp. 111–12, who, when viewing the altarpiece in Sant'Ansano in Castelvecchio, describes it as having: 'piccole piramidi ornate nel mezzo da un coro di Serafini ardenti, da'lati de alcune figururine di Profeti . . .'.

28. For a perceptive analysis of Pietro Lorenzetti's skilful depiction of an interior architectural space (and also that of Ambrogio Lorenzetti in the *Purification of the Virgin*), see White (1957), pp. 99–100, Cämmerer-George (1966), pp. 159–61, Maginnis (1997), pp. 136–8.

29. Paolo di Giovanni Fei's altarpiece, which is clearly highly derivative of Pietro Lorenzetti's altarpiece, was originally painted *c.* 1380–90 for the church of San Maurizio in Siena. See Torriti (1990), pp. 121–2.

30. The height of the painting is 257 centimetres and thus considerably in advance of the *Annunciation* which measures 184 centimetres and the *Birth of the Virgin* which measures 187 centimetres.

31. Maginnis (1991), p. 36, and fig. 7, for an illustration of the back of the panel.

32. The height of the corbels from the base of the painting is approximately 173 cms. The height of the lateral panels on the Saint Ansanus altarpiece is approximately 168 cms and those for the reconstructed Saint Victor altarpiece approximately 170 cms.

33. Maginnis (1991), p. 37 (1997), pp. 113, 138–9, 203.

34. These measurements are taken from Steinhoff-Morrison (1989), p. 86, who has examined the Fogg *Nativity* in detail. For illustration of the embroidery, see Beatson et al. (1986), fig. 5.

35. These are a common feature of Bulgarini's work and, indeed, of a number of later fourteenth-century Sienese altarpieces. See, for example, those illustrated in Torriti (1990), pls 100, 102, 109–11, 119, 126, 151, 182.

36. This reconstruction is based on that of Norman Muller, itself a further refinement of the one offered by him in Beatson et al. (1986). It should be noted that the earlier reconstruction has been challenged by Christiansen (1987), p. 467, who, on the basis of the other three altarpieces, proposes that the central painting on the altarpiece originally had a much more symmetrical composition with the Virgin located on its central axis. In my view, the highly asymmetrical composition of the *Nativity*, proposed in both of Muller's reconstructions, deliberately took account of the original location of the altarpiece. For further discussion of this point, see pp. 81, 82.

37. When reconstructing the predella design for the altarpieces, it is striking that the dimensions of the *Allegory of Redemption* (Pl. 73; 57.5 × 118.5 cm) are considerably larger than those of the *Crucifixion* (Pl. 72; 39.7 × 71.1 cm). However, given the height of Ambrogio Lorenzetti's altarpiece, it would undoubtedly have needed a substantial predella, a point also made by Maginnis (1991), p. 35.

38. This is suggested by the surviving records for payment for the altarpieces, all of which are to be found in the archive of the Opera del Duomo, for which see n. 15, 19–21. There is also evidence that the four 'chapels' later became the burial sites of prominent ecclesiastics belonging to Siena's most eminent families. Thus, it appears the Saint Victor chapel was under the patronage of the Malavolti from the death of Bishop Donusdeo of Siena (d. 1350) onwards. In the mid-fifteenth century, the tomb slab of Giovanni Pecci, Bishop of Massa Marittima (d. 1428), was transferred to the chapel of Saint Ansanus and that of Bishop Carlo Bartoli of Siena (d. 1444) placed in front of the Saint Crescentius altar. It appears, however, that the families concerned had to gain permission from the Rector of the Opera to bury their ecclesiastical relatives in these locations and that their patronal rights were restricted to the installation of tombs and to the specification of procedures for the election of chaplains. See Lusini (1911–39), 1, pp. 257, 317, n.40; 2, pp. 8, 45–6, 75–6; Bacci (1931), p. 3, n. 3; Beatson et al. (1986), p. 613; n. 27; Frederick (1989b), p. 128.

39. See Chapter 2, pp. 22–4, 35, 37, 41.

40. For a perceptive analysis of Ambrogio Lorenzetti's treatment of this religious subject, see Maginnis (1991), p. 33.

41. Further excerpts from Gabriel's salutation to the Virgin appear along the edges of the robes of Gabriel. Martindale (1988), p. 188, gives a full transcription of these texts.

42. Beatson et al. (1986), p. 616, suggest that this architectural structure represents the 'celestial city' described in the *Meditations on the Life of Christ*. Since this devotional text was written locally by an anonymous Franciscan friar, and was apparently very influential for fourteenth-century devotional practice, this appears a plausible suggestion. However, I cannot agree that the triangular structure set within the architectural pavilion also derives from this text's description of an 'empty cave' as the setting for the birth of Christ. It appears to me to be a highly formalised rendition of the traditional stable of the Nativity.

43. Steinhoff-Morrison (1989), p. 80, also notes a formal link between these objects in the three altarpieces.

44. The tradition of giving Saint Ansanus a flag with a *balzana* and thus associating the saint very specifically with the city and its government quickly became established, as seen in the representation of the saint on important civic documents such as the 'Caleffo dell'Assunta' (Pl. 2) and the 'Libro dei Censi' (Pl. 6). In the latter, Saint Crescentius is also represented with a flag, but in this instance, it is embellished with the civic emblem of the lion of the Popolo.

45. Beatson et al. (1986), p. 619, interpret the olive branch as a symbol of peace and link it to the olive branch held by the Archangel Gabriel in Simone Martini and Lippo Memmi's *Annunciation*.

46. The 1215 Customary attests to the presence within the cathedral, at that date, of the 'bodies' of Saint Ansanus and Saint Savinus and the 'head' of Saint Victor (see Chapter 2, pp. 35, 40). The new altars would provide the most obvious and logical locations for such precious relics. According to Gigli (1723) ed. 1854 2, pp. 355-6, a mural depicting the translation of the relics of Saint Crescentius to Siena was commissioned from Martino di Bartolommeo for the altar of Saint Crescentius. Gigli's notice thus provides good circumstantial evidence that the altar of Saint Crescentius also contained a relic of its titular saint.

47. According to Della Valle (1785), 2, pp. 216-17, citing Landi (1655), Crescentius was also represented carrying his head in his hands.

48. See p. 68, and also Chapter 2, pp. 35-6.

49. The early fifteenth-century mural attributed to Benedetto di Bindo of *The Apparition of Saint Michael on the Castel Sant'Angelo* in the Chapel of the Relics in the sacristy (Mongellaz, 1985, pp. 84-5) further suggests that the Archangel Michael was a significant figure within the devotional life of the cathedral.

5 THE SPEDALE

1. This event was recorded by a well-informed eye-witness, the archivist of the Spedale, Girolamo Macchi, in his 'Libro di memoria dall'anno 1716 all'anno 1724'. A copy of this account can be found in BCS, MS A XI 23, fols 100ʳ-101ᵛ (old numbering, fols 72ʳ-73ᵛ), extracts from which are published in Maginnis (1988b), p. 185, n. 21.

2. ASS, Concistoro, 2462, fol. 73ʳ, published in Eisenberg (1981), p. 148.

3. For a detailed discussion of the provenance of each of these predella paintings, see Christiansen et al. (1988), pp. 146, cat. nos 18a-c, pp. 148-51.

4. Christiansen (1988), p. 146, understands the wording of the commissioning document to mean that the *Virgin of the Assumption* was not on the façade of the Spedale. Instead, he argues that Sano di Pietro selected four out of five narrative paintings from the façade. Although often contradictory in their identification of the precise subjects of the paintings, it appears to me, however, that none of the written sources refer to more than four paintings of the early life of the Virgin.

5. Ghiberti (c. 1447-55), ed. 1947, pp. 38, 39. For the dating of the *Commentaries* and Ghiberti's admiration for fourteenth-century Sienese painting, see Krautheimer (1982), pp. 139-40, 219-20, 306-9. Ghiberti's account is repeated in the *Anonimo Magliabechiano* (c. 1537-42), ed. 1968, pp. 92, 93.

6. Ugurgieri Azzolini (1649), 2, p. 338: 'HOC OPUS FECIT PETRUS LAURENTII ET AMBROSIUS EIUS FRATER 1335'; see also Pecci, 'Raccolta universale di tutte l'iscrizioni . . . di Siena (1730), in ASS, MS D 4, fol. 72ᵛ; Della Valle (1785), 2, pp. 212-13. In a catalogue of works in Siena compiled in 1625-6, Fabio Chigi gives a briefer version of this inscription but gives the date as 1337, for which, see n. 14.

7. The frescoes for the chapterhouse and cloister of San Francesco in Siena.

8. Vasari (1550, 1568), ed. 1966-, 2, 'Testo', pp. 143-4; see also Maginnis (1988b), p. 182. In the 1550 edition of the *Vite*, Vasari lists the *Nativity of the Virgin* as by Ambrogio, and the *Presentation in the Temple* and the *Betrothal*, as by Pietro. In the 1568 edition, he adds the scene of 'the Virgin going to the Temple with many Virgins' and assigns it to Ambrogio.

9. See, for example, Mancini (c. 1626), ed. 1956, 1, p. 178; Chigi (1625-6), ed. 1939, p. 302; Pecci (1752), pp. 33-4. Ugurgieri Azzolini (1649), 2, p. 338, relying on Vasari, refers to the participation of only the Lorenzetti, as does Girolamo Macchi in his 'Libro di memoria, 1716-24' and 'Origine dello Spedale di Santa Maria della Scala' (see ASS, MS D 107, fol. 213ᵛ, D 108, fols 227ᵛ, D 113, fol. 25 (2)ᵛ). Della Valle (1752), 2, pp. 99, 212-13, meanwhile, refers to both sets of attribution. Gigli (1723), ed. 1854, 1, pp. 117-18, only names Pietro Lorenzetti as the painter of two paintings 'ormai quasi spenti del tempo'.

10. G. Macchi, 'Libro di memoria, 1716-1724', BCS, MS A XI 23, fols 100ʳ-101ᵛ: 'Memoria dell'imbiancatura della facciata della chiesa dello Spedale e il Palazzo del S.re Rettore, e conventi delle fanciulle fatta dal di 25 di sett.re 1720, e terminata il di 10 Gen. in mesi 3 gni. 15 . . . Il tetto che era per di fuori nelle facciata della chiesa dello Spedale sopra alli murelli . . . Le pitture che erano il sud.etto Tetto in N.5 erano istorie della BVM . . .'. Macchi continues that the paintings were executed on 27 February 1481 (1482, modern style of dating) by Battista Christofano and Onofrio. At first sight, therefore, it appears that Macchi is describing five fifteenth-century paintings, but in the hospital accounts of 1478-87, there are payments to Battista and Onofrio di Frusino on 27 February 1481 (1482, modern style of dating) for the restoration of the façade frescoes. See ASS, Ospedale, 525, fol. 308ʳ, 308ᵛ, transcribed in Maginnis (1988b), p. 186, and n. 22. These entries associate the 'storie dela Nostra Donna' with the 'tetto' of the church of the Spedale.

11. 'Origine dello Spedale di Santa Maria dela Scala di Siena', in ASS, MS D 113, fols 59ᵛ-60ʳ. According to the written annotation on this drawing, the 'convento delle fanciulle' is the building on the left (no. 1 on the drawing), with the 'convento dei fanciulli minori' (the convent of the boys) next to it (no. 2). Macchi's drawing also shows the entrance of the church in its original position (no. 8). It is now the principal entrance to the Spedale complex of buildings.

12. See n. 6.

13. Maginnis (1988b), p. 188. See also, pp. 180-1, for a convenient summary of previous art historians' views concerning who painted what frescoes.

14. Rowlands (1965), pp. 25-6, Martindale (1988), p. 5. Chigi (1625-6), ed. 1939, p. 302, gives the date of Simone Martini's paintings as 1340. Since Simone Martini had left Siena in 1336, it appears that either Chigi was mistaken in the date he gave or alternatively another painter, working in a Simonesque style, was responsible for the last two paintings in the series. Given the fact that just such a painter – the so-called Master of the Palazzo Venezia Madonna – has been credited with the painting of the side panels for the Saint Victor altarpiece (Pls 78, 79), commissioned c. 1348-51, it may be that the same painter was previously commissioned to execute these paintings after Simone had left for Avignon. Alternatively it may simply be that Chigi left an inaccurate record of the dates on these paintings – a view held by Gallavotti Cavallero (1987), p. 69. A third possibility is that, although mainly working in Avignon, Simone Martini nevertheless returned to Siena to complete this particular fresco. For documentary records of Simone Martini's contacts with the Spedale after 1336, see Gallavotti Cavallero (1987), p. 73, n. 6.

15. Two inscriptions on the façade of the building record the foundation of the palace of the Rector in 1290 and the foundation of the 'domus pro Gitatellis' in 1298. According to these inscriptions, the former was built with the hospital's own money and the latter housed 300 girls. For a transcription of the two inscriptions, see Gallavotti Cavallero (1985), pp. 61, 63, and pp. 61-4, for the history of the buildings themselves.

16. Gallavotti Cavallero (1985), pp. 64, 79, 200-1.

17. While considering the precise location of these frescoes, it is also worth noting that in the early part of the fourteenth century part of the Piazza del Duomo was the site of a cemetery. It would, therefore, have constituted a less accessible area than it does today. See Gallavotti Cavallero (1985), pp. 58, 70.

18. As noted by Maginnis (1988b), p. 192. For contemporary records of Giovanni di Tese Tolomei's term of office and wealth, see the 'Cronaca senese' attributed to Agnolo di Tura in *Cronache senesi*, p. 522; and the

'Statuto dello Spedale', ed. 1877, pp. 176–81. For a modern historical assessment, see Mucciarelli (1995), pp. 252, 309, 314.

19. Macchi, 'Libro di memoria, 1716–1724', BCS, MS A XI 23, fols 100ʳ–101ᵛ: 'Il tetto che era per di fuori nella facciata dello chiesa dello Spedale sopra alli murelli, parte ci. Fu fatto l'anno 1325 del mese di maggio al tempo di M.se Gio di Tesi Tolommei Rettore . . . L'anno 1720 il di di 25 sett.e il sopra detto Tetto . . . in uno di quelli mensolani ci vi trovo l'arme di Casa Tolommei Rettore stato che fu nell'Anno 1314 al Anno 1325 qual mensolo si vedde che prima era stato per di fuori e do fu rimesso dentro alla muraglia'.

20. Gallavotti Cavallero (1985), p. 72.

21. ASS, Ospedale di Santa Maria della Scala, 119 (II), fols 259ʳ–260ʳ. This manuscript contains two sequences of pagination, the first (designated here as I) running from fols 1–299, the second (designated here as II) running from fols 200–725. For the construction of the Pellegrinaio, see Gallavotti Cavallero (1985), p. 77.

22. ASS, Ospedale di Santa Maria della Scala, 850, 'Entrata e uscita (1328, Jan. Dec.), fol. 25ᵛ 'lunedi vintesette di guigno. Messer Giovanni n[ost]ro signore die cap[ito]li fare la chappella del pelligrinaio nuovo [in right margin] C.V. libr[e].

23. ASS, Ospedale di Santa Maria della Scala, 119 (II), fols 265ᵛ, 267ʳ. For the details of Giovanni di Tese's extensive bequests to the Spedale, see also (I), fols 82ʳ, fol. 264ʳ/ᵛ (II), 257ʳ–267ʳ. In 1316, Giovanni di Tese had requested the Pope that he and his wife be buried in the Spedale church. See Gallavotti Cavallero (1985), p. 132, n. 106.

24. ASS, Con. Gen., 114, fols 41ʳ–42ᵛ.

25. An important observation made by Maginnis (1988b), pp. 192–3.

26. Eisenberg (1981). For further discussion of the Cappella dei Signori and its altarpiece, see Chapter 9, pp. 202–3.

27. For more detailed discussion of these reliefs, see Middeldorf Kosegarten (1984), cat. no. XI, 1–8, and Pls 130–3.

28. Although scholars have cited a wide range of paintings to support this point (see, Gallavotto Cavallero, 1987, pp. 70–1), the most significant examples appear to be: Lippo Vanni, c. 1360–70, fresco cycle, San Leonardo al Lago (*Presentation* and *Betrothal*, see Pls 151, 140); Bartolo di Fredi, early 1360s, fresco cycle, Cappella di S. Guglielmo, S. Agostino, San Gimignano (*Birth*, *Presentation* and *Betrothal*); Paolo di Giovanni Fei, c. 1380–90, altarpiece, probably for San Maurizio, Siena (*Birth*, see Pl. 87); Bartolo di Fredi, 1388, polyptych for the Cappella di SS. Annunziata, San Francesco, Montalcino (*Birth*, *Presentation*, *Betrothal* and *Return*, see Pls 176, 177, 186); Paolo di Giovanni Fei, 1398, altarpiece for altar of SS. Pietro e Paolo, Duomo, Siena (*Presentation* now in National Gallery, Washington D.C.); attrib. Benedetto di Bindo, c. 1412–15, fresco cycle, central chapel of the cathedral sacristy, Siena (*Birth*, *Presentation*, *Betrothal* and *Return*); Master of the Osservanza, 1440s, altarpiece (*Birth* now in Museo d'Arte Sacra, Asciano).

29. The tendency to replication of earlier images in late medieval and Renaissance Sienese painting has long fascinated art historians who have offered a variety of explanations for the phenomenon. For representative examples, see Meiss (1951); Van Os (1969), (1984–90); and Hoeniger (1995).

30. For the early history of the hospital from its origins until the end of the fourteenth century, see Gallavotti Cavallero (1985), pp. 55–130.

31. An important part of this mythology was a vision which Sorore's mother purportedly had before his birth. In this vision she was reputed to have seen a ladder upon which babies were climbing up to heaven to be received by the Virgin herself. The prominent presence of a ladder (*scala* in Italian) in this vision acts as a graceful compliment to the hospital's name and emblem.

32. Part of this late twelfth-century building probably survives on the ground floor of the palace of the Rector. See Gallavotti Cavallero (1985), pp. 57–8. As early as 1090 donations of land were being received on behalf of the 'xenodochium' (pilgrim hostel) and 'hospitalis' (hospital) of the canons of 'Sancta Maria' which suggests that the hospital belonged to the widespread development of such institutions in early medieval Europe. Its foundation must also have been the result of the development of the Via Francigena as a route for pilgrims and merchants travelling from northern Europe to Rome. See ibid., pp. 55–6.

33. Gallavotti Cavallero (1985), p. 70, and Pl. 30, for an illustration of the 'voltoni' of the Spedale.

34. References to the 'oblati ospedalieri' first begin in 1195. See Gallavotti Cavallero (1985), p. 57. The precise rules for this lay order are set out in detail in the Statutes of 1305 which were written in both Latin and the vernacular. The latter are published in *Statuti volgari de lo Spedale*, ed. 1864. For a useful summary, see *Archivio dell'Ospedale di Santa Maria della Scala. Inventario* (1960–2), 1, pp. xlviii–lii.

35. See, for example, *Il costituto* (1309–10), dist. I, rubrics 6–9 (ed. 1903, 1, pp. 48–54); rubric 51 (1, p.74), rubric 509 (1, p. 320), rubrics 584–5 (1, pp. 363–6); dist. II, rubric 269 (1, pp. 504–5); dist. VI, rubric 21 (2, p. 500). See also Gallavotti Cavallero (1985), p. 69.

36. For an account of the Spedale's social and charitable functions over the centuries, see the essay by Balestracci and Piccinni in Gallavotti Cavallero (1985), pp. 21–39.

37. See *Archivio dell'Ospedale di Santa Maria della Scala. Inventario* (1960–2), 1, pp. xxvi, li. According to rubric CXIV of the 1305–8 Statutes of the Spedale, the Spedale would confer a dowry of 50 *lire* to young women marrying or entering a convent. Otherwise they had to remain in the service of the Spedale.

38. See p. 90.

39. Other later paintings in the Pellegrinaio depict further aspects of the hospital's functions as seen in the frescoes of the *Care of the Sick*, the *Reception of Pilgrims and the Giving of Alms* and the *Feeding of the Poor* on one wall of the Pellegrinaio. These were executed by Domenico di Bartolo between 1440 and 1442 and appear opposite four other paintings of events in the Spedale's history, painted by Domenico di Bartolo and other artists.

40. For example, see Bartolo di Fredi's paintings of this subject in Sant'Agostino, San Gimignano (illus. in Freuler, 1994, Pl. 26), and on the predella from the Montalcino altarpiece (illus. in Torriti, 1990, fig. 144); the fresco attributed to Benedetto di Biondo in the sacristy of Siena cathedral (illus. in Gallavotti Cavallero, 1987, Pl. 2) and the altarpiece by the Master of the Osservanza, now in the Museo di Arte Sacra, Asciano (illus. in Maginnis, 1988b, Pl. 8).

41. In the altarpiece by the Master of the Osservanza (illus. in Maginnis, 1988b, Pl. 8).

42. See Maginnis (1988b), p. 189.

43. As seen in Paolo di Giovanni Fei's altarpiece for an altar in Siena cathedral, now in the National Gallery, Washington, D.C. (illus. in Carli, 1981, Pl. 282), and the fresco attributed to Benedetto di Biondo in the cathedral sacristy (illus. in Gallavotti Cavallero, 1987, Pl. 3). These centralised depictions of the Temple provide a striking contrast to Bartolo di Fredi's portrayal of the Temple at the left-hand side of his fresco of the *Presentation in the Temple* in Sant'Agostino, San Gimignano (illus. in Freuler, 1994, Pl. 27).

44. A detail that also appears in Lippo Vanni's treatment of this theme at San Leonardo al Lago (see Pl. 151). The possible relationship between the Spedale paintings and those by Lippo Vanni will be discussed in Chapter 7, pp. 135–6, 145–55.

45. In early sources dating as far back as the twelfth century, the Spedale is identified by its location 'ante gradus maioris Ecclesiae' (before the steps of the cathedral), a descriptive term also used in the city statutes of 1262 and 1309–10. Therein, probably, lay the origins of the name, Santa Maria della Scala. However, the name was also associated with aspects of the hagiography of the hospital's legendary founder, Sorore. See n. 31 and Gallavotti Cavallero (1985), pp. 57, 66, n. 42.

46. For illustration of the small *Maestà*, see Torriti (1990), Pl. 89, cat. no. 65, pp. 76–8. It has been proposed that this painting was the centre-piece of a triptych commissioned for the Spedale. See Moran and Seymour (1967). For Ambrogio Lorenzetti's documented contacts with the Spedale on 12 September 1341, and 10 June 1344, see ASS, Ospedale di Santa Maria della Scala, 514 , fol. 63ᵛ, 851, fol. 81ᵛ (old 47ᵛ), published in Maginnis (1989), 'Appendice', nos 27, 36, pp. 20, 23 (albeit with an incorrect date for the 1344 record).

47. Thus, for example, in his altarpiece for Montalcino, Bartolo di Fredi represented the Temple as the setting of both the *Presentation* and the *Betrothal*, portraying it as a polygonal building. For illustration of the two paintings, see Pl. 176, and Freuler (1994), Pl. 192.

48. The trumpeters are strikingly evident, for example, in Lippo Vanni's version of this subject at San Leonardo al Lago (Pl. 140) and in the fresco in the cathedral sacristy, attributed to Benedetto di Bindo (illus. in Gallavotti Cavallero, 1987, Pl. 4).

49. Illus. in Gallavotti Cavallero (1987), Pl. 4.

50. The link between the representation of musicians at Assisi and the lost *Betrothal* is also made in both Gallavotti Cavallero (1987), p. 72, and Maginnis (1988b), p. 191. The former also illustrates (Pl. 9) an anonymous fourteenth-century Italian drawing, now in the British Museum which, although squarer in format, is strikingly similar to Sano's *Betrothal*. For illustration in colour of the *Saint Louis of Toulouse* altarpiece, see Leone de Castris (1989), p. 45. For discussion of the political significance of the inclusion of such a richly patterned carpet within the imagery of this Angevin altarpiece, see Monnas (1993), p. 168.

51. These are: a side panel on Bartolo di Fredi's Montalcino altarpiece (Pl. 186), and the fresco, attributed to Benedetto di Biondo, in the sacristy of Siena cathedral (illus. in Gallavotti Cavallero, 1987, Pl. 5). The fresco shows a much more complex architectural setting beyond the crenellated wall than the panel painting.

52. Vasari (1550, 1568) ed. 1966–, 2, 'Testo', '. . . quando [Nostra Donna] va fra le vergini al tempio'. It is likely, however, that the prominent peacock perched on the portico in front of the Temple is an embellishment by Sano di Pietro (Pl. 110).

53. For example, the procession of women carrying a child in the *Miracle of the Crib* (illus. in colour in Leone de Castris, 1989, p. 103) from the *Blessed Agostino Novello and his Miracles* (Pl. 147) provides a simplified but analogous figural grouping to that of the Virgin and her companions in Sano's painting (as noted in Gallavotti Cavallero, 1987, p. 72), and Jerusalem in the *Road to Calvary* (Musée du Louvre, Paris, illus. in Leone de Castris, 1989, p. 117), provides a representation of a domed church set behind a city wall.

54. For a detailed discussion of the acquisition of this relic and the creation of the chapel, see Chapter 7, pp. 149–51.

55. See n. 10.

56. See Chapter 3, p. 45, for the association of Coppo di Marcovaldo and Guido da Siena's late thirteenth-century paintings of the *Virgin and Christ Child Enthroned* (Pls 51, 52) with, respectively, the high altars of Santa Maria dei Servi and San Domenico. It has also been proposed that three early fourteenth-century polyptychs of the *Virgin and Child with Saints*, two attributed to Duccio and one to Ugolino di Nerio, were once the high altarpieces of respectively, San Domenico, the hospital church, and San Francesco. For illustration of these polyptychs, see Van Os (1984–90), 1, Pls 38, 73 and 75, and for the possibility of their original location over these important city altars, see Cannon (1982), pp. 79–80; Van Os (1984–90), 1, pp. 64–5; Gardner von Teuffel (1979), p. 48, n. 68. Accounts given by Ghiberti and Vasari imply that Siena's principal gateways to the north (the Porta di Camollia) and to the south (the Porta Romana), were embellished with frescoes of the *Coronation of the Virgin*. For the attribution of the Porta Romana *Coronation* to Simone Martini and the complex history of the later repainting of these frescoes, see Procacci (1961), pp. 245–6, Martindale (1988), p. 43, cat. no. 40, p. 211. For the surviving early fourteenth-century fresco of the Virgin and Child (which probably also once depicted Saints Ansanus, Savinus, Crescentius and Bartholomew or Victor) over the southwestern city gate of Due Porte, see Leoncini (1994), pp. 48–50, and *passim* for a comprehensive survey of Siena's street tabernacles. Most of the surviving examples date from the fifteenth century onwards, but for evidence of a few earlier examples, see pp. 97, 148, 149–50, 183.

6 MASSA MARITTIMA

1. ASS, Biccherna, 746, fols 37ᵛ, 38ᵛ, published in Nardi et al. (1986), pp. 159–60. See also Chapter 1, pp. 6–7, 10.

2. Coconi (1947–8); Norman (1997).

3. Cammarosano and Passeri (1985), 'Repertorio', 28.1, pp. 323–4; Lombardi (1985), pp. 13–47, 50–7.

4. Coconi (1947–8), pp. 10–12, 30–2. The treaty of 1242 is recorded in ASS, Diplomatico Riformagioni di Massa, 9 March 1241 (1242, modern style of dating), and is transcribed in ibid., appendix, doc. 1. The treaty of 1276 is recorded in ASS, Diplomatico Riformagioni, 27 April 1276, and is transcribed in ibid., appendix, doc. 5. It also features in both the 'Caleffo Vecchio' and the 'Caleffo dell'Assunta', see ASS, Capitoli 1, fols 494ʳ–495ʳ, Capitoli 2, fol. 524ʳ/ᵛ.

5. For a summary of this campaign, see Norman (1997); and for further detail, see Coconi (1947–8), chs 3 and 4, pp. 43–81.

6. See ASS, Con. Gen., 117, fols 37ʳ–40ᵛ; Diplomatico Riformagioni, 5 October 1335; Capitoli 2 (the 'Caleffo dell'Assunta'), fols 542ʳ–553ᵛ;

Capitoli 58. The contents of the treaty are summarised in detail in Coconi (1947–8), appendix, doc. 9.

7. ASS, Capitoli 3 (the 'Caleffo Nero'), fols 67ʳ–93ʳ, 104ʳ/ᵛ. See also ASS, Biccherna 183, fols 64ᵛ, 65ʳ; 185, fols 27ʳ, 112ᵛ, 125ᵛ, 145ʳ; 187, fol. 100ᵛ, which itemise payments made between December 1335 and July 1337 by the Sienese government to send and finance master-builders to construct this fortress (published, in part, by Petrocchi, 1900, p. 116, n. 1, p. 117, n. 1).

8. *Cronache senesi*, ed. 1931–9, pp. 522, 525. See also Malavolti (1599) ed. 1982, pt 2, bk 5, p. 98ᵛ.

9. See pp. 109–10.

10. It is generally recognised that the painting – although clearly conceived by Ambrogio Lorenzetti himself – shows evidence of another painter collaborating with him on it. See Borsook (1966), pp. 32–3 (1969), p. 33, who suggests that this talented assistant also worked with Ambrogio on the San Procolo triptych (Uffizi, Florence), the frescoes in the Sala dei Nove (Pl. 11), the *Maestà* in Sant'Agostino, Siena (Pl. 142) and the frescoes in the oratory at Montesiepi (Pl. 159).

11. For the historical and technical evidence for such dating, see Norman (1995f) pp. 486–7. It should be noted, however, that new archival evidence strongly suggests that the dates for the Sala dei Nove commission were 1338–9 (and not 1338–40, as stated in my earlier study). During 1335 to 1337 Ambrogio Lorenzetti was probably also collaborating with his brother, Pietro, on an ambitious project of fresco paintings for the church of Santa Margherita in Cortona. I am grateful to Joanna Cannon for discussing this point with me. The coincidence of projects in Massa Marittima and Cortona is by no means impossible since it appears that Ambrogio Lorenzetti utilised the help of a talented assistant for the painting of the Massa Marittima *Maestà*.

12. ASS, Diplomatico, 'Riformagioni di Massa', 8 January 1315 (1316, modern style of dating), published in Milanesi (1854–6), 1, pp. 179–80.

13. De Nicola (1912), p. 121. De Nicola's suggestion is generally accepted by later scholars. See, for example, Carli (1976), p. 54, Van Os (1984–90), 1, p. 56.

14. This was certainly the case for the celebration on 10 October of the feast day of the city's patron saint, the sixth-century Saint Cerbone. As in Siena, offerings made on this day comprised both *ceri* and sums of money. See the various instances cited in Lombardi (1985), pp. 27, 149, 287.

15. See Chapter 1, pp. 1–3. For the celebration of the feast of the Assumption in Pisa, see Webb (1996), pp. 115, 204–5.

16. This impression is confirmed by photographs of the *Madonna delle Grazie* taken before its restoration in 1947. See *Mostra di opere d'arte restaurate* (1979–83), 1, fig. 15. From these, it is clear that, at some point in its history, later accretions such as heavily tooled haloes and gilt crowns were added to the cult figures of the Virgin and the Christ Child. The painting was again restored between 1979 and 1980. After its last restoration it was placed in a chapel to the left of the chancel.

17. These are the *Agony in the Garden, Christ in the House of Annas and Peter's First Betrayal*, the *Way to Calvary*, the *Deposition* and the *Entombment*. Carli (1976), p. 54, also identifies *Christ's Arrest* and *Christ before Pontius Pilate* amongst the most heavily cut-down of these narrative scenes.

18. For further discussion of the date and design of this altar table, see n. 54. The *Madonna delle Grazie* presently measures 99 centimetres in width and 179 in height.

19. It has been suggested that two early fourteenth-century panel paintings of the *Nativity* and *Adoration of the Magi*, now in a private collection in The Hague, were once pinnacle panels for this double-sided altarpiece. See Van Os (1984–90), 1, figs 69, 70, pp. 56–7. The two paintings owe their general compositional layout and certain of their details to the corresponding scenes from the front predella of Duccio's *Maestà* (illus. in Deuchler, 1984, figs 134, 137). In terms of style, however, they are not very close to the surviving Passion scenes from the back of the Massa Marittima altarpiece. Given the known difficulties surrounding the production of this complex altarpiece, it may be that such stylistic anomalies can be accounted for by several painters contributing to its final completion.

20. Massa Marittima owed much of its economic wealth and prosperity to the rich silver and copper mines in its vicinity. Evidence of the importance of mining for the city can be gauged from the 'Ordinamenta super arte fossarum rameriae et argenteriae civitatis Massae', a legislative record of mining practice compiled in the early fourteenth century. See Lombardi (1985), pp. 172–99, 215–36. This valuable codex, which represents one of

the judicial achievements of medieval Italy is now housed in the Archivio di Stato, Florence. In 1317, the Zecca or mint was also established in the city. See ASS, Diplomatico, Riformagioni di Massa, 11 April 1317. The Zecca was responsible for minting a silver *grosso* with the head of Saint Cerbone on its verso. See Petrocchi (1900), pp. 101–2.

21. The primary evidence for such Pisan workmanship occurs on an inscription on a capital near the crossing of the cathedral which records the date 1287 as the year in which the extension to the building was built and the artist responsible as Pisan. The series of mid-twelfth-century capitals in the nave of the cathedral and the late thirteenth-century sculpture on the upper sections of the exterior façade are also very close in style to contemporary Pisan work. See Carli (1976), pp. 17–25; White (1993), p. 54. See also the documented examples of other builders and sculptors working in Massa Marittima given in Carli (1976), pp. 13, 27, 28, 37, 39. Of these artists, it is striking that the majority appear to have come from Lombardy, Pisa and Siena. It appears, therefore, that as in the case of painters, the Massetani relied on foreign expertise for the construction and embellishment of their principal buildings.

22. See pp. 109–10. The renewed treaty of 1276 is recorded in ASS, Diplomatico Riformagioni di Massa, 31 October 1307. See also Coconi (1947–8), pp. 44–50.

23. For a summary of this critical debate, see Carli (1976), p. 54; see also his entry in *Arte senese nella Maremma* (1964), pp. 8–9. To the works cited by Carli should be added, Van Os (1984–90), I, pp. 56–7.

24. The crucifix was first attributed to Segna di Bonaventura by De Nicola (1912). For later critical discussion of the crucifix, see *Arte senese nella Maremma* (1964), cat. no. 3, pp. 51–4; Carli (1976), pp. 51–4; Van Os (1984–90), I, p. 56. It is presently displayed in a chapel to the right of the chancel and high altar.

25. Coletti (1949); Berenson (1957–68), I, pp. 117, 402, 493.

26. See *Art in the Making* (1989), pp. 83–9; Norman (1995b), pp. 63–7.

27. An inscription, dated 1588 (transcribed in Lombardi, 1986, p. 38), in the chancel behind the high altar, records the consecration of the high altar at that date to Saint Cerbone. The hagiography of the city's patron saint, Cerbone, describes how the saint regularly celebrated mass at an altar dedicated to the Virgin in his cathedral at Populonia which was also dedicated to her. See *Acta Sanctorum*, Octobris V, p. 97, Cesaretti (*c.* 1770), p. 81. Since the cathedral of Populonia was the original seat of the bishops of Massa Marittima from where they reputedly brought the relics of Saint Cerbone to Massa Marittima, this aspect of Cerbone's legend might well have had a bearing on the choice of imagery for the new high altarpiece in the early fourteenth century.

28. This particular terrain necessitated the construction of a substantial substructure below the chancel. This, in turn, allowed for the building of a large, well-lit crypt, known locally as the *chiesina* or the Succorpo, which, in the fifteenth century, became the meeting place of a local confraternity, the Compagnia della Santissima Trinità e del Santo Nome di Gesù. The Succorpo still contains a crudely painted fifteenth-century fresco of the *Crucifixion with the Virgin, Saints John the Evangelist, Cerbone and Bernardino* (illus. in Carli, 1976, p. 69).

29. Archaelogical evidence from the exterior south wall of the cathedral suggests that possibly the east end of the twelfth-century cathedral comprised a simple apse which was raised above the level of the crossing thus providing for a crypt beneath it. See Lombardi (1986), p. 14.

30. See Carli (1976), pp. 22–5; Santi (1995), p. 31. Both authors plausibly discount any involvement of Giovanni Pisano in this project, cf. Lombardi (1986), pp. 22, 24.

31. See Chapter 2, pp. 26–7.

32. If, as was common practice, the painted Crucifix once hung over the chancel arch, such Passion imagery would also have had a more public face as well.

33. As patron saint of the city and titular saint of its cathedral, the sixth-century bishop saint, Cerbone, had a well-established cult within Massa Marittima (for which, see pp. 115–20). Due to the city's flourishing mining industry, Saints Agatha and Lucy (as the patron saints of miners and metalworkers, respectively) also attracted the devotion of the Massetani. See Carli (1976), pp. 27, 67; Lombardi (1985), pp. 271–2; (1986), pp. 35, 60.

34. For further discussion of its original location, see pp. 118–20.

35. All that remains now are traces of blue and green pigment and gilding on such details as draperies and furnishings. For the similarities between the *arca* and contemporary reliquaries, see Carli (1946a), p. 37; Bartalini (1985), p. 32; Pierini (1995), pp. 13–15.

36. For the saint's hagiography, see Saint Gregory the Great, *Dialogorum* (PL LXXVII, cols 237–40), *Acta Sanctorum*, Octobris V, pp. 87–102; Cesaretti (*c.* 1770), pp. 12–23, 77–92. While the *Dialogues* of Saint Gregory provides a near-contemporary source for the 'miracle of the bears', the other scenes on the *arca* belong to a later, more legendary, *Life* of the saint.

37. *Acta Sanctorum*, Octobris V, p. 100; Cesaretti (*c.* 1770), p. 18. The centrality of this event for the cult of Saint Cerbone is confirmed by the design of a stained-glass oculus on the façade of the cathedral which depicts, as its central scene, the meeting between Pope Vigilio and Saint Cerbone. The date of the oculus is a matter of debate but it is generally considered to be from the late fourteenth century. See Carli (1976), pp. 68–70, Santi (1995), p. 33.

38. ANNO D[OMI]NI M.CCCXXIIII I[N]DIT[IONE] VII MAGIST[ER] PERUC[C]I[US] OP[ER]ARI[US] EC[C]L[ESIA]E FECIT FI[E]RI H[OC] OPUS MAG[IST]RO GORO GREGORII DE SENIS.

39. See pp. 109–10. Although not uncommon for an *operaio* to act in such a capacity, it appears that there was a well-established tradition for this type of patronage within Massa Marittima's cathedral. Inscriptions within the cathedral (transcribed in Lombardi, 1986, pp. 22, 24, 30, 33, 36, 38) indicate that between 1267 and 1447 responsiblity for the commissioning of the cathedral's baptismal font, extended east end, sacristy and choir stalls were all the responsibility of named *operai*. It appears from ASS, Diplomatico Riformagioni di Massa, 6 November 1411, that the *operai* of San Cerbone was chosen by the Consiglio Maggiore in consultation with the bishop and that one of their tasks was to ensure that the relics of Saint Cerbone were kept in a dignified location.

40. Pierini (1995), pp. 3–5, on the basis of entries in ASS, Lira, 7, fol. 50ʳ, Lira 10, fol. 124ᵛ, thus correcting a number of inaccuracies given in E. Romagnoli, 'Biografia cronologia de'bellartisti senesi . . .' (*c.* 1835), BCS, MS L II 1, fols 319–20.

41. ASS, Con. Gen., 15, fols 59ᵛ–60ʳ, published in Milanesi (1854–6), I, no. 1, pp. 153–4. This petition for citizenship, made under the auspices of Fra Melano, the current *operaio* of the cathedral, also names Lapo and Donato, known members of Nicola Pisano's workshop.

42. Goro's presence in Pisa in 1326, and his establishment of a workshop there, is attested by a document of 10 September 1326, published in Caleca and Fanucci Lovitch (1991), pp. 83–6. For the sculptor's work in Sicily, see Carli (1946a), pp. 8, 41–4; Pierini (1995), pp. 26–8.

43. Formerly in the cloister of San Domenico, Siena, and now placed in the nineteenth-century courtyard of the Università degli Studi. The relief and the effigy of Guglielmo di Ciliano have been incorporated with the remains of another tomb monument belonging to the juro-consul, Niccolò Aringhieri (d.1374). For further discussion of the tomb monument, its attribution to Goro to Gregorio and its close stylistic affinities to the *arca*, see Bartalini (1985); Pierini (1995), pp. 21–2.

44. The *arca* was photographed in this location by Alinari. See, for example, White (1993), Pl. 274. After 1950, the *arca* was placed in the Succorpo, where it was reported by Carli (1976), p. 39. By 1990, however, it had been moved to its present location in the chancel.

45. Carli (1946a), p. 63. For the contract of 29 March 1623, awarded to Flaminio del Turco, see ACMM, Decreti e Consigli Priorali, libro 452, fol. 467ʳ, published in Petrocchi (1904), pp. 639–42.

46. Petrocchi (1904), p. 343.

47. Petrocchi (1900), pp. 49–50; (1904), p. 342. Writing in 1884, Canon Arturo Arus also refers to a local tradition which stated that until 1538 the *arca* rested upon the high altar. See Pierini (1995), p. 47. The series of statues of prophets, apostles and saints, are presently located in the Succorpo but, until 1921, were displayed over the fifteenth-century choir stalls in the chancel. For further discussion of their relationship to the *arca*, see n. 49.

48. Carli (1946a), pp. 14, 63; Garms (1990), pp. 89–90; Pierini (1995), pp. 16–21; Ames-Lewis (1997), pp. 175–6. This view ostensibly finds support from the detailed record of the translation of the relics of Saint Cerbone in June 1600, which states that Bishop Achille Segardi placed the relics, 'in capsulam marmoream diu prius constructam subtus altare majus cathedralis dicte'. See ACMM, Riformagioni, 30 (old 662, 1548–1691), fols 65ʳ–67ʳ, cited in Carli (1946a), p. 58, n. 15. See also the eye-witness accounts given in ASS, Notarile post-cosimiano, Originali 236, Ser Cosimo di Girolamo Melchiorri da Massa, 6 June 1600, no. 414; 'Relazione della traslatione di Santo Cerbone', in BCS, MS K VII 24, fols 291ʳ–293ᵛ, published in Pierini

(1995), pp. 33–9. It should be noted, however, that by the end of the sixteenth century there was already considerable confusion about the history of these precious relics, for which, see n. 56.

49. See Carli (1946a), pp. 45–54, where he makes the perceptive points that the statues show no physical evidence of having once functioned as caryatid figures; that their subject would have been appropriate for the canons' collective devotions in the chancel; and that their irregular number would have corresponded to a logical sequence arranged around the five sides of the polygonal chancel. Although attributed to different sculptors by various authors, it is generally agreed that they are not by Goro di Gregorio but are of Sienese manufacture. See Carli (1976), pp. 44–7; (1990), pp. 32–3; Bellosi (1984); Santi (1995), p. 46.

50. A point also noted by Moskowitz (1994), pp. 43, 51, n. 62.

51. On the site of the present Palazzo Vescovile. For the hospital and its activities which were comparable, albeit on a more modest scale, to those of the Spedale di Santa Maria della Scala in Siena, see Lombardi (1985), pp. 16, 47; (1986), pp. 15, 18.

52. For a detailed treatment of thirteenth- and fourteenth-century *arcae* of this type, see Moskowitz (1994), pp. 1–43. For examples of early fourteenth-century *arcae* that combined a wall tomb and an altar below, see Bardotti Biasion (1984), pp. 4–6. For the *arca* of Saint Margherita of Cortona which combined a wall tomb and reliquary cupboard, see Bardotti Biasion (1984), pp. 6–17, and Cannon (1995), pp. 408–10, figs 5–6.

53. See the detailed reconstruction and analysis of this monument given in Moskowitz (1994), pp. 1–27, Pls 1–3, 7–34. In this context, it is also worth noting that Goro di Gregorio's father may have been part of Nicola Pisano's workshop for Siena cathedral. See n. 41.

54. The altar table is currently supported by four composite piers of red Maremma marble and three colonettes of white marble. The composite columns have capitals of white marble carved with highly naturalistic flora and fauna, and the colonettes capitals carved with acanthus motifs. See Carli (1946a), pp. 14, 63, and Pl. XXXIX (which shows a detail of one of the capitals of the composite columns). Clearly of fourteenth-century workmanship and of a comparable style to the decorative framework of the *arca* itself, it is possible that these columns could once have acted as supports for a free-standing, architectonic monument.

55. As in the case of the subterranean chapel beneath the fourteenth-century chancel of Naples cathedral which in the early sixteenth century was converted into a chapel to house the relics of that city's patron saint, Januarius. See Norman (1986), pp. 323–4, 339–41.

56. It is likely that the *arca* was designed specifically to house the relics of Saint Cerbone. The presence in the cathedral of a fourteenth-century reliquary, probably of Sienese manufacture, purporting to contain the finger of Saint Cerbone (for which, see Santi, 1995, p. 36), suggests that at least one relic was known to the cathedral authorities in the fourteenth century. The detailed account of the translation of the relics of Saint Cerbone, given in BCS, MS K VII 24, fols 291ʳ–293ᵛ, reveal that in 1599 the whereabouts of the relics was no longer known. A search was duly instigated by Bishop Segardi and the civic authorities, first in the *arca* itself (which was then under the high altar) and then under the pavement below it. The relics were found on 26 June 1599, in an iron box on which were seals with the impression of the coats of arms of Massa Marittima and Bishop Girolamo de'Conti Romano (fol. 292ʳ). According to Cesaretti (c. 1770), pp. 59–60, this bishop reigned from 1483 to c. 1491. It appears, therefore, that in the 1480s, the relics were buried under the high altar and the *arca* converted into a sarcophagus and placed under the high altar, possibly in an attempt to make it look more *all'antica* in design.

57. Petrocchi (1900), p. 84, n. 1; Cagnola (1902); Perkins (1904 a & b).

58. See Santi's entry in *Mostra di opere d'arte restaurate* (1979–83), I, p. 65; Van Os (1984–90) 1, pp. 58–61. For the association of the painting with the document of 1316, see Petrocchi (1900), p. 84, n. 1; a mistake corrected by Perkins (1904 a & b).

59. ASS, Diplomatico, S. Agostino di Massa, 18 November 1348, published in condensed form in Milanesi (1854–6), 1, pp. 246–7, no. 54. The work on the east end of the church was to be executed according to the design of the Sienese sculptor, Domenico di Agostino. The foundation of the church in 1300 is recorded in ASS, Diplomatico. S. Agostino di Massa, 14 March 1299 (1300, modern style of dating), for which see Norman (1995 f), p. 488.

60. A further piece of historical information also puts such a location in some doubt. In his 'Biografia cronologia de'bellartisti senesi . . .' (c. 1835), (BCS,

L II 2, fol. 256), E. Romagnoli reports that the early nineteenth-century connoisseur, Giovanni Gaye, had seen in the *cancelleria comunitativa* of Massa Marittima, a painting by Ambrogio Lorenzetti whose description closely fits the one presently under discussion. This account, if accurate, would place the painting in the Palazzo Comunale, some thirty years before its rediscovery in the priory of Sant'Agostino. For further discussion of this point, see n. 77.

61. Ghiberti (c. 1447–55), ed. 1947, p. 38; Vasari (1550/1568) ed. 1966–, 2, 'Testo', p. 181.

62. See the detailed account of the painting's condition given in *Mostra di opere d'arte restaurate* (1979–83), I, pp. 60–6.

63. Carli (1976), p. 60; Van Os (1984–90), 1, pp. 58–61; White (1993), pp. 382–4.

64. For example, Jacopo di Cione's *Coronation of the Virgin* altarpiece of c. 1370–1 for the high altar of San Piero Maggiore, Florence (illus. in Norman, ed., 1995, 2, Pls 256–7). Ambrogio Lorenzetti may have studied the *Coronation of the Virgin* (illus. in ibid., Pl. 214), signed by Giotto and painted for the Baroncelli Chapel in Santa Croce, Florence. The Baroncelli *Coronation* is dated between 1328 and 1334 and could, therefore, have been seen by Ambrogio Lorenzetti whose presence in Florence is documented between 1329 and 1330 (for which, see Hueck, 1972), p. 120.

65. For more detailed discussion of the identification of these saints, see Norman (1995 f), pp. 481–4.

66. See, for example, Petrocchi (1900), pp. 84–5; Carli (1976), p. 62; Perrig (1981), p. 232.

67. Santi in *Mostra di opere d'arte restaurate* (1979–83), I, p. 64; Norman (1995 f), pp. 83–4.

68. Freyhan (1948), pp. 68–86, esp. p. 81.

69. See p. 128.

70. Muller (1979), pp. 101–2; Dale (1989), p. 6: Norman (1995 f), p. 484.

71. Hibbard (1957), pp. 137–8.

72. Gardner von Teuffel (1985), p. 391.

73. On the site of the present eighteenth-century Ospedale di Sant'Andrea. In 1336, the Bishop of Massa Marittima, the Sienese Dominican, Galgano di Leonardo Pagliericci, was prevailed upon by the Sienese authorities to move his residence to the Palazzino dei Conti di Biserno, adjacent to the Palazzo Comunale in the *città vecchia*, in order that the new fortress could be built. See Lombardi (1985), pp. 62, 286; (1986), pp. 50–1.

74. ASS, Diplomatico, S. Agostino in Massa, 20 February 1272 (1273, modern style of dating). The gift was made to Fra Placido, Provincial of the Augustinian Hermits, who undertook, in five years time, to acquire the rights of the church from the bishop and cathedral canons.

75. Carli (1976), pp. 66–7, 69: Norman (1995 f), pp. 488–90.

76. For the later history of San Pietro all'Orto which is largely uninformative about the church and its interior embellishment, see Norman (1995 f), pp. 490–1.

77. Faced with the conflicting dates of Romagnoli's report of Ambrogio Lorenzetti's *Maestà* in the Palazzo Comunale in c. 1835 and Petrocchi's report of the painting's discovery in the priory of Sant'Agostino in 1867, I suggest that the latter event probably in fact occurred in 1810 when the religious community there was suppressed and an extensive inventory of the priory and its church made by the regional authorities. See Norman (1995 f), pp. 491–2.

78. ANNO MILLENO CENTENO BIS QUADRAGENO/ ADDITO SESTENO POST ISTOS ATQUE DECENO/ HOC TEMPLUM LAPIDI CO[N]IUNGITUR ISTI/ SCS PETRUS + SCS PAULUS + [SCS] IOH[ANNE]S (in the year one thousand, one hundred and ninety seven, this church was joined to this stone, Saint Peter, Saint Paul, Saint John). The inscription is recorded with minor variations in Giovanni Pecci, 'Le memorie storiche . . . che sono stato suddite alla . . . Siena', c. 1730, ASS, MS D 70, fol. 76; Targioni Tozzetti (1768–79), 4, p. 124.

79. Norman (1995 f), pp. 493–5. Santi in *Mostra di opere d'arte restaurate* (1979–83), I, pp. 63–4, suggests that the now blank pages may have originally contained further letters from the opening verse of the Gospel according to John. If this was the case, the Massa Marittima *Maestà* would have shared an iconographic feature of Lippo Memmi's *Maestà* at San Gimignano (Pl. 64) where the saint is portrayed with an open book, on the pages of which the opening verses of the gospel are still visible.

80. Norman (1995 f), pp. 495–6. See also, pp. 498–500, 501–3, for discussion of two early fourteenth-century Augustinian Hermits whose scholarship provides evidence of a preoccupation with similar kinds of theological issues.

81. Freyhan (1948), pp. 68–9, 72–3, 78, 81; Norman (1995f), pp. 496–7.

82. Augustine, *De Trinitate*, lib. XV, cap. XI, art. 20–1 (PL XLII, col. 1071–73).

83. Augustine, *In Ioannis Evangelium Tractatus*, 'Tractatus 1', cap. i, art. 9 (PL XXXV, col. 1384). Dale (1989), pp. 8–9, argues that the source for the four-storied tower was a passage in Augustine's *Enchiridion,* and indeed sees the *Enchiridion* as seminal for the painting's programme. The two sources are not, however, mutually exclusive.

84. Augustine, *Enchiridion ad Laurentium sive de Fide, Spe et Charitate* (PL XL, cols 231–90).

85. 'De antiquis ordinis eremitarum Sancti Augustini bibliothecis', ed. 1954, pp. 213–17, esp. p. 215. This inventory, which features as part of a larger inventory of libraries within Augustinian priories compiled in 1360 by the order of the Prior General of the Order, was drawn up during the priorate of Fra Michele Nucci of Siena.

86. Perrig (1981), pp. 232–4, sees Ambrogio Lorenzetti's *Maestà* as a vehicle of political propaganda foisted on Massa Marittima by unnamed Sienese in 1335 as a means of exerting their political control over the newly subdued city. Much of his argument is impaired, however, by his uncorroborated claim that the painting was executed for the cathedral of the city.

87. According to the early historical accounts, it was these two families, in particular, who offered their support to the Sienese in 1335. See, for example, *Cronache senesi*, ed. 1931–9, p. 514; Malavolti (1599), ed. 1982, pt 2, bk 5, p. 96ʳ/ᵛ. For evidence of these two families' patronage of the cathedral and San Francesco in the mid decades of the fourteenth century, see Lombardi (1986), pp. 28, 35, 66.

88. One such official, Francesco Accarigi, was paid on 31 August 1336, a total of 504 *lire*, 10 *soldi*, as his salary as *capitano* of Massa Marittima. See ASS, Biccherna, 185, fol. 113ʳ. Three other Sienese officials are named on an inscription dated 19 February 1337 (1338, modern style of dating), over the Porta alle Sicili which leads from the fortress to the *città vecchia* (transcribed in Lombardi, 1985, p. 57). This inscription also gives the name of a local nobleman, Lucio di Biserno, here named as Siena's Capitano della Guerra. In this context, it is significant that in 1336 the current Sienese bishop of Massa took up residence in this nobleman's palace (see n. 73). According to the local eighteenth-century Augustinian scholar, Fra Agostino Cesaretti, Bishop Pagliericci served his fellow Sienese well. See Cesaretti (c. 1770), p. 49.

89. I am grateful to Christa Gardner von Teuffel for this information.

90. A possible link between the Augustinian community and the wider society of Massa Marittima is furnished by the eminent Augustinian theologian, Fra Michele who may have belonged to the Beccucci family of Massa Marittima and probably died in Paris in 1336. For Fra Michele and the Beccucci, see Norman (1995f), pp. 498–500.

91. For a number of striking instances of this trend, see White (1993), pp. 352–4, 358–68, 374–9, 398–400, 435–50, 453–70; Norman (1995a), pp. 32, 34–5, 37, 43–44. Within the cathedral of Massa Marittima itself, there are also two works which exemplify the skill of fourteenth-century Sienese goldsmithing: the reliquary of Saint Cerbone (for which, see n. 56) and the reliquary of the Holy Thorn which carries the date of 1389 and the name of the noted Sienese *orafo*, Goro di Ser Neroccio. See Santi (1995), p. 36.

7 SAN LEONARDO AL LAGO

1. See, for example, ASS, Statuti, 3 (1274), fol. 4ᵛ; Statuti 5 (1287), fols 23ᵛ, 24ᵛ, cited in Redon (1990), p. 39, n. 9.

2. ASS, Diplomatico, 1 March 1306 (1307, modern style of dating). This will is also transcribed in a 1713 copy of the parchments then existing in the archive of Sant'Agostino. See BCS, MS B VI 18, fols 277ᵛ–283ʳ.

3. A group of hermits founded in the twelfth century by Saint Guglielmo at Malavalle near Castiglione della Pescaia in south-western Tuscany.

4. For the papal bulls of 1243 and 1256, see 'Bullarium Ordinis Eremitarum S. Augustini' (ed. 1962–4) 12, no. 32, pp. 190–1, 14, no. 163, pp. 239–41. For the early history of the order, see Elm (1960); Van Luijk (1972); Gutièrrez (1980); for its early history in Tuscany, see Roth (1952–4); Van Luijk (1968); Hackett (1990).

5. For further discussion of this point, see pp. 137, 155. See also the evidence cited in Redon (1990), pp. 32, 37, 41 (n. 60, 62, 69), 42 (n. 104, 106, 128), 42–3 (n. 129, 130); Hackett (1990), pp. 48–9, 51, 56, 69 (n. 23), 70 (n. 47).

6. Redon (1990), p. 16.

7. In the statutes of 1262 and 1274, the Commune contributed substantial quantities of bricks for the construction of the church and priory. See Redon (1990), p. 42, n. 104. On 27 April 1298, the Consiglio Generale additionally agreed a sum of 600 *lire* for the construction of the new church. See, ASS, Consiglio Generale 53, fol. 107ʳ/ᵛ, published in Butzek et al. (1985), doc. 2, p. 457; see also, pp. 3–5, for examples of other instances of communal financing in the thirteenth and fourteenth centuries.

8. See Butzek et al. (1985), pp. 159, 210, 212 (n. 67). For these families' contacts with Massa Marittima, see Petrocchi (1900), pp. 33, 57; Lombardi (1985), pp. 114–28, 183; Mucciarelli (1995), pp. 22, 59, 69 (n. 120), 76–8, 129, 220–1, 231 (n. 98), 243–4, 245, 268–9, 300–4, 334 (n. 49).

9. In the acts of the General Chapter held in 1312 in Viterbo (published in 'Antiquiores . . . definitiones Capitulorum Generalium Ordinis', 1909–10, pp. 152–3), reference is made to the foundation of *studia generalia* in the priories of both Siena and Florence.

10. 'Antiquiores . . . definitiones Capitulorum Generalium Ordinis' (1911–12), pp. 177–83.

11. See Chapter 6, pp. 128, 130.

12. The original parchment detailing this property transaction of 27 April 1327, survives amongst the manuscripts of the eighteenth-century antiquarian, Girolamo Bichi. See ASS, MS B 74 (Pergamene Bichi, L 587), fol. 192ʳ/ᵛ.

13. Recorded in a 'Sepultuario' for the church, dated 1382. See AAS, no. 3554, fol. 83ᵛ, cited in Butzek et al. (1985), p. 159, n. 488.

14. Transcribed in BCS, MS B VI 18, fol. 243ʳ.

15. For the history of the attribution of this *Maestà* to Ambrogio Lorenzetti, see Seidel (1978), pp. 223–9.

16. For a reconstruction of the original appearance of the chapterhouse, and its patronage by the Ruffaldi family, see Seidel (1978), pp. 185–200; and Butzek et al. (1985), pp. 28, 151, 230, who date its construction and embellishment to 1322–38.

17. See Ghiberti (c. 1447–55) ed. 1947, p. 38. Vasari (1550, 1568) ed. 1966-, 2, 'Testo', p. 180, substantially repeats Ghiberti's description but adds that the twelve apostles were depicted in the vault each holding a text on which was written a single article of the Creed and with an *istorietta* exemplifying it. For the appropriateness of these subjects for the decoration of a chapterhouse, see Seidel (1978), pp. 201–6.

18. For the identification of these two saints in the Massa Marittima painting, see Chapter 6, pp. 123–4. In the case of the Sienese painting, Seidel (1978), pp. 210–11, 221–2, identifies the hermit saint on the right-hand side of the painting as the twelfth-century saint Guglielmo of Malavalle, founder of the Guglielmiti who, in 1243, were exempted from joining the Augustinian Hermits. The relatively high incidence of Saint Anthony Abbot being represented in paintings commissioned for Augustinian churches leads me to believe that it is this fourth-century saint, not Guglielmo, who is represented here.

19. Seidel (1978), pp. 202–5, 211–12, and pp. 28, 115, for the relevance of the other saints represented in the Siena *Maestà* to specific cults practised within Sant'Agostino itself or to particular theological preoccupations of the Augustinian Hermits.

20. Seidel (1978), pp. 201–29. See also, Butzek et al. (1985), pp. 28, 115.

21. See p. 134, and n. 17.

22. Seidel (1978), pp. 205–6, who cites an influential Augustinian text, attributed in the fourteenth century to Augustine himself, which makes the claim that at Pentecost, each one of the apostles recited an article of the Creed. Pentecost was the day on which the General and the Provincial Chapters of the Augustinian Hermits were held.

23. Augustine, *Enchiridion*, PL XL, col. 235–85. See also Chapter 6, p. 128; Norman (1995f), p. 496.

24. See Chapter 5, pp. 87–90.

25. Redon (1990), pp. 34, 37.

26. Thus in six months in 1288, the Selva del Lago yielded 1,080 *lire* for the Commune. See Waley (1991), p. 179. See also the evidence of the Commune's energetic policy towards the Selva del Lago, drawn from such official sources as the city's account books, taxation records and statutes, cited in Bowsky (1970), pp. 39–40, 122–3, 131, 161, 210–12; (1981), pp. 195, n. 15; Redon (1990), pp. 34, 37, 42 (n. 122, 124–6); Massai (1998), pp. 15–19, 57–65, 73–101.

27. See Cammarosano and Passeri (1984), 'Repertorio', 32.27; Hackett (1990), pp. 45–9. Due to their union between 1251 and 1516, the early history of San Leonardo is frequently confused with the neighbouring – and even

more famous – Augustinian hermitage of Lecceto. For clarification of the early histories of these two hermitages, see Hackett (1977), pp. 18–22.

28. Radan (1980), pp. 85, 91, 93; (1990), pp. 81, 92. See also the figure in Radan (1990), p. 81, which illustrates a reconstruction of the grotto-chapel.

29. A document of 1119, recording a donation of land, makes a reference to a church of Saint Leonard in the Selva del Lago which suggests that by that date the oratory had been constructed. For further discussion of the status of this historical source, see Hackett (1990), p. 46. See Radan (1980), pp. 85, 87, 93, 97–8, and (1990), pp. 88, 92, for revised proposals about the date and appearance of the oratory. See also the figures in Radan (1990), pp. 85, 86, which illustrate elevations of the south wall of the present church incorporating remnants of the oratory, and reconstructions of the oratory itself.

30. For the papal decree assigning San Leonardo al Lago to the Augustinian Order, see 'Bullarium Ordinis Eremitarum S. Augustini' (ed. 1962–4), 13, no. 85, p. 475.

31. See Massai (1998), pp. 21–5.

32. *Il costituto* (1309–10), dist. 1, rubrics 54, 563, ed. 1903, 1, pp. 78, 351–2. See also other examples of government directives concerning San Leonardo, cited in Redon (1990), pp. 37, 42 (n. 127–9).

33. ASS, Con. Gen., 175, fols 52ᵛ–54ᵛ, esp. fol. 53ʳ/ᵛ, a decision made at a debate held on 27 November 1366. For further discussion of this decision, see Hackett (1990), pp. 48–9. Remains of a circuit of stone walls and of two towers, one round, one square, still survive on the outer confines of the hermitage. See Cammarosano and Passeri (1984), 'Repertorio', 32–27.

34. There are two fourteenth-century sources for the life and miracles of the Blessed Agostino Novello. One is the 'Vita' located in BCS, MS K VII 36, a manuscript probably compiled at Sant'Agostino in Siena and used as the basis of the 'Vita' given in *Acta Sanctorum*, Maii, vol. IV, pp. 616–21. The other is the 'Vita' in the Legendary of 1326–42, located in Florence, Laurenziana, Cod. Plut. 90 sup. 48, fols 51ʳ–53ʳ, and published in Arbesmann (1966), pp. 44–7.

35. Arbesmann (ed.), 'Henry of Freimar's Treatise', ed. 1956, p. 117; Jordan of Saxony, *Liber Vitasfratrum*, ed. 1943, p. 153.

36. *Cronache senesi*, ed. 1931–9, pp. 306, 307. According to this source, the feast was marked by the running of a *palio* by several of the city's *contrade*.

37. ASS, Con. Gen., 100, fols 10ʳ–12ʳ, esp. fol. 10ᵛ, recording the debate of 16 June 1324, where the council agreed by 182 votes to 23 to contribute 44 *lire* and 18 *soldi* towards the expenses for staging these celebrations. ASS. Con. Gen., 107, fols 39ᵛ–41ᵛ, recording the debate of 20 February 1328 (1329, modern style of dating) where the council agreed that officials of the Commune would visit the tomb of Agostino Novello on that day. For the relevant clause from the 1324 debate and the entire 1329 debate, see Seidel (1985), pp. 139 (n. 50), 130–2 (n. 34). For the wider ramifications of the 1329 petition which was made in the context of the other major mendicant orders also petitioning the government on behalf of their own *beati* and saints, see Vauchez (1977), ed. 1990, pp. 194–205.

38. Bagnoli and Seidel in *Simone Martini e "chompagni"* (1985), pp. 56–61, 68–72; Seidel (1985), pp. 77–110; Seidel (1988), pp. 75–80; Martindale (1988), cat. no. 41, pp. 211–14.

39. For the evidence to support such a location, see Butzek et al. (1985), pp. 210, 212.

40. Seidel in *Simone Martini e "chompagni"* (1985), pp. 68–72; Seidel (1985), pp. 77–111. The principal source for the painted imagery on the wooden *arca* is a visitation report of 1575 (AAS, 21, fol. 710ᵛ), published in Seidel (1985), p. 84.

41. Hackett (1990), p. 48. For other evidence of the hermitage as a place of pilgrimage, see Massai (1998), pp. 4, 57.

42. The exact date of its construction is not known, but it is usually dated to the mid-fourteenth century. See Carli (1969), p. 4; Hackett (1990), p. 48; Radan (1990), pp. 81, 88, 92, and the plans illustrated on p. 84.

43. BCS, MS B IX 18, fols 193ʳ–194ᵛ, dated 15 May 1611, and published, in full, in Cornice (1990), pp. 297–9.

44. BCS, MS B IX 18, fol. 193ʳ, Cornice (1990), pp. 297–8.

45. BCS, MS B IX 18, fol. 194ʳ, Cornice (1990), p. 299. This source also refers to a panel painting on the high altar depicting the Virgin and Child with Saints Martin, Augustine, John the Baptist, Bartholomew, Leonard and Paul the Hermit and, on the predella, five scenes of the Passion alternating with four standing figures of Saints Catherine, Agnes, Tecla and Agatha. It is hard to determine from this very general description at what date this high altarpiece was executed. It could have been painted in the mid-

fourteenth century at the time of the chancel frescoes (for which, see pp. 143, 145) or it could have been painted in the fifteenth century at the time that Giovanni di Paolo executed the monochrome *Crucifixion* for the chapterhouse of the adjacent priory (for which, see Alessi, 1990). Reference is also made to a third altarpiece which has been identified with the early fourteenth-century triptych, now in the Palazzo Gondi, Florence. As noted by Cannon (1994), pp. 45–7, esp. p. 47, the central panel of this triptych has plausibly been attributed to Segna di Bonaventura and its side panels to another painter – the latter appearing to be a later addition made after 1329.

46. The 1638 report is published in an appendix to the 'Vita' of the Blessed Agostino Novello in the *Acta Sanctorum*, Maii, vol. IV, pp. 622–3; the 1756 report is recorded in AAS, n. 5956, fol. 393ʳ. Radan (1990), p. 92, reports traces of paintings on the walls of the one-time oratory.

47. See Chapter 3, p. 60.

48. Carli (1966), pp. 180–2; (1969), pp. 4–5, 20 (n. 43). For a summary of what paintings were visible to nineteenth- and early twentieth-century scholars, see Borsook (1956); pp. 351–8, esp. p. 352; Cornice (1990), p. 287.

49. Illustrated in Carli (1969), figs 35–43. The saints are clearly identified as: Colomba, Mary Magdalen and Cecilia (below the *Presentation*); Agnes and Agatha (below the *Annunciation*); and Lucy, Martha and Margaret (below the *Betrothal*). The third saint below the *Annunciation* is identified by a heavily repainted title as Saint Catherine. Since Catherine is depicted elsewhere in the chancel and the saint in question holds an arrow and a standard, it is likely that she represents the fifth-century saint, Ursula.

50. *Acta Sanctorum*, Novembris, vol. III, pp. 139–210. As remarked by Kaftal (1952), col. 632–3, these paintings of Saint Leonard and his miracles have the character of *ex voto* images, but whether they had a personal significance for the commissioners of this painted scheme, it is now impossible to determine.

51. For the adoption of Saint Leonard by the Augustinian Hermits, see Seidel (1985). pp. 126–9. One pertinent aspect of this saint's life for the order was that he abandoned the court of King Clovis to become a hermit in the forest near Limoges.

52. For the 'Vita' of the saint and her role in the conversion of her son, see *Acta Sanctorum*, Maii, vol. I, pp. 479–96, esp. pp. 480–1.

53. The identity of these two figures will be discussed in further detail on pp. 151–4.

54. [S]P[IRITU]S S[AN]C[TU]S SUP[ER]VENIET I[N] TE ET VIRT[US] ALTU[S]SIM[I] OBU[M]RABIT TIBI (Luke 1:35). ECCE ANCILLA D[OMI]NI FIAT (Luke 1:38).

55. DASIENA E NON . . . NJ CORE[N]TE MILLE/ ET SETANTA A . . . TO FOIJ QUESTA CA/PELLA. NEL SES[A]NTA . . . OB . . . PIU BELLA INCO.

56. Romagnoli (1840), ed. 1990, p. 105.

57. Carli (1969), pp. 5–6; Cornice (1990), p. 287.

58. Gallavotti Cavallero (1985), p. 134, n. 219. The rectors in the 1360s were: Andrea di Toro (1357–61) and Galgano di Colo Bargagli (1362–74). See 'Statuto dello Spedale, 1318–1379', ed. 1877, pp. 191–8.

59. First suggested by Berenson (1932), pp. 590, 706, and substantially confirmed by Borsook (1956). Previously the paintings had been attributed to one or other of the Lorenzetti or to an unknown fifteenth-century painter. For a succinct summary of the history of the attribution of these paintings, see Cornice (1990), pp. 287–8.

60. These fresco paintings are: the *Coronation of the Virgin* (dated 1352, but substantially repainted in the fifteenth century), in the Sala della Biccherna of the Palazzo Pubblico (Pl. 180); *Saint Paul and the Virtues* and the *Battle in the Val di Chiana* (dated 1363) over the north-west arcade of the Sala del Consiglio of the Palazzo Pubblico; the *Virgin and Child with Saints*, a frescoed altarpiece in the Martinozzi chapel in San Francesco, dated on stylistic grounds to c. 1360–70; fragments of a *Virgin Annunciate*, now in the Pinacoteca in Siena, but formerly in the cloister of the priory of San Domenico and dated, on the testimony of a seventeenth-century report of the painting, to 1372. For more detailed discussion of these and other paintings attributed to this painter, see Carli (1981), pp. 232–4; Cornice (1990), pp. 289, 296.

61. Payments made on 11 and 30 March, 10 April, 14 August, and 31 December, recorded in ASS, Spedale, 851, fols 54ᵛ, 59ᵛ, 63ᵛ, 101ʳ, 126ᵛ. The last two payments are published in Milanesi (1854–6), 1, p. 27, albeit with an incorrect date and folio number for the December payment. The work

described is for books, a lectionary and an antiphonary.

62. ASS, Spedale, 514, fol. 64ᵛ, published in De Nicola (1912), p. 13. Carli (1969), pp. 5–6, raises the possibility that Romagnoli's rector of 1360 – Giacomo di Vanni – might be the Spedale's treasurer, Jacomo di Chino. Even when one takes into account the variations given to a single name by medieval scribes, the patronymics of the two men appear very different from one another.

63. Museo dell'Opera del Duomo (MS 98–4), fols 3ʳ, 8ʳ, 14ʳ, 22ʳ, 27ʳ. For a description of this gradual and discussion of the attribution of its illuminated initials to Lippo Vanni and others, see Gallavotti Cavallero (1985), pp. 73–6.

64. In three of the payments to Lippo di Vanni in 1344, the painter is also described as a miniaturist, and with this in mind, a number of illuminations belonging to other fourteenth-century Sienese choir-books have also been attributed to him. For which, see Van Os (1967–8); (1974a).

65. The relevance of Lippo Vanni's paintings at San Leonardo for the lost paintings on the façade of the Spedale was first noted by Andreas Péter (1929–30) and given wider currency by Borsook (1952), p. 352. See also Carli (1969), p. 8; Maginnis (1988b), p. 190.

66. As, for example, the figure of Simeon in the illuminated initial of the *Purification of the Virgin* (Museo dell'Opera del Duomo, MS 98–4, fol. 22ʳ), or the prophets in the predella of the frescoed altarpiece in San Francesco, Siena, illus. in Carli (1969), figs 3, 9.

67. See Chapter 5, pp. 93, 95.

68. Carli (1969), p. 12, and Cornice (1990), p. 288, also note the importance of the High Priest in these two paintings, although not specifically in relation to the concerns of the friars of San Leonardo.

69. For precise definition of what the various instruments are, see Ghisi (1966), pp. 309–11.

70. As noted by Ghisi (1966), pp. 309, 312–13, and Cornice (1990), p. 288.

71. Meiss (1945), ed. 1976, pp. 5–9, citing, in particular, Saint Bernard.

72. All that now remains of the original painting is a *sinopia* of the Virgin Annunciate, now displayed on a side wall of the chapel. For a detailed investigation of the chapel and its paintings, see Borsook (1969). For more recent discussion of the circumstances of its commissioning and date, see Norman (1993), who associates the commission with a clause in the will of Vannes di Tofo Salimbeni (ASS, Diplomatico, Archivio Generale, 1 June 1340).

73. The date of the repainting of the *Annunciation*, and of the *Maestà* above it is not known. It is generally agreed, however, that it was executed in the second half of the fourteenth century. In 1368, another *Annunciation* utilising the window of the church was painted in the chancel of San Michele at Paganico. Although close in date to the San Leonardo *Annunciation*, the treatment of this subject at Paganico has a much more Christological emphasis, relating it to the *Adoration of the Shepherds* and the *Adoration of the Magi* also represented within the chancel. For the identification of the painter of the scheme as Biagio di Goro Ghezzi, see Freuler (1986a).

74. The contract, in the form of an act of donation (in order to avoid the accusation of effecting a commercial transaction in holy objects), was drawn up on 28 May 1359, between Andrea di Grazia, the Spedale's procurator, and Pietro di Giunta Torrigiani, the Venetian merchant acting on behalf of the Spedale in Constantinople. It survives today in the archive of the Spedale di Santa Maria della Scala and is published, in full, by Derenzini in *L'Oro di Siena* (1996), doc. II, pp. 73–8. For a detailed account and analysis of the acquisition of the relics, see ibid., pp. 67–78.

75. According to the chronicle written by Donato di Neri and his son, Neri, the relics arrived at Talamone in October 1359, and were transported to Siena by the Commune at the cost of 1,625 *lire*. See *Cronache senesi*, ed. 1931–9, p. 590. For an analysis of the Commune's role in the acquisition of the relics, see Piccinni (1996), p. 39.

76. Piccinni (1996), pp. 40, 43–4. For the relics and their reliquaries, many of which were crafted by fourteenth-century Sienese goldsmiths, see *L'Oro di Siena* (1996), cat. nos 1–17, pp. 80–138, and Gallavotti Cavallero (1985), pp. 80–107.

77. The construction of the pulpit was debated by the Consiglio Generale on 30 January 1359 (1360, modern style of dating). See ASS, Con. Gen., 164, fol. 9ᵛ. Now lost, it was situated between the two original doors of the church. See Gallavotti Cavallero (1985), p. 105. Its presence on the inner face of the façade of the hospital church is probably recorded in Domenico

di Bartolo's *Giving of Alms* in the Pellegrinaio, illustrated in Gallavotti Cavallero (1985), fig. 121. It appears from this painting that it was reached from inside the church by a raised walkway.

78. For a contemporary account of the levelling of the piazza in early 1371, see the entry in the chronicle of Donato di Neri, and his son Neri, in *Cronache senesi*, ed. 1931–9, p. 636. For payment for the stone bench, see ASS, Ospedale 20, fol. 17ᵛ. See also Piccinni (1996), p. 43.

79. See Chapter 1, pp. 1–3, Chapter 2, pp. 28, 42.

80. Museo dell'Opera del Duomo (MS 98–4), fol. 22ʳ.

81. As listed in the act of donation of 28 May 1359, published by Derenzini in *L'Oro di Siena* (1996), p. 75; '. . . mediam centuram Virginis Marie'. Also amongst the relics from Constantinople were pieces of the Virgin's alleged veil and bonnet. All three Marian relics are now housed in an eighteenth-century reliquary. See *L'Oro di Siena*, p. 342. For their importance for the Spedale, see Gallavotti Cavallero (1985), p. 80; Gagliandi in *L'Oro di Siena*, p. 55.

82. The painting's provenance is the Spedale. The earliest reference to it appears to be the record in two visitation reports, one of 1575 and one of 1598, of an image of the Assumption of the Virgin and other saints on the altar of the Assumption. See ASS, Ospedale, 120, fol. 101ᵛ (published in Van Os, 1974c, appendix, p. 83), and fol. 124ʳ. According to Girolamo Macchi, the eighteenth-century archivist of the Spedale, the altar of the *Assunta* also had as its titular saints Anthony Abbot and John. See ASS, MS D 108, fol. 295ᵛ. Although merely describing the painting as a *'tavola'* of the Virgin Mary, the earliest attribution of this painting to Bartolommeo Bulgarini appears to be that of Fabio Chigi in 1625–6 (ed. 1939, p. 302). Chigi reports a date of 1350 for this painting. It may be, however, that by that date several numerals were missing from the painted inscription. On technical and stylistic grounds, Steinhoff-Morrison (1989), pp. 10, 47, 51, 242–4, 603–4, 606–7, offers a date of 1360–1. However, since the chapel of relics appears to have been completed only in the mid-1360s, I would suggest a date of *c.* 1365 for this altarpiece by Bulgarini.

83. Later known as the Cappella del Manto after a fifteenth-century fresco of the *Madonna della Misericordia* painted there by Domenico di Bartolo. A number of fourteenth-century frescoes of saints (including half-length figures of Saint Anthony Abbot and the Blessed Agostino Novello) survive in this location and are plausibly related to documented payments to Cristoforo di Bindoccio and Meo di Pietro. For the transformation of this part of the Rector's palace into a chapel for the relics, see Gallavotti Cavallero (1985), pp. 105–7.

84. Steinhoff-Morrison (1989), pp. 603–13.

85. See Chapter 5, pp. 99–101.

86. Carli (1969), p. 6; a suggestion also given credence by Cornice (1990), p. 288.

87. BCS, MS B IX 18, fol 193ᵛ.

88. As portrayed on the reliquary cupboard (the *Arliquiera*) by Lorenzo Vecchietta (Pl. 164), a number of book covers, the frescoes of the Pellegrinaio (where the rectors appear in a brocade robe of black or maroon and a cloak of either colour), and the *Madonna della Misericordia* by Domenico di Bartolo. See Gallavotti Cavallero (1985), figs 36, 108–12, 119, 121, 123–5, 128, 131.

89. 'Statuto dello Spedale, 1318–79', ed. 1877, p. 123. See also the instruction given in the statutes of 1318 that the brothers are to be tonsured and wear a long robe and a cloak of grey cloth with a hood with the symbol of the hospital on it. See ibid., p. 53.

90. This is how the rector of the Spedale is later portrayed in Priamo della Quercia's *Investiture of the Rector by the Blessed Agostino Novello* and Domenico di Bartolo's *Celestine III's Concession of Privileges to the Hospital Authorities*, illustrated in Gallavotti Cavallero (1985), figs 124, 125.

91. Unfortunately none of the information given in 'Statuto dello Spedale, 1318–79', ed. 1877, pp. 191–8, on Andrea di Toro (rector from 1357 until 1361) and Galgano di Colo Bargagli (rector from 1362 until 1374) helps to establish the identity of the votive figure at San Leonardo. Andrea di Toro had a brother, Lorenzo, who could be the younger votive figure. Likewise Galgano di Colo Bargagli had a son, Pietro, who predeceased him and could also be the second votary. In his will of 8 December 1362 (ASS, Diplomatico a Quaderni, Archivio Generale, n. 97) Galgano Bargagli makes a number of bequests to named Augustinian friars. There is no reference made, however, to San Leonardo al Lago.

92. Van Os (1974c), pp. 1, 20–1, 78; Gallavotti Cavallero (1985), pp. 57, 66, n. 44.

93. See *Acta Sanctorum*, Maii, vol. IV, pp. 618, 623; *Statuti de lo Spedale* (1305), ed. 1864, p. xxi. See also, Gallavotti Cavallero (1985), pp. 69, 130, n. 2, who expresses the view that the hospital statutes of 1305 represent a codification of rules that the hospital community had evolved over the previous centuries. It is significant, moreover, that an image of Agostino Novello (illustrated in Kaftal, 1952, col. 119, fig. 124) was included in the 1360s fresco decoration of the chapel of relics in the Spedale.

94. Gallavotti Cavallero (1985), figs 124, 135, 136.

95. For a later example of such a relationship, this time involving the Spedale selling, in 1398, a property on the edge of the Selva to the Augustinian Hermits of San Leonardo al Lago, see Massai (1998), p. 24.

96. *Il costituto* (1309–10), dist. 1, rubric 509, ed. 1903, 1, p. 320. Massai (1998), pp. 4, 57, identifies this commodity (*lopprica*) as reeds not straw. However, another rubric in these statutes (dist. 1, rubric 13, ed. 1903, 1, p. 56) which makes a deliberate distinction between it and hay strongly suggests that in this instance *lopprica* is straw. For another piece of historical evidence which demonstrates the co-operation between the rectors of the Spedale and the Commune in respect of the farming of the Selva del Lago, see Massai (1998), p. 99.

97. See p. 137, and n. 32.

98. See p. 137, and n. 33.

8 MONTALCINO

1. ASS, Diplomatico, 'S. Agostino di Siena', 1 March 1306 (1307 modern style of dating).

2. For the possible association between this bequest and the altar of the Blessed Agostino Novello in Sant'Agostino, see Chapter 7, n. 39.

3. Cosona, to the north-east, Camigliano to the south-west and Castelnuovo dell'Abate to the south-east, for which see Pl. 7. See also Cammarosano and Passeri (1985), 'Repertorio', 29.3, 29.5, 40.3; Mucciarelli (1995), pp. 162, 166, 174, 187–8 (n. 61), 196.

4. Mucciarelli (1995), p. 277, n. 32.

5. ASS Biccherna 746, fol. 9ᵛ, published in Nardi et al. (1986), pp. 111–12. As in the entry for Massa Marittima, this entry makes detailed reference to earlier agreements made in the thirteenth century between the two communes.

6. The following account is based on the excellent entry for the town given in Cammarosano and Passeri (1985), 'Repertorio', 29.1.

7. ASS, Capitoli 2, fols 260ʳ–263ᵛ; ASS, Biccherna, 746, fol. 9ᵛ, published in Nardi et al. (1986), p. 111.

8. As recorded in the 'Caleffo dell'Assunta', ASS, Capitoli 2, fols 268ᵛ–272ʳ. The destruction of Montalcino features amongst the stipulations of the city statutes of 1262. See *Il costituto* (1262), dist. III, rubrics 357–8, ed. 1897, p. 385.

9. According to the local Franciscan, Pietro Bovini, in his 'Campione e rapporti di notizie . . . spettante alla chiesa e venerabil monastero de'padri minori . . .' (1750, AOMC, Fondi aggregati, 11, fols 1–9), Saint Francis, on a visit to Montalcino in 1218, obtained from the Benedictines of Sant'Antimo the ancient church and 'ospizio' of San Marco in Castelvecchio for the use of his fellow friars. In 1285 the abbot of Sant'Antimo ceded the neighbouring oratory of San Michele Arcangelo to the Franciscans. This act of cession is recorded in AVM, perg. 3 and 4. (These parchments, originally in the Archivio Vescovile, Montalcino, have now been removed to the Seminario Arcivescovile, Siena, for safe-keeping. At the time of writing, the library of the Seminario was undergoing reorganisation and I was unable, therefore, to consult the originals. I was, however, able to consult an accurate, modern *spoglio* compiled in 1970 by Don Brandi. All such references will be based, therefore, on this *spoglio*.) The two churches were subsequently remodelled to provide the large church which survives today. In the case of Sant'Agostino, there are historical notices of a religious community there from 1227 onwards. See ASF, 'Spoglio Diplomatico', vol. 112, fols 3ʳ–86ᵛ. It was probably located in a small priory and church which was enlarged in the fourteenth century when the Augustinian Hermits decided to build the imposing church that survives today. Documents of 1348 (fol. 19ᵛ) and 1365 (fol. 30ʳ/ᵛ) suggest that by the mid-fourteenth century the church had been completed and was functioning as a place of worship.

10. The foundation stone of 1325 is displayed on the south wall of the church.

11. ASS, Capitolo 3, fols 441ʳ–445ᵛ.

12. According to the chronicler, Donato di Neri (in *Cronache senesi*, ed. 1931–9, p. 599), the fortress was built by Giovanni di Gionta, under the supervision of Mino Foresi and Domenico di Feo, between 1367 and 1368. For extensive photographic illustration and succinct analysis of its structure, see Cammarosano and Passeri (1985), 'Repertorio', 29, figs 78–82, pp. 105–10.

13. There is a record, however, of a Tolomei burial in the church in 1380 which suggests that the family's patronage of the church continued throughout the fourteenth century. See ASF, 'Spoglio Diplomatico', vol. 112, fol. 41ʳ.

14. For a detailed reconstruction of the original appearance of all three altarpieces and the precise circumstances of their commissions, see Freuler (1994), pp. 134–87, cat. nos 30–8, pp. 453–61.

15. As recorded in membership lists of 1356, 1363, and 1389. See Milanesi (1854–6), 1, pp. 31, 40, 50; Freuler (1994), pp. 416 (doc. 2), 417 (doc. 7), 426 (doc. 71).

16. As agreed on 13 December 1353. See Freuler (1994), p. 416 (doc. 1).

17. See the records of payments to the painter published in Freuler (1994), pp. 417–20 (docs 4, 5, 11, 25, 27, 32).

18. In San Gimignano he had painted (*c.* 1360–4), four saints (as additions to Lippo Memmi's *Maestà* in the Palazzo Comunale, Pl. 64); a fresco cycle of the early life of the Virgin for a chapel in Sant'Agostino; an extensive series of scenes from the Old Testament (signed and dated 1367) for the north wall of the Pieve; and, in 1374, a *Nativity and Adoration of the Shepherds with Saints John the Baptist and John the Evangelist*, for the church of San Domenico (Pl. 192). In the late 1370s he painted an ambitious fresco scheme depicting, amongst other scenes, the *Fall of the Rebel Angels* for the chancel of Volterra cathedral, only fragments of which survive. In the 1360s he also appears to have received altarpiece commissions for Perugia and Corsignano. See Freuler (1994), pp. 5–12, 21, 26–45, 50–95, 105–23, 434–9, 443–7 (cat. nos 1–5, 7–8, 14–18).

19. For this confraternity commission, see Freuler (1994), pp. 124–33, 449–52 (cat. nos 21–7), who dates it to 1382.

20. For which he received payment in February and April 1385. See Freuler (1994), p. 425 (docs 66–7.)

21. On 25 April 1389, Bartolo together with his son, Andrea, and the Sienese painter, Luca di Tommè, received payment for a now lost altarpiece for the altar of the Calzolai (shoe-makers) in the north aisle. See Pl. 73 and Freuler (1994), pp. 131, 280, 284, 286, 310, 426–7 (docs 72–7). Its subject was, in all probability, the Assumption of the Virgin with saints. For the commission of a second altarpiece for the adjacent altar, and the likelihood of it having the *Adoration of the Magi* (Siena, Pinacoteca) as its centrepiece, see Pl. 73 and Freuler (1994), pp. 284–300, 476–8 (cat. nos 60–2) who dates it to *c.* 1385–8.

22. For a reconstruction of the altarpiece for Sant'Agostino with the *Purification of the Virgin* (Paris, Louvre) as its centrepiece, see Freuler (1994), pp. 260–70, 481–3 (cat. nos 64–7). For the reliquary bust, see, ibid., pp. 272–4, 485 (cat. no. 70). Freuler gives a date of 1388 to both altarpiece and sculpture.

23. See Freuler (1994), pp. 418–25 (docs 13, 15–22, 24, 29–31, 33–42, 49–50, 52–5, 60–3, 65).

24. For an exemplary analysis of the changed political circumstances post 1355 and the high incidence of painters and other professional artisans taking government office, see Wainwright (1978), pp. 10–83, 114–91. In the case of Bartolo di Fredi, it should be noted, however, that some of her research has been superseded by Freuler (1994).

25. ASS, Concistoro, 76, fol. 17ʳ, published in Freuler (1994), p. 420 (doc. 30). Between June 14 and September 28 1369, Bartolo di Fredi's partner, Andrea Vanni, had been castellan at Montalcino. See Concistoro, 2403, fol. 137ʳ. Also noted by Wainwright (1978), pp. 114, 124, but with the incorrect date of 7 September.

26. On 11 and 27 September 1376, respectively. See ASS, Concistoro, 1602, fols 6ᵛ, 14ᵛ, published in Freuler (1994), p. 421 (doc. 36).

27. BARTHOLUS MAGISTRI FREDI DE SENIS ME PINXIT ANNO D[OMI]NI MCCCLXXXVIII.

28. Bovini, 'Campione . . .', AOMC, Fondi aggregati, 11, fols 115–16. The relevant passages have been published in Freuler (1985b), pp. 23–4. For the early provenance of the various panels, see Freuler (1994), pp. 469–76 (cat. no. 48–59).

29. The reconstruction proposed in Freuler (1985b), (1994), pp. 190–3, 204, appears the most attentive to the full range of technical and historical evidence. For earlier proposals, see Bush (1963); Kanter (1983), pp. 17–21; Van Os (1985).

30. See, *Museo civico e diocesano d'arte sacra di Montalcino* (1997), cat. nos 9MC, 10MC, 11MC, 1–10PN, pp. 20, 24, 28.

31. Siena, ASS, PR, 3148, fol. 47ʳ. Published by Milanesi (1854–6), I, pp. 292–3, but with an incorrect date of 9 May 1382, a mistake corrected by Wainwright (1978), p. 169; Van Os (1985), p. 57; and Freuler (1985b), pp. 21, 36 (n. 5), the latter publishing a more accurate transcription of the document in question.

32. Nuccio di Menchino features prominently in the confraternity's records of membership for the 1350s and 1360s, as recorded in ASS, PR, 3165.

33. Shortly after the contract was drawn up, Bartolo di Fredi was in receipt of 8 florins from the confraternity. The receipt (published Freuler, 1994, p. 424, doc. 57), appears on the verso of a second page belonging to the record of the contract of May 1383. It has now been bound in ASS, PR, 3148, to fall between two pages both confusingly numbered folio 56. On 22 July, meanwhile, a woman, Mona Giema is recorded (on fol. 49ᵛ) as paying 2 gold florins for 'la tavola che si di fare a la capella de la vergine Maria di Sco Francesco'. Since this woman is listed (on fol. 4ᵛ) as a donatrix to the Compagnia di San Pietro, it appears that the funding of this altarpiece was a collaborative enterprise.

34. See n. 28.

35. In 1362, the confraternity appointed an *operaio* for building work and in 1363 paid builders and carpenters for work on the chapel of the Annunziata. See ASS, PR, 3164, fol. 67ʳ. Freuler (1985a) p. 153, suggests that this building work related to the addition of two chapels on the eastern side of the Cappella dell'Annunziata. Dedicated to Saint Peter and to Saint Blaise, the patronage of these chapels was apparently secured by Ser Griffo di Ser Paolo, an eminent Montalcinese lawyer, and Filippo Ciardelli, a local textile worker. Both men are regularly recorded between the 1330s and 1360s as subscribing members of the confraternity. See ASS, PR, 3155 and 3165. Between January and February 1343 (1344, modern style of dating), Ser Griffo served a two-month term of office as prior (PR, 3155, fol. 32ʳ). His wife Lina Cacciati probably commissioned, *c.* 1380, an altarpiece from Bartolo di Fredi for her husband's chapel in San Francesco. For a detailed discussion of this altarpiece commission, see Freuler (1985a), (1994), pp. 134–52, 453–6 (cat. nos 30–2).

36. See n. 9.

37. Now displayed on either side of the *Coronation of the Virgin* polyptych in the Museo Civico e Diocesano d'Arte Sacra.

38. Alongside the name of Bartolo di Fredi. See n. 15.

39. See ASS, PR, 3155, fol. 208ᵛ (unnumbered and undated, but written in a fourteenth-century hand). See also *Scultura dipinta* (1987), p. 72; Freuler (1994), p. 219 (n. 21). It is striking in this context to note that in 1369 (the date of the execution of the statue of the Virgin Annunciate) Bartolo di Fredi is listed with one 'Angelus Nalduccii' as representatives on the Consiglio Generale for the Terzo di Camollia. See Freuler (1994), p. 418 (doc. 16).

40. A tradition that carried on well into the seventeenth century. In 1676, the state auditor, Bartolommeo Gherardini, reported that the principal activity of the Montacinesi was the leather trade and shoe-making with the town boasting thirty-five workshops for shoe-making, thirty for tanning and one for the manufacture of shoe-lasts. This far exceeded the numbers listed for other kinds of commercial enterprise in the town. See ASS, MS D 84, fols 4–5.

41. Bovini, 'Campione . . .', AOMC, Fondi aggregati, 11, fol. 116. Significantly, Saint Nicholas of Bari is represented amongst the saints on the framing piers of the polyptych. Given the connections between the Arte dei Calzolai and the chapel of the Annunziata, it is possible that Bartolo di Fredi used his Montalcinese connections to good effect when securing the commission of 1389 for the altarpiece of the Arte dei Calzolai in Siena cathedral, for which, see n. 21.

42. Modern reconstruction of the polyptych suggests that it once measured 370 × 280 cm.

43. See Chapter 2, p. 35.

44. See Southard (1980), I, pp. 165–71, who publishes the payment by the Biccherna to Lippo Vanni on 30 June 1352.

45. See Van Os (1984–90), 2, p. 158, who also raises the question of the extent to which this painting made an impact upon fourteenth-century painters like Bartolo di Fredi.

46. See Chapter 2, n. 3.

47. See Chapter 7, p. 149.

48. First noted by Andreas Pétér in 1929–30, for which, see Gallavotti Cavallero (1987), pp. 70–1. See also, Maginnis (1988b), p. 190; Freuler (1994), pp. 40, 212.

49. The principal difference lies in the treatment of the two women involved in tending the new-born child. Here Bartolo di Fredi (or a member of his workshop) appears to have utilised figural types from his earlier fresco painting of *c.* 1360–4 for Sant'Agostino in San Gimignano, illustrated in Freuler (1994) Pl. 26.

50. As he had already done earlier for the fresco in the same series cited in n. 49. See Freuler (1994), Pl. 28.

51. In terms of its subject, the *Adoration of the Shepherds* would have acted as a reminder of the Saint Victor altarpiece in Siena cathedral (particularly the detail of including the dove of the Holy Ghost above the new-born Christ Child, see Pl. 76). In terms of the treatment of the figures, meanwhile, it would have provided the confraternity with a scaled-down version of the painter's altarpiece of *c.* 1382 for the Dominicans of San Gimignano (Pl. 192). The *Adoration of the Magi* would have presented a much simplified version of the painter's own altarpiece of *c.* 1385–8 for the altar of the Magi in the north aisle of Siena cathedral (for which, see n. 21 and Pl. 73).

52. Goffen (1986), pp. 6–7.

53. Belting (1977), pp. 56–61, 126–31, fig. B (p. 5), Pls 25–39. The frescoes are now in a very ruined state and their condition made more vulnerable by the damage sustained to the church in the earthquakes of 1997.

54. Thus, *c.* 1328, Giotto signed an altarpiece depicting the Coronation of the Virgin for the altar of the chapel of the Baroncelli family in Santa Croce, Florence. See Norman (1995e) pp. 172–3. Paolo Veneziano's *Coronation of the Virgin* polyptych of *c.* 1350 was painted for the Franciscan convent of Santa Chiara in Venice. Humfrey (1993), pp. 39–40, has made the plausible suggestion that this altarpiece may have been a workshop variant of a lost altarpiece by the painter for the high altar of the Frari, the order's principal church in Venice. The chancel of the Frari was completed by 1336. Gardner (1981), p. 34, basing his remark on later fifteenth-century examples, has called the Coronation of the Virgin 'almost the preferred theme of Franciscan high altarpieces'.

55. Some scholars have identified these as cherubim (see, for example, Meiss, 1951, ed. 1978, p. 43; Harpring, 1993, p. 87), but the red wings which enclose the angels' faces are the distinguishing feature attributed to seraphim. Bovini ('Campione . . .', AOMC, Fondi aggregati, 11, fol. 115) also describes how: 'si vede tra serafini effigiata la incorazione di Maria SS. dal suo figlio SS. N. S. G. C . . .'.

56. Meiss (1951), ed. 1978, pp. 43–4, 45. See also Van Os (1984–90) 2, pp. 156–7, who ascribes the 'airy' nature of the composition to 'late Trecento taste'.

57. As described by Thomas of Celano in 1229, three years after the saint's death. Although Saint Bonaventura's account in the *Legenda major* (1263) modifies the characterisation of the vision experienced by the saint and his companion on Mount Verna, the most canonic images of the stigmatisation show Francis receiving the stigmata from the crucified Christ enveloped in the wings of a seraph. See Norman (ed. 1995), I, Pls 67, 69, 88, and Derbes (1996), pp. 18–19, 20, 21, 188 (n. 36–9), 195 (n. 71). From the end of the thirteenth century, the Franciscan Order also produced a series of official seals which portray Saint Francis within a mandorla of seraphim. See Van Os (1974b), p. 123, fig. 10.

58. Wadding (1625–48), bk 5, pp. 575–6; *Acta Sanctorum*, Aprilis III, pp. 407–10; Kaftal (1952), col. 849–52.

59. A papal indulgence of 1369, described by Bovini in his 'Campione . . .' (AOMC, Fondi aggregati, 11, fol. 129) and addressed to those who visited the chapel of the Annunziata, refers specifically to the feast of the *beato*. Freuler (1994), pp. 174–5, 186 (n. 21), argues that the cult of Filippo Ciardelli was established in San Francesco between 1329 and 1362.

60. The two paintings represent the *beato* healing a man with an ulcerous leg outside the hermitage and his levitation witnessed by Fra Bonaventura da Podia and a companion (for which, see *Acta Sanctorum*, Aprilis III, p. 408, nos 3, 6). For the reconstruction of the altarpiece, see Van Os (1985), pp. 57–9, who mistakenly associates the pier bases from the *Coronation of the Virgin* polyptych with this earlier altarpiece; Freuler (1985b), p. 21; (1994), pp. 166–87, 457–61 (cat. nos 36–8).

61. Siena, Pinacoteca, no. 77. The provenance of this painting (once part of a composite altarpiece) was the Franciscan convent of Santa Petronilla in Siena. See Torriti (1990), p. 70. Although the nuns did not take up residence within Siena until shortly after 1526, they probably brought this

early fourteenth-century altarpiece from their earlier church outside the Porta di Camollia.

62. Also noted by Freuler (1985b), p. 34; (1994), p. 207.

63. ASS, PR, 3148, fol. 9v.

64. The complex history of this process is charted by Freuler (1985b), pp. 26–8; (1994), p. 203. Again there are similarities with the history of the Disciplinati Compagnia degli Raccomandati di Giesù Christo Crocifisso and its relationship with the Laudesi Compagnia di Santa Maria Vergine, both based in the Spedale di Santa Maria della Scala (for which, see Wainwright, 1978, pp. 84–113). For the differences between the practices of the Disciplinati and Laudesi (albeit from a Florentine perspective), see Wilson (1992), pp. 28–36.

65. ASS, PR, 3148, fols 9$^{r/v}$. In the 1295 statutes of the Sienese Compagnia degli Raccomandati di Giesù Christo Crocifisso, members are instructed to say daily 7 Lord's Prayers and 7 Ave Marias, confess at least 15 times a year and communicate at least 3 times a year. See BCS, IV 23, nos 11, 12, fols 13r–14r.

66. ASS, PR, 3148, fol. 10r.

67. Bovini, 'Campione . . .', AOMC, Fondi aggregati 11, fols 129–30, summarising the content of an indulgence dated 24 June 1369.

68. ASS, PR, 3148, fol. 14v. According to Bovini ('Campione . . .', AOMC, Fondi aggregati 11, fol. 142), the confraternity also venerated the relics of the Blessed Filippo Ciardelli on Easter Monday. This act of veneration would presumably have taken place at the altar of Filippo Ciardelli in San Francesco.

69. Bovini, 'Campione . . .', AOMC, Fondi aggregati 11, fol. 130, summarising the contents of an indulgence dated 9 March 1369 (1370, modern style of dating).

70. ASS, PR, 1348, fol. 10v. See also Wainwright (1978), p. 94.

71. Freuler (1985b), pp. 28–32; (1994), pp. 202–5.

72. See, for example, the late thirteenth-century vernacular *laude* from the laudario produced for a confraternity that met in the Franciscan church of San Francesco, Cortona (published in Wilson, 1992, pp. 32, 189–91, 262) and the fourteenth-century *laude* from the laudario produced for the confraternity which met in the Augustinian church of Santo Spirito, Florence (published in Wilson, 1992, pp. 23, 189–91). See also the late medieval Latin *lauda* published in Freuler (1985b), pp. 29–30.

73. See, for example, the references to 'l'alta donna encoranata', and 'tu se'rosa, ti se' gillio' in the late thirteenth-century Franciscan laudario in Cortona (published in Wilson, 1992, p. 190). Similar references occur in a verse (published in Freuler (1985b), p. 36; (1994), pp. 216–17), in a late thirteenth-century antiphonary, now in the Archivio Comunale, Montalcino, but probably originally from San Francesco.

74. The 1330 statutes instruct the *confratelli* that they say 100 Lord's Prayers and 100 Ave Marias for the soul of a deceased member of the confraternity. In addition, the prior had to hold a session of penitential exercises for the members within a month of the death and the chamberlain had to arrange for twenty-five requiem masses on behalf of the deceased. See ASS, PR, 1348, fol. 14v. Such practices correspond to those of the Compagnia degli Raccomandati di Giesù Christo Crocifisso, for which, see BCS, MS, IV 23, nos 25–31, fols 18v–20r.

75. For a detailed discussion of the particular relevance to the confraternity of all the saints portrayed on the piers, see Freuler (1985b), pp. 32–33; (1994), pp. 210–11.

76. See pp. 168–9.

77. Ser Griffo's membership of the Compagnia degli dei Raccomandati is recorded in a list of members dated 1360 and contained in BCS, MS, IV 22, fol. 22r. The same membership list (fols 22v–23r) records one Fra Filippo, an Augustinian Hermit from Montalcino. A document of 1373 (described in ASF, 'Spoglio Diplomatico', vol. 112, fol. 35r) refers to a Fra Filippo as vicar of the priory of Sant'Agostino in Montalcino. For Ser Griffo's membership of the Compagnia di San Pietro, see n. 35, 79.

78. See Chapter 5, p. 93.

79. In the list of fourteenth-century rectors compiled by Tullio Canali, in his 'Libro di memorie dell'origine degli spedali di Montalcino in Toscana' (ACM, MSL, 8, fols 13v, 15v, 118r, 121r), appear the names of Bartolommeo Covarini (as rector of the Spedale di Santa Maria della Croce) and Ser Griffo di Ser Paolo and his wife, Lina Cacciati (as rector and rectoress of the Spedale della Misericordia). Canali's information on Ser Griffo is confirmed by the record of his election as rector in June 1355 (ASS, Diplomatico Montalcino, B32, perg. 217 and 218), his will of 8 February

1365 (1366 modern style of dating) and that of Lina Cacciati, dated 8 June 1400, where both testators make the Spedale della Misericordia their eventual, universal heir. Lina's sister, Petra Cacciati, meanwhile, made the Spedale di Santa Maria della Croce her universal heir on 7 December 1401. (All three bequests are transcribed in Bovini, 'Campione . . .', AOMC, Fondi aggregati. 11, fols 27–8, 35, 44–8, and published in Freuler, 1985a). The records of the Compagnia contained in ASS, PR, 3155 and 3164, regularly record both Bartolommeo Covarini and Ser Griffo as members and officials of the confraternity. Both Cacciati women also bequeathed property to the Compagnia di San Pietro (see ASS, PR, 3148, fol. 1v, PR, 3164, fol. 68r).

80. For a well-informed account of the history of the two Spedali, see the editorial introduction to *L'Archivio Comunale di Montalcino* (1989–90), 2, pp. 13–31. In 1548, the two institutions were merged to form the Spedale di Santa Maria della Croce which – as a number of eighteenth-century sources attest – continued to furnish Montalcino with the same range of charitable functions. These are conveniently recorded in Pecci (1759–61) ed. 1987, pp. 9–10, and *Montalcino: immagini e memorie* (ed. 1986), pp. 16, 18.

81. Principally through the endowment of the Cappella di San Pietro founded by Lina and Petra Cacciati in 1400 and 1401, respectively. In their wills, the two women instruct the officials of both Spedali to pay for the celebration of requiem masses in memory of themselves and their families. In 1548 when the two hospitals amalgamated the chapel came under the patronage of the Spedale di Santa Maria della Croce. See Freuler (1985a), p. 163 (n. 6), p. 164 (n. 11, 14). According to Bovini ('Campione . . .', AOMC, Fondi aggregati, 11, fols 18, 21), an earlier rector of the Spedale della Misericordia, Ser Daddo di Brunicelli, contributed handsomely in 1329 to the rebuilding of San Francesco.

82. During that time he continued to hold public office (albeit on a less active scale), and to receive a number of commissions for work in Siena's principal churches and the Palazzo Pubblico (the latter suggesting, furthermore, that he had the status of an official painter of the Commune). See Freuler (1994), pp. 300–3, 324–32, 341–67, 427–9 (docs 78, 82–3), 490–1 (cat. no. 76), 491–2 (cat. no. 77), 493–4 (cat. no. 80).

83. First attributed to this painter by Brandi (1931), pp. 209–10, (1933), p. 36, and subsequently confirmed by other scholars. For the early bibliography for this painting, see Freuler (1994), pp. 500–1 (cat. no. 90). Hitherto, the dating of this painting has varied between 1366 and 1388, but on grounds of stylistic comparison with the painter's work in the 1390s, Freuler (1994), p. 368, has plausibly dated it to after 1397.

84. Beatson et al. (1986), p. 616; Van Os (1984–90), 2, p. 115 (although acknowledging the differences between the representation of the central event in the two altarpieces).

85. The earliest note of the painting being in SS. Fiora e Lucilla appears to be an entry in a visitation report of 1699, for which, see Freuler (1994), p. 400 (n. 8). For Torrita di Siena, see Cammarosano and Passeri (1985), 'Repertorio', 63.1.

86. Freuler (1994), pp. 368–81, 500–2 (cat. no. 89–90).

87. From where it was taken, probably in the 1690s, and placed by the Augustinian Hermits over an altar in SS. Fiora e Lucilla, the rights to which they had acquired in 1463 when Andreoccia di Bandino from Torrita had made the community at Sant'Agostino, Siena, his universal heir. See Freuler (1994), pp. 373–6, 400 (n. 8–14).

88. See Freuler (1994), Pls 329, 330, and also pp. 152 (n. 43), 376–7.

89. ASS, Notarile Antecosimiano, 229, fols 89v–90r, published in Freuler (1994), p. 400 (n. 16). An entry amongst the records of the Compagnia di San Pietro records that on 22 July 1383, Monna Giema gave 2 florins for work in Sant'Agostino at the place called 'la natività di xpo'. See ASS, PR, 3148, fol. 49v and also Bovini, 'Campione . . .', AOMC, Fondi aggregati, 11, fol. 36. These records suggest that there was already a chapel of the Nativity of Christ in Sant'Agostino but that it probably only comprised an altar set in a recessed arch on the north wall of the church.

90. AOMC, Diplomatico 376, 7 September 1402.

91. This undoubtedly refers to Antonio di Giovanni Cioli who is named in Petra Cacciati's will as the rector of the Spedale of Santa Maria della Croce.

92. AOMC, Diplomatico 484. Another copy of this document survives in AVM, perg. 36.

93. AOMC, Diplomatico 483.

94. As noted above, Freuler has suggested that the patronage of the chapel was entrusted to a confraternity attached to the Spedale di Santa Maria della

Croce. However, the surviving documents describing the endowment of the new chapel only refer to the rector or to the Spedale itself.

95. For detailed discussion of this fresco scheme and its Augustinian programme, see Freuler (1994) pp. 224–59, 485–8 (cat. no. 71). Harpring (1993), pp. 102–5, prefers a date of 1384–8, for these paintings. This seems unlikely since during those years Bartolo di Fredi would have been engaged in producing the complex *Coronation of the Virgin* polyptych for San Francesco as well as a number of other important commissions elsewhere. For other possible work by the painter in Sant'Agostino, see Freuler (1994), pp. 256–7, 405, 461–8 (cat. nos 39–45), 488 (cat. no. 72).

96. Freuler (1994), p. 373, pp. 501–2 (cat. no. 91), has suggested that the altarpiece in the Cappella del Parto may originally have had four side panels, the outer panels depicting Saints James the Minor and Phillip, thus commemorating the titular saints of the church. He also proposed that the panel painting of Saint James the Minor, attributed to Bartolo di Fredi and auctioned in Milan in 1971, might be a side panel from the altarpiece. The identical tooling on this panel and that on the side panels in Torrita makes the proposal highly plausible.

97. An item in a visitation report of 1573 (published in Freuler, 1985b, p. 39, n. 80) states that the altar was dedicated to the Virgin Annunciate but that it was attached to the Compagnia di S. Antonio Abate. The presence of niches on either side of the mural suggest that wooden statues (like those of the Cappella dell'Annunziata) would have once framed this frescoed altarpiece (a point also noted by Van Os, 1985, p. 64; Freuler, 1985b, p. 31).

98. Indeed, the decision to make the Spedale di Santa Maria della Croce her universal heir with the proviso that she retain an income for food and clothing during her lifetime, is characteristic of a person entering the third order and bequeathing her or his worldly goods to that order. Like the Spedale di Santa Maria della Scala in Siena, the Spedale di Santa Maria della Croce clearly had close links with the Augustinian Hermits and may therefore have been administered by Augustinian tertiaries. Petra's will of 7 December 1401, survives in AVM Perg. 34, is transcribed in Bovini's 'Campione . . .' (AOMC, Fondi aggregati, 11, fols 44–8) and has been published in Freuler (1985a), p. 164 (n. 11).

99. D[OMI]NA PETRA IE[KAT]IS FECIT. First noted by Freuler (1985a), p. 163 (n. 7). For Augustine and the Trinity, see Chapter 6, p. 128.

100. For which, see Freuler (1985a). Although the inscription on the main panel from this altarpiece only refers to Lina and her son, Jacopo (thus suggesting that they were primarily responsible for the commissioning of the altarpiece), Petra's act of donation of 1401 (cited in n. 79) makes it clear that both Petra and Lina had been responsible for the construction and endowment of the family chapel in San Francesco.

101. Freuler (1985a), pp. 155–6, 158–9.

102. As, for example, on an altarpiece for the Dominicans of San Gimignano (Pl. 192) and on a pinnacle panel for the *Coronation of the Virgin* polpytych (Pl. 175). For these two earlier examples, together with a third, now in the Musée du Petit Palais, Avignon, see Van Os (1984–90), 2, p. 115; Freuler (1994), pp. 105–14, 443–6 (cat. nos 14–16), 502 (cat. no. 92).

103. Given the likely connection between this painting and the Spedale di Santa Maria della Croce, it is significant to note that the Compagnia della Vergine Maria based in the Spedale di Santa Maria della Scala in Siena owned a copy of Saint Bridget's *Revelations* (now housed in BCS, I V 25/26). This copy is dated 1399 but may indicate a more long-standing interest in this text. Van Os (1984–90) 2, pp. 114, 116, however, sees the late thirteenth-century Franciscan *Meditations on the Life of Christ* as the most likely influence for Bartolo di Fredi's treatment of this subject.

104. See p. 166 and n. 39.

105. In February 1348 (1349, modern style of dating), Ser Griffo became a Sienese citizen. See ASS Diplomatico Montalcino, B 32, perg. 199. For his prominent role in Sienese and Montalcinese politics in the 1350s and early 1360s, see ASS, Diplomatico Montalcino, B 32, perg. 237; B 33, perg. 221; B 35, perg. 138, 161, 165; and the eighteenth-century 'Notizie storiche della famiglia Griffoli, ACM, MSL 5, fols 1ʳ/ᵛ, 3ᵛ, 5ᵛ, 6ʳ (unpaginated); and Freuler (1985a) pp. 154–5, (1994), p. 25 (n. 45). Ser Griffo is also named as the syndic of Montalcino in the treaty of 1361 agreed between Siena and Montalcino. See ASS, Capitoli 2, fol. 444ʳ, and also fol. 445ᵛ. For his membership of the Sienese Compagnia degli Raccomandati, see n. 77. His son, Jacopo, was a member of Consistory in 1374 and between 1366 and 1390 was involved in a large number of property transactions in the city, for which see, Freuler (1994), pp. 151 (n. 31), 257.

106. It should be noted that Bartolo di Fredi worked for the Augustinian Hermits of San Gimignano in the 1360s and in 1388 (for which see n. 18 and 22). It should also be noted that during the 1380s and 1390s two Augustinian Hermits from Montalcino held positions of importance at the papal court (for which, see Pecci, 1759–61, ed. 1987, pp. 70–1), and that in the early fifteenth century Fra Scolaiolo di Ser Lodovico of Montalcino secured high office within the Franciscan order (for which, see Freuler, 1985b, p. 39, n. 106).

9 MONTEPULCIANO AND SIENA

1. Bellosi (1972), pp. 75–6; De Benedictis (1979), pp. 51–2, 84; Van Os (1984–90), 2, p. 153. The date generally given to this painting is the 1350s.

2. Fumi (1894), ed. 1989, p. 62; Lightbown (1980), 1, p. 142.

3. The following account of Montepulciano's history is drawn from the informative entry in Cammarosano and Passeri (1985), 'Repertorio', 31.1, pp. 329–31. See also the useful table of dates given in Calabresi (1987), pp. 46–54.

4. ASS, 'Caleffo dell'Assunta', fols 250ᵛ–257ᵛ; 'Libro dei Censi', Biccherna, 746, fol. 9ʳ, published in Nardi, et al. (1986), pp. 109–11.

5. Referred to in the 'Libro dei Censi' of 1400. See ASS, Biccherna 746, fol. 9ʳ, published in Nardi, et al. (1986), p. 109.

6. The following description of medieval Montepulciano is indebted to Calabresi (1968).

7. The Franciscans were based at the church of San Francesco on the 'Sasso' (on the site of an earlier parish church dedicated to Saint Margaret), the Augustinian Hermits at the church of Sant'Agostino, and the Servites at the church of Santa Maria dei Servi. The Dominicans, meanwhile, had a church and priory (which no longer survives) near the Pieve and the church and convent of Sant'Agnese just outside the walls. Although remodelled in later centuries, these mendicant churches were all originally constructed in either the late thirteenth or the early fourteenth century. See Repetti (1833–45), 3, p. 482; Fumi (1894), ed. 1989, pp. 31–2, 43, 58, 62–3; *Siena e il Senese* (1996), pp. 221–2, 223, 225, 228–9; and the end map in Calabresi (1987).

8. As indicated in the 1337 statutes. See *Statuto di Montepulciano* (1337) bk 1, rubrics 64–7, ed. 1966, pp. 76–87. See also rubrics 1–3 of the revised statutes of 1359, published in Calabresi (1987), pp. 197–200.

9. In 1561 Montepulciano became a bishopric. The Pieve was subsequently rebuilt as a cathedral, the construction only being completed in 1680. See Lightbown (1980), 1, p. 181; Solberg (1991), p. 487, n. 2.

10. In 1624, the altarpiece appears still to have been over the high altar, since the pastoral visitor for that year ordered the renewal or repair of 'una tavola di legna' on the high altar. Montepulciano, Archivio di Curia Vescovile, 'Visita pastorale 1624', fol. 3ʳ, cited in Solberg (1991), p. 487, n. 1. Between 1835 and c. 1889, the altarpiece is described as displayed on the entrance wall of the cathedral. It was probably at this time that the outer piers were cut thus losing approximately half of the predella painting set at the side and base of each of the piers. From c. 1889 onwards the altarpiece was again over the high altar, only to be removed in 1940 for safe-keeping during the Second World War. For a detailed account of the present condition of the altarpiece and its restoration in the late nineteenth and twentieth centuries, see Solberg (1991), pp. 486–98.

11. Since these scenes were probably included as antitypes for the scenes of the Passion of Christ on the predella, their choice may have been influenced by the presence of a series of Old Testament prophets framing the scenes of the early life of Christ on the front predella of Duccio's *Maestà*.

12. TADDEO DI BARTOLO DA SIENA DIPINSE QUESTA OP[ER]A AL TEMPO DI MESSERE IACOPO DI BARTOLOMEO ARCIPRETE DI MONTE PULCIANO ANO DNI MCCCC. . . . The date is now partly illegible but nineteenth-century sources (for which, see Solberg, 1991, pp. 488–9) state that it originally read 1401.

13. Lightbown (1980), 1, p. 138, and Solberg (1991), p. 501, the latter giving the date of the papal bull of 1217 as 11 October, cf. Barcucci (1991), p. 8, who gives the date as 1 October.

14. For Jacopo Aragazzi and his brother, Francesco, see Lightbown (1980), 1, pp. 139–45, 160, 164–5; Solberg (1991), pp. 501–2, 504, 505–8.

15. As suggested by Barcucci (1991), p. 9. Solberg (1991), pp. 33, 137–9, 478, 510–12, 514–16, 521–22, 524, has argued that, on grounds of style, parts of the altarpiece were begun in the late 1390s and then completed in

1400/1401 and that the work was, therefore, initiated in anticipation of Jacopo Aragazzi's new title. It appears more likely, however, that the commission was awarded to Taddeo di Bartolo after April 1400, in celebration of Jacopo's newly-won status.

16. According to Vasari (1550, 1568) ed. 1966–, 2, 'Testo', p. 310, the painter also worked for the Da Carrara family in Padua. Solberg (1991), pp. 44–50, 121–2, dates this visit to *c.* 1392. For his commissions in Collegalli (some 40 kilometres east of Pisa), Pisa, Genoa and the Ligurian town of Triora, which span a period between 1389 and 1397, see Solberg, pp. 13–135, and the relevant entries in her catalogue, pp. 277 ff.

17. Later re-titled the Compagnia di Santa Caterina della notte in honour of Saint Catherine of Siena. See Gallavotti Cavallero (1985), p. 398. Taddeo di Bartolo's *Virgin and Child with Saints John the Baptist and Andrew* (for which, see Solberg, 1991, p. 185–6, 869–82) is still located in the Oratorio di Santa Caterina della notte.

18. For his Sienese commissions, see pp. 195–207. For detailed discussion of the commissions in Perugia, San Gimignano and Volterra, which cover the first two decades of the fifteenth century, see Solberg (1991), pp. 139–40, 153–62, 215–23, 236–41, and the relevant catalogue entries, pp. 591 ff.

19. These property interests of Francesco Aragazzi are listed in the Florentine *catasto* of 1427 (ASF, Catasto 219, fol. 232ᵛ) and transcribed in Lightbown (1980), 2, p. 303.

20. Repetti (1833–45), 3, pp. 465, 484; Lightbown (1980), 1, pp. 134, 135; cf. Calabresi (1987), p. 95, n. 131.

21. In 1712 the newly-built cathedral was dedicated to the Virgin of the Assumption and it is quite plausible that this dedication followed an earlier tradition.

22. Although it still featured in the list of tributes recorded in the 'Libro dei Censi' of 1400, for which, see p. 185.

23. This technique was frequently used by the Emilian painter, Barnaba da Modena whose work apparently influenced Taddeo di Bartolo when he was working in Pisa and Genoa. See Van Os (1984–90), 2, pp. 68–70; Solberg (1991), pp. 59–60, 69, 123–9.

24. See Chapter 2, pp. 37–43, Chapter 6, pp. 121–30.

25. Solberg (1991), p. 520; Norman (1995e), pp. 206–11.

26. Van Os (1984–90) 2, p. 65; Solberg (1991), pp. 520–1.

27. For Francesco Aragazzi's dealings with Florence, see Lightbown (1980), 1, pp. 140, 141, 152. It is significant to note, in this context, that Francesco apparently enjoyed the friendship of the eminent Florentine scholar, Ambrogio Traversari.

28. Solberg (1991), p. 523, makes the further suggestion that the unusual placing of Christ to the left of the spectator implies the presence of God above and behind the couple, with Christ to His right. Such an arrangement also resulted in the Virgin being on the same side of the altarpiece as the Virgin Annunciate on the right pinnacle panel.

29. For a detailed analysis of the extent to which Taddeo di Bartolo sought to emulate Duccio's series, see Barcucci (1991), pp. 29–48; Solberg (1991), pp. 525–41.

30. Solberg (1991), pp. 447, 478, gives the widths as: 140 cm for the *Assumption* and 98.5 cm for the *Crucifixion*.

31. It is also appropriate that one of the quadrilobes located in the frame directly above the *Crucifixion* depicts the Sacrifice of Isaac which, in late medieval Christianity, was frequently cited as an antitype for the Crucifixion.

32. The view of the east end of the Pieve given in Taddeo di Bartolo's own representation of Montepulciano on the altarpiece itself (see Pl. 195), suggests that, unlike the cathedrals of Siena and Massa Marittima, the church did not have an extensive chancel behind the high altar but rather a semicircular apse. It should, however, be noted that in a deposition taken from various clerics in 1597, when the new cathedral was under discussion, one canon described how the church: 'ha un poco di Coro dietro all'altare grande all'antica'. See the copy of the 'Instrumentum Processus super statu Ecclesiae Politianae dell'anno 1597' kept in a file on Montepulciano in the archive of the Soprintendenza per i beni artistici e storici, Siena.

33. As acknowledged by Calabresi (1968), pp. 281–3. See also Barcucci (1991), p. 21, and the captions on pp. 22, 23; Solberg (1991), p. 499, n. 19. The head of Saint Antilla is kept in the cathedral housed in a seventeenth-century silver reliquary.

34. No. 12 on the map of the town in Calabresi (1987). See also Barcucci (1991), p. 16.

35. No. 8 on the map of the town in Calabresi (1987). See also Barcucci (1991), pp. 19–20, and Fumi (1894) ed. 1989, p. 43. The relic of the ring was stolen from Chiusi in 1473 and taken to Perugia where it is now preserved in the cathedral.

36. A suggestion made by Freuler (1985a), p. 165, n. 47.

37. The statutes of 1337 set out the regulations for the five day fair held annually to celebrate the saint's feast day, and also record the practice of presenting a quantity of wax to the Pieve on that feast day. See *Statuto di Montepulciano* (1337), bk 1, rubrics 31, 44, ed. 1966, pp. 48–9, 55–6. A *palio* was also run on that day, see rubric 4 of the revised statutes of 1373, published in Calabresi (1987), pp. 228–30. The town also had an oratory and a hospital dedicated to this saint. See *Umanesimo e Rinascimento a Montepulciano* (*c.* 1994), pp. 104–5, and *Siena e il Senese* (1995), p. 229.

38. Barcucci (1991), p. 22; Solberg (1991), pp. 502, 507, the latter also noting that one of the *contrade* on the 'Sasso' was called San Donato. A foundation stone, dated 1137, which records the consecration by Bishop Mauro of Arezzo of a church dedicated to Saint Donatus survives today in the cathedral. For the site of this twelfth-century church, see no. 34 on the map of the town in Calabresi (1987).

39. Calabresi (1968) p. 286. The third *terzo* was named Santa Maria, after the Virgin.

40. Barcucci (1991), p. 23, and *Umanesimo e Rinascimento a Montepulciano* (*c.* 1994), pp. 104–5. See also Chapter 7, p. 155.

41. The following discussion on the relevance of the altarpiece's iconography for Jacopo Aragazzi is indebted to Solberg (1991), pp. 502, 504, 508–9.

42. The town also had a church dedicated to Saint Laurence (San Lorenzo) and a confraternity to Saint Stephen (the Compagania di San Stefano), for which see Lightbown (1980), 1, pp. 141, 165; and nos 27 and 40 on the map of the town in Calabresi (1987).

43. The Aragazzi family altar which was located to the right of the high altar of the Pieve was also dedicated to the Archangel Michael. See Lightbown (1980), 1, pp. 179–80, 204–5.

44. Jacopo's nephew was the eminent humanist, Bartolommeo Aragazzi.

45. A number of scholars have proposed that this is a self-portrait of Taddeo di Bartolo (see, for example, Symeonides, 1965, p. 90; Van Os, 1984–90, 2, pp. 149–50; Barcucci, 1991, p. 14). Solberg (1991), p. 519, thinks it highly unlikely that the youthful saint could represent the by then middle-aged painter.

46. The date of construction is generally assumed to be between 1404 and 1405. See Cairola and Carli (1963), p. 72; Southard (1980), 1, pp. 143, 321; Eisenberg (1981), p. 134; Solberg (1991), pp. 176, 982. This dating is borne out by the political events of these years, for which see pp. 197–8.

47. THADEUS BARTHOLI DE SENIS/ PINXIT ISTA[M] CAPELLA[M] MCCCCVII/ CUM FIGURA S[AN]C[T]I XPOFORI/ ET CU[M] ISTIS ALIIS FIGURIS 1414. The latter part of the text refers to Taddeo di Bartolo's later fresco paintings of Saint Christopher (doc. 1408) and a series of antique heroes (doc. 1413–14) painted for the vaulted space between the chapel and the then Sala del Concistoro. Described in contemporary documents as the 'ante concistoro', this location is now more commonly called the ante-chapel. Solberg (1991), pp. 991–2, taking up a point made by the French scholar Didron, suggests that the use of Roman and Arabic numerals in the inscription might have been a deliberate reference to the 'medieval religiosity' of the chapel programme when compared to the 'new humanistic concerns' of the ante-chapel programme.

48. ASS, Concistoro, 243, fol. 18ʳ. The Consistory also agreed on 29/30 August (fol. 19ᵛ), that the balance of the next two months' communal revenues should be allocated to the decoration of the 'capella palatii'. Any money left over should be added to the funds in a 'cassettina' and spent on the embellishment of the Sala di Balìa (for which, see p. 197). The relevant extracts from this document are published in Milanesi (1854–6), 2, pp. 27–8.

49. ASS, Concistoro, 248, fol. 32ᵛ (published in Milanesi, 1854–6, 2, p. 28).

50. ASS, Concistoro, 251, fol. 9ʳ (9 November), fol. 11ᵛ (16 November), published in Milanesi, ibid. On 19 October, the painter had received a commission (ASS, Concistoro, 250, fol. 19ʳ) to paint a now lost *Christ and Saint Thomas* for the Sala del Concistoro.

51. ASS, Concistoro, 251, fol. 31ᵛ (published in Milanesi, ibid.). Taddeo di Bartolo chose Cecco di Nanno as an appraiser and Martino di Bartolommeo was chosen for the Commune. On 8 January 1408, Taddeo received the commission for the ante-chapel *Saint Christopher* and on 31 January/1 February, Giovanni di Francesco di Giovannino was elected as

52. ASS, Concistoro, 252, fols 7r, 15r.

52. ASS, Concistoro, 253, fol. 33r, published in Milanesi (1854–6), 2, p. 29. Giovanni di Francesco and Cecco di Nanno declared 205 gold florins a fair payment to Taddeo and his apprentices for their salary, labour, colours and other expenses for the paintings in the chapel and the figures of Christ (and Saint Thomas) in the Sala del Concistoro. Five years later Taddeo di Bartolo continued his work in this part of the Palazzo Pubblico by painting the erudite programme of antique heroes for the ante-chapel. In the fifteenth century, the chapel itself was further embellished with a series of historiated choir-stalls, a water stoup and a wrought-iron screen (for which, see Southard, 1980, 1, pp. 345–9). Between 1448 and 1452, the chapel's altarpiece was also extensively renovated (for which, see pp. 202–3). For discussion of the present condition of Taddeo di Bartolo's frescoes, see Solberg (1991), pp. 175–6.

53. For a detailed account of events between 1399 and 1404, see Malavolti (1599), ed. 1982, pt 2, bk 10, pp. 184v–195v.

54. Malavolti (1599), ed. 1982, pt 3, bk 1, pp. 2r–4r. For a description of Gregory's entry into Siena on 4 September 1407, see Paolo di Tommaso Montauri's account in *Cronache senesi*, ed. 1931–9, p. 763.

55. ASS, Concistoro, 250. Executed in sepia ink with yellow and pink washes. For further analysis of this drawing, see Solberg (1991), pp. 862–5.

56. For the commission of 30 June 1407, see ASS, Consistoro, 248, fol. 29r. For further discussion of this painted scheme and its relevance to the politics of the day, see Martindale (1995), pp. 40–5.

57. ASS, Concistoro, 243, fol. 1r. A fellow representative for the *terzo* of San Martino was the woodworker, Barna di Turino.

58. In June 1401, he was commissioned to paint six *storie* and six Old Testament figures over the door of the sacristy and between 1404 and 1405 frescoes in the chancel of the cathedral. Now lost, they were probably scenes from the Old Testament (for which, see Solberg, 1991, pp. 142–8, 162–5, 167–173, 866–8, 1240–3). On 21 July 1401 (ASS, Concistoro, 222, fol. 11v) he also received a commission to paint, by August, a predella for an altar panel in the chapel of the palace and residence of the priors. It is likely that this was for the altarpiece of the Cappella dei Nove on the ground floor of the Palazzo Pubblico. For further discussion of the latter commission, see n. 74, and Solberg (1991), pp. 148–9, 1244–50.

59. Solberg (1991), pp. 174, 177, 971. For the Pisan frescoes themselves, which were executed between 1395 and 1397, see ibid., pp. 728–68.

60. Southard (1980), 1, p. 333; Eisenberg (1981), p. 139. By the eighteenth century the chapel had also become the location for the annual celebration of the feast of the Patrocinio di Maria on 22 September, for which see Gigli (1723) ed. 1854/1974, 2, p. 257. The celebration of this feast in the chapel still continues today.

61. As graphically described in Jacobus de Voragine's account of the Feast of the Assumption in the *Golden Legend*, ed. 1969, pp. 449–65. See also Southard (1980), 1, pp. 328–34.

62. For the last painting in the series, I have adopted the descriptive title used by Solberg (1991). The painting does not depict a conventional *Assumption of the Virgin* where the Virgin is portrayed as a heavenly apparition in the company of angels. The *Ascension*, used by Southard (1980), 1, p. 332, or the *Resurrection of the Virgin*, used by Eisenberg (1981), p. 139, both neglect the presence of Christ actively assisting at this miraculous event.

63. For a thorough discussion of the extent to which Taddeo di Bartolo imitated his earlier Pisan frescoes, see Solberg (1991), pp. 971–4, 1005–6, 1008.

64. He also displayed his topographical skills in his altarpiece of *Saint Geminianus and Scenes from His Life* which portrays the saint holding a remarkably accurate model of the town of San Gimignano on his lap. For discussion of the accuracy of this representation of the town, see Solberg (1991), pp. 139–40, 839–40; Norman (1995g), pp. 165–7.

65. Symeonides (1965), p. 116; Southard (1980), 1, p. 331.

66. Solberg (1991), pp. 1006–7, specifically suggests that it may be intended to evoke the proposed design for the Duomo Nuovo, although, since these ambitious plans had proved unsuccessful, it seems unlikely that the Sienese authorities would have wished to draw attention to this failed scheme.

67. Solberg (1991), p. 1007. For a more cautious assessment of the painted city's resemblance to Siena, see Southard (1980), 1, p. 327; and Hook (1979), p. 93.

68. Solberg (1991), p. 973, also notes that the Virgin faces the direction of the altar.

69. Solberg (1991), p. 972, simply suggests that the Virgin is oriented towards the spectator entering the chapel.

70. All that survives of the painting in the Cappella dei Nove is the *Virgin Annunciate* which is attributed to Bartolo di Fredi and his workshop, for which see Southard (1980), 1, p. 149–53; and Freuler (1994), pp. 324–32, 491–2 (cat. no. 77). For the relevance of the Annunciation theme for the Cappella dei Signori, see Solberg (1991), pp. 1003–4.

71. Southard (1980), 1, p. 58, remarking on the frequent representation of these two saints in the Palazzo Pubblico frescoes, suggests that they were chosen because they enunciated the principle of subordination of the individual to the common good. Although the painted texts of Simone Martini's *Maestà* and Ambrogio Lorenzetti's Sala dei Nove frescoes provide evidence of the concern of Siena's governors with such issues, it is by no means clear why Saints Peter and Paul should also be particularly associated with them.

72. The evidence for this altarpiece is scrupulously rehearsed in Eisenberg (1981). It can be found in ASS, Concistoro, 497, fol. 27r (16 December 1448, published in Borghesi and Banchi, 1898, p. 162, no. 96; Eisenberg, 1981, appendix 1, p. 147) which records the decision to make a wooden canopy and predella for an altarpiece with 'beautiful figures' which 'brought fame to the chapel' but which was in danger of ruin, and in Concistoro 2462, fol. 72v–73r (24 December 1448, published in Milanesi, 1854–6, 2, pp. 256–58, no. 183; Eisenberg, 1981, appendix 2, pp. 147–8) which presents the painter and woodworker with a highly detailed description of the work required. It is the latter document which explicitly refers Sano di Pietro to the paintings on the façade of the Spedale di Santa Maria della Scala as the models for his new predella paintings (for which, see Chapter 5, p. 87). Chigi (1625–6), ed. 1939, p. 311, attributes the chapel's altarpiece to Simone Martini; Pecci (1752), p. 79, names the Virgin as its subject; Faluschi (1784), p. 115, refers to a Virgin with many saints; and Della Valle (1785), 2, p. 88, to 'una tavola ritagliata a piramidi secondo il gusto de'tempi . . .'. All the eighteenth-century sources were describing the altarpiece after its removal from the chapel altar.

73. Boscovits (1974), p. 376, has tentatively proposed that five panel paintings, attributed to Simone Martini, depicting the Virgin and Child with Saints Peter, Andrew, Ansanus and Luke, and now in various North American collections could once have constituted the altarpiece for the chapel. Eisenberg (1981), p. 147, n. 49, rejects Boscovit's proposal, on the plausible grounds that this reconstructed altarpiece would be too small for the chapel setting and would repeat the Saint Peter on the altar wall.

74. Eisenberg (1981), pp. 146–7. Solberg (1991), pp. 175–6, suggests that the 1401 commission to Taddeo di Bartolo for a predella for the Cappella dei Nove (see n. 58) might have been for Simone Martini's altarpiece while it was still standing in that chapel. It is rather odd, however, that forty-seven years later the altarpiece should then be in urgent need of another new predella.

75. Gigli (1723), ed. 1854, 2, p. 257, states that an earlier chapel (and thus altar) indeed existed on this site, and that it was dedicated to Saint Luke, a reference that gains further credibility from the fact that, in order to build the section of the Palazzo Pubblico where the Sala del Consiglio is located, a church dedicated to Saint Luke had to be demolished.

76. The document of 24 December 1448 (cited in note 72), instructs the woodworker not to allow the framework of the altarpiece to obstruct the 'piei del salvatore che corona nostra donna' which strongly implies the presence of a painting of the Coronation of the Virgin over the altarpiece – a point first noted and discussed by Eisenberg (1981), pp. 139–41, and substantiated by Solberg (1991), pp. 177–8, 994, 1002–3.

77. Southard (1980), 1, pp. 340–1.

78. This is particularly evident in the figures of Faith and Justice. Faith is represented with a paten and host in one hand and an amphora in the other, with which she baptises a small, nude figure. Justice is depicted holding a sword and a globe, with castles and land surrounded by water – the latter possibly being a miniature version of Ambrogio Lorenzetti's monumental *Mappamundi* that was once displayed on the west wall of the adjacent Sala del Consiglio.

79. A portrayal of Charity which Ambrogio Lorenzetti also used in his Massa Marittima altarpiece (Pls 133, 135), for which see Chapter 6, p. 124.

80. See Chapter 3, p. 55.

81. Southard (1980), 1, pp. 339–40, identifies a number of these but is sceptical if they ever read as authentic Hebrew texts.

82. Southard (1980), 1, pp. 340–1.

83. Eisenberg (1981), p. 142.

84. Jacobus de Voragine, *Golden Legend*, ed. 1969, pp. 464–5. See also Southard (1980), 1, p. 335–6.

85. Albert Siculus was a Sicilian Carmelite who, although only canonised in 1457, was immediately venerated as a saint after his death in 1307. The Sienese Servite, Giovacchino Piccolomini, attracted much local devotion, particularly at Santa Maria dei Servi where he was buried. Quite apart from these representations of male saints, the arches above the piers dividing the chapel from the Sala del Consiglio are decorated with half-length figures of female saints, together with the civic emblem of the *balzana*.

86. Gigli (1723) ed. 1854, 2, p. 258, who describes how the clergy involved were obliged to sing masses for twelve days at the hours assigned to them by Siena's governors.

87. Solberg (1991), pp. 989–91. See also, Tommasi (1625–6) ed. 1973, pt 2, bk 7, pp. 65–6; and Della Valle (1785), 2, p. 191.

88. Solberg (1991), pp. 987–9.

89. Gigli (1723) ed. 1854, 2, pp. 545–6; see also the reference to the celebration made in Malavolti (1599) ed. 1982, pt 2, bk 10, p. 195ᵛ.

EPILOGUE

1. The act of dedication of 1944 is formally recorded on a piece of decorated parchment which is currently displayed in a glass case to the left of the entrance to the Cappella del Voto in the cathedral (Pl. 37).

2. See, most recently, Maginnis (1997), p. 183, who, whilst paying tribute to the stylistic variety of fourteenth-century Sienese painting, argues that Sienese painters deliberately 'forged a culture of retrospection that would eventually find its final flowering in the quattrocento versions of early trecento compositions, primarily in the work of Giovanni di Paolo and Sassetta'.

SELECT BIBLIOGRAPHY

Acta Sanctorum, ed. J. Carnandet et al., 62 vols, Paris and Rome, 1863–75.

ADEMOLLO, L., *I monumenti medioevali e moderni della provincia di Grosseto*, Grosseto, 1894.

ALESSI, C., 'La Crocifissione di Giovanni di Paolo', in *Lecceto* (1990), pp. 309–14.

AMES-LEWIS, F., *Tuscan Marble Carving 1250–1350: Sculpture and Civic Pride*, Aldershot and Brookfield (Vermont), 1997.

ANGELINI, A., 'I restauri di Pietro di Francesco agli affreschi di Ambrogio Lorenzetti nella "Sala della Pace"', *Prospettiva*, 31 (1982), pp. 78–82.

L'Anonimo Magliabechiano (c. 1537–42), ed. A. M. Ficarra, Naples, 1968.

'Antiquiores quae extant definitiones Capitulorum Generalium Ordinis', *Analecta Augustiniana*, 3 (1909–10), pp. 150–5; 4 (1911–12), pp. 177–83.

ARBESMANN, R. (ed.), 'Henry of Freimar's "Treatise on the origin and development of the Order of the Hermit Friars and its true and real title"', *Augustiniana*, 6 (1956), pp. 37–145.

ARBESMANN, R., 'A Legendary of early Augustinian Saints', *Analecta Augustiniana*, 29 (1966), pp. 5–58.

Archivio dell'Ospedale di Santa Maria della Scala. Inventario, eds G. Cantucci and U. Morandi, 2 vols, Rome, 1960–2.

L'Archivio Comunale di Montalcino, eds P. G. Morelli, S. Moscadelli and C. Santini, 2 vols, Siena, 1989–90.

L'Archivio Storico Comunale di Massa Marittima, ed. S. Soldatini, Siena, 1996.

ARONOW, G., 'A description of the altars in Siena cathedral in the 1420s', in Van Os (1984–90), 2, pp. 225–42.

L'art gothique siennois: enluminure, peinture, orfèvrerie, sculpture (catalogue of exhibition, Avignon, Musée du Petit Palais, 1983), Florence, 1983.

Art in the Making: Italian Painting before 1400 (catalogue of exhibition, London, National Gallery, 1989–90), London, 1989.

Arte senese nella Maremma grossetana (catalogue of exhibition, Grosseto, 1964), ed. E. Carli, Grosseto, 1964.

ASCHERI, M., *Siena nel Rinascimento: istituzioni e sistema politico*, Siena, 1985.

ASCHERI, M., 'Siena in the Fourteenth Century: State, Territory and Culture', in *The Other Tuscany*, eds T. W. Blomquist and M. F. Mazzaoui, Kalamazoo, Michigan (1994), pp. 163–97.

ASHTON, M., 'Segregation in Church', in *Women in the Church*, eds W. J. Sheils and D. Woods, *Studies in Church History*, 27 (1990), pp. 237–94.

BACCI, P., 'Una tavola inedita e sconosciuta di Luca di Tommè con alcuni documenti ignorati della sua vita', *Rassegna d'arte senese*, 1 (1927), pp. 31–62.

BACCI, P., 'Il pittore Mattia Preti a Siena', *Bullettino senese di storia patria*, n.s. 2 (1931), pp. 1–16.

BACCI, P., *Dipinti inediti e sconosciuti di Pietro Lorenzetti, Bernardo Daddi ecc. in Siena e nel contado*, Siena, 1939.

BACCI, P., *Fonti e commenti per la storia dell'arte senese*, Siena, 1944.

BAGNOLI, A., 'I tempi della *Maestà*. Il restauro e le nuove evidenze', in *Simone Martini: atti del convegno* (1988), pp. 109–18.

BALESTRACCI, D., and PICCINNI, G., *Siena nel trecento. Assetto urbano e strutture edilizie*, Florence, 1977.

BALESTRACCI, D., and PICCINNI, G., 'L'Ospedale e la città', in Gallavotti Cavallero (1985), pp. 19–42.

BANCHI, L., *I Rettori dello Spedale di Santa Maria della Scala di Siena*, Bologna, 1877.

BARCUCCI, E., *Il Trittico dell'Assunta nella Cattedrale di Montepulciano*, Montepulciano, 1991.

BARDOTTI BIASION, G., 'Gano di Fazio e la tomba-altare di Santa Margherita da Cortona', *Prospettiva*, 37 (1984), pp. 2–19.

BARTALINI, R., 'Goro di Gregorio e la tomba del giurista Guglielmo di Ciliano', *Prospettiva*, 41 (1985), pp. 21–38.

BASCAPÉ, G. C., *Sigillografia*, 3 vols, Milan, 1969–1984.

BEATSON, E. H., MULLER, N. E., STEINHOFF, J. B., 'The St. Victor Altarpiece in Siena Cathedral: A Reconstruction', *Art Bulletin*, 68 (1986), pp. 610–31.

BELLOSI, L., 'Jacopo di Mino del Pellicciaio', *Bollettino d'Arte*, 17 (1972), pp. 73–7.

BELLOSI, L., ' "Castrum pingatur in palatio" 2. Duccio e Simone Martini pittori di castelli senesi "a l'esemplo come erano"', *Prospettiva*, 28 (1982), pp. 41–65.

BELLOSI, L., 'Gano a Massa Marittima', *Prospettiva*, 37 (1984), pp. 19–22.

BELLOSI, L., 'Per l'attività giovanile di Bartolo di Fredi', *Antichità viva*, 24 (1985), pp. 21–6.

BELTING, H., *Die Oberkirche von San Francesco in Assisi*, Berlin, 1977.

BELTING, H., 'The New Role of Narrative in Public Painting of the Trecento: *Historia* and Allegory', *Studies in the History of Art*, 16 (1985), pp. 151–68.

BENCI, S., *Storia di Montepulciano*, Florence, 1646, ed. I. Calabresi, Verona, 1968.

BENEDICTIS, C. DE, *La pittura senese 1330–1370*, Florence, 1979.

BENNETT, B. A., '*Lippo Memmi, Simone Martini's "Fratello in Arte"*: The Image Revealed by His Documented Works', (Ph.D. thesis, University of Pittsburgh, 1977), Ann Arbor, 1979.

BENTON, T., 'The design of Siena and Florence Duomos', in Norman (1995), 2, pp. 129–43.

BERENSON, B., *Italian Pictures of the Renaissance*, Oxford, 1932.

BERENSON, B., *Italian Pictures of the Renaissance: Central Italian and North Italian Schools*, 3 vols, London, 1957–68.

Bibliotheca Sanctorum, 12 vols, Vatican City, 1961–9.

BORGHESI, S., and BANCHI, L., *Nuovi documenti per la storia dell'arte senese*, Siena, 1898.

BORGIA, L., et al., *Le Biccherne: tavole dipinte delle magistrature senesi (secoli XIII–XVIII)*, Rome, 1984.

BORSOOK, E., 'The Frescoes at San Leonardo al Lago', *Burlington Magazine*, 98 (1956), pp. 351–8.

BORSOOK, E., *Ambrogio Lorenzetti*, Italian translation by P. Bertolucci, Florence, 1966.

BORSOOK, E., *Gli affreschi di Montesiepi*, Florence, 1969.

BORSOOK, E., *The Mural Painters of Tuscany*, 2nd ed., Oxford, 1980.

BORTOLOTTI, L., *Siena*, in *Le città nella storia d'Italia*, ed. C. De Seta, 2nd ed., Rome and Bari, 1987.

BOSKOVITS, M., 'A Dismembered Polyptych, Lippo Vanni and Simone Martini', *Burlington Magazine*, 116 (1974), pp. 367–76.

BOWSKY, W. M., 'The Impact of the Black Death upon Sienese Government and Society', *Speculum*, 39 (1964), pp. 1–34.

BOWSKY, W. M., 'Medieval Citizenship: The Individual and the State in the Commune of Siena, 1287–1355', *Studies in Medieval and Renaissance History*, 4 (1967), pp. 193–243.

BOWSKY, W. M., *The Finance of the Commune of Siena, 1287–1355*, Oxford, 1970.

BOWSKY, W. M., 'City and Contado: Military Relationships and Communal Bonds in Fourteenth-Century Siena', in *Renaissance Studies in Honor of Hans Baron*, eds A. Molho and J. A. Tedeschi, Florence (1971), pp. 75–98.

BOWSKY, W. M., *A Medieval Italian Commune: Siena under the Nine, 1287–1355*, Berkeley, Los Angeles, London, 1981.

BRANDI, C., 'Reintegrazione di Bartolo di Fredi', *Bullettino senese di storia patria*, n.s. 2 (1931), pp. 206–10.

BRANDI, C., *La Regia Pinacoteca di Siena*, Rome, 1933.

BRANDI, C., 'Il restauro della Madonna di Coppo di Marcovaldo nella Chiesa dei Servi di Siena', *Bollettino d'Arte*, 35 (1950), pp. 160–70.

BRANDI, C., and CARLI, E., 'Relazione sul restauro della Madonna di Guido da Siena del 1221', *Bollettino d'Arte*, 36 (1951), pp. 248–60.

BRAUNFELS, W., *Mittelalterliche Stadtbaukunst in der Toskana*, Berlin, 1979.

'Bullarium Ordinis Eremitarum S. Augustini. Periodus formationis 1187–1256', ed. B. van Luijk, *Augustiniana*, 12 (1962), pp. 161–95, 358–90; 13 (1963), pp. 474–510; 14 (1964), pp. 216–49.

BUSH, L. E., 'Pinnacles from a polyptych', *Los Angeles County Museum of Art Bulletin*, 15 (1963), pp. 3–12.

BUTZEK, M., 'Die Papstmonumente im Dom von Siena', *Mitteilungen des kunsthistorischen Institutes in Florenz*, 24 (1980), pp. 15–78.

BUTZEK, M., et al., 'S. Agostino' in *Die Kirchen von Siena* (1985), pp. 1–254.

CAGNOLA, G., 'Di un quadro poco noto del Lorenzetti', *Rassegna d'arte*, 2 (1902), p. 143.

CAIROLA, A., and CARLI, E., *Il Palazzo Pubblico di Siena*, Rome, 1963.

CALABRESI, I., 'Montepulciano e il suo territorio nel medio-evo', in Benci (1646), ed. 1968, pp. 275–92.

CALABRESI, I., *Montepulciano nel Trecento: contributi per la storia giuridica e istituzionale*, Siena, 1987.

CALECA, A., and FANUCCI LOVITCH, M., 'Due nuovi documenti sull'attività artistica a Pisa: Giovanni Pisano (1307), Goro di Gregorio (1326)', *Bollettino storico pisano*, 60 (1991), pp. 77–86.

Il Caleffo Vecchio del Comune di Siena, ed. G. Cecchini et al., 5 vols, Florence, 1931–91.

CAMMAROSANO, P., and PASSERI, V., *I Castelli del Senese: strutture fortificate dell'area senese-grossetana*, Milan and Siena, 1985.

CÄMMERER-GEORGE, M., *Die Rahmung der toskanischen Altarbilder im Trecento*, Strassburg, 1966.

CANESTRELLI, A., *L'Abbazia di S. Galgano*, Florence, 1895; republished Pistoia, 1989.

CANESTRELLI, A., *L'Abbazia di S. Antimo*, Siena, 1910–12; republished Castelnuovo dell'Abate-Montalcino, 1987.

CANNON, J., 'Simone Martini, the Dominicans and the Early Sienese Polyptych', *Journal of the Warburg and the Courtauld Institutes*, 45 (1982), pp. 69–93.

CANNON, J., 'The Creation, Meaning and Audience of the Early Sienese Polyptych: Evidence from the Friars', in *Italian Altarpieces 1250–1550: Function and Design*, eds E. Borsook and F. Superbi Gioffredi, Oxford, 1994, pp. 41–79.

CANNON, J., 'Marguerite et les Cortonais: iconographie d'un "culte civique" au XIVᵉ siècle', in *La religion civique à l'époque médiévale et moderne*, ed. A. Vauchez, Rome, 1995, pp. 403–13.

Capitoli della Compagnia dei Disciplinati di Siena de'secoli XIII, XIV, e XV, ed. L. Banchi, Siena, 1866.

CARLI, E., *Il pulpito di Siena*, Bergamo, 1943.

CARLI, E., *Goro di Gregorio*, Florence, 1946 (1946a).

CARLI, E., *Vetrata duccesca*, Florence, 1946 (1946b).

CARLI, E., 'Ancora dei Memmi a San Gimignano', *Paragone*, 159 (1963), pp. 27–44.

CARLI, E., 'Ricuperi e restauri senesi III – Affreschi della seconda metà del Trecento', *Bollettino d'Arte*, 51 (1966), pp. 178–82.

CARLI, E., *Lippo Vanni a San Leonardo al Lago*, Florence, 1969.

CARLI, E., *L'Arte a Massa Marittima*, Siena, 1976.

CARLI, E., 'Le sculture del coro del Duomo di Siena', *Antichità viva*, 17 (1978), pp. 25–39.

CARLI, E., *Il Duomo di Siena*, Genoa, 1979.

CARLI, E., *La Pittura Senese del Trecento*, Milan, 1981.

CARLI, E., 'Sculture senesi del Trecento tra Gano, Tino e Goro', *Antichità viva*, 29 (1990), pp. 26–39.

CARLI, E., *Simone Martini. La Maestà*, Milan, 1996.

CARLI, E., and CECCHINI, G., *San Gimignano*, Milan, 1962.

CARNIANI, A., *I Salimbeni quasi una signoria: tentativi di affermazione politica nella Siena del '300*, Siena, 1995.

CASTALDI, E., *Santo Bartolo, il Giob della Toscana*, Florence, 1928.

CASTELNUOVO, E., et al., *Ambrogio Lorenzetti: Il Buon Governo*, Milan, 1995.

CATONI, G., and FALASSI, A., *Palio*, Milan, 1983.

CECCARINI, I., *San Gimignano: Palazzo Comunale*, San Gimignano, 1983.

CECCHINI, G., 'Le grance dell'Ospedale di S. Maria della Scala in Siena', *Economia e Storia*, 6 (1959), pp. 405–22.

CECCHINI, G., 'Palio and Contrade: Historical Evolution' (1958). Translated from the Italian by E. Borghese, republished in Catoni and Falassi (1983), pp. 309–58.

CESARETTI, A., *Serie cronologica de'vescovi della diocesi di Populonia e Massa Marittima con documenti e memorie a'medesimi appartenenti*, Florence, c. 1770.

CHERUBINI, G., 'Proprietari, contadini e campagne senesi all'inizio del Trecento', in *Signori, contadini, borghesi*, Florence (1974), pp. 231–311.

CHIGI, F., 'L'Elenco delle pitture, sculture e architetture di Siena compilato nel 1625–26', ed. P. Bacci, *Bullettino senese di storia patria*, n.s.10 (1939), pp. 197–213, 297–337.

CHITTOLINI, G., 'Civic Religion and the Countryside in Late Medieval Italy', in *City and Countryside in Late Medieval and Renaissance Italy*, eds T. Dean and C. Wickham, London and Ronceverte (1990), pp. 69–80.

CHRISTIANSEN, K., 'The S. Vittorio Altarpiece in Siena Cathedral', letter to the editor (re: Beatson et al., 1986), *Art Bulletin*, 69 (1987), p. 467.

CHRISTIANSEN, K., et al., *Painting in Renaissance Siena, 1420–1500* (catalogue of exhibition, New York, Metropolitan Museum of Art, 1988–9), New York, 1988.

CIACCI, G., *Gli Aldobrandeschi nella storia e nella "Divina Commedia"*, 2 vols, Rome, 1935.

CINELLI, G., *Le bellezze della città di Firenze*, Florence, 1677.

COCONI, S., 'L'espansione della Repubblica di Siena nella Maremma e la Sottomissione di Massa Marittima', Ph.D. thesis, Università degli Studi, Florence, 1947–8.

COHN, S. K. Jr., *Death and Property in Siena, 1205–1800*, Baltimore and London, 1988.

COLE, B., 'Old in New in the Early Trecento', *Mitteilungen des kunsthistorischen Institutes in Florenz*, 17 (1973), pp. 229–48.

COLETTI, L., 'The Early Works of Simone Martini', *Art Quarterly*, 12 (1949), pp. 291–308.

CONSOLINO, F. E. (ed.), *I santi patroni senesi fra agiografia e iconografia. Atti di un seminario*, Siena, 1991.

Il constituto del comune di Siena dell'anno 1262, ed. L. Zdekauer, Milan, 1897.

COOR-ACHENBACH, G., 'A Visual Basis for the Documents relating to Coppo di Marcovaldo and His Son Salerno', *Art Bulletin*, 28 (1946), pp. 233–47.

COOR-ACHENBACH, G., 'Contribution to the Study of Ugolino di Nerio's Art', *Art Bulletin*, 37 (1955), pp. 153–65.

CORDARO, M., 'Le vicende costruttive', in *Il Palazzo Pubblico* (1983), pp. 29–146.

CORNICE, A., 'Gli affreschi di Lippo Vanni', in *Lecceto* (1990), pp. 287–308.

CORRIE, R. W., 'The Political Meaning of Coppo di Marcovaldo's Madonna and Child in Siena', *Gesta*, 29 (1990), pp. 61–75.

COSCARELLA, G., and FRANCHI, F. C., *La Grancia di Cuna in Val d'Arbia, un esempio di fattoria fortificata medievale*, Florence, 1983.

COSCARELLA, G., and FRANCHI, F. C., 'Le grance dello Spedale di Santa Maria della Scala nel contado senese', *Bullettino senese di storia patria*, 3rd series, 92 (1985), pp. 66–92.

Il costituto del comune di Siena volgarizzato nel MCCCIX–MCCCX, ed. A. Lisini, 2 vols, Siena, 1903.

Cronache senesi, in *Rerum Italicarum Scriptores*, eds A. Lisini and F. Iacometti, n.s. 15, 6, Bologna, 1931–39.

CUNNINGHAM, C., 'For the honour and beauty of the city: the design of town halls', in Norman (1995), 2, pp. 29–53.

DALE, S., 'Ambrogio Lorenzetti's *Maestà* at Massa Marittima', *Source*, 2 (1989), pp. 6–11.

DAVIDSOHN, R., *Forschungen zur älteren Geschichte von Florenz*, 4 vols, Berlin, 1896–1908.

DAVIES, M., *The Early Italian Schools before 1400*, revised by D. Gordon, London, 1988.

'De antiquis ordinis eremitarum Sancti Augustini bibliothecis', ed. D. Gutiérrez, *Analecta Augustiniana*, 23 (1954), pp. 213–17.

DERBES, A., *Picturing the Passion in Late Medieval Italy: Narrative Painting, Franciscan Ideologies and the Levant*, Cambridge, 1996.

DEUCHLER, F., *Duccio*, Milan, 1984.

'Diffinitiones capituli generalis de Senis', *Acta Augustiniana*, 4 (1911–12), pp. 177–83.

DONATI, F., 'Il Palazzo del Comune di Siena: notizie storiche', *Bullettino senese di storia patria*, 11 (1904), pp. 311–54.

DOUGLAS, L., *A History of Siena*, London, 1902.

DUNDES, A., and FALASSI, A., *La Terra in Piazza: An Interpretation of the Palio of Siena*, Berkeley, Los Angeles, and London, 1975.

EISENBERG, M., 'The first altar-piece for the "Cappella de'Signori" of the Palazzo Pubblico in Siena: "... tales figure sunt adeo pulchre ..." ', *Burlington Magazine*, 123 (1981), pp. 134–48.

ELM, K., 'Neue Beiträge zur Geschichte des Augustiner-Eremitenordens im 13. und 14. Jahrhundert', *Archiv für Kulturgeschichte*, 42 (1960), pp. 357–87.

EPSTEIN, S., *Alle origini della fattoria toscana: L'Ospedale della Scala di Siena e le sue terre (metà '200–metà '400)*, Florence, 1986.

FALUSCHI, G., *Breve relazione delle cose notabili della città di Siena*, Siena, 1784.

FELDGES, U., *Landschaft als topographisches Porträt: Der wiederbeginn der europäischen Landschaftsmalerei in Siena*, Bern, 1980.

FELDGES-HENNING, U., 'The Pictorial Programme of the Sala dei Pace: A New Interpretation', *Journal of the Warburg and the Courtauld Institutes*, 35 (1972), pp. 145–62.

FIUMI, E., *Storia economica e sociale di San Gimignano*, Florence, 1961.

FREDERICK, K., 'A Program of Altarpieces for the Siena Cathedral', *Rutgers Art Review*, 4 (1983), pp. 18–35.

FREDERICK, K., 'A Program Completed: The Identification of the San Vittorio Altarpiece', in W. Clark et al., *Tribute to Lotte Brand Philip: Art Historian and Detective*, New York, 1985, pp. 57–63.

FREDERICK, K., 'The dating of Simone Martini's S. Ansano altar-piece: a re-examination of two documents', *Burlington Magazine*, 131 (1989), pp. 468–9 (1989a).

FREDERICK, K., letter to the editor (re: Beatson et al., 1986), *Art Bulletin*, 71 (1989), pp. 128–31 (1989b).

FREULER, G., 'L'altare Cacciati di Bartolo di Fredi nella chiesa di San Francesco a Montalcino', *Arte Cristiana*, 73 (1985), pp. 149–66 (1985a).

FREULER, G., 'Bartolo di Fredis Altar für die Annunziata-Kapelle in S. Francesco in Montalcino', *Pantheon*, 43 (1985), pp. 21–39 (1985b).

FREULER, G., *Biagio di Goro Ghezzi a Paganico*, Florence, 1986 (1986a).

FREULER, G., 'Lippo Memmi's New Testament cycle in the Collegiata in San Gimignano', *Arte Cristiana*, 79 (1986), pp. 93–102 (1986b).

FREULER, G., *Bartolo di Fredi Cini*, Disentis, 1994.

FREYHAN, R., 'The Evolution of the Caritas Figure in the Thirteenth and Fourteenth Centuries', *Journal of the Warburg and Courtauld Institutes*, 11 (1948), pp. 68–86.

FRINTA, M. S., 'Stamped haloes in the *Maestà* of Simone Martini' in *Simone Martini* (1988), pp. 139–45.

FRUGONI, C., *A Distant City: Images of Urban Experience in the Medieval World* (1983). Translated from the Italian by W. McCuaig, Princeton, 1991.

FRUGONI, C., *Pietro and Ambrogio Lorenzetti* (1988). Translated from the Italian by L. Pelletti, Antella (Florence), 1991.

FUMI, E., *Guida di Montepulciano* (1894), reprinted Montepulciano, 1989.

GAGLIARDI, I., 'Le reliquie dell'Ospedale di Santa Maria della Scala (XIV–XV secolo)', in *L'Oro di Siena* (1996), pp. 49–66.

Galantuomini e Birboni. Il 1700 a Massa Marittima: riflessioni e testimonianze, eds V. Galliani and M. Sozzi, Carmignano, 1991.

GALLAVOTTI CAVALLERO, D., *Lo Spedale di Santa Maria della Scala in Siena: vicenda di una committenza artistica*, Pisa, 1985.

GALLAVOTTI CAVALLERO, D., 'Pietro, Ambrogio e Simone, 1335, e una questione di affreschi perduti', *Prospettiva*, 48 (1987), pp. 69–74.

GARDNER, J., 'The Stefaneschi Altarpiece: A Reconsideration', *Journal of the Warburg and Courtauld Institutes*, 37 (1974), pp. 57–103.

GARDNER, J., 'Guido da Siena, 1221 and Tommaso da Modena', *Burlington Magazine*, 121 (1979), pp. 107–8.

GARDNER, J., 'Some Franciscan Altars of the Thirteenth- and Fourteenth-Centuries', in *The Vanishing Past: Studies of Medieval Art, Liturgy and Metrology presented to Christopher Hohler*, eds A. Borg and A. Martindale, Oxford, 1981, pp. 29–38.

GARDNER VON TEUFFEL, C., 'The Buttressed Altarpiece: A Forgotten Aspect of Tuscan Fourteenth-Century Altarpiece Design', *Jahrbuch der Berliner Museen*, 21 (1979), pp. 21–65.

GARDNER VON TEUFFEL, C., review of Van Os, vol. 1 (1984–90), *Burlington Magazine*, 127 (1985), p. 391.

GARMS, J., 'Graber von Heiligen und Seligen', in *Skulptur und Grabmal des spätmittelalters in Rom und Italien: Akten des Kongress Sculptura e monumento sepolcrale del tardo Medio Evo a Roma e in Italia* (Rome, 1985), eds J. Garms and A. M. Romanini, Vienna, 1990, pp. 83–105.

GARRISON, E., 'Sienese Historical Writings and the Dates 1260, 1221, 1262 applied to Sienese Paintings', in *Studies in the History of Medieval Painting*, 4 vols, Florence, 1953–62, 4, pp. 23–58 (1960a).

GARRISON, E., 'Towards a New History of the Siena Cathedral Madonnas' in *Studies in the History of Medieval Painting*, 4 vols, Florence, 1953–62, 4, pp. 5–22 (1960b).

GHIBERTI, L., *I commentari* (c. 1447–55), ed. O. Morisani, Naples, 1947.

GHISI, F., 'An Angel Concerto in a Sienese Fresco', in *Aspects of Medieval and Renaissance Music: A Birthday Offering to Gustave Raese*, New York (1966), pp. 308–13.

GIGLI, G., *Diario sanese* (1723), 3 vols, Siena, 1854, reprinted Bologna, 1974.

GOFFEN, R., *Piety and Patronage in Renaissance Venice: Bellini, Titian and the Franciscans*, New Haven and London, 1986.

GORDON, D., 'A Perugian provenance for the Franciscan double-sided altarpiece by the Maestro di S. Francesco', *Burlington Magazine*, 124 (1982), pp. 70–7.

GORDON, D., 'Martini shaken and stirred', review of Martindale (1988), *Art History*, 12 (1989), pp. 370–3.

GORDON, D., 'Simone Martini's Altar-piece for S. Agostino, San Gimignano', *Burlington Magazine*, 133 (1991), p. 771.

GREENSTEIN, J. M., 'The vision of peace: meaning and representation in Ambrogio Lorenzetti's *Sala della pace* cityscapes', *Art History*, 11 (1988), pp. 492–510.

GUTIÉRREZ, D., *Los Agustinos en la edad media, 1256–1356*, vol. 1, part 1, Rome, 1980.

HACKETT, M. B., 'The Medieval Archives of Lecceto', *Analecta Augustiniana*, 40 (1977), pp. 16–45.

HACKETT, B., 'Cinque eremi agostiniani nei dintorni di Siena', in *Lecceto* (1990), pp. 45–72.

HAGER, H., *Die Anfänge des italienischen Altarbildes: Untersuchung der zur Enstehungsgeschichte des toskanischen Hochaltarretabels*, Munich, 1962.

HARPRING, P., *The Sienese Trecento Painter Bartolo di Fredi*, London and Toronto, 1993.

HIBBARD, H., 'A Representation of *Fides* by Ambrogio Lorenzetti', *Art Bulletin*, 39 (1957), pp. 137–8.

HOENIGER, C., *The Renovation of Paintings in Tuscany, 1250–1500*, Cambridge, 1995.

HOOK, J., *Siena: A City and its History*, London, 1979.

HUECK, I., 'Le matricole dei pittori fiorentini prima e dopo il 1320', *Bollettino d'Arte*, 57 (1972), pp. 114–21.

HUMFREY, P., *The Altarpiece in Renaissance Venice*, New Haven and London, 1993.

HYDE, J. K., *Society and Politics in Medieval Italy: The Evolution of the Civil Life, 1000–1350*, London, 1973.

IMBERCIADORI, J. V., *Fina dei Ciardi: un simbolo nella realtà storica e sociale di San Gimignano*, San Gimignano, 1979.

JACOBUS DE VORAGINE, *The Golden Legend*, translated G. Ryan and H. Ripperger, New York, 1969.

JONES, P., *The Italian City-State: From Commune to Signoria*, Oxford, 1997.

JORDAN OF SAXONY, *Liber Vitasfratrum*, eds R. Arbesmann and W. Hümpfner, New York, 1943.

KAFTAL, G., *Iconography of the Saints in Tuscan Painting*, Florence, 1952.

KANTER, L. B., 'A *Massacre of the Innocents* in the Walters Art Gallery', *Journal of the Walters Art Gallery*, 41 (1983), pp. 17–27.

KEMPERS, B., *Painting, Power and Patronage: The Rise of the Professional Artist in Renaissance Italy* (1987). Translated from the Dutch by B. Jackson, London, 1992.

KEMPERS, B., 'Icons, Altarpieces and Civic Ritual in Siena Cathedral, 1100–1530', in *City and Spectacle in Medieval Europe*, eds B. A. Hanawalt and K. L. Reyerson, Minneapolis and London, 1994, pp. 89–136.

Die Kirchen von Siena, eds P. A. Riedl and M. Seidel, 'Abbadia all'Arco – S. Biagio', Vol. 1.1, Munich, 1985.

KRAUTHEIMER, R., and KRAUTHEIMER-HESS, T., *Lorenzo Ghiberti*, 3rd ed., Princeton, 1982.

KREYTENBERG, G., 'Das Grabmal von Kaiser Heinrich VII in Pisa', *Mitteilungen des kunsthistorischen Institutes in Florenz*, 28 (1984), pp. 33–64.

KUPFER, M., 'The Lost Wheel Map of Ambrogio Lorenzetti', *Art Bulletin*, 78 (1996), pp. 286–310.

KURZE, W., 'Il monastero di San Salvatore al Monte Amiata e la sua proprietà terriera', in *L'abbazia di San Salvatore al Monte Amiata*, eds W. Kurze and C. Prezzolini, Florence (1988), pp. 1–38.

KURZE, W., *Monasteri e nobiltà nel Senese e nella Toscana medievale*, Siena, 1989.

Lecceto e gli eremi agostiniani in terra di Siena, Milan, 1990.

LEONCINI, A., *I tabernacoli di Siena: arte e devozione popolare*, Siena, 1994.

LEONE DE CASTRIS, P., *Simone Martini: catalogo completo dei dipinti*, Florence, 1989.

LIBERATI, A., 'Chiese, monasteri, oratori e spedali senesi (ricordi e memorie)', *Bullettino senese di storia patria*, 3rd series, 20 (1961), pp. 263–74.

LIGHTBOWN, R. W., *Donatello and Michelozzo: An Artistic Partnership and its Patrons in the Early Renaissance*, 2 vols, London, 1980.

LOMBARDI, E., *Massa Marittima e il suo territorio nella storia e nell'arte*, Siena, 1985.

LOMBARDI, E., *Massa Marittima*, 1986.

LUIJK, B. VAN, *Gli eremiti neri nel Dugento, con particolare riguardo al territorio pisano e toscano: origine, sviluppo ed unione*, Pisa, 1968.

LUIJK, B. VAN, *Le monde augustinien du XIII^e au XIV^e siècle*, translated by E. J. J. van Duuren, Assen, 1972.

LUSINI, V., 'San Domenico in Camporegio', *Bullettino senese di storia patria*, 13 (1906), pp. 263–95.

LUSINI, V., *La basilica di Santa Maria dei Servi in Siena*, Siena, 1908.

LUSINI, V., *Il Duomo di Siena*, 2 vols, Siena, 1911–39.

MAGINNIS, H. B. J., 'The "Guidoriccio" Controversy: Notes and Observations', *Revue d'art canadienne (Canadian Art Review)*, 15 (1988), pp. 137–44 (1988a).

MAGINNIS, H. B. J. 'The Lost Façade Frescoes from Siena's Ospedale di S. Maria della Scala', *Zeitschrift für Kunstgeschichte*, 51 (1988), pp. 180–94 (1988b).

MAGINNIS, H. B. J., 'Chiarimenti documentari: Simone Martini, i Memmi e Ambrogio Lorenzetti', *Rivista d'arte*, 41 (1989), pp. 3–23.

MAGINNIS, H. B. J., 'Ambrogio Lorenzetti's *Presentation in the Temple*', *Studi di storia dell'arte*, 2 (1991), pp. 33–50.

MAGINNIS, H. B. J., *Painting in the Age of Giotto: A Historical Reevaluation*, University Park, Pennsylvania, 1997.

MALAVOLTI, O., *Dell'historia di Siena*, Venice, 1599, reprinted Bologna, 1982.

MALLORY M., and MORAN, G., 'New evidence concerning "Guidoriccio"', *Burlington Magazine*, 128 (1986), pp. 250–9.

MANCINI, G., *Considerazioni sulla pittura* (c. 1626), ed. A. Marchucci, vol. 1, Rome, 1956.

MARCUCCI, L., *Gallerie Nazionali di Firenze. I dipinti toscani del secolo XIV*, Rome, 1965.

MARTINDALE, A., 'Painting for pleasure – some lost fifteenth century secular decorations of Northern Italy', in *The Vanishing Past. Studies of Medieval Art, Liturgy and Metrology presented to Christopher Hohler*, eds A. Borg and A. Martindale, Oxford, 1981, pp. 109–31.

MARTINDALE, A., 'The problem of "Guidoriccio"', *Burlington Magazine*, 128 (1986), pp. 259–73.

MARTINDALE, A., *Simone Martini*, Oxford, 1988.

MARTINDALE, A., 'The Pope in the Palace: The Alexander Cycle, Siena', *History Today*, 45 (1995), pp. 40–5.

MARTINES, L., *Power and Imagination: City States in Renaissance Italy*, 2nd ed., London, 1980.

MASSAI, S., *La Selva del Lago: il bosco di Siena nel Medioevo*, Siena, 1998.

MEISS, M., *Painting in Florence and Siena after the Black Death* (1951), Princeton, 1978.

MEISS, M., 'Light as Form and Symbol in Some Fifteenth-Century Paintings' (1945), republished in *The Painter's Choice: Problems in the Interpretation of Renaissance Art*, New York (1976), pp. 3–18.

MIDDELDORF KOSEGARTEN, A., 'Zur Bedeutung der Sieneser Domkuppel', *Münchner Jahrbuch der bildenden Kunst*, 21 (1970), pp. 73–98.

MIDDELDORF KOSEGARTEN, A., *Sienesische Bildhauer am Duomo Vecchio: Studien zur Skulptur in Siena 1250–1330*, Munich, 1984.

MILANESI, G., *Documenti per la storia dell'arte senese*, 3 vols, Siena, 1854–6.

MINA, G. A., 'Studies in Marian Imagery: Servite Spirituality and the Art of Siena (c. 1261–c. 1328)', Ph.D. thesis, University of London, Courtauld Institute of Art, 1993.

MONGELLAZ, J., 'Reconsidération de la distribution des rôles à l'intérieur du groupe des Maîtres de la Sacristie de la cathédrale de Sienne', *Paragone*, 36 (1985), pp. 73–89.

MONNAS, L., 'Dress and Textiles in the St. Louis Altarpiece: New Light on Simone Martini's Working Practice', *Apollo*, 137 (1993), pp. 166–74.

Montalcino: immagini e memorie, ed. Circolo ARCI-Casa del Popolo di Montalcino, Sinalunga, 1986.

MORAN, G., and SEYMOUR, C., 'The Jarves Saint Martin and the Beggar', *Yale University Art Gallery Bulletin*, 31 (1967), pp. 28–39.

MOSKOWITZ, A. F., *Nicola Pisano's Arca di San Domenico and its Legacy*, University Park, Pennsylvania, 1994.

Mostra di opere d'arte restaurate nelle province di Siena e Grosseto, 3 vols, Genoa, 1979–83.

MUCCIARELLI, R., *I Tolomei banchieri di Siena: la parabola di un casato nel XIII e XIV secolo*, Siena, 1995.

MULLER, N. E., 'Reflections in a Mirror: Ambrogio Lorenzetti's Depiction of the Trinity', *Art Bulletin*, 61 (1979), pp. 101–2.

Museo archeologico della Collegiata di Casole d'Elsa, eds G. C. Cianferoni and A. Bagnoli, Florence, 1996.

Museo civico e diocesano d'arte sacra di Montalcino, ed. A. Bagnoli, Siena, 1997.

NARDI, L. et al., 'Il territorio per la festa dell'Assunta: patti e censi di Signori e Comunità dello Stato', in *Siena e il suo territorio nel Rinascimento*, eds M. Ascheri and D. Ciampoli, Siena (1986), pp. 81–249.

NICOLA, G. DE, 'Una copia di Segna di Tura della *Maestà* di Duccio', *L'Arte*, 15 (1912), pp. 21–32.

NORMAN D., 'The Succorpo in the Cathedral of Naples: "Empress of all Chapels"', *Zeitschrift für Kunsgeschichte*, 49 (1986), pp. 323–55.

NORMAN, D., 'The Commission for the Frescoes of Montesiepi', *Zeitschrift für Kunstgeschichte*, 57 (1993), pp. 289–300.

NORMAN, D. (ed.), *Siena, Florence and Padua: Art, Society and Religion 1280–1400*, 2 vols, New Haven and London, 1995.

NORMAN, D., 'City, *contado* and beyond: artistic practice', in Norman (1995), 1, pp. 29–47 (1995a)

NORMAN, D., '"A noble panel": Duccio's *Maestà*', in Norman (1995), 2, pp. 55–81 (1995b).

NORMAN, D., '"Love justice you who judge the earth": the paintings of the Sala dei Nove in the Palazzo Pubblico, Siena', in Norman (1995), 2, pp. 145–67 (1995c).

NORMAN, D., '"Those who pay, those who pray, those who paint": two funerary chapels' in Norman (1995), 2, pp. 169–93 (1995d).

NORMAN, D., '"Hail most saintly Lady": change and continuity in Marian altar-pieces', in Norman (1995), 2, pp. 195–215 (1995e).

NORMAN, D., '"In the Beginning was the Word": An Altarpiece by Ambrogio Lorenzetti for the Augustinian Hermits of Massa Marittima', *Zeitschrift für Kunstgeschichte*, 58 (1995), pp. 478–503 (1995f).

NORMAN, D., 'The Case of the *Beata* Simona: Iconography, Hagiography and Misogyny in Three Paintings by Taddeo di Bartolo', *Art History*, 18 (1995), pp. 154–84 (1995g).

NORMAN, D., 'Pisa, Siena and the Maremma: A Neglected Aspect of Ambrogio Lorenzetti's Paintings in the Sala dei Nove', *Renaissance Studies*, 11 (1997), pp. 310–57.

OFFNER, R., et al. *A Critical and Historical Corpus of Florentine Painting*, New York, 1930–81.

Ordo Officiorum Ecclesiae Senensis (1215), ed. J. C. Trombelli, Bologna, 1766.

L'Oro di Siena. Il Tesoro di Santa Maria della Scala (catalogue of exhibition held in Siena, Ospedale di Santa Maria della Scala, Siena, 1996–9), ed. L. Bellosi, Milan and Siena, 1996.

OS, H. W. VAN, 'A Choir Book by Lippo Vanni', *Simiolus*, 2 (1967–8), pp. 117–33.

OS, H. W. VAN, *Marias Demut und Verherrlichung in der sienesischen Malerei 1300–1450*, The Hague, 1969.

OS, H. W. VAN, 'Lippo Vanni as a Miniaturist', *Simiolus*, 7 (1974), pp. 67–90 (1974a)

OS, H. W. VAN, 'Saint Francis of Assisi as a Second Christ in Early Italian Painting', *Simiolus*, 7 (1974), pp. 115–32 (1974b)

OS, H. W. VAN, *Vecchietta and the Sacristy of the Siena Hospital Church*, The Hague, 1974 (1974c).

OS, H. W. VAN, 'Tradition and Innovation in Some Altarpieces by Bartolo di Fredi', *Art Bulletin*, 67 (1985), pp. 50–66.

OS, H. W. VAN, *Sienese Altarpieces 1215–1460*, 2 vols, Groningen, 1984–90.

Il Palazzo Pubblico in Siena: vicende, costruttive e decorazione, ed. C. Brandi, Milan, 1983.

PECCI, G. A., *Relazione delle cose più notabili della città di Siena*, Siena, 1752.

PECCI, G. A., *Memorie storiche della Città di Montalcino* (1759–61), ed. Circolo ARCI Montalcino, Sinalunga, 1987.

PECORI, L., *Storia della terra di San Gimignano*, Florence, 1853, reprinted Rome, 1975.

PERKINS, F. M., 'Di alcune opere poco note di Ambrogio Lorenzetti', *Rassegna d'arte*, 4 (1904), pp. 186–90 (1904a)

PERKINS, F. M., 'The forgotten masterpiece of Ambrogio Lorenzetti', *Burlington Magazine*, 5 (1904), pp. 81–4 (1904b)

PERRIG, A., 'Formen der politischen Propaganda der Kommune von Siena in der ersten Trecento-Hälfte', in *Bauwerk und Bildwerk im Hochmittelalter*, eds K. Clausberg et al., Giessen, 1981, pp. 213–34.

PETROCCHI, L., *Massa Marittima. Arte e storia*, Florence, 1900.

PETROCCHI, L., 'Cattedrale di Massa Marittima: l'altare maggiore, lavoro di Flaminio Del Turco, Senese', *Bullettino senese di storia patria*, 11 (1904), pp. 637–43.

PICCINNI, G., 'I "villani incittadinati" nella Siena del XIV secolo', *Bullettino senese di storia patria*, 3rd series, 82–3 (1975–6), pp. 158–219.

PICCINNI, G., 'L'Ospedale di Santa Maria della Scala e la città di Siena nel Medioevo', in *L'Oro di Siena* (1996), pp. 39–47.

PIERINI, M., *L'arca di San Cerbone*, Massa Marittima, 1995.

PIETRAMELLARA, C., *Il Duomo di Siena*, Florence, 1980.

PINO, F. A. DAL, 'I Servi di S. Maria a Siena', in *Mélanges de l'École Française de Rome*, 89 (1977), pp. 749–55.

PLOEG, K. VAN DER, 'Architectural and Liturgical Aspects of Siena Cathedral in the Middle Ages', in Van Os (1984–90), 1, pp. 105–56.

PLOEG, K. VAN DER, *Art, Architecture and Liturgy: Siena Cathedral in the Middle Ages*, Groningen, 1993.

POLZER, J., 'The Technical Evidence and the Origin and Meaning of Simone Martini's *Guidoriccio* Fresco in Siena', *Revue d'art canadienne (Canadian Art Review)*, 12 (1985), pp. 143–8.

POPE-HENNESSY, J., and LIGHTBOWN, R., *Catalogue of Italian Sculpture in the Victoria and Albert Museum*, 3 vols, London, 1964.

PREISER, A., *Das Entstehen und die Entwicklung der Predella in der italienischen Malerei*, Hildesheim and New York, 1973.

PREVITALI, G., 'Il possibile Memmo di Filippuccio', *Paragone*, 155 (1962), pp. 3–11.

PROCACCI, U., *Sinopie e affreschi*, Milan, 1961.

RADAN, G., 'Out of the Cave: Excavations at San Leonardo al Lago in Tuscany', *Patristic, Medieval and Renaissance Studies*, 5 (1980), pp. 83–105.

RADAN, G., 'Gli eremi nell'area senese: una prospettiva archeologica', in *Lecceto* (1990), pp. 73–95.

REDON, O., *Uomini e comunità del contado senese nel duecento*, Siena, 1982.

REDON, O., 'L'eremo, la città e la foresta', in *Lecceto* (1990), pp. 9–43.

REDON, O., 'Il Comune e le sue frontiere', in *Storia di Siena* (1995), pp. 27–40 (1995a).

REDON, O., 'Le Comunità del contado', in *Storia di Siena* (1995), pp. 55–68 (1995b).

REPETTI, E., *Dizionario geografico, fisico, storico della Toscana*, 5 vols, Florence, 1833–45.

RIEDL, H. P., *Das Maestà-Bild in der Sieneser Malerei des Trecento*, Tübingen, 1991.

ROMAGNOLI, E., *Cenni storico-artistici di Siena e suoi suburbi*, Siena, 1840, reprinted Bologna, 1990.

ROTH, E., 'Cardinal Richard Annibaldi: First Protector of the Augustinian Order 1243–1276', *Augustiniana*, 2 (1952), pp. 26–60, 108–49, 230–47; 3 (1953), pp. 21–34, 283–313; 4 (1954), pp. 5–24.

ROWLANDS, D., 'The date of Simone Martini's arrival in Avignon', *Burlington Magazine*, 107 (1965), pp. 25–6.

ROWLEY, G., *Ambrogio Lorenzetti*, Princeton, 1958.

SALIMEI, F., *I Salimbeni di Siena*, Rome, 1986.

SANTI, B., 'Massa Marittima', in *Guida storico-artistica alla Maremma*, ed. B. Santi, Siena, 1995, pp. 27–47.

SCHEVILL, F., *Siena: The History of a Medieval Commune*, London, 1909.

SCHOTTMÜLLER, F., 'Sassettas Gemälde: Die Messe des Hl. Franz', *Amtliche Berichte aus des Königlichen Kunstsammlungen*, 31 (1910), col. 145–48.

SCHULTZE, J., 'Ein Dugento-Altar aus Assisi?', *Mitteilungen des kunsthistorischen Institutes in Florenz*, 10 (1961), pp. 59–66.

'La sconfitta di Montaperto secondo il manoscritto di Niccolò di Giovanni di Francesco Ventura' (1442–3), in *Miscellanea storica sanese* ed. G. Porri (Siena), 1844, pp. 3–98.

Scultura dipinta maestri di legname e pittori a Siena 1250–1450 (catalogue of exhibition, Siena, Pinacoteca Nazionale, 1987), Florence, 1987.

SEIDEL, M., 'Die Verkündigungsgruppe der Sieneser Domkanzel, *Münchner Jahrbuch der bildenden Kunst*, 21 (1970), pp. 18–72.

SEIDEL, M., 'Die Fresken des Ambrogio Lorenzetti in S. Agostino', *Mitteilungen des kunsthistorischen Institutes in Florenz*, 22 (1978), pp. 185–252.

SEIDEL M., ' "Castrum pingatur in palatio" I. Ricerche storiche e iconografiche sui castelli dipinti nel Palazzo Pubblico di Siena', *Prospettiva*, 28 (1982), pp. 17–41.

SEIDEL, M., 'Ikonographie und Historiographie: "Conversatio Angelorum in Silvis", Eremiten-Bilder von Simone Martini und Pietro Lorenzetti', *Städel-Jahrbuch*, 10 (1985), pp. 77–142.

SEIDEL, M., 'Condizionamento iconografico e scelta semantica: Simone Martini e la tavola del Beato Agostino Novello', in *Simone Martini: atti del convegno* (1988), pp. 75–80.

SHEARER, C., *The Renaissance of Architecture in Southern Italy. A Study of Frederick II of Hohenstaufen and the Capua Triumphator Archway and Towers*, Cambridge, 1935.

Siena e il Senese, ed. M. Ausenda, Milan, 1996.

Simone Martini e "chompagni" (catalogue of exhibition, Siena, Pinacoteca, 1985), eds A. Bagnoli and L. Bellosi, Florence, 1985.

Simone Martini: atti del convegno (Siena, 1985), ed. L. Bellosi, Florence, 1988.

SKAUG, E., 'Notes on the Chronology of Ambrogio Lorenzetti and a New Painting from his Shop', *Mitteilungen des kunsthistorischen Institutes in Florenz*, 20 (1976), pp. 301–32.

SKINNER, Q., 'Ambrogio Lorenzetti: The Artist as Political Philosopher', *Proceedings of the British Academy*, 72 (1986), pp. 1–56.

SOLBERG. G., 'Taddeo di Bartolo: his life and work', Ph.D. thesis, New York University, 1991.

SOUTHARD, E. C., *The Frescoes in Siena's Palazzo Pubblico, 1289–1539: Studies in Imagery and Relations to Other Communal Palaces in Tuscany* (Ph.D. thesis, Indiana University, Michigan, 1978), 2 vols, Ann Arbor, 1980.

STARN, R., 'The republican regime of the "Room of Peace" in Siena, 1338–40', *Representations*, 18 (1987), pp. 1–32.

STARN, R., and PARTRIDGE, L., *Arts of Power: Three Halls of State in Italy, 1300–1600*, Berkeley, Los Angeles and Oxford, 1992.

Statuti volgari de lo Spedale di Santa Maria Vergine di Siena, scritti l'anno MCCCV, ed. L. Banchi, Siena, 1864.

Statuto del Comune di Montepulciano (1337), ed. U. Morandi, Florence, 1966.

'Statuto dello Spedale di Santa Maria di Siena, 1318–1379', in vol. 3 of *Statuti senesi scritti in volgare ne'secoli XIII e XIV*, ed. L. Banchi, Bologna, 1877.

STEINHOFF-MORRISON, J., 'Bartolommeo Bulgarini and Sienese Painting of the Mid-Fourteenth Century', Ph.D. thesis, Princeton University, 1989.

Storia di Siena: dalle origini alla fine della Repubblica, eds R. Barzanti, G. Catoni, M. De Gregorio, vol. 1, Siena, 1995.

STRNAD, A. A., 'Francesco Todeschini-Piccolomini: Politik und Mäzenatentum im Quattrocento', *Römische historische Mitteilungen*, 8–9 (1964–6), pp. 101–425.

STUBBLEBINE, J. H., *Guido da Siena*, Princeton, 1964.

STUBBLEBINE, J. H., 'Duccio's *Maestà* of 1302 for the Chapel of the Nove', *Art Quarterly*, 35 (1972), pp. 239–68.

STUBBLEBINE, J. H., *Duccio di Buoninsegna and His School*, 2 vols, Princeton, 1979.

SWARZENSKI, G., 'A Sienese Bookcover of 1364', *Bulletin of Museum of Fine Arts*, 88 (1950), pp. 44–6.

SYMEONIDES, S., *Taddeo di Bartolo*, Siena, 1965.

TARGIONI TOZZETTI, G., *Relazioni d'alcuni viaggi fatti in diverse parti della Toscana*, 12 vols, Florence, 1768–79.

TINTORI, L., ' "Golden tin" in Sienese murals of the early trecento', *Burlington Magazine*, 124 (1982), pp. 94–5.

TORRITI, P., *Tutta Siena Contrada per Contrada*, Florence, 1988.

TORRITI, P., *La Pinacoteca Nazionale di Siena*, 3rd. ed., Genoa, 1990.

TOMMASI, G., *Dell'historie di Siena*, Venice, 1625–6, reprinted Bologna, 1973.

TREXLER, R., 'Florentine Religious Experience: The Sacred Image', *Studies in the Renaissance*, 19 (1972), pp. 7–41.

UGURGIERI AZZOLINI, I., *Le pompe sanesi*, 2 vols, Pistoia, 1649.

Umanesimo e Rinascimento a Montepulciano (catalogue of exhibition, Montepulciano, 1994) ed. A. Sigillo, Montepulciano, *c.* 1994.

VALLE, G. DELLA, *Lettere sanesi*, vol. 2, Rome, 1785.

VASARI, G., *Le vite de'più eccellenti pittori, scultori, e architettori*, (1550, 1568) eds R. Bettarini and P. Barocchi, Florence, 1966–.

VAUCHEZ, A., 'Il comune di Siena, gli Ordini Mendicanti e il culto dei santi. Storia e insegnamento di una crisi (novembre 1328–aprile 1329)', 1977, republished in *Ordini mendicanti e società italiana XIII–XV secolo*, Milan (1990), pp. 194–205.

VOLPE, C., *Pietro Lorenzetti*, ed. M. Lucco, Milan, 1989.

WADDING, L., *Annales Minorum seu Trium Ordinum a S. Francisco Istitutorum*, 6 vols., Lyons, 1625–48.

WAINWRIGHT, V. L., 'Andrea Vanni and Bartolo di Fredi: Sienese Painters in their Social Context', Ph.D. thesis, University of London, 1978.

WALEY, D., *The Italian City-Republics*, 3rd ed., London and New York, 1988.

WALEY, D., *Siena and the Sienese in the Thirteenth Century*, Cambridge, 1991.

WEBB, D., *Patrons and Defenders: The Saints in the Italian City States*, London and New York, 1996.

WEISSMAN, R. 'Taking Patronage Seriously: Mediterranean Values and Renaissance Society', in *Patronage, Art and Society in Renaissance Italy*, eds F. W. Kent and P. Simons, Oxford, 1987, pp. 25–45.

WESSELOW, T. DE, 'The Decoration of the West Wall of the Sala del Mappamondo in Siena's Palazzo Pubblico', M. A. dissertation, University of London, Courtauld Institute of Art, 1995.

WHITE, J., *The Birth and Rebirth of Pictorial Space* (1957), 3rd ed., London, 1972.

WHITE, J., *Duccio: Tuscan Art and the Medieval Workshop*, London, 1979.

WHITE, J., *Art and Architecture in Italy: 1250–1400*, 3rd ed., New Haven and London, 1993.

WILSON, B., *Music and Merchants: The Laudesi Companies of Republican Florence*, Oxford, 1992.

INDEX

Works of art are listed under names of artists. Where attributions are not known, works are listed under locations. Names that contain reference to parentage or place of origin or principal activity are listed under first names. Other names are listed under family names. Pages on which illustrations appear are italicised.

PHOTOGRAPHIC ACKNOWLEDGEMENTS

Fabio Lensini, Siena 1, 2, 5, 6, 10, 11, 12, 13, 14, 15, 16, 17, 18, 19, 20, 23, 25, 28, 33, 34, 35, 36, 37, 38, 39, 44, 45, 46, 47, 49, 51, 52, 53, 54, 55, 56, 59, 60, 61, 63, 64, 65, 66, 67, 68, 69, 71, 72, 74, 81, 84, 87, 90, 91, 95, 98, 99, 104, 115, 116, 117, 120, 121, 123, 124, 125, 126, 127, 128, 129, 133, 134, 135, 136, 137, 138, 139, 140, 141, 142, 143, 147, 148, 149, 150, 151, 152, 153, 154, 155, 156, 157, 158, 159, 160, 161, 162, 163, 164, 165, 166, 172, 176, 177, 178, 179, 180, 181, 184, 185, 186, 187, 189, 190, 191, 193, 194, 195, 196, 197, 198, 199, 200, 201, 202, 203, 204, 205, 206, 207, 208, 210, 211, 212, 213, 214, 215, 216, 217, 218, 219, 220; Author 3, 9, 97, 101, 103, 113, 118, 119, 144, 167, 168, 169, 171; ©Tim Benton 4, 8, 21, 22, 29, 31, 43, 48, 50, 62; D. Waley, *Siena and the Sienese in the Thirteenth Century*, Cambridge, 1991: 7; K. van der Ploeg, *Art, Architecture and Liturgy: Siena Cathedral in the Middle Ages*, Groningen, 1993: 24, 30, 32, 42; Staatliche Museen Preussischer Kulturbesitz Gemäldegalerie, Berlin 26, 27; Soprintendenza per i Beni Ambientali, Architettonici, Artistici, Storici, per le province di Pisa, Livorno, Lucca, Massa-Carrara 40, 209; Biblioteca Apostolica Vaticana, Vatican City 41, 58; *Siena e il Senese*, Touring Club Italiano, Milan, 1996: 57, 102; *Simone Martini: atti del convegno*, Florence, 1988: 70; H. van Os, *Sienese Altarpieces 1215–1460*, Groningen, 1984–90, volume 2: 73; Scala, Antella (Florence): 75, 77, 92, 93, 94, 109, 114; Harvard University Art Museums, Cambridge, Massachusetts 76; Statens Museum for Kunst, Copenhagen 78, 79; ©Réunion des musées nationaux, Paris 80; National Gallery, London 82; Ursula Edelmann, Frankfurt am Main 83; Author and The Open University, Milton Keynes 85, 86, 88; Norman Muller 89; Sächsische Landesbibliothek, Abteil Deutsche Fotothek, Dresden 96, 110, 111, 112; *L'Oro di Siena: Il Tesoro di Santa Maria della Scala*, Milan and Siena, 1996: 100; The University of Michigan Museum of Art, Ann Arbor 105; Archivio Fotografico, Sacro Convento, Assisi 106; Archivio Fotografico, Monumenti Musei e Gallerie Pontificie, Vatican City 107, 108; D. Negri, *Chiese romaniche in Toscana*, Pistoia, 1978: 122; Fratelli Alinari, Florence 130, 131; ©1998 Board of Trustees, National Gallery of Art, Washington D.C.: 132; *Lecceto e gli eremi agostiniani in terra di Siena*, Milan, 1990: 145, 146; Ministero per i Beni Culturali e Ambientali di Archivio di Stato, Siena, n. 334/1998: 170; G. Freuler, *Bartolo di Fredi Cini*, Disentis, 1994: 173, 174, 175, 188; Los Angeles County Museum of Art, Los Angeles 182, 183; The Metropolitan Museum of Art, New York 192.